Sculpture in Stone and Bronze

Additions to the Collections of Greek, Etruscan, and Roman Art 1971–1988

in the Museum of Fine Arts, Boston

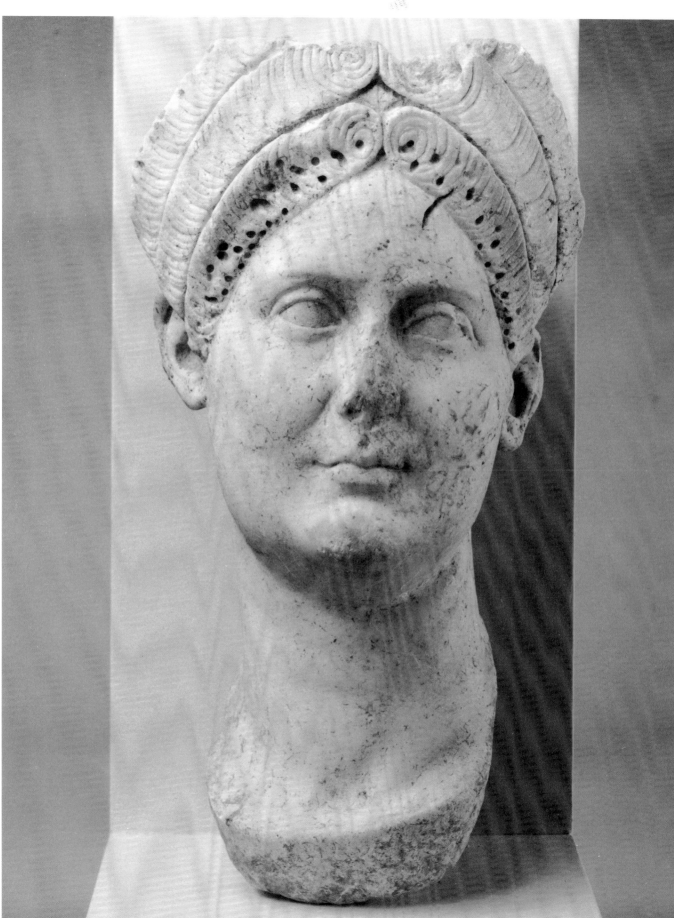

Sculpture in Stone and Bronze

Additions to the Collections of Greek, Etruscan, and Roman Art 1971–1988

in the Museum of Fine Arts, Boston

CORNELIUS C. VERMEULE III (Catalogue)
and
MARY B. COMSTOCK (Bibliography)

with contributions by
Ariel Herrmann, John J. Herrmann, Jr., Emily T. Vermeule,
and Florence Z. Wolsky

Museum of Fine Arts

Boston

Copyright © 1988
by the Museum of Fine Arts
Boston, Massachusetts
Library of Congress catalogue
card no. 88–60106
ISBN 0–87846–264–3
Typeset, printed, and bound in U.S.A. by
Meriden-Stinehour Press
Meriden, Connecticut, and Lunenburg, Vermont
Designed by Carl Zahn

*This publication was made possible, in part,
through a grant from the J. Paul Getty Trust. In
addition, gifts from the following have been
made toward the publication: Esther D.
Anderson, Leon Levy, Dr. Josephine L. Murray,
and Maurice Tempelsman*

Frontispiece:
FRAGMENT OF STATUE: ULPIA MATIDIA AUGUSTA,
NIECE OF TRAJAN, MOTHER-IN-LAW OF HADRIAN
(born about 60, died 119)
Roman Imperial, carved ca. 90, hair recarved
about 110 and again after 119.
Asia Minor marble; H: 0.36 m.
Mary S. and Edward J. Holmes Fund. 1988.327

Cover:
BUST OF ELAGABALUS (218–222)
Carved in August–September 219, probably
in a workshop in Rome
Cloudy crystalline marble, probably from
southwestern Asia Minor; H (max.): 0.71 m.
H (of face): 0.23 m.
Mary S. and Edward J. Holmes Fund. 1977.337

Contents

Acknowledgments

The first words of thanks are to the former director, Jan Fontein, with whose guidance, support, and scholarly observations these additions were made. William B. Osgood (Vice-President and Chairman of the Trustees' Committee on the Collections), his successor in the chair, Stephen D. Paine, Mrs. E. Ross Anderson (also a Vice-President and current Trustee Chairman of the Visiting Committee to the Department of Classical Art), and their Trustee colleagues during the years in question have seen these works of art into the Museum of Fine Arts. M. Linda Thomas (Museum Registrar) and her colleagues, as in years past, handled the sometimes-difficult tasks of import and initial recording.

All major purchases passed through an extensive process of examination in the Research Laboratory, which, under William J. Young, Edward V. Sayre, Lambertus van Zelst, and Arthur Beale, dealt with problems of examination, conservation, and restoration or remounting. Pamela A. England, Merville E. Nichols, Margaret A. Leveque, Jean-Louis Lachevre, and Richard M. Newman deserve thanks in connection with all this work. Successive Museum photographers and their collaborators have prepared most of the pictures, although several were taken in European studios before the sculptures reached Boston. The most recent in Boston are the work of Alan B. Newman and his colleagues, John D. Woolf, John C. Lutsch, Thomas P. Lang, and Joseph E. Logue. The addition of these new Museum negative numbers to the bibliographic information on each sculpture, both in stone and in bronze, was suggested by Janice Sorkow. In the Department of Publications, thanks are due Judy Spear for editing the manuscript and Carl F. Zahn for his design.

Each member of the Department of Classical Art has contributed in some way to this supplement. Mary B. Comstock has written basic descriptions, kept published references up to date, and compiled the massive bibliography that forms the second section of this publication. John J. Herrmann, Jr., has composed texts for various purposes that are incorporated into these entries. He is preparing a detailed publication of sculptures (nos. 29 and 41) and paintings from the villa near Contrada Bottaro along the Bay of Naples. Florence Z. Wolsky has also described pieces for the Museum's permanent inventory and has both edited and provided research for the entries in this catalogue. Emily T. Vermeule, Ariel Herrmann, and Miriam G. Braverman have contributed expertise and support.

Expressions of gratitude must go to the donors of a number of these sculptures. Gifts were often made with a view to the educational importance of the works of art, and reaction from the Gallery Instructors in the Department of Education has been of continuing value. The members of the Department of Classical Art have fitted the sculptures into the current designs of the galleries, as laid out by Museum designers Carl F. Zahn, Duncan Smith and, more recently, T. J. Wong.

Two curatorial colleagues at the Harvard University Art Museums, David Gordon Mitten and Amy Brauer, offered much help in preparing this book for publication. In the Development Office of the Museum of Fine Arts, Janet H. Spitz, Elizabeth W. Lilly, and Charles L. Taggart provided assistance, as did Sandra Knudsen Morgan and Arthur A. Houghton III at the J. Paul Getty Museum in Malibu, California.

Introduction

The Museum's holdings of Greek, Etruscan, and Roman art in stone (marble, limestone, and related materials) and in bronze were published in two books in 1976 and 1971, respectively. The 152 additional works in this supplement, following the divisions of the earlier volumes, were chosen to round out an already-comprehensive collection. Pieces bearing the names of private foundations or individuals are almost without exception destined for permanent addition to the Museum.

Sculpture in Stone

Among the earliest works included are four Cycladic pieces: a complete "idol" (no. 2), a fragment of one of the rare "double-decker" figures (no. 3), a big bucket-shaped vessel (no. 4), and a pyxis or circular box with a lid (no. 5). The fourth century B.C. is well documented with Attic funerary stelai (nos. 8–9) and also with an Attic votive relief to Artemis and Apollo or a Deme (no. 10), carved about the year of the death of Alexander the Great. Several unusual Hellenistic works (including nos. 12 and 16) are originals of the period, as are fragments of a Tarentine votive or sepulchral relief (no. 13) with Herakles restraining Cerberus in the presence of Artemis Bendis (only her torch remains).

The entire sweep of Greek sculpture from Pheidias through Lysippos (roughly 440 to 320 B.C.) is strengthened in aesthetic and chronological terms with the addition of Graeco-Roman adaptations as well as undoubted Greek reliefs of the time of Alexander the Great or slightly later. Sculptural creations of the Roman era used to be judged solely for their faithfulness to lost originals in whatever materials—gold and ivory or bronze or marble—but in recent decades they have been prized for their own qualities as sculptures or for their elaborations and variations on the masters' original compositions.

The so-called Roman copies range from a reduced-scale Athena Parthenos after Pheidias (no. 19) through the Eros of Centocelle in the traditions of Praxiteles (no. 20) to a version of the Weary Herakles (Farnese Hercules) after Lysippos (no. 22) acquired in conjunction with Leon Levy. The acquisition of this formidable triumvirate was particularly auspicious because Boston's collections have always been weak in what can be termed relatively complete statues, there being all too many heads without bodies and bodies bereft of heads. Both the Athena and the Eros not only exhibit considerable completeness in themselves but add or confirm details of the originals not surviving in other replicas.

The same desire for complete statues, rather than just heads or just torsos, led to the acquisition of two small Aphrodites, one leaning against a pillar and holding the golden apple of the Judgment of Paris in her extended right hand (no. 25) and a later figure—Aphrodite Anadyomene—wringing seawater from her tresses (no. 24). In an age when plaster casts have all but disappeared and labor costs are high, one of the advantages of having complete small statues becomes obvious: they can be moved around with ease and displayed in juxtaposition with one another. (Boston's classical benefactor Edward Perry Warren recognized the value of small statues long ago, when he bought for the Museum a tabletop-sized marble Myronian Herakles [no. S139] and a similar Ephesian Apoxyomenos [no. S155], the true Lysippic statuary type.) The largest and the most complete statue acquired in recent years is a draped figure of the empress Sabina, Hadrian's consort (no. 48) of about 136.

Roman portraits span the centuries from the emperor Domitian (A.D. 81–96) to the fall of the Roman Empire in the Latin West. Domitian as Hercules (no. 45) is the form of idealization that emperor brought from the Hellenistic East to the Rome area when it was still premature in the traditional Latin world, still unacceptable to the Roman Senate. If a helmeted head of Ares-Mars after a cult statue by Leochares at Halicarnassus (no. 21) is counted as an ideal likeness of Hadrian (117–138), then the number of Imperial portraits is increased. One of the finest portraits in this supplement is a very Roman, very official togate bust of the unfortunate emperor Marcus Aurelius Antoninus, better known as Elagabalus (no.

51), who reigned from 218 to 222. The limits of Roman portraiture were reached in the late fifth century with the head and neck (designed for insertion into a draped statue or a bust) of a high official from the Latin West (no. 52).

A head of a boy as the resting Dionysos (no. 47) from a statue based on the Lycian Apollo of Praxiteles deserves special mention in this introduction. At the time the portrait was acquired, a slender marble body, like that of the Apollino in Florence,[1] was postulated; a relationship with the Antinous-Dionysos head set on the Apollo with tripod support from the baths at Lepcis Magna was also suggested (see no. 47, n. 1). Publication in the Annual Report of the Museum of Fine Arts and in *Greek and Roman Sculpture in America*[2] called the scholarly world's attention to the head. Fortunately for the history of Roman portraiture and the science of museography, Professor Eugenio La Rocca, Director of the Capitoline Museums, read the publications, recognized the head, and reported the body to be in the storage area of the Museo Capitolino in Rome. The head had been broken off the statue, further mutilated by the vandals, and then sold in Europe. The Museum of Fine Arts acted promptly to return the work to that institution in Rome, where it can be exhibited in perpetuity in its proper context.

The latest group of sculptures (in limestone) are architectural elements from North Syria, spanning the period from 450 to 500 (nos. 54–56). A closure slab from a parapet in the altar area of a church is enriched with a network of knots around rosettes, intricate carving dating from the fifth century. A Corinthian pier capital of about 500 derives from a decorative style developed at the Church of Saint Simeon Stylites under the emperor Zeno (474 to 491), ruler in the East at the time when the Roman Empire was ending in the West. Generous donors concerned also with architectural history in the transition from Rome to Byzantium added a huge Corinthian capital of about 550 that takes the stylization of foliage into the reign of Justinian (527 to 565).

The last entry in *Sculpture in Stone* is an over-life-sized head of a Dacian (no. S465), probably carved in the nineteenth century from a block of porphyry recovered in the ruins of Imperial Rome. The image of the Dacian was related to finds that had been made in the Forum of Trajan in the heart of the city. Another work of the late nineteenth or very early twentieth century is added here to demonstrate skill in forgery after the then-latest discoveries in Late Archaic sculpture. It is a fragment of a head of a youth (no. 58) in imitation of sculptures from the older pediments of the Temple of Aphaia on the island of Aegina. Finally, our understanding of ancient portraiture and its neoclassical revivals may be increased by publication of a bust of a man in the style of about A.D. 315 (no. 60).

Sculpture in Bronze

The bronze birds and animals in the collection give a rich and varied repertoire of statuary in miniature. New additions include a Geometric bird (no. 62), an Archaic bull of rustic, traditional form (no. 63), a ketos, or sea-beast, being tamed by Oceanus (no. 71), an eagle on an altar from the northern coast of Asia Minor (no. 81), and a bear from the mountains of ancient Phoenicia (no. 82). Heads of lions fighting over a ball (no. 88) recall scenes on modern playgrounds where canines frolic. Small sphinxes on columns (no. 90), once the tops of early Classical Greek pins, have all the charm and force of larger counterparts in marble. Mountings in the form of bull's heads from inner Anatolia (nos. 97 and 98) are both sophisticated and primitive in their direct, frontal presentation of powerful animal anatomy. Finally, a table support in the form of a heavily spotted leopard (no. 111) unites the interest in feline curiosities with the best Roman techniques of work in two metals: bronze and silver.

Several works add a touch of lightness to the collections. An Etruscan bronze kouros (no. 87), as the top element of a candelabrum or stand, provides everything the northern Italian provinces saw in the sculpture of Archaic to Early Classical Greece. Mirrors of the Roman period (nos. 94 and 95) give us a message of female beauty and the disciplines of education with erotic overtones. Italians of

the Hellenistic period made forceful and elegant handles for basins (nos. 102 and 103), while Romans terminated the handles of their paterae or pans with the same fierce heads of boars or wolves (no. 104) with which they ornamented their warships and pleasure galleys. A hexagonal bottle of Roman date (no. 107) provides qualities of unusual grace in a culture whose bronze vessels or utensils tended to be heavy and dull.

Throughout the supplement to the MFA catalogue of bronzes runs a common denominator evocative of the unusual from the peripheries of the old Greek and Roman worlds. Dispater from Gaul (no. 65), Horus in armor from Roman Egypt (no. 67), Zeus of Cappadocia (no. 73), Zeus or Jupiter Dolichenus (no. 74), a youthful Mên with features recalling those of Alexander the Great (no. 75), another miniature Mên of canonical type (no. 76), and an eagle from near Aintab (no. 80) all join with a Parthian helmet (no. 120), a steelyard weight of Mount Argaios in Cappadocia (no. 123), and a western Anatolian plaque to Apollo as a rider-god (no. 131) in suggesting the lands where Roman legionaries served on active duty or settled after their military careers. A reclining figure of Oceanus (no. 71) personifies the Mediterranean, across which Roman armies, merchants, and colonists moved in their pursuit of all aspects of the *pax Romana*. A life-sized hand and wrist of a professional boxer (no. 85) comes from an ideal statue of one of those brutal humans who made their living (as long as they survived) going from athletic festival to athletic festival among the cities of Thrace, Macedonia, and Asia Minor.

The most prominent addition is a kalpis with silver inlay (no. 100). This funerary vase of about 340 B.C. was purchased at the initiative of the former director, Jan Fontein, to give Boston its first bronze vessel worthy of the masterpieces shown in the various versions of the exhibition "The Search for Alexander," which toured North America from 1980 to 1983.

In summation, the bronze figures and functional objects catalogued and illustrated here are a mixed collection. They bring additional breadth and depth to the group of creations in metal published in the 1971 catalogue of bronzes in the Museum of Fine Arts.

1. In the Tribune of the Uffizi; see W. Klein, *Praxiteles* (Leipzig, 1898), p. 159, fig. 24.
2. Vermeule, *Sculpture in America*, p. 312, no. 268.

Short Titles

Abbate, *Art*
F. Abbate, ed. *The Art of Classical Greece and the Etruscans* (trans. E. Gordon). London, 1972.

Alvarez, *Celestial*
O. Alvarez. *The Celestial Brides: The Visions of the Eastern Paradise Infiltrate the Mediterranean Afterlife: A Study in Mythology and Archaeology*. Stockbridge, 1978.

Amiet, *Handbook*
P. Amiet, C.D. Noblecourt, A. Pasquier, F. Baratte, and C. Metzger. *Art in the Ancient World: A Handbook of Styles and Forms*. New York, 1981.

Amyx and Forbes, *Echoes*
D.A. Amyx and B.A. Forbes, eds. *Echoes from Olympus: Reflections of Divinity in Small-scale Classical Art*. Berkeley, 1974.

Ancient Greece
Aspects of Ancient Greece. Allentown, Penna.: Allentown Art Museum, 16 September–10 December 1979.

Andreae, *Rome*
B. Andreae. *The Art of Rome*. New York, 1977.

Armstrong, *Mediterranean Spirituality*
A.H. Armstrong, ed. *Classical Mediterranean Spirituality: Egyptian, Greek, Roman*. New York, 1986.

Arnold, *Polykletnachfolge*
D. Arnold. *Die Polykletnachfolge* (*JdI*, suppl. 25). Berlin, 1969.

Art and Technology
S. Doeringer, D.G. Mitten and A. Steinberg, eds. *Art and Technology: A Symposium on Classical Bronzes*. Cambridge, Mass., 1970.

Art for Boston
Art for Boston: A Decade of Acquisitions under the Directorship of Jan Fontein. Boston, 1987.

Babelon and Blanchet, *Bronzes Antiques*
E. Babelon and J.-A. Blanchet. *Catalogue des bronzes antiques de la Bibliothèque Nationale*. Paris, 1895.

Baggio, *Oderzo*
E. Baggio, M. De Min, F. Ghedini, D. Papafava, M. Rigoni, and G. Rosada. *Sculture e mosaici romani del Museo Civico di Oderzo*. Treviso, 1976.

Barr-Sharrar, *Decorative Bust*
B. Barr-Sharrar. *The Hellenistic and Early Imperial Decorative Bust*. Mainz, 1987.

Barron, *Greek Sculpture*
J. Barron. *An Introduction to Greek Sculpture*, rev. ed. New York, 1984.

Bastis Collection
Antiquities from the Collection of Christos G. Bastis. New York, 1987.

Beck, *Ares*
I. Beck. *Ares in Vasenmalerei, Relief und Rundplastik*. Frankfurt, 1984.

Berger, *Parthenon-Kongress*
E. Berger, ed. *Parthenon-Kongress Basel: Referate und Berichte 4. bis 8 April 1982*. Mainz, 1984.

Bergmann, *Römischen Porträt*
M. Bergmann. *Studien zum römischen Porträt des 3. Jahrhunderts n. Chr*. Bonn, 1977.

Bieber, *Antiken Skulpturen*
M. Bieber. *Die antiken Skulpturen und Bronzen des Königl. Museum Fridericianum in Cassel*. Marburg, 1915.

Bieber, *Copies*
M. Bieber. *Ancient Copies: Contributions to the History of Greek and Roman Art*. New York, 1977.

Bieber, *Sculpture*
M. Bieber. *The Sculpture of the Hellenistic Age*. New York, 1961.

Biers, *Greece*
W.R. Biers. *The Archaeology of Greece: An Introduction*. Ithaca and London, 1980.

Boardman, *Archaic*
J. Boardman. *Greek Sculpture: The Archaic Period: A Handbook*. New York and Toronto, 1978.

Boardman, *Classical*
J. Boardman. *Greek Sculpture: The Classical Period: A Handbook*. New York, 1985.

Boardman and La Rocca, *Eros in Greece*
J. Boardman and E. La Rocca. *Eros in Greece*. New York, 1975.

Bol, *Bildwerke*
P.C. Bol. *Bildwerke aus Stein und aus Stuck: Von archaischer Zeit bis zur Spätantike* (Liebieghaus-Museum alter Plastik, Frankfurt-am-Main, *Antike Bildwerke*, vol. 1). Melsungen, 1983.

Bol, *Grossplastik*
P.C. Bol. *Grossplastik aus Bronze in Olympia* (*Olympische Forschungen*, vol. 9). Berlin, 1978.

Bol and Weber, *Bildwerke*
P.C. Bol and T. Weber. *Bildwerke aus Bronze und Bein aus minoischer bis byzantinischer Zeit* (Liebieghaus-Museum alter Plastik, Frankfurt-am-Main, *Antike Bildwerke*, vol. 2). Melsungen, 1985.

Bonanno, *Portraits*
A. Bonanno. *Portraits and other heads on Roman Historical Relief up to the Age of Septimius Severus* (BAR suppl. series 6). Oxford, 1976.

Bonfante, *Etruscan Dress*
L. Bonfante. *Etruscan Dress*. Baltimore and London. 1975.

Boucher, *Lyon Bronzes*
S. Boucher. *Bronzes grecs, hellénistiques et étrusques (sardes ibériques et celtiques) des Musées de Lyon*. Lyon, 1970.

Boucher, *Recherches*
S. Boucher. *Recherches sur les bronzes figurés de Gaule pré-romaine et romaine*. Rome, 1976.

Bowder, *Who was Who*
D. Bowder, ed. *Who was Who in the Greek World: 776 BC–30 BC*. Ithaca, 1982.

Brendel, *Etruscan Art*
O.J. Brendel. *Etruscan Art*. New York, 1978.

Brijder, Drukker, and Neeft, *Enthousiasmos*
H.A.G. Brijder, A.A. Drukker, and C.W. Neeft, eds. *Enthousiasmos: Essays on Greek and Related Pottery Presented to J.M. Hemelrijk*. Amsterdam, 1986.

Brilliant, *Pompeii*
R. Brilliant. *Pompeii, A.D. 79: The Treasure of Rediscovery*. New York, 1979.

Brinkerhoff, *Aphrodite*
D.M. Brinkerhoff. *Hellenistic Statues of Aphrodite: Studies in the History of their Stylistic Development.* New York and London, 1978.

Brommer, *Denkmälerlisten*
F. Brommer. *Denkmälerlisten zur griechischen Heldensage*, vols. 1–3. Marburg, 1971–1976.

Brummer Collection
The Ernest Brummer Collection, Ancient Art, vol. 2. Galerie Koller and Spink & Son, Zurich, 1979.

Bruschetti, *Lampadario*
P. Bruschetti. *Il Lampadario di Cortona.* Cortona, 1979.

Cain, *Marmorkandelaber*
H.-U. Cain. *Römische Marmorkandelaber (Beiträge zur Erschliessung hellenistischer und kaiserzeitlicher Skulptur und Architektur*, vol. 7). Mainz, 1985.

Calza, *Ostia*, vol. 5
R. Calza. *Scavi di Ostia: I ritratti*, pt. 1: *Ritratti greci e romani fino al 160 circa d.C.*, vol. 5. Rome, 1964.

Calza, *Ostia*, vol. 9
R. Calza. *Scavi di Ostia: I ritratti*, pt. 2: *Ritratti romani dal 160 circa alla metà del III secolo d.C.*, vol. 9. Rome, 1978.

Calza, *Villa Doria Pamphilj*
R. Calza et al. *Antichità di Villa Doria Pamphilj.* Rome, 1977.

Capecchi, Lepore, and Saladino, *Poggio Imperiale*
G. Capecchi, L. Lepore, and V. Saladino. *La Villa del Poggio Imperiale.* Rome, 1979.

Caputo and Traversari, *Leptis Magna*
G. Caputo and G. Traversari. *Le sculture del teatro di Leptis Magna.* Rome, 1976.

Carter, *Ivory-Carving*
J.B. Carter. *Greek Ivory-Carving in the Orientalizing and Archaic Periods.* New York and London, 1985.

Carter, *Taras*
J.C. Carter. *The Sculpture of Taras* (TAPS 65, pt. 7, 1975).

Coldstream, *Geometric*
J.N. Coldstream. *Geometric Greece.* New York, 1977.

Colledge, *Palmyra*
M.A.R. Colledge. *The Art of Palmyra.* London, 1976.

Comstock and Vermeule, *Bronzes*
M. Comstock and C. Vermeule. *Greek, Etruscan & Roman Bronzes.* Boston: Museum of Fine Arts, 1971.

Comstock and Vermeule, *Stone*
M. Comstock and C. Vermeule. *Sculpture in Stone: The Greek, Roman and Etruscan Collections.* Boston: Museum of Fine Arts, 1976.

Congdon, *Caryatid Mirrors*
L.O. Keene Congdon. *Caryatid Mirrors of Ancient Greece: Technical, Stylistic and Historical Considerations of an Archaic and Early Classical Bronze Series.* Mainz, 1981.

Cristofani, *Civiltà Arcaica*
M. Cristofani. In P. Santoro, ed. *Civiltà arcaica dei Sabini nella valle del Tevere*, vol. 3. Rome, 1977.

Cristofani, *Etruschi*
M. Cristofani. *I bronzi degli Etruschi.* Novara, 1985.

Cristofani, *Volterra*
M. Cristofani. *Volterra* (NSc, suppl. to vol. 27, 1973).

De Grummond, *Etruscan Mirrors*
N.T. de Grummond, ed. *A Guide to Etruscan Mirrors.* Tallahassee, 1982.

De Puma, *Corpus*
R.D. De Puma. *Corpus Speculorum Etruscorum: U.S.A.*, vol. 1: *Midwestern Collections.* Ames, Iowa, 1987.

De Puma, *Tomb-Groups*
R.D. De Puma. *Etruscan Tomb-Groups: Ancient Pottery and Bronzes in Chicago's Field Museum of Natural History.* Mainz, 1986.

De Ridder, *Bronzes Antiques*
A. de Ridder. *Les Bronzes antiques du Louvre*, vols. 1–2. Paris, 1913–1915.

De'Spagnolis and De Carolis, *MNR Lucerne*
M. de'Spagnolis and E. De Carolis. *Museo Nazionale Romano, I Bronzi*, vol. 4, pt. 1: *Le Lucerne.* Rome, 1983.

Del Chiaro, *Sculpture*
M.A. Del Chiaro. *Classical Art: Sculpture.* Santa Barbara: Santa Barbara Museum of Art, 1984.

Devambez, *Great Sculpture*
P. Devambez (trans. H. Tunikowska). *Great Sculpture of Ancient Greece.* New York, 1978.

Diehl, *Hydria*
E. Diehl. *Die Hydria: Formgeschichte und Verwendung im Kult des Altertums.* Mainz, 1964.

Di Stefano, *Palermo*
C.A. Di Stefano. *Bronzetti figurati del Museo Nazionale di Palermo.* Rome, 1975.

Dohrn, *Etruskische Kunst*
T. Dohrn. *Die etruskische Kunst im Zeitalter der griechischen Klassik: Die Interimsperiode.* Mainz, 1982.

Dörig, *Art Antique*
J. Dörig. *Art Antique: Collections privées de Suisse romande.* Mainz, 1975.

Early Christian
Early Christian and Byzantine Art. Baltimore: Walters Art Gallery, 25 April–22 June, 1947.

Eğilmez, *Artemis*
E.T. Eğilmez. *Darstellungen der Artemis als Jägerin aus Kleinasien* (Inaugural-Dissertation). Mainz, 1980.

Eisenberg, *Ancient World*
J.M. Eisenberg. *Art of the Ancient World.* Vols. 1–2, New York, 1965–1966; vol. 4, New York and Beverly Hills, 1985.

Eisenberg, *Late Egyptian and Coptic*
J.M. Eisenberg. *A Catalog of Late Egyptian and Coptic Sculptures.* New York, 1960.

Enea nel Lazio
Enea nel Lazio: Archeologia e mito. Rome, 1981.

Faison, *New England*
S.L. Faison, Jr. *The Art Museums of New England.* Boston, 1982.

Falconi Amorelli, *Pesaro*
M.T. Falconi Amorelli. *I materiali archeologici pre-romani del Museo Oliveriano di Pesaro.* Rome, 1982.

Farmer, *Festival*
J.D. Farmer. In *Birmingham Festival of Arts 1976* (Birmingham Museum of Art Bulletin 27, Spring 1976).

Festschrift Amelung
Antike Plastik: Walther Amelung zum sechzigsten Geburtstag. Berlin and Leipzig, 1928.

Festschrift Arias
ΑΠΑΡΧΑΙ: *Nuove ricerche e studi sulla Magna Grecia e la Sicilia antica in onore di Paolo Enrico Arias.* Pisa, 1982.

Festschrift Avi-Yonah
D. Barag, G. Foerster, and A. Negev, eds. *Eretz-Israel: Archaeological, Historical, and Geographical Studies*, vol. 19: *Michael Avi-Yonah Memorial Volume.* Jerusalem, 1987.

Festschrift Bellido
Homenaje a Garcia Bellido, vol. 3 (Revista de la Universidad Complutense 26, no. 109). Madrid, 1977.

Festschrift Brommer
U. Höckmann and A. Krug, eds. *Festschrift für Frank Brommer.* Mainz, 1977.

Festschrift Dörner
S. Şahin, E. Schwertheim, and J. Wagner, eds. *Studien zur Religion und Kultur Kleinasiens: Festschrift für Friedrich Karl Dörner zum 65. Geburtstag am 28. Februar 1976.* Leiden, 1978.

Festschrift Dohrn
Miscellanea Archaeologica Tobias Dohrn dedicata. Rome, 1982.

Festschrift Hampe
H.A. Cahn and E. Simon, eds. *Tainia: Festschrift für Roland Hampe.* Mainz, 1980.

Festschrift Hanfmann
Studies Presented to George M.A. Hanfmann. Cambridge, Mass., 1971.

Festschrift Homann-Wedeking
Wandlungen: Studien zur antiken und neueren Kunst: Ernst Homann-Wedeking gewidmet. Waldsassen-Bayern, 1975.

Festschrift Jucker
Eikones: Studien zum griechischen und römischen Bildnis: Hans Jucker zum sechzigsten Geburtstag gewidmet (AntK, suppl. 12). Bern, 1980.

Festschrift Schauenburg
E. Böhr and W. Martini, eds. *Studien zur Mythologie und Vasenmalerei: Konrad Schauenburg zum 65. Geburtstag am 16. April 1986.* Mainz, 1986.

Festschrift Renard
Hommages à Marcel Renard, vol. 3 (Collection Latomus 103). Brussels, 1969.

Festschrift Trell
L. Casson, ed. *Coins, Culture, and History in the Ancient World: Numismatic and other Studies in honor of Bluma L. Trell.* Detroit, 1981.

Festschrift Trendall
A. Cambitoglou, ed. *Studies in Honour of Arthur Dale Trendall.* Sydney, 1979.

Festschrift von Blanckenhagen
G. Kopcke and M.B. Moore, eds. *Studies in Classical Art and Archaeology: A Tribute to Peter Heinrich von Blanckenhagen.* Locust Valley, N.Y., 1979.

Fischer-Graf, *Spiegelwerkstätten*
U. Fischer-Graf. *Spiegelwerkstätten in Vulci.* Berlin, 1980.

Fittschen, *Schloss Erbach*
K. Fittschen. *Katalog der antiken Skulpturen in Schloss Erbach.* Berlin, 1977.

Fittschen and Zanker, *Römischen Porträts*
K. Fittschen and P. Zanker. *Katalog der römischen Porträts in den Capitolinischen Museen und den anderen kommunalen Sammlungen der Stadt Rom,* vol. 1: *Kaiser- und Prinzenbildnisse;* vol. 3: *Kaiserinnen und Prinzessinnenbildnisse Frauenporträts.* Mainz, 1985 and 1983.

Fleischer, *Artemis*
R. Fleischer. *Artemis von Ephesos und verwandte Kultstatuen aus Anatolien und Syrien.* Leiden, 1973.

Foerst, *Gravierungen*
G. Foerst. *Die Gravierungen der Pränestinischen Cisten.* Rome, 1978.

Freyer-Schauenburg, *Bildwerke*
B. Freyer-Schauenburg. *Bildwerke der archaischen Zeit und des Strengen Stils (Samos,* vol. 11). Bonn, 1974.

Freytag Gen. Löringhoff, *Telamon*
B. von Freytag Gen. Löringhoff. *Das Giebelrelief von Telamon und seine Stellung innerhalb der Ikonographie der "Sieben gegen Theben" (RM,* suppl. 27). Mainz, 1986.

Frischer, *Sculpted Word*
B. Frischer. *The Sculpted Word: Epicureanism and Philosophical Recruitment in Ancient Greece.* Berkeley, Los Angeles, London, 1982.

Froning, *Marmor-Schmuckreliefs*
H. Froning. *Marmor-Schmuckreliefs mit griechischen Mythen im 1. Jh. v. Chr.: Untersuchungen zu Chronologie und Funktion.* Mainz, 1981.

Fuchs, *Skulptur*
W. Fuchs. *Die Skulptur der Griechen.* Munich, 1969.

Galliazzo, *Treviso*
V. Galliazzo. *Sculture greche e romane del Museo Civico di Treviso.* Rome, 1982.

Galliazzo, *Vicenza*
V. Galliazzo. *Sculture greche e romane del Museo Civico di Vicenza.* Treviso, 1976.

Gauer, *Olympia*
W. Gauer. In *Bericht über die Ausgrabungen in Olympia,* no. 10. Berlin, 1981.

Gazda, *Portraiture*
E.K. Gazda, ed. *Roman Portraiture: Ancient and Modern Revivals.* (Kelsey Museum of Archaeology, The University of Michigan, 28 January–15 April 1977). Ann Arbor, 1977.

Getz-Preziosi, *Early Cycladic Art*
P. Getz-Preziosi, with J.L. Davis and E. Oustinoff. *Early Cycladic Art in North American Collections.* (Virginia Museum of Fine Arts, Richmond, 10 November 1987–10 January 1988; Kimbell Art Museum, Fort Worth, 5 March–15 May 1988; The Fine Arts Museums of San Francisco,

California Palace of the Legion of Honor, 25 June–25 September 1988). Richmond, 1987.

Ghedini, *Padova*
F. Ghedini. *Sculture greche e romane del Museo Civico di Padova.* Rome, 1980.

Ghedini and Rosada, *Torcello*
F. Ghedini and G. Rosada. *Sculture greche e romane del Museo Provinciale di Torcello.* Rome, 1982.

Geominy, *Niobiden*
W.A. Geominy. *Die Florentiner Niobiden.* Bonn, 1984.

Goulandris Collection
Exhibition of Ancient Greek Art: From the N. P. Goulandris Collection. Athens, 1978.

Greece and Italy
Greece and Italy in the Classical World: Acta of the XI International Congress of Classical Archaeology. London, 1978.

Grigson, *Aphrodite*
G. Grigson. *Aphrodite: Göttin der Liebe.* Bergisch Gladbach, 1978.

Gschwantler, *Guss*
K. Gschwantler et al. *Guss + Form: Bronzen aus der Antikensammlung.* Vienna: Kunsthistorisches Museum, 1986.

Hamdorf, *Olympia*
F.W. Hamdorf. In *Bericht über die Ausgrabungen in Olympia,* no. 10. Berlin, 1981.

Hammond, *Petra*
P.C. Hammond. *The Excavation of the Main Theater at Petra, 1961–1962: Final Report.* London, 1965.

Hampe and Simon, *Greek Art*
R. Hampe and E. Simon. *The Birth of Greek Art: From the Mycenaean to the Archaic Period.* New York, 1981.

Hanfmann and Ramage, *Sculpture from Sardis*
G.M.A. Hanfmann and N.H. Ramage. *Sculpture from Sardis: The Finds through 1975.* Cambridge, Mass., and London, 1978.

Hanhisalo, *Enjoying Art*
J.E. Hanhisalo. *Enjoying Art: Painting, Sculpture, Architecture, & the Decorative Arts.* Englewood Cliffs, 1983.

Hayes, *Metalware*
J.W. Hayes. *Greek, Roman, and Related Metalware in the Royal Ontario Museum: A Catalogue.* Toronto, 1984.

Haynes, *Etruscan Bronzes*
S. Haynes. *Etruscan Bronzes.* London, 1985.

Heilmeyer, *Tiervotive*
W.-D. Heilmeyer. *Frühe olympische Bronzefiguren: Die Tiervotive (Olympische Forschungen,* vol. 12). Berlin, 1979.

Herrmann, *Kessel*
H.-V. Herrmann. *Die Kessel der orientalisierenden Zeit,* pt. 2: *Kesselprotomen und Stabdreifüsse (Olympische Forschungen,* vol. 11). Berlin, 1979.

Herrmann, *Shadow*
J.J. Herrmann, Jr. *In the Shadow of the Acropolis: Popular and Private Art in 4th Century Athens.* Brockton: Brockton Art Museum—Fuller Memorial, September 1984–August 1987.

Von Hesberg, *Aufstieg*
H. von Hesberg. In Temporini and Haase, *Aufstieg,* pt. 2, vol. 17, no. 2.

Hill, *Metalware*
D.K. Hill. *Greek and Roman Metalware: A Loan Exhibition.* Baltimore: Walters Art Gallery, 14 February–14 April 1976.

Hiller, *Grabreliefs*
H. Hiller. *Ionische Grabreliefs der ersten Hälfte des 5. Jahrhunderts v. Chr. (IstMitt,* suppl. 12). Tübingen, 1975.

Himmelmann, *Alexandria*
N. Himmelmann. *Alexandria und der Realismus in der griechischen Kunst.* Tübingen, 1983.

Himmelmann, *Hirten-Genre*
N. Himmelmann. *Über Hirten-Genre in der antiken Kunst.* Opladen, 1980.

Höckmann, *Kassel*
U. Höckmann. *Antike Bronzen: Eine Auswahl (Katalog der Staatlichen Kunstsammlungen Kassel,* no. 4). Kassel, 1972.

Höckmann, *San Mariano*
U. Höckmann. *Die Bronzen aus dem Fürstengrab von Castel San Mariano bei Perugia (Staatliche Antikensammlungen München, Katalog der Bronzen,* vol. 1). Munich, 1982.

Hoffmann, *Ten Centuries*
H. Hoffmann. *Ten Centuries that Shaped the West: Greek and Roman Art in Texas Collections.* Mainz, 1971.

Horn and Rüger, *Numider*
H.G. Horn and C.B. Rüger, eds. *Die Numider: Reiter und Könige nördlich der Sahara.* Bonn, 1979.

Hornbostel, *Etrusker*
W. Hornbostel. *Kunst der Etrusker: In Zusammenarbeit mit dem Museum für Kunst und Gewerbe Hamburg.* Hamburg, 1981.

Hornbostel, *Gräbern*
W. Hornbostel. *Aus Gräbern und Heligtümern: Die Antikensammlung Walter Kropatscheck.* Mainz, 1980.

Hornbostel, *Schätze*
W. Hornbostel et al. *Kunst der Antike: Schätze aus norddeutschem Privatbesitz.* Mainz, 1977.

Hostetter, *Spina*
E. Hostetter. *Bronzes from Spina,* vol. 1: *The Figural Classes: Tripod, Kraters, Basin, Cista, Protome, Utensil Stands, Candelabra and Votive Statuettes.* Mainz, 1986.

Houser, *Bronze Sculpture*
C. Houser. *Greek Monumental Bronze Sculpture of the Fifth and Fourth Centuries B.C.* New York, 1987.

Houser, *Dionysos*
C. Houser. *Dionysos and His Circle: Ancient through Modern.* Cambridge, Mass., 1979.

Human Figures
Boston Museum exhibition: *Human Figures in Fine Arts.* The National Museum of Western Art, Tokyo, 25 April–11 June 1978.

Hunt Collections
Wealth of the Ancient World: The Nelson Bunker Hunt and William Herbert Hunt Collections. Fort Worth, 1983.

Hus, *Civiltà Arcaica*
A. Hus. In *La civiltà arcaica di Vulci e la sua espansione (Atti del X Convegno di Studi Etruschi e Italici).* Florence, 1977.

Hyde, *Victor Monuments*
W.W. Hyde. *Olympic Victor Monuments and Greek Athletic Art*. Washington, D.C., 1921.

Iconographie Classique
Iconographie classique et identités régionales (*BCH*, suppl. 14).

Inan, *Side*
J. Inan. *Roman Sculpture in Side*. Ankara, 1975.

Inan and Alföldi-Rosenbaum, *Porträtplastik*
J. Inan and E. Alföldi-Rosenbaum. *Römische und frühbyzantinische Porträtplastik aus der Türkei: Neue Funde*. Mainz, 1979.

Johns, *Sex or Symbol*
C. Johns. *Sex or Symbol: Erotic Images of Greece and Rome*. Austin, Texas, 1982.

Jucker and Willers, *Gesichter*
H. Jucker and D. Willers. *Gesichter: Griechische und römische Bildnisse aus schweizer Besitz*. Bern, 1982.

Karo, *Greek Personality*
G. Karo. *Greek Personality in Archaic Sculpture*. Cambridge, Mass., 1948.

Kater-Sibbes, *Sarapis*
G.J.F. Kater-Sibbes. *Preliminary Catalogue of Sarapis Monuments*. Leiden, 1973.

Kendall, *Nuzi*
T. Kendall. In M.A. Morrison and D.I. Owen, eds. *Studies on the Civilization and Culture of Nuzi and the Hurrians in Honor of Ernest R. Lacheman*. Winona Lake, Ind., 1981.

Kiss, *Études*
Z. Kiss. *Études sur le portrait impérial romain en Egypte*. Warsaw, 1984.

Knigge, *Griechische Plastik*
U. Knigge. In *Archaische und klassische griechische Plastik* (Akten des internationalen Kolloquiums vom 22.–25. April 1985 in Athen), vol. 2. Mainz, 1986.

Koch, *Meleager*
G. Koch. *Die mythologischen Sarkophage, Meleager* (*Die antiken Sarkophagreliefs*, vol. 12, pt. 6). Berlin, 1975.

Koch and Sichtermann, *Sarkophage*
G. Koch and H. Sichtermann. *Römische Sarkophage*. Munich, 1982.

Kokula, *Marmorlutrophoren*
G. Kokula. *Marmorlutrophoren* (*AM*, suppl. 10). Berlin, 1984.

Koppel, *Tarraco*
E.M. Koppel. *Die römischen Skulpturen von Tarraco* (*Madrider Forschungen*, vol. 15). Berlin, 1985.

Korres, *Kephalon*
G. Korres. *Ta Meta Kephalon Krion Krane*. Athens, 1970.

Kranz, *Jahreszeiten-Sarkophage*
P. Kranz. *Jahreszeiten-Sarkophage: Entwicklung und Ikonographie des Motivs in der vier Jahreszeiten auf kaiserzeitlichen Sarkophagen und Sarkophagdeckeln* (*Die antiken Sarkophagreliefs*, vol. 5, pt. 4). Berlin, 1984.

Krauskopf, *Supplemento Annali*
I. Krauskopf. In *Supplemento Annali 22 dell' Istituto Italiano di Numismatica*. Naples, 1975.

Krull, *Herakles*
D. Krull. *Der Herakles vom Typ Farnese:*

Kopienkritische Untersuchung einer Schöpfung des Lysipp. Frankfurt, 1985.

Kyrieleis, *Bildnisse*
H. Kyrieleis. *Bildnisse der Ptolemäer*. Berlin, 1975.

Lambrechts, *Miroirs*
R. Lambrechts. *Les Miroirs étrusques et prénestins des musées royaux d'art et d'histoire à Bruxelles*. Brussels, 1978.

Lane, *Corpus*
E.N. Lane. *Corpus Monumentorum Religionis Dei Menis*, vol. 2: *The Coins and Gems*, Leiden, 1975; vol. 3: *Interpretations and Testimonia*. Leiden, 1976.

Langlotz, *Nordostgriechischen Kunst*
E. Langlotz. *Studien zur nordostgriechischen Kunst*. Mainz, 1975.

Leibundgut, *Westschweiz*
A. Leibundgut. *Die römischen Bronzen der Schweiz*, vol. 3: *Westschweiz Bern und Wallis*. Mainz, 1980.

Letta, *Coroplastica*
C. Letta. *Piccola coroplastica metapontina nel Museo Archeologico Provinciale di Potenza*. Naples, 1971.

Levi, *Atlas*
P. Levi. *Atlas of the Greek World*. New York, 1980.

Liepmann, *Skulpturen*
U. Liepmann. *Griechische Terrakotten Bronzen Skulpturen*. Hannover: Kestner-Museums, catalogue, vol. 12, 1975.

Linfert, *Kunstzentren*
A. Linfert. *Kunstzentren hellenistischer Zeit: Studien an weiblichen Gewandfiguren*. Wiesbaden, 1976.

Loeb, *Geburt der Götter*
E.H. Loeb. *Die Geburt der Götter in der griechischen Kunst der klassischen Zeit*. Jerusalem, 1979.

Lohmann, *Grabmäler*
H. Lohmann. *Grabmäler auf unteritalischen Vasen*. Berlin, 1979.

Lullies, *Griechische Plastik*
R. Lullies. *Griechische Plastik: Von den Anfängen bis zum Beginn der römischen Kaiserzeit*. Munich, 1979.

Maehler and Strocka, *Ptolemäische Ägypten*
H. Maehler and V.M. Strocka. *Das ptolemäische Ägypten*. Mainz, 1978.

Manfrini-Aragno, *Bacchus*
I. Manfrini-Aragno. *Bacchus dans les bronzes hellénistiques et romains: Les artisans et leur répertoire* (Cahiers d'Archéologie Romande, no. 34). Lausanne, 1987.

Marshall, *Finger Rings*
F.H. Marshall. *Catalogue of the Finger Rings, Greek, Etruscan, and Roman*. London: British Museum, 1907.

Martelli Cristofani, *Céramiques*
M. Martelli Cristofani. In *Les Céramiques de la Grèce de l'est et leur diffusion en occident*. Paris and Naples, 1978.

Masterpieces
Masterpieces from the Boston Museum. Boston: Museum of Fine Arts, 1981.

Megale Hellas
Megale Hellas: Storia e civiltà della Magna Grecia. Milan, 1983.

Mélanges Mansel
Mansel'e Armağan: Mélanges Mansel, vol. 1. Ankara, 1974.

Menzel, *Aufstieg*
H. Menzel. In Temporini and Haase, *Aufstieg*, pt. 2, vol. 12, no. 3.

Menzel, *Bonn*
H. Menzel. *Die römischen Bronzen aus Deutschland*, vol. 3: *Bonn*. Mainz, 1986.

Merkelbach, *Assos*
R. Merkelbach. *Die Inschriften von Assos* (Inschriften griechischer Städte aus Kleinasien, vol. 4). Bonn, 1976.

MFA *Art in Bloom*
Art in Bloom. Boston: Museum of Fine Arts (1977–1987).

MFA *Handbook*
Illustrated Handbook. Boston: Museum of Fine Arts, 1975.

MFA *Western Art*
Western Art. Boston: Museum of Fine Arts, 1971.

Mildenberg Collection
A.P. Kozloff, ed. *Animals in Ancient Art from the Leo Mildenberg Collection*. Mainz, 1981.

Mildenberg Collection, Supplement
A.P. Kozloff, D.G. Mitten, and M. Sguaitamatti, eds. *More Animals in Ancient Art from the Leo Mildenberg Collection*. Mainz, 1986.

Mitten, *Classical Bronzes*
D.G. Mitten. *Classical Bronzes*. Providence: Rhode Island School of Design, 1975.

Mitten and Doeringer, *Master Bronzes*
D.G. Mitten and S.F. Doeringer. *Master Bronzes from the Classical World*. Cambridge, Mass., 1967.

MNR Sculture
A. Giuliano, ed. *Museo Nazionale Romano: Le Sculture*, vol. 1, pts. 1–7. Rome, 1979–1984.

Morgan, *Ancient Mediterranean*
S.K. Morgan. *The Ancient Mediterranean*. Brockton: Brockton Art Center—Fuller Memorial, 4 September 1975–1 July 1977.

Morrow, *Footwear*
K.D. Morrow. *Greek Footwear and the Dating of Sculpture*. Madison, 1985.

Mulas, *Eros*
A. Mulas. *Eros in Antiquity*. New York, 1978.

Muscarella, *Schimmel Collection*
O.W. Muscarella, ed. *Ancient Art: The Norbert Schimmel Collection*. Mainz, 1974.

Mustilli, *Museo Mussolini*
D. Mustilli. *Il Museo Mussolini*. Rome, 1939.

Nardi, *Orte*
G. Nardi. *Le antichità di Orte: Esame del territorio e dei materiali archeologici*. Rome, 1980.

Neumann, *Weihreliefs*
G. Neumann. *Probleme der griechischen Weihreliefs*. Tübingen, 1979.

Neumer-Pfau, *Aphrodite-Statuen*
W. Neumer-Pfau. *Studien zur Ikonographie und gesellschaftlichen Funktion hellenistischer Aphrodite-Statuen*. Bonn, 1982.

13

Noelke, *Iupitersäulen*
P. Noelke. In G. Bauchhenss and P. Noelke. *Die Iupitersäulen in den germanischen Provinzen* (*BonnJb*, vol. 41, suppl.). Cologne, 1981.

Offerings
A Table of Offerings: 17 Years of Acquisitions of Egyptian and Ancient Near Eastern Art by William Kelly Simpson for the Museum of Fine Arts, Boston. Boston, 1987.

Oggiano-Bitar, *Bouches-du-Rhône*
H. Oggiano-Bitar. *Bronzes figurés antiques des Bouches-du-Rhône* (*Gallia*, suppl. 43). Paris, 1984.

L'Orange, Unger, and Wegner, *Spätantike Herrscherbild*
H.P. L'Orange and R. Unger. *Das spätantike Herrscherbild von Diokletian bis zu den Konstantin-Söhnen 284–361 n. Chr.*, and M. Wegner. *Die Bildnisse der Frauen und des Julian* (*Das römische Herrscherbild*, pt. 3, vol. 4, ed. M. Wegner). Berlin, 1984.

Palagia, *Euphranor*
O. Palagia. *Euphranor*. Leiden, 1980.

Paoletti, *Archivio*
M. Paoletti. In *Archivio Storico per la Calabria e la Lucania* 44–45 (1977–1978).

Parlasca, *Proceedings*
K. Parlasca. *Proceedings of the Xth International Congress of Classical Archaeology.* Ankara, 1978.

Pedley, *Island Workshops*
J.G. Pedley. *Greek Sculpture of the Archaic Period: The Island Workshops.* Mainz, 1976.

Petit, *Dutuit*
J. Petit. *Bronzes antiques de la collection Dutuit: Grecs, hellénistiques, romains et de l'Antiquité tardive.* Paris, 1980.

Philipp, *Bronzeschmuck*
H. Philipp. *Bronzeschmuck aus Olympia* (*Olympische Forschungen*, vol. 13). Berlin, 1981.

Picón, *Antiquities*
C.A. Picón. *Classical Antiquities from Private Collections in Great Britain: A Loan Exhibition in Aid of the Ashmole Archive.* London, 1986.

Pollini, *Portraiture*
J. Pollini. *The Portraiture of Gaius and Lucius Caesar.* New York, 1987.

Pollitt, *Hellenistic*
J.J. Pollitt. *Art in the Hellenistic Age.* Cambridge, 1986.

Poulsen, *Einzelaufnahmen*
F. Poulsen. In Arndt and Amelung, *Photographische Einzelaufnahmen antiker Skulpturen*, Serie 13. Munich, 1932.

Prima Italia
Prima Italia: L'Arte italica del I millennio a. C. Rome, 1981.

Quilici and Quilici Gigli, *Antemnae*
L. Quilici and S. Quilici Gigli. *Antemnae.* Rome, 1978.

Raftopoulou, *Études Delphiques*
É.G. Raftopoulou. *Études Delphiques* (*BCH*, suppl. 4). Paris, 1977.

Rathbone Years
The Rathbone Years: Masterpieces Acquired for the Museum of Fine Arts, Boston, 1955–1972 and for the St. Louis Art Museum, 1940–1955. Boston: Museum of Fine Arts, 1972.

Reinach, *Monuments*
S. Reinach. *Monuments nouveaux de l'art antique*, vols. 1–2. Paris, 1924.

Reinach, *Rép. rel.*
S. Reinach, *Répertoire de reliefs grecs et romains*, vols. 1–3. Paris, 1909–1912.

Reinach, *Rép. stat.*
S. Reinach. *Répertoire de la statuaire grecque et romaine*, vols. 1–6. Paris, 1897–1930.

Richardson, *Votive Bronzes*
E. Richardson. *Etruscan Votive Bronzes: Geometric, Orientalizing, Archaic.* Mainz, 1983.

Richter, *Bronzes*
G.M.A. Richter. *Greek, Etruscan and Roman Bronzes.* New York: Metropolitan Museum of Art, 1915.

Richter, *Portraits* (1984)
G.M.A. Richter. *The Portraits of the Greeks* (abridged and revised by R.R.R. Smith). Ithaca, 1984.

Richter, *Sculpture*
G.M.A. Richter. *The Sculpture and Sculptors of the Greeks.* New Haven, 1970.

Ridgway, *Archaic*
B.S. Ridgway. *The Archaic Style in Greek Sculpture.* Princeton, 1977.

Ridgway, *Copies*
B.S. Ridgway. *Roman Copies of Greek Sculpture: The Problem of the Originals.* Ann Arbor, 1984.

Ridgway, *Fifth Century*
B.S. Ridgway. *Fifth Century Styles in Greek Sculpture.* Princeton, 1981.

Riis, *Heads*
P.J. Riis. *Etruscan Types of Heads: A Revised Chronology of the Archaic and Classical Terracottas of Etruscan Campania and Central Italy* (*Det Kongelige Danske Videnskabernes Selskab, Historisk-filosofiske Skrifter* 9:5). Copenhagen, 1981.

Robertson, *History*
M. Robertson. *A History of Greek Art.* Cambridge, 1975.

Robertson, *Shorter History*
M. Robertson. *A Shorter History of Greek Art.* Cambridge, 1981.

Rolley, *Bronzes Grecs*
C. Rolley. *Les Bronzes grecs.* Fribourg, 1983.

Rolley, *Greek Bronzes*
C. Rolley. *Greek Bronzes* (trans. R. Howell). London, 1986.

Roma medio repubblicana
Roma medio repubblicana: Aspetti culturali di Roma e del Lazio nei secoli IV e III a. C. Rome, 1977.

Romans and Barbarians
Romans and Barbarians. Boston: Museum of Fine Arts, 17 December 1976–27 February 1977.

Rotroff, *Agora*
S.I. Rotroff. *The Athenian Agora*, vol. 22: *Hellenistic Pottery, Athenian and Imported Moldmade Bowls.* Princeton, 1982.

Rühfel, *Kind*
H. Rühfel. *Das Kind in der griechischen Kunst: Von der minoisch-mykenischen Zeit bis zum Hellenismus.* Mainz, 1984.

Sams, *Small Sculptures*
C.K. Sams, ed. *Small Sculptures in Bronze from the Classical World: An Exhibit in Honor of Emeline Hill Richardson.* Chapel Hill: William Hayes Ackland Memorial Art Center and the Department of Classics of the University of North Carolina, 7 March–18 April 1976.

Schanz, *Sculptural Groups*
H.L. Schanz. *Greek Sculptural Groups: Archaic and Classical.* New York and London, 1980.

Schefold, *Göttersage*
K. Schefold and F. Jung. *Die Göttersage in der klassischen und hellenistischen Kunst.* Munich, 1981.

Schmaltz, *Metallfiguren*
B. Schmaltz. *Metallfiguren aus dem Kabirenheiligtum bei Theben: Die Statuetten aus Bronze und Blei* (*Das Kabirenheiligtum bei Theben*, vol. 6). Berlin, 1980.

Schneider, *Asymmetrie*
L.A. Schneider. *Asymmetrie griechischer Köpfe vom 5. Jh. bis zum Hellenismus.* Wiesbaden, 1973.

Scritti Paribeni
Scritti di Enrico Paribeni. Rome, 1985.

Search for Alexander
N. Yalouris, M. Andronikos, K. Rhomiopoulou, A. Herrmann, and C. Vermeule. *The Search for Alexander.* Boston: Museum of Fine Arts, 1980.

Second Greatest Show
"*. . . The Second Greatest Show on Earth*": *The Making of a Museum: An Exhibition of Works of Art, Documents, & Photographs.* Boston: Museum of Fine Arts, 8 November 1977–15 January 1978.

Self and Society
Roman Portraits: Aspects of Self and Society, First Century B.C.–Third Century A.D., a loan exhibition. The Regents of the University of California and The J. Paul Getty Museum [Malibu], 1980.

Shefton, *Phönizier*
B.B. Shefton. In *Phönizier im Westen* (*Madrider Beiträge 8*). Mainz, 1982.

Snowden, *Image*
F.M. Snowden, Jr. In J. Vercoutter, J. Leclant, F.M. Snowden, Jr., and J. Desanges, *The Image of the Black in Western Art*, vol. 1: *From the Pharaohs to the Fall of the Roman Empire.* New York, 1976.

Snowden, *Prejudice*
F.M. Snowden, Jr. *Before Color Prejudice: The Ancient View of Blacks.* Cambridge, Mass., and London, 1983.

Söldner, *Eroten*
M. Söldner. *Untersuchungen zu liegenden Eroten in der hellenistischen und römischen Kunst.* Frankfurt, 1986.

Sprenger and Bartoloni, *Etruscans*
M. Sprenger and G. Bartoloni. *The Etruscans: Their History, Art, and Architecture* (trans. R.E. Wolf). New York, 1983.

Sprenger and Bartoloni, *Etrusker*
M. Sprenger and G. Bartoloni. *Die Etrusker: Kunst und Geschichte.* Munich, 1977.

Stary, *Eisenzeitlichen*
P.F. Stary. *Zur eisenzeitlichen Bewaffnung und Kampfesweise in Mittelitalien (ca. 9. bis 6. Jh. v. Chr.).* Mainz, 1981.

Steingräber, *Möbel*
S. Steingräber. *Etruskische Möbel.* Rome, 1979.

Stemmer, *Panzerstatuen*
K. Stemmer. *Untersuchungen zur Typologie, Chronologie und Ikonographie der Panzerstatuen.* Berlin, 1978.

Stewart, *Skopas*
A.F. Stewart. *Skopas of Paros.* Park Ridge, N.J., 1977.

Stuart Jones, *Museo Capitolino*
H. Stuart Jones. *The Sculptures of the Museo Capitolino.* Oxford, 1912.

Sturgeon, *Corinth*
M.C. Sturgeon. *Corinth,* vol. 9, pt. 2: *Sculpture, The Reliefs from the Theater.* Princeton, 1977.

Süsserott, *Griechische Plastik*
H.K. Süsserott. *Griechische Plastik des 4. Jahrhunderts vor Christus: Untersuchungen zur Zeitbestimmung.* Rome, 1968.

Temporini and Haase, *Aufstieg*
H. Temporini and W. Haase, eds. *Aufstieg und Niedergang der römischen Welt: Geschichte und Kultur Roms im Spiegel der neueren Forschung.* Berlin, 1978–1987.

Thimme, Getz-Preziosi, and Otto, *Cyclades*
J. Thimme, P. Getz-Preziosi, and B. Otto, eds. *Art and Culture of the Cyclades: Handbook of an Ancient Civilisation.* (Karlsruhe, Landesmuseum, 18 June–24 October 1976). Karlsruhe, 1976.

Thomas, *Athletenstatuetten*
R. Thomas. *Athletenstatuetten der Spätarchaik und des Strengen Stils.* Rome, 1981.

Torelli, *Elogia*
M. Torelli. *Elogia Tarquiniensia.* Florence, 1975.

Toynbee, *Hadrianic School*
J.M.C. Toynbee. *The Hadrianic School: A Chapter in the History of Greek Art.* Cambridge, 1934.

Toynbee, *Historical Portraits*
J.M.C. Toynbee. *Roman Historical Portraits.* Ithaca, 1978.

True and Vermeule, *Bulletin*
M. True and C. Vermeule. *Boston Museum Bulletin* 72 (1974).

Türr, *Fälschungen*
K. Türr. *Fälschungen antiker Plastik seit 1800.* Berlin, 1984.

Uhlenbrock, *Herakles*
J.P. Uhlenbrock. *Herakles: Passage of the Hero through 1000 Years of Classical Art.* Annandale-on-Hudson: Bard College, Edith C. Blum Art Institute, 1 March–31 May 1986.

Vermeule, *Cuirassed Statues*
C. Vermeule. *Hellenistic and Roman Cuirassed Statues.* Boston, 1980.

Vermeule, *Cult Images*
C. Vermeule. *The Cult Images of Imperial Rome (Archaeologica* 71). Rome, 1987.

Vermeule, *Cyprus*
C. Vermeule. *Greek and Roman Cyprus: Art from Classical through Late Antique Times.* Boston, 1976.

Vermeule, *Divinities*
C. Vermeule. *Divinities and Mythological Scenes in Greek Imperial Art.* Cambridge, Mass., 1983.

Vermeule, *Egypt*
C. Vermeule. In W.K. Simpson and W.M. Davis, eds. *Studies in Ancient Egypt, the Aegean, and the Sudan: Essays in honor of Dows Dunham on the occasion of his 90th birthday, June 1, 1980.* Boston, 1981.

Vermeule, *Gold and Silver*
C. Vermeule. *Greek and Roman Sculpture in Gold and Silver.* Boston, 1974.

Vermeule, *Iconographic Studies*
C. Vermeule. *Iconographic Studies: The Flavians to the Fall of the Roman Empire.* Boston, 1980.

Vermeule, *Jewish Relationships*
C. Vermeule. *Jewish Relationships with the Art of Ancient Greece and Rome.* Boston, 1981.

Vermeule, *North Carolina Bulletin*
C. Vermeule. *North Carolina Museum of Art: Bulletin* 14, nos. 2 and 3 (1980).

Vermeule, *Numismatic Art*
C. Vermeule. *Numismatic Art of the Greek Imperial World: Interactions between Rome, Greece, Asia Minor, Syria, The Holy Land and Egypt.* Cambridge, Mass., 1986.

Vermeule, *Prehistoric through Perikles*
C. Vermeule. *The Art of the Greek World: Prehistoric through Perikles: From the Late Stone Age and the Early Age of Bronze to the Peloponnesian Wars.* Boston, 1982.

Vermeule, *Roman Art*
C. Vermeule. *Roman Art: Early Republic to Late Empire.* Boston, 1978.

Vermeule, *Sculpture and Taste*
C. Vermeule. *Greek Sculpture and Roman Taste: The Purpose and Setting of Graeco-Roman Art in Italy and the Greek Imperial East.* Ann Arbor, 1977.

Vermeule, *Sculpture in America*
C. Vermeule. *Greek and Roman Sculpture in America: Masterpieces in Public Collections in the United States and Canada.* Malibu, Berkeley, and Los Angeles, 1981.

Vermeule, *Socrates to Sulla*
C. Vermeule. *Greek Art: Socrates to Sulla: From the Peloponnesian Wars to the Rise of Julius Caesar.* Boston, 1980.

Vermeule, Cahn, and Hadley, *Gardner Museum*
C. Vermeule, W. Cahn, and R.V.N. Hadley. *Sculpture in the Isabella Stewart Gardner Museum.* Boston, 1977.

Vermeule and Neuerburg, *Getty Catalogue*
C. Vermeule and N. Neuerburg. *Catalogue of the Ancient Art in the J. Paul Getty Museum: The Larger Statuary, Wall Paintings and Mosaics.* Malibu, 1973.

Vermeule, *Death*
E. Vermeule. *Aspects of Death in Early Greek Art and Poetry.* Berkeley, 1979.

Vierneisel-Schlörb, *Glyptothek: Skulpturen*
B. Vierneisel-Schlörb. *Glyptothek München: Katalog der Skulpturen,* vol. 2: *Klassische Skulpturen des 5. und 4. Jahrhunderts v. Chr.* Munich, 1979.

Vollenweider, *Catalogue Raisonné*
M.-L. Vollenweider. *Catalogue raisonné des sceaux, cylindres, intailles et camées,* vol. 2: *Les portraits, les masques de théâtre, les symboles politiques.* Mainz, 1979.

Waelkens, *Dokimeion*
M. Waelkens. *Dokimeion: Die Werkstatt der repräsentativen kleinasiatischen Sarkophage: Chronologie und Typologie ihrer Produktion.* Berlin, 1982.

Waldbaum, *Metalwork*
J.C. Waldbaum et al. *Metalwork from Sardis: The Finds through 1974.* Cambridge, Mass., and London, 1983.

Wallenstein, *Korinthische Plastik*
K. Wallenstein. *Korinthische Plastik des 7. und 6. Jahrhunderts vor Christus.* Bonn, 1971.

Walter-Karydi, *Bildhauerschule*
E. Walter-Karydi. *Die äginetische Bildhauerschule: Werke und schriftliche Quellen (Alt-Ägina,* vol. 2, pt. 2). Mainz, 1987.

Walters, *Bronzes*
H.B. Walters. *Catalogue of the Greek, Roman and Etruscan Bronzes in the Department of Greek and Roman Antiquities.* London, 1899.

Waywell, *Halicarnassus*
G.B. Waywell. *The Free-Standing Sculptures of the Mausoleum at Halicarnassus in the British Museum: A Catalogue.* London, 1978.

Webster, *New Comedy*
T.B.L. Webster. *Monuments Illustrating New Comedy* (2nd ed., rev., *BICS,* suppl. 24). London, 1969.

Weill, *Études Thasiennes*
N. Weill. *La Plastique archaïque de Thasos: figurines et statues de terre cuite de l'Artémision, I—le haut archaïsme (Études Thasiennes,* vol. 11). Paris, 1985.

Weitzmann, *Spirituality*
K. Weitzmann, ed. *Age of Spirituality: Late Antique and Early Christian Art, Third to Seventh Century.* New York: Metropolitan Museum of Art, 19 November 1977–12 February 1978.

Weski, *Antiquarium*
E. Weski and H. Frosien-Leinz et al. *Das Antiquarium der Münchner Residenz: Katalog der Skulpturen.* Munich, 1987.

Willers, *Archaistischen Plastik*
D. Willers. *Zu den Anfängen der archaistischen Plastik in Griechenland (AM,* suppl. 4, 1975).

Williams, *Johns Hopkins*
E.R. Williams. *The Archaeological Collection of the Johns Hopkins University.* Baltimore and London, 1984.

Wood, *Portrait Sculpture*
S. Wood. *Roman Portrait Sculpture, 217–260 A.D.: The Transformation of an Artistic Tradition.* Leiden, 1986.

Wrede, *Consecratio*
H. Wrede. *Consecratio in Formam Deorum: Vergöttlichte Privatpersonen in der römischen Kaiserzeit.* Mainz, 1981.

Young, *Application of Science*
W.J. Young, ed. *Application of Science in Examination of Works of Art.* Boston, 1973.

Zanker, *Klassizistische*
P. Zanker. *Klassizistische Statuen: Studien zur Veränderung des Kunstgeschmacks in der römischen Kaiserzeit.* Mainz, 1974.

Abbreviations

AA — Archäologischer Anzeiger

AAA — Athens Annals of Archaeology

AJA — American Journal of Archaeology

AM — Mitteilungen des Deutschen Archäologischen Instituts, Athenische Abteilung

Annuario — Annuario della R. Scuola Archeologica di Atene

AntK — Antike Kunst

ArchCl — Archeologica Classica

ArchEph — Archaiologike Ephemeris

BABesch — Bulletin van de Vereeniging tot Bevordering der Kennis van de Antieke Beschaving

BCH — Bulletin de correspondance hellénique

BdA — Bolletino d'Arte

BICS — Bulletin of the Institute of Classical Studies of the University of London

BMFA — Bulletin of the Museum of Fine Arts, Boston

BonnJb — Bonner Jahrbücher

BSA — British School at Athens, Annual

BullComm — Bullettino della Commissione Archeologica Comunale di Roma

BurlMag — Burlington Magazine

CJ — The Classical Journal

Deltion — Archaiologikon deltion

EA — Photographische Einzelaufnahmen

EAA — Enciclopedia dell'arte antica, classica e orientale

GettyMusJ — Getty Museum, Journal

HASB — Hefte des archäologischen Seminars der Universität Bern

IstMitt — Mitteilungen des deutschen archäologischen Instituts, Abteilung Istanbul

JARCE — Journal of the American Research Center in Egypt

JdI — Jahrbuch des Deutschen Archäologischen Instituts

JHS — Journal of Hellenic Studies

JOAI — Jahreshefte des Österreichischen Archäologischen Instituts

LIMC — Lexicon Iconographicum Mythologiae Classicae

MAAR — Memoirs of the American Academy in Rome

MarbWPr — Marburger Winckelmann-Programm

MedKøb — Meddelelser fra Ny Carlsberg Glyptotek

MJb — Münchner Jahrbuch der bildenden Kunst

MonPiot — Monuments et mémoires, Fondation E. Piot

Museum Year — Annual Report of the Museum of Fine Arts, Boston

NSc — Notizie degli Scavi

OJA — Oxford Journal of Archaeology

Opus Rom — Opuscula Romana

PAPS — Proceedings of the American Philosophical Society

PBSR — Papers of the British School of Archaeology at Rome

RA — Revue archéologique

RM — Mitteilungen des Deutschen Archäologischen Instituts, Römische Abteilung

TAPS — Transactions of the American Philosophical Society

TrWPr — Trierer Winckelmannsprogramm

Sculpture in Stone

Cycladic Statuettes and Vessels

1 (S1)*
Six "Idols" in Banjo and Palette Shapes
Cycladic and Northwest Anatolian, ca. 2500 B.C.
Marble (except f); (a) H (combined): 0.075 m. W (max.): 0.052 m. (b) H: 0.087 m. W: 0.045 m. (c) H: 0.072 m. W: 0.032 m. (d) H: 0.054 m. W: 0.03 m. (e) H: 0.033 m. W: 0.02 m. (f) (green stone) H: 0.037 m. W: 0.024 m.
John Wheelock Elliot and John Morse Elliot Fund. 1984.92–97

Provenance: collected many years ago by a young Oxford archaeologist and long in his family's possession
Reference: Museum Year: 1983–1984, p. 43.
Neg. No. C42434
Condition: One of the "idols" has been broken through the middle and has been chipped. The first three have heavy encrustation, including root marks. The last two have less deposit on their front surfaces, but what is there is similar in color and structure. The object in green stone is almost free of deposit and pitting.

The "idols," with their simple and elegant detail, have close parallels among the objects excavated at early Bronze Age Troy. Such parallels have been noted in other publications of similar sculptures.[1]

1. *Hesperia Art Bulletin* 34 (Philadelphia, n.d.), pp. 11–12, no. A1, illus.; also *Hesperia Art Bulletin* 20, pp. 6–8, no. 232 (illus.), from the Hadji Arslan collection; Sotheby's sale, New York, 10 June 1983, no. 45 (formerly Pomerance Collection, no. 73); and (for bibliography) J. Thimme, *Kunst und Kultur der Kykladeninseln* (Karlsruhe, 1976), under no. 487, etc.

* Numbers in parentheses refer to related objects in *Sculpture in Stone: The Greek, Roman and Etruscan Collections of the Museum of Fine Arts, Boston*, 1976 (S), and to *Greek, Etruscan and Roman Bronzes in the Museum of Fine Arts, Boston*, 1971 (B).

2 (S3)
Statuette of a Woman
Cycladic, ca. 2500 to 2000 B.C.
Island marble; H: 0.335 m.
Gift of Dr. and Mrs. Richard Kaplan. 1978.647

Provenance: from private collections in Philadelphia and New York
References: Eisenberg, *Ancient World*, vol. 2 (1966), no. 133, cover; *Museum Year: 1978–1979*, p. 39.
Neg. No. C40856
Condition: The left shoulder is chipped, but otherwise the "idol" is intact. Head, feet, and portions of the back are slightly corroded. A pale golden patina appears on several areas of the body.

The body is long and thin, bent slightly at the knees and the ankles. There is a backwards curve at the upper part of the head. The folded arms, the area below the waist,

1

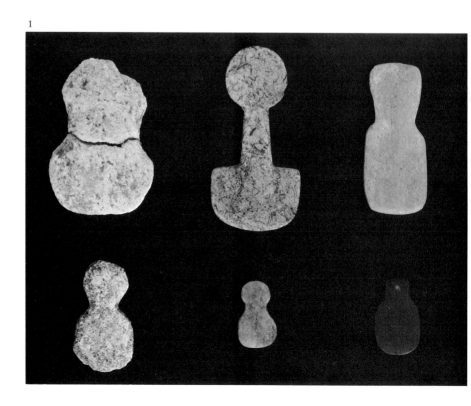

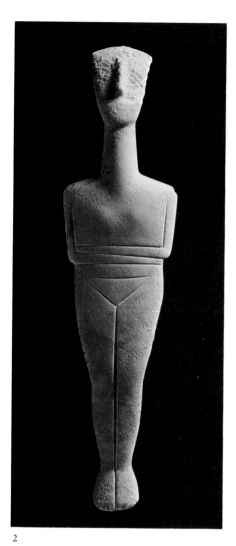

2

Condition: The head is broken off at the neck and a break occurs above the toes on both feet. The curved back of the top of the head is also broken off. The patina is a light tan color.

What survives is the head of a larger figure and fragments of two feet from a smaller figure that stood on top of the head. There are at least six such "double idols" recorded in the major collections of similar works of art, the sculptures coming from various islands and the end of the Knidos peninsula. They have been interpreted as images of the divine mother and her daughter.[1]

The double idol from Paros in Karlsruhe has been dated 2700 to 2300 B.C.[2] An example in condition similar to that of the Boston fragment, in the Goulandris collection in Athens, is slightly higher, coarser, and broken in a somewhat different fashion.[3]

1. Thimme, Getz-Preziosi, and Otto, *Cyclades*, p. 497.
2. It is classified in Early Cycladic Phase II; see ibid., pp. 494–495, 497, no. 257.
3. *Goulandris Collection*, p. 122, no. 138.

4 (S6)
VESSEL WITH LUG HANDLES
Cycladic, ca. 2400 B.C.
Island marble; H: 0.165 m.
Helen and Alice Colburn Fund. 1977.799

References: Museum Year: 1977–1978, p. 41; Vermeule, *Prehistoric through Perikles*, pp. 12, 208, 256, fig. 28.

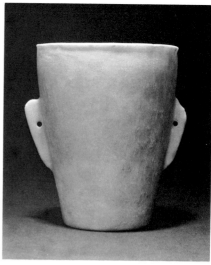

4

Exhibition: Virginia Museum of Fine Arts, Richmond; Kimbell Art Museum, Fort Worth; The Fine Arts Museums of San Francisco, California Palace of the Legion of Honor (Getz-Preziosi, *Early Cycladic Art*, pp. 281, 285 [no. 110, 2 illus.], 286–287).

Neg. No. C32757

Condition: There are minor chips at the rolled-fillet rim and here and there on the body. The vessel has a slightly yellowish-buff patina.

The lug handles on either side are pierced horizontally. This container and a number of comparable "beakers" fall within a class in which the shapes of the lugs, the size of the rolled rim, and the profiles vary slightly.[1]

1. They are discussed and illustrated in the following books and catalogues: Thimme, Getz-Preziosi, and Otto, *Cyclades*, pp. 313 (fig. 280), 504, no. 280; *Kunstwerke der Antike*, Münzen und Medaillen A.G., Basel, Auktion 51, 14–15 March 1975, p. 7, no. 10, pl. 2 (slightly smaller, dated 2500 to 2000 B.C.), with parallels, including examples (one larger, one smaller) from Paros and Amorgos; C. Zervos, *L'Art des Cyclades* (Paris, 1957), figs. 1 and 2; *Neuerwerbungen 1952–1965* (Karlsruhe: Badisches Landesmuseum, 1966), p. 4; Galerie Heidi Vollmoeller, Zurich, Auktion 1, 1975, p. 8, no. 24 (allegedly from Naxos and dated 2300 B.C.).

3

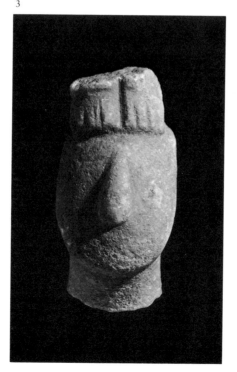

the legs (front and back), and the toes are indicated by incised lines.

Of the many similar figures, an example in private hands in Switzerland has the same elongation, roundness, and sharpness of contours. It is termed of the "Keros-Syros culture" and dated 2400 to 2300 B.C.[1]

1. J.-L. Zimmermann, in Dörig, *Art Antique*, pp. 28–30, no. 29; see Thimme, Getz-Preziosi, and Otto, *Cyclades*, pp. 270 (no. 170), 276 (no. 192), 459–460, Early Cycladic, Late Spedos variety.

3 (S4)
FRAGMENT FROM FIGURE OF DOUBLE IDOL
Cycladic, ca. 2500 B.C.
Island marble; H: 0.05 m.
Classical Department Exchange Fund. 1980.44

References: Museum Year: 1979–1980, p. 39; Vermeule, *Prehistoric through Perikles*, pp. 9, 208, 253, fig. 25.

Neg. No. E902

5 (S6)
PYXIS WITH LID
Cycladic, ca. 2500 B.C. or slightly later
Island marble; H: 0.078 m. W: 0.128 m.
Chatswold Collection. 119.1978

Provenance: from private collections in London (in the early 1970s) and previously in Cairo

Exhibition: Virginia Museum of Fine Arts, Richmond; Kimbell Art Museum, Fort Worth; The Fine Arts Museums of San Francisco, California Palace of the Legion of Honor (Getz-Preziosi, *Early Cycladic Art*, pp. 71, 309, 312, no. 133, 2 illus.).

Neg. Nos. B20913 (profile), B20914 (angled to show lid)

19

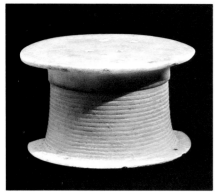

5

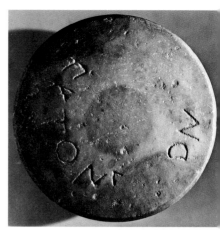

6

Fifth-Century Sculpture

6

DISCUS

Mainland Greek, ca. 500 B.C.

Attic marble; D: 0.285 m. Weight (as preserved): 14 lb., 10 oz. (originally at least 15 lb.)

Gifts in Memory of Albert Gallatin.

1987.621

Provenance: from the collections of Catherine Gallatin, Albert Gallatin, and Edward Perry Warren (previously on the art market in London and Athens)

References: Sotheby's sale, London, May 1929, no. 89; P. Jacobsthal, *Diskoi* (93 Winckelmannsprogramm) (Berlin and Leipzig, 1933), pp. 14–18, fig. 8; E.N. Gardiner, *Athletics of the Ancient World* (Oxford, 1930), p. 156, fig. 112; W. Sweet, *Sport and Recreation in Ancient Greece* (New York and Oxford, 1987), p. 40.

Neg. No. C26795

Condition: A substantial area is missing at the middle of the inscription and two large chips have broken away on the edges opposite the main damage. There is a yellow patina on the gray and white surfaces of the marble.

The inscription reads ΕΚ ΤΩΝ Α[ΘΛ]ΩΝ ("From the Games"). There was a painted tondo, 0.0613 m. in diameter in the center, but the composition (once perceived as a horseman riding to the right with a lance) is now illegible.[1] It is possible that this discus was buried (and subsequently excavated) with one now in the Metropolitan Museum of Art in New York, which bears the inscription "From the tumulus of Telesarchos."[2] The tumulus cited was probably the tomb of the victorious athlete or magistrate in whose honor the games were held. Similar types of injury and patinas suggest that the site was damaged long before the objects were rediscovered.

1. P. Jacobsthal, *Diskoi* (93 Winckelmannsprogramm) (Berlin and Leipzig, 1933), pp. 14–18, fig. 8; E.N. Gardiner, *Athletics of the Ancient World* (Oxford, 1930), p. 156, fig. 112. From ultraviolet photographs of the painting made on March 7, 1949, it can be deduced that the horseman was painted in red (and white?) probably on a black background; the composition can be visualized from the interior of the famous Geryon and Herakles cup of about 510 B.C. by Euphronios in Munich (see R. Lullies and M. Hirmer, *Griechische Vasen der Reifarchaischen Zeit* [Munich, 1953], p. 12, pls. 12–13). Dietrich von Bothmer has spoken of the convention of painting a marble discus with a blazon, on the analogy of shields seen on Attic black-figure and red-figure vases. Thus, the painted tondo would have been the emblem of the family who owned the discus.

2. 1985.11.4; the two objects have identical provenance. See Jacobsthal, op. cit., fig. 9; Gardiner, op. cit., fig. 113; and D. von Bothmer, in *Annual Report for 1984–1985* (New York: Metropolitan Museum of Art, 1986), p. 38.

Condition: There is a large, long irregular chip off the rim at the base and the surface, with light encrustation, is worn.

The body of the pyxis has incised stripes and a projecting rim at the base, originally with four evenly spaced round holes or perforations, two being no longer present as a result of chips. The lid has a diameter similar to the rim at the base and is also perforated four times in the center.[1]

1. Related Cycladic pyxides of this type have been well documented. Compare Thimme, Getz-Preziosi, and Otto, *Cyclades*, p. 329, nos. 339–341; Sotheby's sale, London, 12 July 1971, p. 44, no. 120 (with the holes at the rim, not in the center of the lid, and, therefore, matching the holes on the rim at the base of the body). An example from a private collection in Switzerland was known at least as long ago as the end of the nineteenth century, having been in the Ralli(s) collection in Athens; see G. Ortiz, in Dörig, *Art Antique*, no. 37.

7 (S41)

FOUR ARCHITECTURAL FRAGMENTS FROM FUNERARY MONUMENT

Sicilian Greek, ca. 450 B.C.

Limestone; (a) w: 0.28 m. (b-d) Av. w: 0.15 m.

Benjamin and Lucy Rowland Fund.

1984.439–442

Provenance: private collections in Switzerland (to 1962) and Boston (1962 to 1984)

Reference: Museum Year: 1984–1985, p. 48.

Neg. Nos. C42672 (molding), C42673 (three volutes)

Condition: Except at the breaks, the fragments have a yellow patina.

These fragments from Selinunte (ancient Selinus) in Sicily belong with two published extensively.[1] The segment of molding illustrated here joins the carved molding of MFA no. 61.153,[2] and it is apparent that they are part of the roof slab from the lower left rising corner of a pediment. There are fuller views of the palmettes, honeysuckle, and volute-tendrils carved in relief on the flat front surface.

The three volutes of Ionic capitals are similar to another in the MFA collection,[3] although slightly less complete in two instances. Two are left-hand volutes, and one is a right-hand example, the first to be included in this context of publication. A complete capital of this type, presumably found with these fragments, was in a private collection in Zurich in 1962, approximately the time when the fragments were reaching Boston. The complete capital shows the same simplicity of carving and a combination of strength and elegance, with the most refined details being in the inner spirals of the volutes.[4]

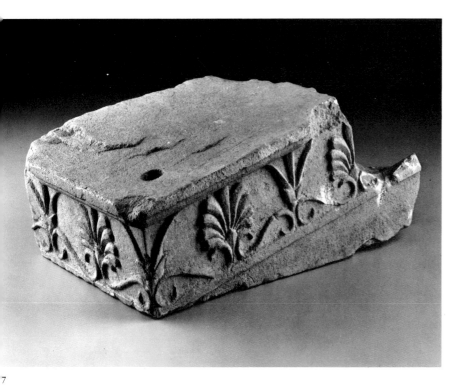

7

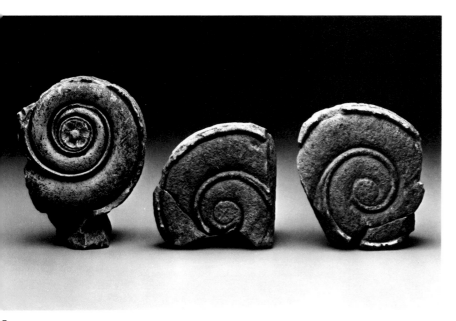

7

1. In Comstock and Vermeule, *Stone* (no. 41) and elsewhere.

2. Ibid.

3. 61.152; see ibid.

4. See Sotheby's sale, London, 13 July 1970, p. 101, no. 175; also pp. 100–101, nos. 174, 176; and D. Théodorescu, *Chapiteaux Ioniques de la Sicile Méridionale* (Cahiers du Centre Jean Bérard, vol. 1) (Naples, 1974), pls. III–X (works in Palermo and Selinunte).

Fourth-Century and Hellenistic Sculpture

8 (S70)

ATTIC FUNERARY MONUMENT
Greek, ca. 325 B.C.
Pentelic marble; H: 0.75 m. W: 0.56 m.
Classical Department Exchange Fund.
1979.510

Provenance: from the Ernest Brummer collection and the Brummer Gallery in New York

References: Museum Year: 1979–1980, p. 39; *Brummer Collection*, pp. 206 (illus.), 207, no. 615; Vermeule, *Sculpture in America*, p. 116, no. 87; idem, MFA *Art in Bloom* (Boston, 1984), p. 117, illus.; O. Palagia, *Hesperia* 51 (1982), p. 100, n. 3; Herrmann, *Shadow*, pp. 13, 14, 16, 21–22 (no. 11, illus.), 53.

Neg. No. C35273

Condition: Most of two figures and part of a third survive, as does a section of the right *anta* (or pilaster) of the niche, which framed the figures in varying degrees of relief. The cushion and part of one turned leg of the woman's stool also remain. Other breaks are evident and the surfaces have suffered the weathering of Attic winters in Antiquity.

A maid presents a small chest or casket to her mistress, who is seated in partly frontal view against the right-hand pilaster of the pedimented funerary monument. The right shoulder with drapery and the bare chest of a standing man is seen between the two women, against the background. He was presumably the seated lady's husband or father, and she is the deceased. An inscription on the frieze and architrave above would have given their names and defined their relationship, as is the case with other stelai in family plots near Athens and in rural cemeteries of Attica.

The servant wears her hair in a cloth and is clad in the simple long-sleeved garment fashionable in the kitchens of Attic homes from the times of Perikles to Demosthenes. The mistress has a more complex costume: a chiton tied above the waist and an ample himation wrapped around her lower body and brought up over her left shoulder. Her hair is arranged in melon waves and a curl of braids on the back of her head, a presentation fashionable in the Athens that witnessed the march of Alexander the Great from Macedonia to India. Endowed with a pleasing yellow patina common to the Pentelic marble of such tombstones, this ensemble in high relief expressed the poetic sentiment of Greek funerary sculpture before the Hellenistic world made art excessively emotional, naturalistic, and often mundane.

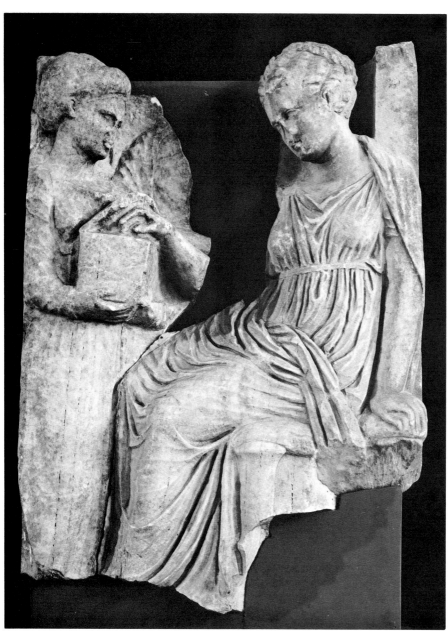

8

9 (S75)

ATTIC FUNERARY MONUMENT
Greek, ca. 325 B.C.
Low-grade Pentelic or "Hymettan" marble;
H: 0.82m. W: 0.46m.
Classical Department Exchange Fund.
1979.511

Provenance: from the Ernest Brummer collection
and the Brummer Gallery in New York (acquired
by Joseph and Ernest Brummer in 1926)

References: Museum Year: 1979–1980, pp. 20
(illus.), 39; *Brummer Collection,* pp. 196 (illus.),
197, no. 609; Vermeule, *Sculpture in America,*
p. 125, no. 96; Kokula, *Marmorlutrophoren,*
pp. 124, 129, 131–132, 138, 202–203, no.
O 43; Armstrong, *Mediterranean Spirituality,* p.
237, fig. 19.

Neg. No. C35274

Condition: The rectangular shaft of a funerary
monument from the vicinity of Athens was
carved out of grayish architectural marble from
the hills near the city. It has been broken irregu-
larly at the top and bottom and the rim of the
vase in relief has been damaged.

The chief design, carved in relatively low
relief, is a loutrophoros (or ceremonial
vessel) with contexts of marriage and pre-
mature death. The two big handles, making
this a loutrophoros-amphora, suggest a
vase awarded to young athletes at the
Panathenaic festival and therefore a symbol
of manhood.[1] The man near whose grave
this commemorative shaft stood may have
died young, or, like many men, he may
have wished to be remembered for the
deeds of a long-lost youth.

The loutrophoros-amphora carved on
this relatively thin slab gives a careful imita-
tion of elaborate, luxurious metalwork,
especially the scale pattern, the guilloche
band, and the gadrooning on the ovoid
body. At the time it was fashioned, Athe-
nian sculptures for cemeteries were becom-
ing big, complex, and costly, something the
citizens could ill afford while the Macedo-
nians were changing the world around
them so very much. Within a few years
such tombstones were curtailed, partly by
municipal action and partly by the uncer-
tain political conditions in the generation
after the death of Alexander the Great in
323 B.C.

1. A woman would have been represented by a
loutrophoros-hydria, suggesting the ritual bath
of a wedding and the domesticity of the village
fountain.

10 (S78)

VOTIVE RELIEF TO TWO DIVINITIES
Attic, ca. 323 B.C.
Pentelic marble; H: 0.545m. W: 0.71m.
*Gift of Mr. and Mrs. Cornelius C. Vermeule
III. 1977.171*

References: Museum Year: 1976–1977, pp. 25
(illus.), 40; Vermeule, *Socrates to Sulla,* pp.
34–35, 123, fig. 48; idem, *Sculpture in America,*
p. 92, no. 62; L. Kahil and N. Icard, in *LIMC,*

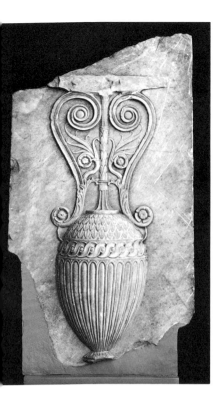

ol. 2, pt. 1, p. 690, no. 911; Armstrong, *Mediterranean Spirituality*, p. 419, fig. 31.

Neg. No. C33515

Condition: Faces, details of drapery, the imitation roof tiles, fillet moldings (cornice and architrave), pilasters on the sides, and frame below are effaced or chipped. The surfaces were weathered in Antiquity and now have a yellow patina.

An altar in the center divides the four mortals at the left (two men in the foreground and two women beyond) from the much larger divinities at the right. The bearded man in the front rank and the two women raise their hands in gestures of salutation, and the woman closest to the altar holds an offering vessel in her extended left hand. The god, in his ample cloak, has a scepter-staff in his right hand; the goddess wears a long tunic and a similar cloak—the latter arranged as a veil, its edge held out with one hand. A tiny crescent on her head identifies her as Selene, goddess of the moon, often equated with Artemis. Her impressive divine companion might be Helios or Apollo if he bore the traditional attributes and costume of these divinities; alternatively he may be the personification of a *deme*, or rural township in Attica. The frame of the relatively deep relief is in the form of a shrine with pilasters on either side and a carefully detailed roof above.

The ensemble was probably the offering of a well-to-do family at a well-known shrine, and the precise date, close to the death of Alexander the Great, is reached by stylistic comparison with an honorary-decree relief for an official named Euphron in the National Museum at Athens.[1]

1. No. 1482; see H. Speier, in *RM* 47 (1932), pp. 62, 70–71, 94, pl. 29, fig. 1.

11 (S89)

FUNERARY MONUMENT

South Italian Greek (Tarentine), ca. 330 B.C.

Limestone; H (max.): 0.245 m. W: 0.209 m. D: 0.064 m.

Frank B. Bemis Fund. 1977.718

Provenance: from the art market in Tokyo and, earlier, Basel

References: Museum Year: 1977–1978, pp. 23 (illus.), 41; C. Vermeule in *Art for Boston,* pp. 70–71 (illus.); *Schweizerische Kunst und Antiquitätenmesse Basel,* Münzen und Medaillen A.G., Basel, 17–27 March 1977, p. 94 (illus.).

Condition: Missing from the relief are the upper part with the head of the woman, the raised right hand of the servant girl, and edges of the fillet molding.

Within a simple, deep frame in the form of a fillet molding a woman stands facing to the right, wearing a long chiton with heavy folds and an ample himation wrapped around the waist and brought up behind the left shoulder, over the left arm, and down the left side. A section of himation to the left of the woman's neck suggests that she may have been veiled. She holds a jewel box or vanity case, from which she selects an object. Seated on a couch with an elaborately turned leg, a servant girl wearing an Ionian chiton rests her left arm on a plump cushion.

This miniaturist version of a late Attic grave stele formed part of a funerary monument dedicated to an apparently well-to-do woman. The figures are carved in deep relief, remarkably close to the freestanding statuary produced in Tarentum in the fourth century B.C. Although limestone is sometimes difficult to carve with precision, the sculptor has rendered the drapery in definite, delicate detail.

12 (S101)

STATUETTE: GODDESS, WATER NYMPH, OR OTHER MYTHOLOGICAL IDEAL BEING

Late Hellenistic, ca. 100 B.C.

Marble from Aegean islands; H: 0.43 m. W (max.): 0.29 m. D: 0.19 m.

Frank B. Bemis Fund. 1986.20

Provenance: from a collection in the British Isles

Reference: Museum Year: 1985–1986, pp. 28 (illus.), 49.

Neg. Nos. E1098 (front), E1099 (three-quarter view to right), E1100 (three-quarter view to left), E1101 (back)

Condition: The head is broken away roughly across the neck. The arms were made separately and attached with iron dowels (partly remaining in right shoulder). The cloak, otherwise complete, is broken off at the top, behind the raised left arm. The back of the object from which the figure steps is roughly finished. There is an uncertain rectangular block and another fragmentary piece rising from near the right front corner of a curving basin or boat. The surfaces are well preserved and appear to have been

10

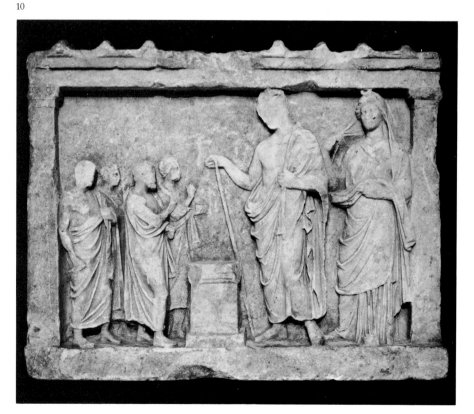

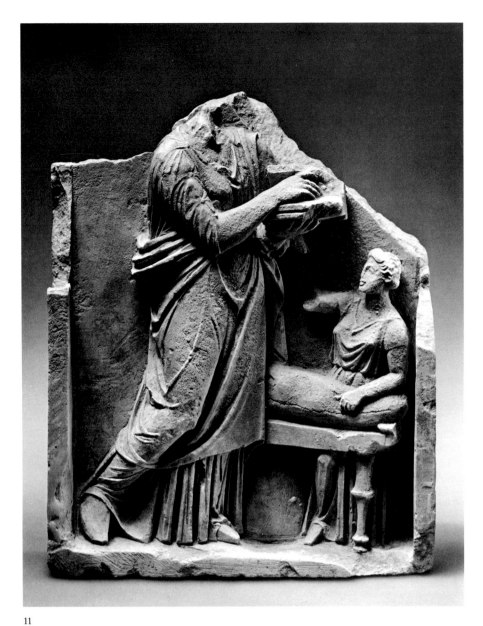

11

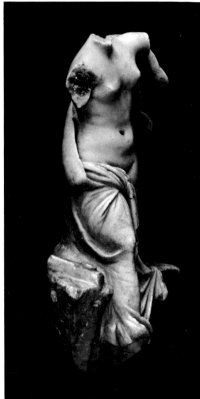

12

12

cleaned of some encrustation, perhaps in the nineteenth century.

The precise mythological significance of the figure, who suggests an Artemis surprised at her bath, defies certain definition. The block seems to have been made to be set into a mounting that was probably made of some other material and may well have imitated landscape. Semidraped nymphs frequently lounge on rocks in the sculpture of the eastern Greek island of Rhodes; in Italian houses and villas during the late Republican and Imperial periods they were often placed in niches and grottoes fitted out with water jets to resemble cave-like springs.

On the evidence of a similar figure from southwestern Asia Minor or the nearby Greek islands, less well preserved (now in the Archaeological Museum on Rhodes), it can be concluded that the present sculpture was produced in that area. Although the body of the comparative piece exists only from the navel downward, its anatomy and drapery are handled with a particular lively sensitivity that places it among the finest examples of the Rhodian late baroque. Remains of a dolphin and an Eros at the right side suggest identification as Aphrodite.[1] The rectangle and the puntello above it on the Boston sculpture could have supported a dolphin in similar fashion, or could have been the base for a stake and bonds if the statuette is meant to represent Andromeda.[2]

1. Giorgio Gualandi, "Sculture di Rodi," *Annuario* 54 (1976), pp. 110–113, no. 62, figs. 92–93, Inv. No. E.529.

2. As has been suggested for the figure on Rhodes; see Linfert, *Kunstzentren*, p. 98, n. 336.

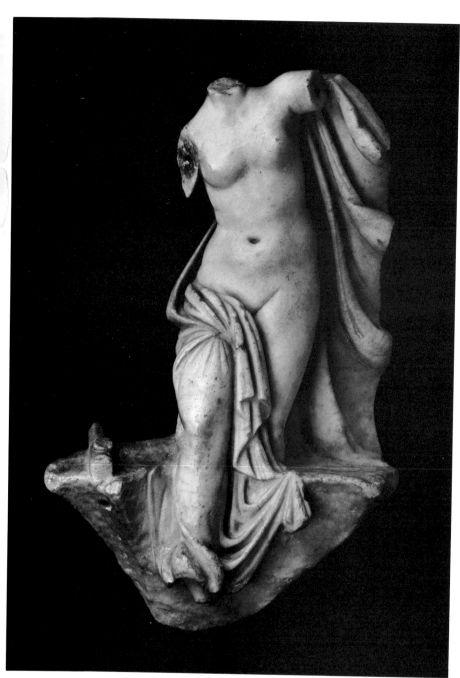

12

13

13 (S112)
TWO FRAGMENTS OF
FUNERARY RELIEF: CERBERUS
South Italian Greek (Tarentine), ca. 320
B.C.
Limestone; H: 0.27m.
*Gift of Mr. and Mrs. Cornelius C. Vermeule
III in the name of Cornelius Adrian Com-
stock Vermeule. 1986.1028*

Provenance: from a private collection in England
Reference: Museum Year: 1986–1987, p. 51.
Neg. No. E618

Condition: The smaller of the two fragments
(rejoined) comprises a horizontal groundline
jutting forward with the remains of the animal's
hind paws on the surface. The limestone has a
yellow patina.

Cerberus is straining at a lead that was
once connected (in paint) to his three col-
lars. He was undoubtedly being restrained
by Herakles standing at the left, the imprint
of his left foot remaining beside the paws
on the ground area. The middle head of
the dog is looking upward at the diagonal
torch, hand, and arm (all badly damaged
and worn) of Artemis Bendis, who was
standing at the right and lighting the way
from the Underworld for the hero and the
guard dog.

A vase from Canosa shows that this
composition was famous in the fourth
century B.C.[1] The common source was
surely a painting, probably one in a major
cult center of the lower Italian peninsula.
The Phlegraean Fields (Campi Flegrei)
between Naples and Cumae, north of
Puteoli, provided the disturbed natural

environment (in this case volcanic) where cults involving the descent to the Underworld could flourish. Lake Avernus, with its limitless depth and noxious gases, was thought to be the entrance to Hades.

1. W.H. Roscher, *Lexikon*, vol. 2, no. 1 (Leipzig, 1890–1894), cols. 1125, 1126, fig. 2.

14 (S112)
SECTION OF FUNERARY PEDIMENT: FALLEN AMAZON (?)
South Italian Greek (Tarentine), ca. 320 to 280 B.C.
Limestone; H (left end): 0.13m. H (right end): 0.077m. W (max.): 0.215m. D: 0.042m.
Edwin E. Jack Fund. 1985.343

Provenance: from the art market in Paris
Reference: Museum Year: 1984–1985, pp. 27 (illus.), 48.
Neg. No. C43095

Condition: All the edges are finished fairly smoothly, the right edge and the bottom particularly so. The back has the marks of a flat chisel but is evened off to a fair degree of smoothness. The usual yellow patina covers almost every surface except at the upper left corner, where there is slight chipping.

The female—an Amazon, to judge from her northeastern barbarian costume—might appear to be sleeping rather than dead, save for the fact that sleeping Amazons are unknown to Greek art. The bare left leg of what may be a kneeling man appears at the left. A flower is behind him, and a cushion, a bed, and a landscape of rocks are below the figures, above a fillet molding at the bottom.

A similar Amazon, reversed, and a Greek in a position like that postulated for the owner of the leg seen here appear on the bottom of the Strangford Shield, believed to derive from the shield of the Athena Parthenos.[1] This small Tarentine pediment, surely from the façade of a tomb, therefore presented an Amazonomachy that is yet one more reflection, over a century later and a sea away, of the influence of the Pheidian masterpiece on the arts of greater Greece.

1. D. von Bothmer, *Amazons in Greek Art* (Oxford, 1957), p. 210, pl. LXXXVII, fig. 1; N. Leipen, *Athena Parthenos: A Reconstruction* (Toronto: Royal Ontario Museum, 1971), pp. 8 (no. 31), 70 (figs. 26, 27).

15 (S113)
CORINTHIAN CAPITAL FROM FUNERARY MONUMENT
South Italian Greek (Tarentine), ca. 300 to 250 B.C.
Limestone; H (max.): 0.06m. W: 0.168m.
Gift of Mr. and Mrs. Cornelius C. Vermeule III in the name of Cornelius Adrian Comstock Vermeule. 1986.1020

14

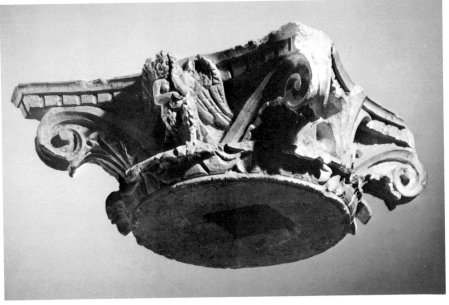

15

Provenance: from the art market in New York and Basel, and earlier, from a private collection in Lugano
Reference: Museum Year: 1986–1987, p. 51.
Exhibition: Art of Ancient Italy (New York: Andre Emmerich Gallery, 4–29 April 1970), p. 55, no. 88.
Condition: Two ends of the projections of the abacus, above the volutes, are damaged. There is minor chipping on the uppermost outer edge of the top molding. Otherwise, the condition is excellent, with the large, rectangular dowel hole preserved on the underside and pink coloring on the back.

A mourning Siren stands in the center of the front, in the pose traditional to the upper elements of Attic funerary stelai.[1] The center of each side is filled by a palmette above a pointed acanthus leaf, and there is a rosette in the center of the rear of the capital. Four volutes, each supported by a large acanthus leaf, spring from a wreath of acanthus foliage. The abacus at the top comprises a concave fillet above a slightly larger row of dentil molding.

1. Compare Comstock and Vermeule, *Stone,* nos. 66, 67, and 71.

16 (S113)

STELE DEPICTING DIVINITIES, SHIP
OF THE ARGONAUTS, AND
DIPLOMATIC TEXT
Boeotian, early Hellenistic, 300 to 250 B.C.
Mainland Greek marble; H: 0.65 m. W:
0.325 m. D: 0.20 m.
John H. and Ernestine A. Payne Fund.
1987.297

Provenance: from a collection in the United
Kingdom

Reference: Museum Year: 1986–1987, p. 52.

Condition: The surface is marked with patches
of encrustation. Edges of the moldings are worn
and chipped in places, and the lower part of the
inscription is broken off irregularly, with most
of the surface at the right edge missing.

In the apex of this pedimented rectangular
block, the infant Herakles strangles the
serpents of Hera. The main scene beneath
depicts the mounted Dioskouroi, Castor
and Polydeukes, facing the Tegean goddess
Athena Alea, who stands at the right. The
Argo, ship of Jason and the Argonauts, is
carved in the space below. The names of
the goddess and the heroes are inscribed
on the molding above the main scene and a
dedicatory inscription filled the lower part
of the stele.

This small public monument, erected
around the outset of the Hellenistic age,
draws together strands of the mythology
and history of Boeotia (central Greece) and
the Peloponnesus. It seems to have been
dedicated by an ambassador from the
Arcadian Confederacy at Tegea, who came
to the area around Thebes at some time
within the half century after the death of
Alexander the Great. These were difficult
times for the city-states of a Greece domi-
nated by Alexander's Macedonian succes-
sors to the northeast, later by Pyrrhus of
Epirus, and eventually by the rising power
of the Roman Republic to the west. Ale-
xander had destroyed Thebes near the
beginning of his odyssey of conquest, but
he spared the city's shrines and temples
and his successors helped to restore the city.

Herakles strangling the serpents in the
pediment connects Thebes, where Herakles
was born and had a major shrine, with
Tegea, where he fathered Telephos. The
meeting between the heavenly twins and
Athena relates Boeotia to Arcadia as far
south as Sparta, home to the Dioskouroi.
The *Argo*, on which the Dioskouroi sailed,
took the Boeotian, Attic, and Peloponne-
sian heroes to the eastern end of the Black
Sea in search of the Golden Fleece.

In its charming primitivism, this piece is
based on an Athenian tradition established
for treaty and honorific reliefs in the fourth
century B.C. Texts similar to the lines below
the reliefs of this stele have long been re-
corded from Boeotia (Thebes, Tanagra, or
Thespiae). This inscription mentions an
Archon named Ergoteleos. Compare it
with a diplomatic (*proxenia*) decree, re-

16

corded centuries ago by Le Bas, built into a wall of the Church of Saint Theodore at Thebes, and the honorific formula copied from a black stone plinth at Tanagra.[1]

1. E. Schwyzer, *Dialectorum Graecorum Exempla epigraphica potiora* (Hildesheim, 1960), pp. 243–244 (no. 487), 233–234 (no. 460; on the same stone as no. 457 on p. 232).

17 (S116)
RELIEF DEPICTING VOTIVE OBJECTS AGAINST ARCHITECTURAL BACKGROUND
Graeco-Roman, 1st century A.D.
Greek island marble; H: 0.295 m.
W: 0.195 m.
Classical Department Exchange Fund.
1979.613

Provenance: from a private collection in England
References: Museum Year: 1979–1980, p. 39; MFA *Preview*, April-May 1980, cover illus.; *Calendar*, May 1980, p. 2 (illus.); M. Grant, *Cities of Vesuvius: Pompeii and Herculaneum* (London, 1971), pp. 118–119 (illus.); Brilliant, *Pompeii*, p. xiv (illus., from Werner Forman Archive); Vermeule, *Sculpture in America*, pp. 232–233, no. 194 (illus.).
Neg. No. C34538

Condition: The rectangular relief is chipped and worn down on the edges; a leg and feelers of the lobster are missing. Otherwise, the condition is excellent. The section of the wall that is broken away was carved in this fashion by the sculptor to suggest a ruin. There is a light brown encrustation over most of the surface.

A dilapidated wall and its gateway, at the lower right, form the background of the relief. Overhanging the scene at the upper part is a gnarled branch of a tree, from which two plucked birds hang. In the foreground, against the wall, is a spiny lobster; below are several knucklebones and a wicker basket containing a *murex brandaris* and more knucklebones. The fowl, shellfish, and other objects are probably the offerings of farmers and fishermen to a rural fertility god such as Pan or Priapus. They are meant to be seen as being within the walls of a rustic shrine, which may have suffered from age or been damaged in the earthquake of A.D. 62 around the Bay of Naples.

There are comparable Graeco-Roman decorative reliefs. An example with a landscape setting[1] includes a small rustic shrine to Priapus at the left. Another such fragmentary relief was drawn for Cassiano dal Pozzo in Rome in the first half of the seventeenth century.[2]

1. British Museum no. 2165; see Reinach, *Rép. rel.*, vol. 2, p. 487, no. 2.

2. *TAPS* 56, pt. 2 (1966), pp. 24 (no. 8381), 104 (fig. 68).

17

18 (S127)
RELIEF DEPICTING EARLY HELLENISTIC PHARAOH AS OSIRIS
Ptolemaic, probably 3rd century B.C.
Limestone; H: 0.635 m. W: 0.413 m.
Gift of Paul E. Manheim. 69.1332 (deaccessioned)

References: Museum Year: 1969–1970, p. 42; Parke-Bernet sale, New York, 11 April 1969, pp. 30 (no. 189), 31 (illus. as Nineteenth Dynasty, ca. 1304–1200 B.C.); *Museum Year: 1985–1986*, p. 49.

Exhibitions: Greek and Roman Sculpture (Corpus Christi: Art Museum of South Texas, 7 February–25 May 1975), no. 24 (illus.); Birmingham (Alabama) Museum of Art, *Bulletin*, no. 27 (Spring 1967), no. 1.
Neg. No. C26820

Condition: The relief is broken on the left side and cut evenly at the top and bottom and on the right. Where damage occurred around the mouth, the face has been reworked; the back is in its original condition.

The pharaoh, perhaps Ptolemy II Philadelphus (285 to 246 B.C.) as a young ruler, is depicted as Osiris, god of the Underworld.

18

He carries a whip and a flail and wears the double crown, horns, and solar disk; the inscription beside his head reads "Of the Radiant King."

Reliefs such as this appear on the pylons of the Ptolemaic temple to Isis on the island of Philae at the First Cataract.[1] They are among the best efforts at presenting the Macedonian Greek rulers in the iconography and sculptural style traditional to ancient Egypt.[2]

1. W.S. Smith, *The Art and Architecture of Ancient Egypt* (Baltimore, 1958), p. 254, pl. 188; 2nd rev. ed. by W.K. Simpson (New York, 1981), pp. 422–424, fig. 416.

2. Compare the similar relief of Ptolemy III Euergetes (246 to 221 B.C.) and the references cited in its publication: *Aegyptische Kunst*, Münzen und Medaillen, A.G., Basel, Auktion 46, 28 April 1972, p. 68, no. 128, pl. 31; compare also Arsinoë II (284 to 247 B.C.) facing right, in Myers/Adams, New York, Auction 8, 10 October 1974, no. 133.

Graeco-Roman Statuary

19 (S139)
REDUCED REPLICA OF ATHENA PARTHENOS
Graeco-Roman (Severan copy), ca. A.D. 200
Attic marble, probably from Mount Hymettus; H: 1.54 m.
Classical Department Exchange Fund. 1980.196

Provenance: from a private collection in Germany

References: Museum Year: 1979–1980, p. 39; *Masterpieces,* no. 24 (color illus.) and p. vi; Vermeule, *Prehistoric through Perikles,* pp. 161, 169, 171–172, 183, 227, 490, fig. 224; idem, *Sculpture in America,* pp. 3–4, 56, no. 29, color pl. 6; B. Shefton, in D. Kurtz and B. Sparkes, *The Eye of Greece* (Cambridge, 1982), pp. 159–160, n. 35; C. Vermeule, in Berger, *Parthenon-Kongress,* p. 197, pl. 14; B.S. Ridgway, in *GettyMusJ* 12 (1984), p. 30, fig. 1; Boardman, *Classical,* pp. 110, 138, 245, fig. 100; A.J.N.W. Prag, in Berger, *Parthenon-Kongress,* p. 408, n. 41; Armstrong, *Mediterranean Spirituality,* p. 127, fig. 9.

Condition: The head and neck were carved of a lighter, softer block of marble than the rest of the figure. Joins are confirmed by matching curls above the left shoulder and the hair below the helmet and on the back of the aegis. Restored areas include a small part of the left eyelid, tip of the nose and left nostril, much of the lower lip and the end of the chin, and the curl of hair on the right side of the neck, including a small portion of the curved lower end of the helmet. There are no restorations on the body. Traces of paint remain on the lower curls on Athena's left shoulder. Ancient iron pegs are visible in the troughs of the arms, along with larger dowel holes for fitting the arms and the weight they supported. Some surfaces were carefully cleaned long ago; others preserve good root marks.

This small statue provides details (of helmet, aegis, and snake belt) preserved in no other copy of the Pheidian image, as distinct from versions of the Parthenos created in Hadrianic times and, in turn, copied for public and private buildings in the Latin West.

On either side of the visor are a Pegasus and what may be a deer beside him (a little "animal" at the front center is damaged beyond recognition). On top of the helmet, larger Pegasoi flank a sphinx as supports for a triple crest, and griffins in relief enrich the upturned insides of the cheekpieces. The snakes of the aegis and belt are well delineated: ten snakes on the front of the aegis, two coming up behind the Gorgoneion, and eight twisting along the edges of the sacred animal skin. Grooved sandals, feet, and a little tear-shaped weight at the bottom of Athena's drapery are one with the block of the body. The holes on the irregular plinth, along the left face, were for attachment of the block that supported the snake and the shield in front of it;

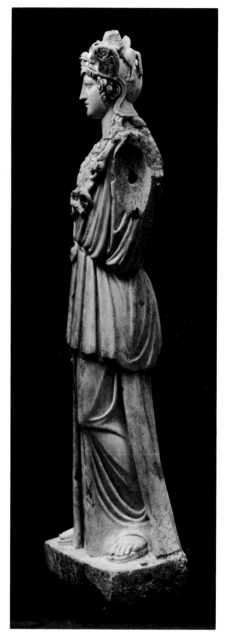

19

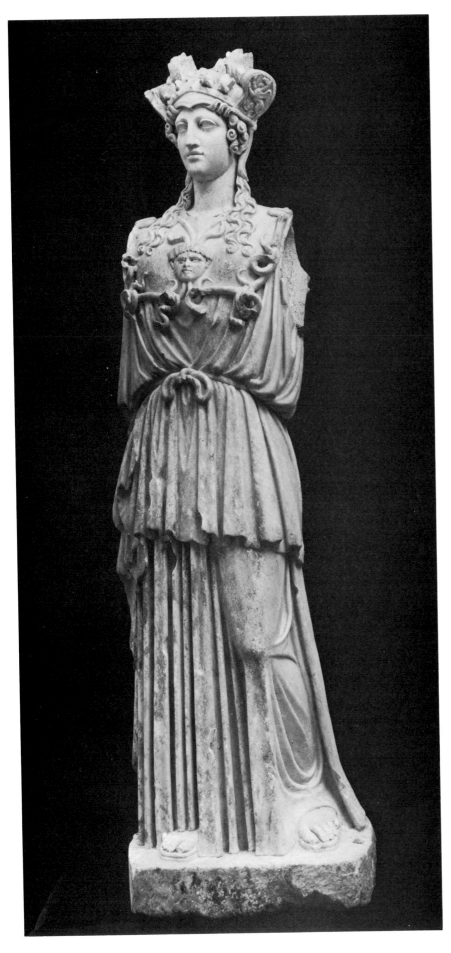

holes at the top left were for inserting the spear.

This statue, patently a Severan copy, is one of the most faithful reduced replicas of the Pheidian image. The figure belongs with the group around the Varvakeion Athena; although less complete, it is also much larger and more detailed. In addition to the truest copies of the Parthenos in various scales, the Baltimore torso[1] and the Copenhagen head[2] represent the Hadrianic version, as does the Berlin head,[3] which shows details only somewhat less well preserved than those of the Boston statue. The head in the Louvre[4] and its body in Civitavecchia (lost and found again since the sketchbooks of the sixteenth century)[5] give the best example of the early Antonine statues. This group also includes the head in the Palazzo Riccardi, Florence,[6] and the body in the Villa Borghese, Rome.[7]

Like the original image by Pheidias, both Roman Imperial prototypes for these Hadrianic and Antonine groups were probably created in the city of Athens, the older prototype perhaps for the Hadrianic Pantheon (the one in Athens; also, conceivably, the one in Rome) and the later one for the Library of Hadrian in Athens, presumably as completed under Antoninus Pius. Copies of the Graeco-Roman Imperial images have long confused discussion of the iconography of Pheidias's statue, but these variants, in comparison with the accuracy of the statue in Boston, all show the vitality of the Parthenos six hundred or more years after Pheidias created his cult image for the Acropolis of Athens.

1. D.K. Hill, *Art Bulletin* 18 (1936), pp. 150–167, figs. 1–13.

2. F. Poulsen, *Catalogue of Ancient Sculpture in the Ny Carlsberg Glyptotek* (Copenhagen, 1951), pp. 91–92, no. 98; F. Brommer, *Athena Parthenos* (Bremen, 1957), fig. 7.

3. C. Blümel, *Katalog der Sammlung antiker Skulpturen* (Berlin, 1931), vol. 4, pp. 31–32, K170, pls. 58–59.

4. E. Michon, *MonPiot* 7 (1900), pp. 153–173, pl. XV.

5. *Nuove scoperte e acquisizione nell' Etruria meridionale* (Rome: Museo Nazionale di Villa Giulia, 1975), pp. 245–247, pl. 75 (with a cast of the head in the Louvre); T. Schreiber, *Die Athena Parthenos des Phidias* (Leipzig, 1883), p. 571, pl. IIIG.

6. *EA*, nos. 301–302; Mustilli, *Museo Mussolini*, pp. 113–114, no. 20.

7. *EA*, no. 2704; W. Fuchs, in W. Helbig, *Führer durch die öffentlichen Sammlungen klassischer Altertümer in Rom* (Tübingen, 1966), vol. 2, pp. 734–736, no. 1980.

19

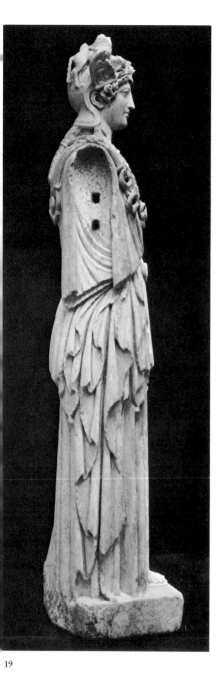

19

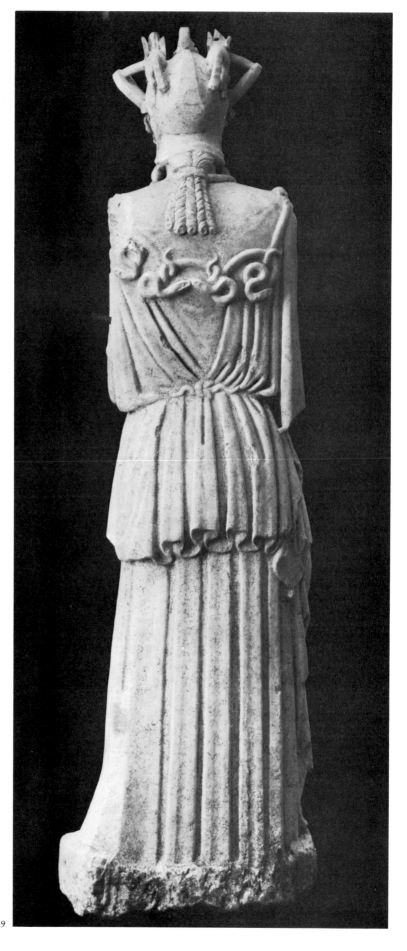

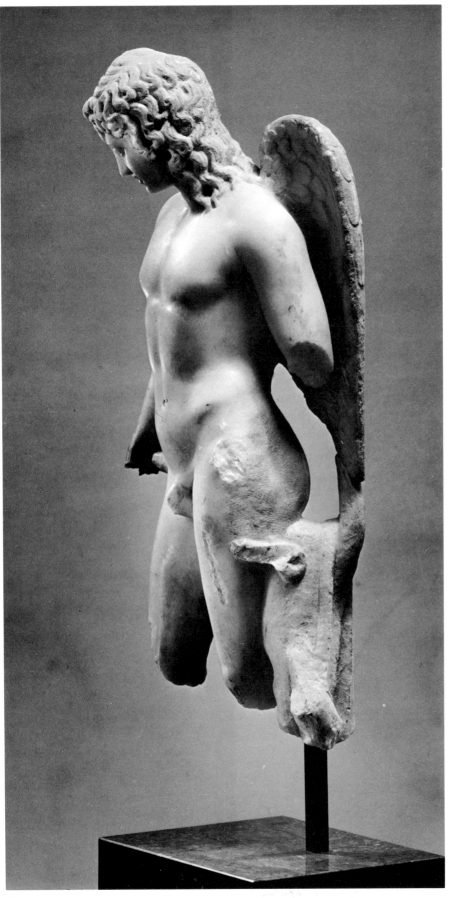

20

20 (S161)

Statue of Eros

Greek Imperial, ca. A.D. 190
Marble from Greek islands or western
Asia Minor; H: 0.63 m.
Classical Department Exchange Fund.
1979.477

References: Museum Year: 1979–1980, pp. 21
(illus.), 39; Vermeule, *Socrates to Sulla,* cover
illustrations; idem, *Sculpture in America,* p. 64,
no. 36, illus.; idem, in *Art for Boston,* pp. 80–
81, illus.

Exhibitions: On Angels' Wings, MFA at Faneuil
Hall Marketplace, Boston, 1979–1980;
Schweizerische Kunst und Antiquitätenmesse,
Münzen und Medaillen A.G., Basel, 24 March–
3 April 1979, "Kunstwerke der Antike," plate
and caption.

Condition: The right hand, lower left arm,
much of the right wing, legs from below the
knees, most of the quiver, the lower part of the
tree-trunk support, and the plinth are missing.
Remains of horizontal struts are visible on the
left thigh, the left hip, the top of the right knee
(?), and between the right wrist and hip. The
right hand was made separately and joined with
an iron dowel, which remains in the center of
the wrist. The surfaces, generally excellent, with
most of the polish remaining on the flesh, have
traces of a yellowish patina and, especially at the
right wrist, iron stains.

The young god of love stands in a thought-
ful, relaxed pose, a large bow once in the
left hand, an arrow in the lowered right,
and a quiver against the tree trunk at the
left side. The high polish of the surfaces is
consistent with second- to third-century
Greek Imperial copies of famous statues in
bronze or marble going back to the age of
Praxiteles around 350 B.C. Brought, it is
said, from the eastern Mediterranean, this
statue was probably fashioned by sculptors
from Aphrodisias in Caria and is a copy,
indeed the most complete to survive with-
out restorations, of the Eros of Centocelle.

The latter work, a half-statue in the
Vatican Museums, was found a century
ago in the ruins of a great Imperial villa at
Centocelle (ancient Centumcellae on the
Via Labicana southeast of Rome). Other
heads and parts of statues reflect the same
original, the most complete (although
heavily restored and carved in Italian mar-
ble) being the Eros in the Hermitage
(Leningrad), from Hadrian's Villa at Tivoli
Many critics have identified the original as
one of the statues of Eros made by Praxi-
teles for Athens about 350 B.C. or for
Thespiae in Boeotia to the northwest,[1]
where the sculptor's beautiful mistress
Phryne was raised. Just as Praxiteles was
famed for his statues of Aphrodite, so he
was admired for his likenesses of her son
Eros. Other aestheticians, however, have
seen this Eros, the Centocelle type, as a
creation of the age of the first Roman em-
peror, Augustus (27 B.C. to A.D. 14), when
Praxitelean taste was back in fashion. The
question must remain open pending future
evidence, but the great number of replicas

32

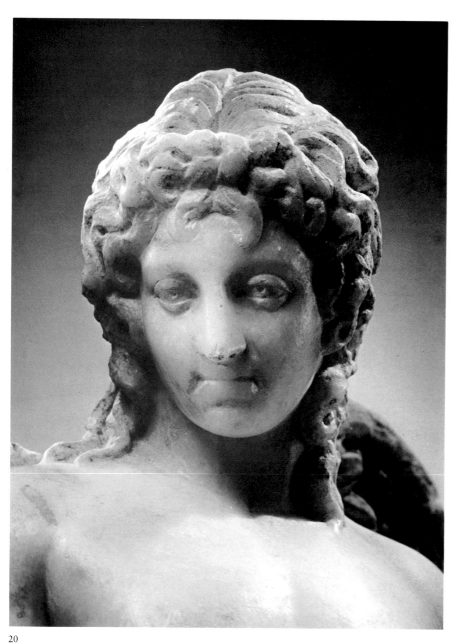

20

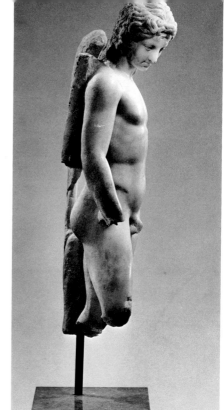

20

20

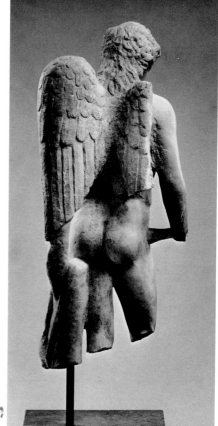

and the style so suggestive of all we know about the divine Athenian sculptor support attribution of the original of this excellent replica to Praxiteles. The dating of this copy, late in the Antonine period, is deduced, in addition to other considerations, from the engraved eyes and the combination of carving and drilling in the hair. Overall treatment of the head, including nostrils and lips, also recalls workmanship on contemporary sarcophagi from Attica and western Asia Minor.

A recent study of the late Roman Republican and early Roman Imperial origins of this Eros includes a list of fifteen replicas.[2]

1. Richter, *Sculpture*, p. 202.
2. See Zanker, *Klassizistische*, pp. 108–109, no. 11, with bibliographies.

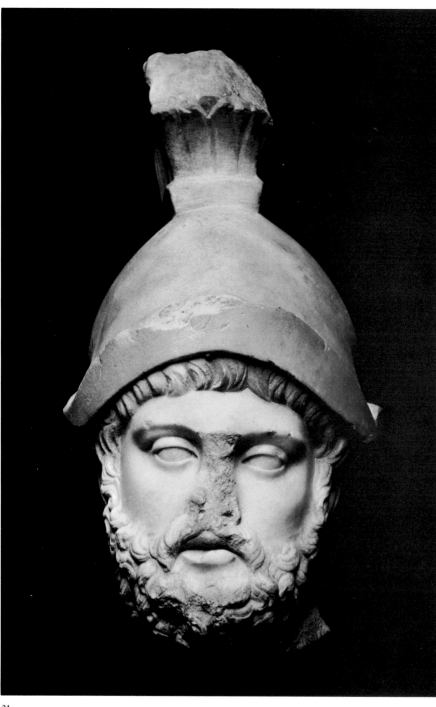

21

This head from an almost life-sized statue belongs to a reduced, somewhat free copy of the colossal cult image in the temple of Ares on the acropolis at Halicarnassus in Caria. The latter was once attributed to either Leochares or Timotheos[1] but, like the Demeter of Knidos, certain "portraits" from the Mausoleum at Halicarnassus, and the young Alexander the Great from the Athenian Acropolis,[2] the image of Ares is to be identified with the former sculptor.

The face owes much to the influence of Imperial sculpture in the era of Hadrian's classicism. It is almost possible to see Hadrian's features very idealized in the hair, eyes, cheekbones, mouth, and beard. If so, the complete, cuirassed statue would have been carved for a temple complex or urban center, like so many from Olympia to Perge in Pamphylia, in which Hadrian was honored as a warrior-hero amid the Olympian pantheon and other divinities or personifications.

The Ares of Halicarnassus and this reduced version doubtless wore a plain cuirass of the type seen on Attic funerary monuments of the period 350 to 320 B.C. The plumed Attic helmet reminds us of the connections between Athens and Halicarnassus implicit in the attribution of the head of the young Alexander, mentioned above, to Leochares. After the sculptor completed his assignment on the Mausoleum, there was no lack of commissions in the cities along the Carian coast.

1. Vitruvius, II, 8, 11.

2. J. Charbonneaux, R. Martin, and F. Villard, *Hellenistic Art: 330–50 BC* (London, 1973), fig. 219.

21 (S161)
Fragment of Statue:
Helmeted Head of Ares
Greek Imperial, ca. A.D. 135
Crystalline white marble, probably from southwestern Asia Minor; H (max.): 0.44m.
Gift of Mr. and Mrs. Cornelius C. Vermeule III. 1977.712

References: Museum Year: 1977–1978, p. 40; MFA *Preview*, December 1977–January 1978, cover; MFA *Art in Bloom* (Boston, 1979), p. 46, illus.; C. Vermeule, *Berytus* 26 (1978), pp. 86–88, fig. 1; idem, *Socrates to Sulla*, pp. 19, 25, 119, fig. 22C; idem, *Sculpture in America*, p. 218, no. 183; idem, in *Alessandria e il Mondo Ellenistico-Romano, Studi in Onore di Achille Adriani* (Rome, 1984), vol. 3, pp. 783–788, pls. CXX–CXXIII.

Neg. Nos. C31020 (front view), C33454 (three-quarter view to right)

Condition: A bit of the upper part of the neck is preserved. The nose is mostly broken away and the visor and plume of the helmet have been chipped. The head, particularly the skin areas of the face, was cleaned aggressively to remove a brown encrustation.

22 (S163)
Upper Part of Statue
after Weary Herakles of
Lysippos
Greek Imperial (late Antonine), ca. A.D. 160 to 192
Marble from Greek islands or western Asia Minor; H: 0.67m.
Collection of Leon Levy and Gift of the Jerome Levy Foundation. 1981.783

Provenance: from a private collection in Germany

References: Museum Year: 1981–1982, pp. 25 (illus.), 44; MFA *Preview*, April-May 1982, illus.; Vermeule, *Divinities*, p. 39, pl. 49; idem, in *Festschrift Schauenburg*, pp. 134–135, pl. 23, fig. 2; Krull, *Herakles*, p. 422.

Neg. Nos. C38148 (front view), C38149 (left profile), C38150 (detail of head), C38151 (back)

Condition: The statue was broken on a slant across the torso from the rib cage on the right toward the pelvis on the figure's left side. It was also broken high on the right arm and above the elbow on the left arm. After cleaning, there remains some discoloration on the shoulders

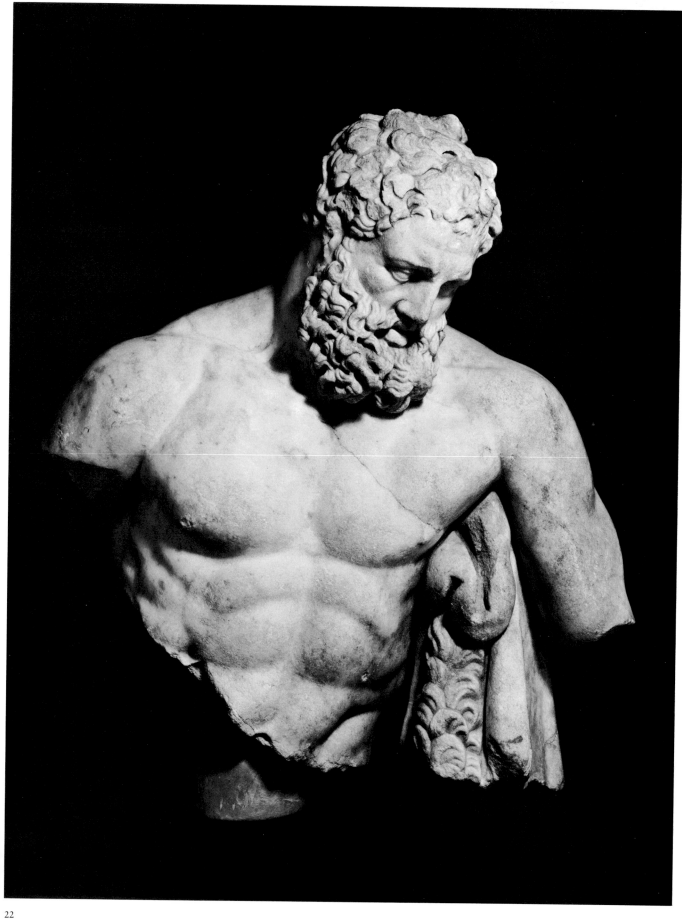

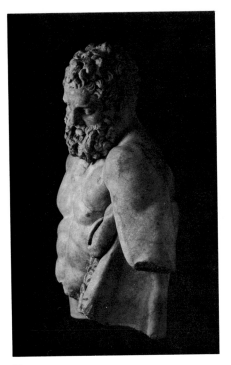

22

and in the deeply cut areas, where traces of the drill are visible. The club, covered by the skin of the Nemean lion and then by a cloak, is preserved from the uppermost part of the left arm to the line of the break at the hero's left side.

This version of a statue identified with Lysippos around 330 B.C.[1] was created in or for Pergamon at the height of that city's artistic prestige in the middle to latter half of the second century A.D. The hair of the head is broken up into bunches of strands going in all directions, and the full, rich beard is divided into two groups of deeply cut masses of large and small curls. The brow is knotted, the eyes are sunken above protruding cheekbones, and the depth of the mouth contributes to the expression of strain, all characteristic of the so-called Pergamene baroque.

The Greek cities of Asia Minor, from Pergamon itself to the Pamphylian and Cilician coast, admired the dramatic aspects of such statues in the late second and early third centuries of the Roman Empire. They were copied widely in workshops along the Ionian coast, at Aphrodisias in Caria, in the Greek islands, and around Athens. The Weary Herakles after Lysippos, as interpreted at Pergamon, was one of the most popular Greek Imperial statues. This late Antonine example demonstrates how the Roman Empire viewed the heroic past of Pergamon and, ultimately, the scientific sculpture of Lysippos in the age of Alexander the Great.

1. C. Vermeule, *AJA* 79 (1975), pp. 323–332, pls. 51–55.

23

23

23 (S164)
FRAGMENT OF STATUE: HERAKLES WRESTLING NEMEAN LION
Roman Imperial (late Flavian), ca. A.D. 90
Dark green stone ("basalt"); H: 0.19 m.
Nuffler Foundation Collection. 159.<u>64</u>

Provenance: from the Joseph Brummer and, later, J. J. Klejman galleries, New York; found, according to R. Lanciani and T. Ashby, in the sunken garden (the so-called Stadium) of Domitian (81 to 96) on the Palatine Hill in Rome

References: C. Vermeule, "Graeco-Roman Statues," *BurlMag* 110, no. 787 (October 1968), p. 549; idem, *Sculpture and Taste*, p. 52, figs. 52a, b.

Neg. Nos. C28621 (front view), B20383 (profile view)

Condition: The hero's head and neck, broken away, are missing, as is all below the waist and

the body of the lion from the area behind the mane. The back of Herakles from the top of the shoulders to the waist has been cut away and squared off roughly, as if the stone had been reused as building material. Finished areas near the edges of this flat, rough surface suggest that the figure could have been carved to be displayed against another background, perhaps in white marble. Thus, it may have been part of a small pediment or a piece of large furniture.

Herakles was depicted bending forward, squeezing the lion's head under his right arm. The animal's paws are on the left side of the hero's chest, at the neck, and on the right arm at the elbow. With the muscles and animal's fur emphasized, as was so often the case with sculptures in this dark green stone, the figure is a reduced version of one of the bronze statues in the cycle "Labors of Herakles" created by Lysippos for the hero's shrine at Alyzia in Acarnania.[1]

Of the many marble versions, Graeco-Roman statues, or figures in high relief on columnar sarcophagi after the Lysippic figures of Herakles, this fragment stands apart as a survivor of Roman Imperial taste for imitating the green patina of weathered bronze in very hard stone. The emperor Domitian (ruled 81 to 96; see below, no. 45) commissioned such statues, on all scales from colossal to that of this figure, for the Domus Flavia, his palatial complex of buildings including the long, hippodrome-like sunken garden on the Palatine Hill in Rome.

1. Bieber, *Sculpture*, p. 36.

24 (S176)
STATUETTE OF APHRODITE ANADYOMENE
Greek Imperial, probably 3rd century A.D.
Marble from western Asia Minor; H: 0.55 m.
Classical Department Exchange Fund.
1982.286

References: Museum Year: 1981–1982, p. 45; Vermeule, *Numismatic Art*, pp. 95, 120, fig. 81.

Condition: The statuette is intact, with an even yellow patina on the surfaces.

Standing with her weight on the left leg and the right leg drawn back, Aphrodite is wringing out her long hair as if emerging from the foam where she was born, along the coast just east of Paphos in southwestern Cyprus. Otherwise, the goddess of beauty and love may be arranging her hair after a bath. She stands on a pedestal, her left hip resting against a support in the form of a drapery-covered stump.

There are many Hellenistic to Graeco-Roman variants of this popular composition, some mirror reversals of others and some with arms and legs positioned as in this example but with the head looking downward to the subject's left instead of to the right.[1]

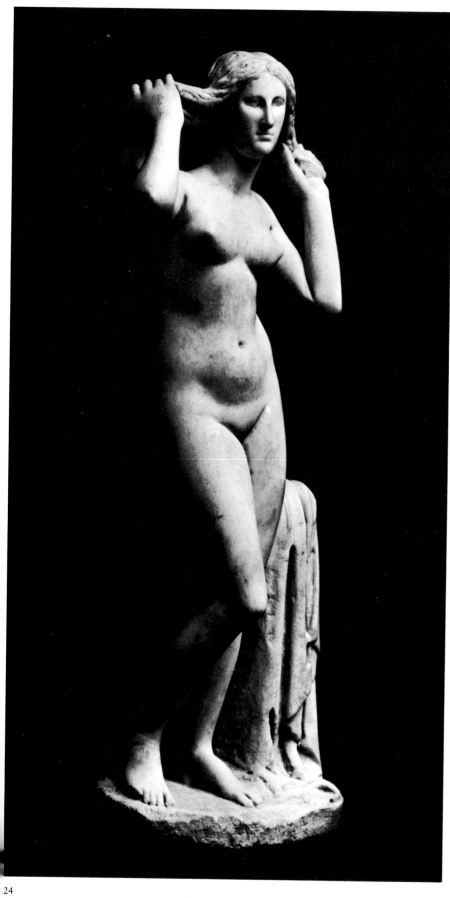

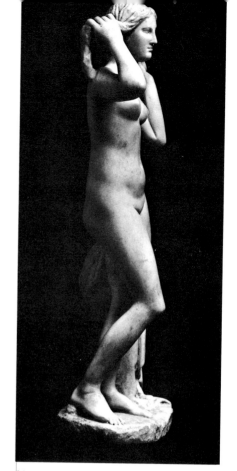

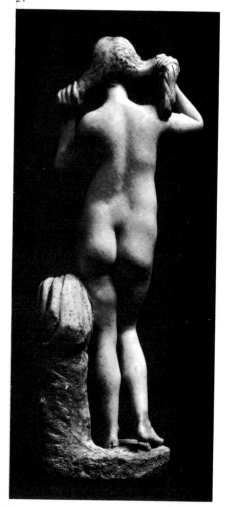

24

24

24

1. Compare statues in the Palazzo Colonna, Rome (extensively restored), and the Walters Art Gallery, Baltimore; see Bieber, *Sculpture*, pp. 143–144, figs. 604, 605. A small statue that adds Eros at the side of the goddess was sold at auction in Switzerland; see Ars Antiqua, Lucerne, Auktion II, 14 May 1960, p. 25, no. 55, and bibliography, pl. 25.

25 (S180)
STATUETTE OF APHRODITE LEANING ON A COLUMN

Late Hellenistic to Graeco-Roman, ca. 50 B.C. to A.D. 50
Sparkling, large-crystaled Greek island marble; H: 0.42 m.
Gift of Emily Dickinson Blake Vermeule. 1979.304

Provenance: from the art market in London and Paris, probably from Egypt
References: Museum Year: 1978–1979, pp. 20 (illus.), 39; A. Delivorrias et al., in *LIMC*, vol. 2, pt. 1, p. 63, no. 519.
Neg. Nos. c33918 (front) and c33919 (back)

Condition: The left hand (now missing) was made separately and attached with an iron pin. Head, lower legs, and lower part of the column were broken across diagonally and have been repaired. The surfaces were rough as a result of weathering and have been smoothed down, particularly where the lower legs, feet, and column were repaired.

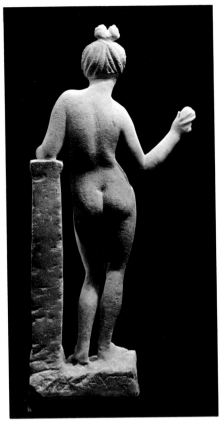

25

25

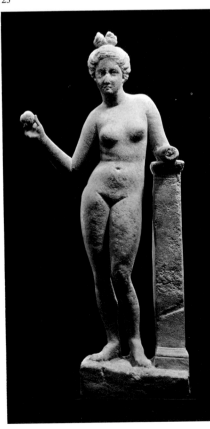

The slender nude goddess has been carved with an almost playful facility, without much detail but with a charming verve and wit. In style she is comparable to many small devotional and decorative figures found on Delos, on Rhodes, and (in a more mechanical form) at Pompeii. A Venus with golden "bikini," necklace, and armlets from Pompeii[1] is a slightly later member of the same series. The group spans the decades from the last great Macedonian kingdoms in Asia Minor to the Julio-Claudian rulers of the Roman Empire.

This rococo version of Aphrodite with the apple, standing demurely at her over-sized pillar, was produced in the Greek East, perhaps for export, during the late second or the first century B.C. to the first century A.D. A nearly complete and delightfully characteristic original from the last phase of Greek art, she takes her place in a collection where concepts of Aphrodite in ceramics, terracotta, or stone can be studied from Greek Archaic times to the third century of the Roman Empire.

1. Naples Museum, inv. 152798; see J. Ward-Perkins and A. Claridge et al., *Pompeii A.D. 79*, p. 189, no. 208, illus.

26 (S180)
STATUETTE OF BABY REACHING

Late Hellenistic, ca. 100 B.C.
Sparkling, large-crystaled Greek island marble; L (as preserved): 0.135 m.
Gift of John J. Herrmann, Jr. 1986.404

Reference: Museum Year: 1986–1987, p. 51.
Condition: The right hand, left forearm, and most of both legs are missing. The right arm was broken and repaired at the shoulder. There is a break on the top of the forehead, and an iron dowel was once placed in the right upper thigh where the leg is now broken. The surface shows damage and remains of encrustation.

A baby resembling this one, from a small statue of Aphrodite and Eros (if wings are present) or a mother and child, was found in the Egyptian Sanctuary on Delos[1]; a young mother in marble embracing a similar baby has been labeled Aphrodite and Eros (he does appear to have tiny wings).[2]

Compare the heavily restored baby Erichthonios cradled in the aegis of Athena on a statue in the Pheidian tradition, found in the so-called villa of Marius at Frascati and long in the Prussian royal collections.[3]

1. J. Marcadé, *Au Musée de Délos: Etude sur la sculpture hellénistique en ronde bosse découverte dans l'île* (Paris, 1969), pp. 242, 396, 402, 433, 434, pl. XLII, no. A5457; A. Hauvette-Besnault, *BCH* 6 (1882), pp. 306–307, no. 5; M. Bulard, *BCH* 30 (1906), p. 620, fig. 2.
2. In the Eretria Museum; see *LIMC*, vol. 2, pt. 2, pl. 125, no. 1245.
3. *Königliche Museen zu Berlin, Beschreibung der Antiken Skulpturen* (Berlin, 1891), p. 37, no. 72.

26

27 (S197)

STATUETTE OF HUNTER WITH DOG
Roman Imperial, ca. A.D. 220 to 240
Crystalline marble, probably from western
Asia Minor; H: 0.465 m.
Arthur Tracy Cabot Fund. 1984.167
References: Museum Year: 1983–1984, pp. 23
(illus.), 43; Sotheby's sale, New York, 9 De-
cember 1981, no. 235, color pl.; L. Bonfante
and C. Carter, "An Absent Herakles and a
Hesperid: A Late Antique Marble Group," *AJA*
91 (1987), pp. 253 (n. 14), 255 (n. 18); C.
Vermeule, in *Art for Boston*, pp. 82–83, illus.
Neg. Nos. C41890 (front view), C41891 (three-
quarter view)

Condition: A number of pieces are missing. The
hound's head was made separately and attached
with a dowel. The hunter's head was broken off
and has been reattached. The surfaces are fresh,
except where they have been stained by a sub-
stance resembling oil.

The hunter has spread his cloak over a
rocky outcropping, next to a trunk of a
tree. His left hand holds a curved club or
throwing stick across his legs, and his
raised right arm and hand once held some-
thing (possibly a dead hare) that tempted
his hound to leap up alongside the tree
trunk. The dog's feet are planted on the
spoils of a dead boar at the front corner of
the plinth.

The hunter may be a mythological hero,
such as Meleager. The thinness, front to
back, and the elaborate moldings of the
plinth are characteristic of Aphrodisian

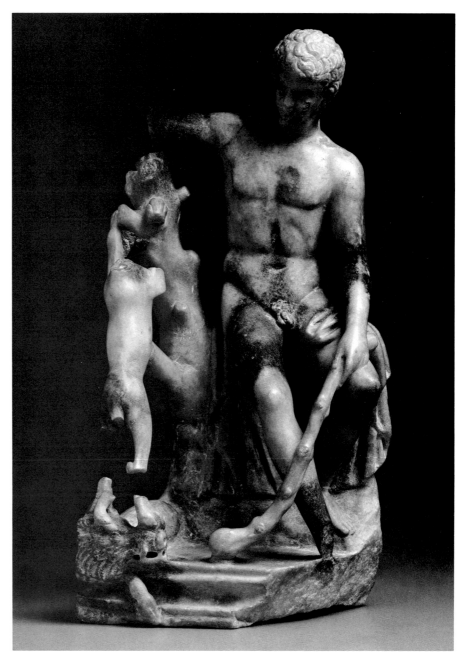

27

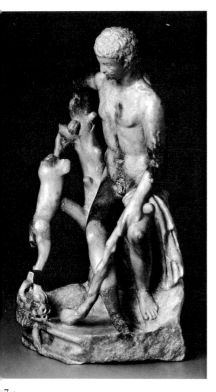

27

sculpture in the late Severan period. Al-
though the ensemble is complete in itself,
the break along the left side of the plinth
(the hunter's left front) could suggest a
much larger flat surface with another figure
on it. Comparable works come to mind,
one described by Lucian: "Next is a hand-
some god and a pretty boy, a scene of fond
foolery. Branchus, sitting on a rock, is
holding up a hare and teasing his dog,
while the dog is apparently going to spring
up at him; Apollo, standing near, is smiling
in amusement at the tricks of the lad and
the efforts of the dog."[1] A Graeco-Roman
marble decorative relief in the Musée du
Louvre, Paris, shows this hunter, without
any divinity, seated in profile to the right.
Restorations have turned him into a faun.[2]

1. Lucian, *The Hall (De Domo)*, Loeb ed., vol.
1, A.M. Harmon, transl. (London and New
York, 1913–1925), pp. 202–203 (24).
2. T. Schreiber, *Die Hellenistischen Reliefbilder*
(Leipzig, 1894), pl. XXII.

28 (S199)

HERM BUST OF DIONYSOS
Roman Imperial (probably late Flavian),
A.D. 81 to 96
Italian marble, resembling limestone; H
(max.): 0.26 m.
*The Benjamin and Lucy Rowland Fund,
Gift of E.D.B. Vermeule, and Gift of Earle
W. Carr. 1979.523*

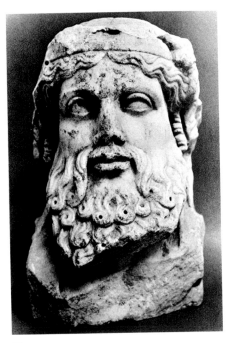

28

28

Provenance: collection of Earle W. Carr, Hingham, Mass.; collection of Isabel Anderson, Brookline, Mass.; collection of Larz Anderson, Brookline, Mass.; acquired in Italy after the Civil War

Reference: Museum Year: 1979–1980, p. 39.

Condition: The left front of the bust has been broken away and subsequently squared or roughed off, perhaps with restoration in mind. On the head, parts of the fillet, grapes, leaves, and vine have been damaged. The sides of the herm were smoothed off in Antiquity, and there are dowel holes for "arms" (supports for wreaths or fillets) set into the sides of the herm. A drill

was used for the sidecurls and beard, suggesting a late Flavian date, which would be in keeping with the dry and academic qualities of the eyes and the surfaces of the face.

This decorative work was fashioned after models going back to Greece, probably Athens, in the fifth century B.C.; the ultimate model, a herm of Hermes, can be seen in a Roman copy in The Albertinum, Dresden.[1] A grand contemporary prototype is in the Museo Nuovo Capitolino of the Palazzo dei Conservatori, Rome.[2] The head also occurs as a double herm, the old and the young Dionysos.[3]

A slightly larger decorative herm of Dionysos, with an elaborate grapevine in the hair and very "rope-like" beard, made to resemble the curls of the hair (as here also), was sold at auction in London in 1981.[4]

1. No. 69 (classified as Type B2); see L. Curtius, *Zeus und Hermes,* First Supplemental Monograph of the German Archaeological Institute in Rome (Munich, 1931), p. 54, no. 2; in a list of replicas and variants turned into different divinities and heroes, pl. 17, figs. 13, 14.

2. Mustilli, *Museo Mussolini,* pp. 49–50, no. 5, pl. XXXIX, 163.

3. See G. Lippold, *Die Skulpturen des Vaticanischen Museums,* vol. 3, pt. 2 (Berlin, 1956), Galleria dei Candelabri, III, no. 50, p. 268, pl. 124.

4. Sotheby's sale, London, 18 May 1981, p. 74, no. 350a.

29 (S210)

STATUE OF HERMAPHRODITE

Late Hellenistic or early Roman Imperial, 1st century B.C. to 1st century A.D.
Marble from Greek islands; H: 0.785 m.
Anonymous Gift. 1981.754

Provenance: from a succession of European private collections; previously from near Pompeii

References: Museum Year: 1981–1982, p. 44; Reinach, *Rép. stat.,* vol. 3, p. 243, no. 6; R. Paribeni, in *NSc,* 1902, p. 576, fig. 4.

Neg. Nos. C40476 (front), C40477 (detail of front), C40478 (back)

Condition: The top of the Hermaphrodite's head, cut diagonally on the subject's left side, was finished in plaster, which is now missing. The upper half of the baby was made separately and is also gone; a metal dowel remains. The front of the left foot and adjacent section of plinth were probably carved or repaired as a separate piece. This piecing and apparent restoration suggest that, as in the marble garden furniture from the same villa (no. 41), the ancient repairs were made after the earthquake of 62.

Found in 1901 in the Villa Matrone (Villa of Contrada Bottaro),[1] which lay outside Italian state property near the ancient seashore of Pompeii, this nearly half-life-sized figure was evidently on a pedestal or in a niche along the peristyle, or garden court. The above-mentioned garden furniture was found at the same time, in roughly the same place, according to the history of

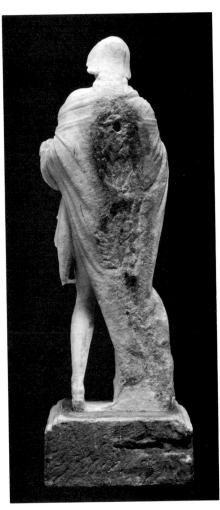

29

the ensemble and the discoveries chronicled by the donor of this statue. G. Matrone, proprietor of the land where the villa was discovered, donated the most notable sculpture from his excavations to the Museo Nazionale in Naples and, in turn, was given permission to sell and/or export the rest of the finds.

The elegant Hermaphrodite was wearing a cloth cap and a cloak around the shoulders. This garment hangs down the back and is arranged over the left arm to a strut-shaped support at the left side. There is a large tree trunk by the right leg. The Hermaphrodite was touching its garment with the right hand and holding a baby on the extended left hand.

The figure has the pose of the Diomedes of Kresilas,[2] but the athletic solidity of 440 B.C. has been replaced by the elongated, youthful softness of Praxitelean and Lysippic influences. While the type may have been a creation of the end of the Hellenistic rococo, about 100 to 50 B.C., its sources came ultimately from the two great centuries of Greek sculpture. Such statues, when life sized, could have been produced as decorative pendants to the type of the

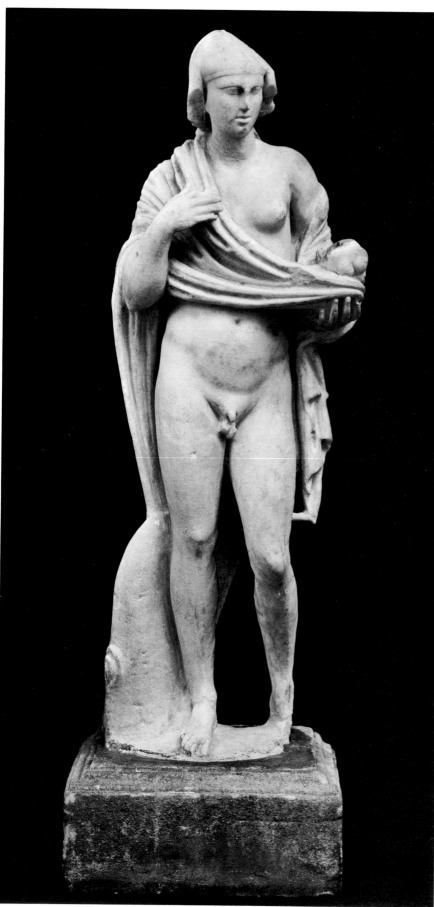

so-called Hermes of Praxiteles, actually a satyr supporting the infant Dionysos. Here the Hermaphrodite could be holding a little Eros, a baby Hermaphrodite, or even, again, the infant Dionysos.

Another type of Hermaphrodite, represented by a statue of size similar to the Villa Matrone figure, ornamented the big imperial villa at Tor Marancia and is based on a fourth-century Herakles, much slenderized.[3]

1. Frescoes from the villa came to the MFA in 1933; see L.D. Caskey, *BMFA* 37 (1939), pp. 9–16.

2. Boardman, *Classical*, fig. 224.

3. See Stuart Jones, *Museo Capitolino*, p. 181, no. 109a, pl. 42.

30 (S230)

FRAGMENT OF STATUE: HEAD AND NECK OF MASTIFF WITH STUDDED COLLAR

Roman Imperial, ca. A.D. 150 to 200
Marble, probably from Luna quarries;
H (max.): 0.23 m. L (as preserved): 0.27 m.
Anonymous Loan

Provenance: from an old private collection in England and said to have been from the area of Rome, perhaps via a collection in Naples

Condition: The head's right side is damaged and worn, the left side less so; something of the left ear is preserved. The mouth or muzzle is also damaged near the right side and all the surfaces are weathered, suggesting that the statue stood outdoors in a garden in Antiquity.

The intent, forward look of the face, with pupils expressed, suggests that this powerful canine was looking directly at something, perhaps an adversary in a hunting scene. He could have been confronting a bear, as in the instance of the Nereid Monument from Xanthos of the late fifth century B.C., the bear-hunt frieze in the British Museum, London.[1] Or he could have been grouped with a bear on a rocky slope from an ancient garden in Rome.[2] A comparable canine is the "Molossian" under the chair in the seated statue of the so-called Agrippina, or the "Aphrodite in the Garden," in the Museo Torlonia collection in Rome.[3]

Collars with studs or bosses are rare in Graeco-Roman art, but some canines wear them, the most famous being the animal in the "Cave Canem" mosaic from Pompeii. Another of these is the hound in the Roman relief of Mithras Slaying the Bull, dated around A.D. 275, in Richmond, Virginia.[4] Similarly equipped is the bronze "Irish Wolfhound" from Lydney in Gloucestershire.[5]

1. I. Maull, "Hadrians Jagddenkmal," *JOAI* 42 (1955), p. 63, fig. 37 (citing Brunn-Bruckmann, pl. 218).

30

31

2. *Catalogue of the Ancient Art in the J. Paul Getty Museum* (Malibu, 1973), pp. 13–14, no. 24.

3. P. Keller, *Die antike Tierwelt*, vol. 1 (Hildesheim, 1963), pp. 105–106, fig. 40.

4. See *Ancient Art in the Virginia Museum* (Richmond, 1973), pp. 130–131, no. 148; and Vermeule, *Sculpture in America*, p. 236, no. 197.

5. J.M.C. Toynbee, *Art in Britain under the Romans* (Oxford, 1964), pp. 126–127, pl. 34b,c.

31 (S233)

PAIR OF FUNERARY SPHINXES
Graeco-Roman (presumably Roman Imperial)
Limestone; L: 0.64m. and 0.615m.
Gift of Paul E. Manheim

Provenance: from Egypt via New York

Reference: C. Vermeule, in *Festschrift Avi-Yonah*, pp. 58–59 (fig. 1), 61, n. 2.

Neg. Nos. C40869, C40881

Condition: The surfaces have suffered from chipping and weathering and have areas of discoloration.

Wearing Egyptian headcloths with the uraeus in front, these male sphinxes are placed in the traditional pose on slightly irregular plinths. Two similar sphinxes, from Sheikh Abada, were published when on the art market in New York;[1] three others are included in the reconstruction of a temple-tomb in the Alexandria Museum;[2] and still another was presented in 1842 to the National Institute (now the Smithsonian Institution)[3] in Washington by George Robins Gliddon, once United States Vice-Consul in Cairo. Such sphinxes in various Egyptian stones were popular in Rome from Augustus to the Severans.[4] Those fashioned for the Egyptian temples in the Campus Martius were much more finished and polished works of sculpture than these rustic examples, whose defects may have been partially hidden by paint.

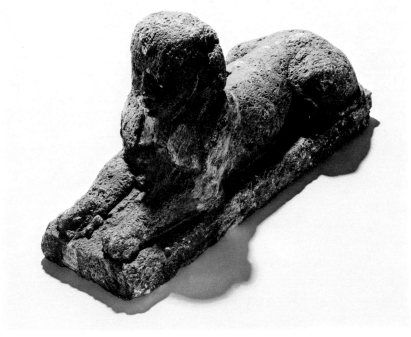

31

1. Eisenberg, *Late Egyptian and Coptic*, p. 3, nos. 2, 3.

2. E. Breccia, *Alexandria ad Aegyptum* (Bergamo, 1922), p. 199, Room 14, no. 6.

3. W.B. Dinsmoor, in *PAPS*, vol. 87, no. 1 (1943), p. 97.

4. A. Roullet, *The Egyptian and Egyptianizing Monuments of Imperial Rome* (Etudes aux Religions Orientales dans l'Empire Romain, vol. 20) (Leiden, 1972), pp. 132–140, nos. 277–313, pls. CCIII-CCXIV, CCXVI, CCXVII.

32 (S239)

SECTION OF GRAECO-ROMAN
ARCHITECTURAL RELIEF:
DIONYSOS WITH ARIADNE
OR MAENAD

Hadrianic, ca. A.D. 120

Pentelic or Hymettan marble of the type
used for architectural sculpture; H:
0.787m. W: 0.584m. H (of plinth):
0.064m. D (of back): 0.082m.

*Gift of the Classical Department Curator's
Fund: Moses Alpers, Mrs. Harvey H.
Bundy, Mrs. William H. Claflin, III, Joseph
Edinburg, Mrs. Laurence B. Ellis, Mr. and
Mrs. De Coursey Fales, Jr., Dr. Ernest
Kahn, Dr. Josephine Murray, Mrs. Benja-
min Rowland, Jr., Adrian Vermeule, Mr.
and Mrs. Philip Weld, Dr. Leonard Wolsky.
1984.19*

Provenance: The relief was seen from about
1949 to 1960 in the storerooms of Messrs.
Spink and Son in London, where it seems to
have been since before the Second World War,
when it belonged to the British branch of an old
aristocratic Sicilian family. From about 1960 on,
the sculpture was in the possession of, or on
consignment to, various collectors and dealers in
London, New York, and Tokyo. It is said to
have been for a time in the collection of Avery
Brundage in Santa Monica, California.[1]

References: Museum Year: 1983–1984, p. 42;
Vermeule, *Divinities,* p. 39, fig. 42; Münzen
und Medaillen A.G., catalogue of the 1978
Basel Antiquities Fair, no. 310.

Condition: Sides, top, bottom, and back of the
slab are finished architecturally. There is damage
at the lower outside, where the slab was perhaps
clamped to its neighbors. Surfaces of the figures
(including their draperies or animal skins) are
finished with a claw chisel, a puntello remaining
on the female's right knee. The heads are missing
and, in addition to weathering, the figures have
suffered minor damages, especially to the attri-
butes. Surfaces have undergone the cleaning
characteristic of an eighteenth- or nineteenth-
century collection.

The relief comprises two divine figures,
Dionysos on the right and Ariadne or a
Maenad on the left. She wears a long Io-
nian chiton pinned on the right shoulder
and tied with a belt just below the breast.
A double layer above forms a long over-
fold. She also wears the skin of a doe
around her left shoulder, pinned above the
chiton on the right shoulder and with the
animal's head and long ears visible behind
the right arm of Dionysos. One leg with
cloven hoof is visible at her right side, the
other sketched in the middle background.
The divine female holds a wine pitcher
(oinochoe) in her lowered right hand and a
staff (probably once a pine-cone-topped
thyrsos) in her raised left hand. The figure's
whole aspect is like that of the cult images
of the late fifth to early fourth century B.C.
in Athens.

Dionysos, god of wine and the theater,
appears, as he does often from the middle
of the fourth century B.C. onward, in the
heroic nude pose of a statue by Skopas of
Paros, who worked on mainland Greece
and in western Asia Minor.[2] He rests his
left hand on his hip as he holds the skin of
a panther, which is wrapped around his
left arm and which trails down behind the
left leg almost to the feet and the heavy
plinth. Dionysos holds out a two-handled
drinking cup (kantharos) toward the
pitcher presumably being proffered by his
divine consort Ariadne or one of his female
followers in the thiasos, or triumphal pro-
cession, to and from India (in imitation of
Xenophon and Alexander the Great).

In both manner of carving and condition
(heads missing), as well as size (0.787m.
high, 0.584m. wide, 0.228m. deep) and
iconography, the natural comparison for
this relief is the reliefs decorating the late
Roman stage front of the Theater of
Dionysos in Athens.[3] The Ariadne or
Maenad of this example is very like the
Maenad or divine daughter at the left end
of Slab II, showing the "Entrance of
Dionysos into Attica" and the Dionysos
compares best with the god in Slab III,
"Sacred Marriage of Dionysos."[4] The sec-
tion in Boston could have been removed
from the Theater of Dionysos in any age
from Byzantine through Venetian or even
Turkish times or it could have come from a
similar set of reliefs, also decapitated. The
puntello on the Maenad's right knee and
the treatment of the drapery around her
lower right leg suggest that the slab was
never completely finished, although other
sculptural parallels from Greece provide
evidence that this would have been no bar
to the relief being set up (a) with the Athe-
nian set, (b) with a similar monument, or
(c), because of its shorter width (the others
are 1.76m. to 1.88m.), as an independent
dedicatory stele from the same workshop.
The thickness of this relief also corresponds
closely to the minimum dimension of the
reliefs in Athens (0.23m.).

Since only the western half of the theater
reliefs survive in situ as mounted in their
present position with the upper back of the
slabs cut away behind the now-missing
heads, there must have been room for
many more scenes of Dionysos, which
might have been reused around A.D. 400
when the Theater of Dionysos was turned
into a small showplace for sham naval
battles and the like. A piece of one of these
reliefs, found "outside the entrance to the
Acropolis in Athens," has been in the Uni-
versity Library and the Fitzwilliam Mu-
seum in Cambridge, England, since be-
tween about 1803 and 1810, the era of the
British travelers to Hellenic lands under
the Ottoman Turks.[5] The relief now in
Boston may have come to England under
similar circumstances, or it may have been
brought there by way of Venice in the
seventeenth century.

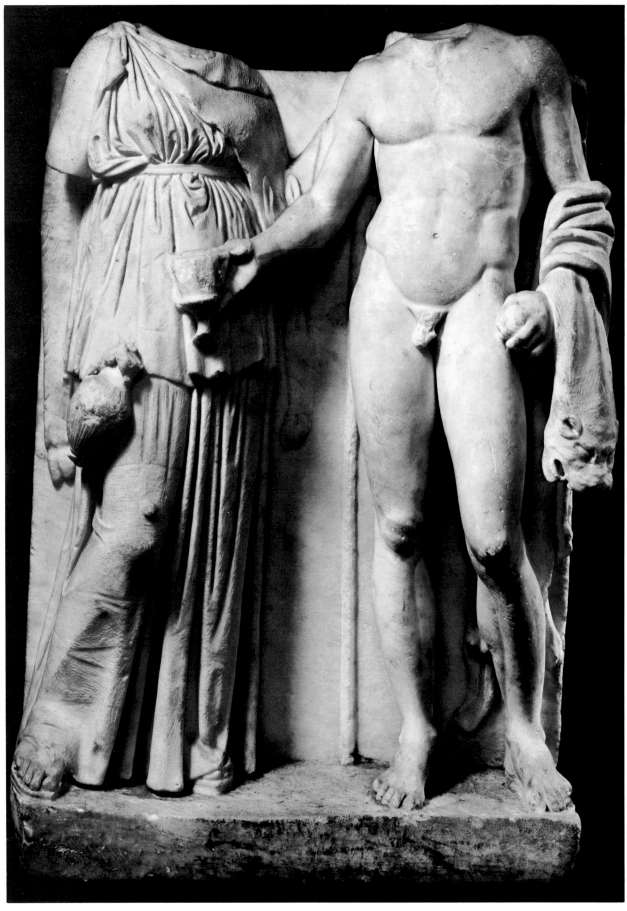

32

1. Münzen und Medaillen A.G., Catalogue of the 1978 Basel Antiquities Fair, no. 310.

2. Robertson, *History*, vol. 1, pp. 452–453; K. Schefold, *The Art of Classical Greece* (New York, 1967), pp. 226ff.

3. The surviving reliefs on the stage front of that famous theater on the southeast slope of the Acropolis in Athens are now thought to have come from the Hadrianic addition to the theater rather than from an altar near the stage and scene building or near the Temple of Dionysos farther down the hill. See M.C. Sturgeon, "The Reliefs on the Theater of Dionysos in Athens," in *AJA* 81 (1977), pp. 31–53, figs. 1–5.

4. Ibid., pp. 37–38 (fig. 3), 39–41 (fig. 4).

5. The discovery was made by Professor E.D. Clarke. See L. Budde, *A Catalogue of the Greek and Roman Sculpture in the Fitzwilliam Museum* (Cambridge, 1964), pp. xii, 75–76, no. 122, pl. 40.

33 (S240)

IDEAL HEAD IN PROFILE FROM SARCOPHAGUS

Greek Imperial (early to middle Antonine), ca. A.D. 160 to 180

Marble, probably Pentelic or possibly from Asia Minor (the Afion region); H: 0.16m. W: 0.19m. D (max.): 0.20m.

Benjamin and Lucy Rowland Collection. 1979.54

Provenance: acquired by Professor Rowland in Boston, London, or Rome.

Reference: Museum Year: 1978–1979, pp. 21 (illus.), 39.

Neg. Nos. C33578 (profile to the right) and C33577 (front view)

Condition: The rectangular slab of the background is broken irregularly behind the head and also across the lower middle of the neck. Nose and mouth are chipped, as are the ends of the locks of hair.

The youthful hair and features appear to be those of a Roman "Genius," for example the "Genius" of the Roman people or of a city in the empire, an abstraction like "Aion" (Eternity), or a geographical personification like Rome's "Campus Marcius," or a river or mountain. The general profile, from hair to chin, recalls portraits of Alexander the Great. The thickness of the back and its relative smoothness would indicate that the fragment might be from a very large sarcophagus.

The hair on the crown is carefully carved, while the locks around the forehead are systematically undercut with the running and pointed drill, characteristics of Antonine and Severan work. Comparison with the river god at the lower left front corner of an Attic sarcophagus with scenes of Meleager's hunt of the Calydonian boar, at Eleusis near Athens, suggests a similar origin for this powerful head in the high Hellenistic tradition.[1]

1. See Koch, *Meleager*, pp. 142–143, no. 170, pl. 136.

34 (S244)

HEAD OF PAN FROM LARGE DIONYSIAC SARCOPHAGUS

Roman Imperial (late Severan), ca. A.D. 220 to 230

Highly crystalline Greek marble from Thasos or northwestern Asia Minor; H: 0.06m.

Anonymous Loan

Provenance: collection of the late Professor Benjamin Rowland, Jr., Cambridge, Mass.; from Rome via London

Neg. No. E619

Condition: A support or attachment to the body of the sarcophagus survives against Pan's left cheek. The head is broken off across the mouth and the hair is damaged. Remains of polish are visible beside Pan's pointed right ear.

The sarcophagus with Dionysos on a panther flanked by the Four Seasons in The Metropolitan Museum of Art in New York (from Badminton House, Gloucestershire), dated about 220 to 235, has an identical Pan frolicking on the panther's back, as Dionysos rides sidesaddle. The drilling of the hair has more running channels and less circular points, the marks of a different workshop producing sarcophagi of somewhat higher quality.[1]

1. See F. Matz, *Die Dionysischen Sarkophage (Die Antiken Sarkophagreliefs*, vol. 4, pt. 4) (Berlin, 1975), p. 449, no. 258, pl. 271.

35 (S258)

FRAGMENT OF SARCOPHAGUS LID: EROS RIDING SEA GRIFFIN

Roman Imperial (late Antonine to Severan), ca. A.D. 180 to 210

Crystalline Greek marble, Pentelic in appearance but possibly from a quarry in western Asia Minor; H: 0.155 m. W: 0.27m.

Gift of Mr. and Mrs. Cornelius C. Vermeule III in the Name of Cornelius Adrian Comstock Vermeule. 1983.404

Provenance: from the art market in Amsterdam

References: Museum Year: 1983–1984, p. 42; C. Vermeule, in MFA *Art in Bloom* (Boston, 1985), p. 101, illus.; Jacques Schulman B.V., Amsterdam, List 225, May 1983, pp. 16 (illus.), 19, no. 73; *Apollo* 113 (March 1981), p. 40, illus.

Exhibition: "To Bid Farewell" (Providence: Museum of Art, Rhode Island School of Design, 3 April–7 June 1987).

Neg. No. C40868

Condition: The fillet moldings at the top and at the right are preserved, including the edge of the mask that formed the right front corner. The back is finished, as was the case with lids of Roman sarcophagi, with flat tops, long rectangular panels across the fronts, and masks at the front ends. Here the irregular break runs behind the head of the Eros, across the chest, under the left arm, and across the griffin's neck.

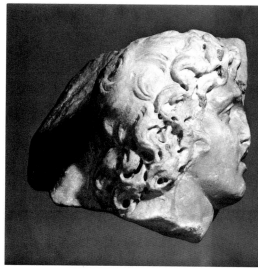

33

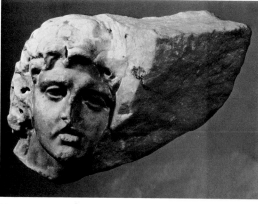

33

34

35

Most of these "Delta class" stelai come from Kom Abou Billou (Terenuthis).[1] Lacking a mixture of Greek form and Egyptian symbols (as in no. 37), the work is probably relatively early in the series. The deceased wears a chiton and an ample himation, while holding a phiale in his extended right hand and reclining on a couch with cushions and turned legs. Around a three-legged round table laden with food are (from left to right) a cuirass, an amphora on a stand, and, at the right beyond the right leg, what appears to be an oval shield on a helmet. The subject could have seen military service but, generally speaking, these objects are all traditional, inherited from the funerary art of western Asia Minor and the Greek islands in the Hellenistic period.[2]

1. Compare Eisenberg, *Late Egyptian and Coptic*, pp. 31–36, nos. 51–58.

2. For other similar stelai from Terenuthis and surrounding areas, see C.C. Edgar, *Catalogue général des antiquités égyptiennes du Musée du Caire*, vol. 13: *Greek Sculpture* (Cairo, 1903), pp. 41 (no. 27544, pl. XXI), 52 (no. 27629, pl. XXIII); see also Ars Antiqua, Lucerne, Auktion II, 14 May 1960, p. 16, no. 30, and bibliography, pl. 13; *Aegyptische Kunst*, Münzen und Medaillen A.G., Basel, Auktion 46, 28 April 1972, pp. 81–82, no. 153, and bibliography, pl. 37.

The Eros or wingless Amorino appears to be riding to the right on the back of a griffin. He controls the creature by a tight rein or bridle, which runs through the tight grasp of his left hand, around the upper part of the griffin's neck, and upward to the bit in its beak. The symbolism is obvious: the soul riding and controlling powerful forces through the skies or seas of eternity.

There are a number of general parallels. An Eros or Amorino appears on a sea griffin near the right front corner of the lid of a Roman garland sarcophagus in the Pawlowsk collection;[1] the Eros or Amorino with a garland at the molding, on the right front corner of the lid of a sarcophagus from Rome, gives position, pose, and style for this fragment,[2] as does the Eros controlling a sea panther on the lid of a sarcophagus in the Museo Nazionale Romano in Rome.[3] The same relationships occur on the lid of the Education of Dionysos sarcophagus in the Museo Capitolino in Rome.[4]

Such lids were produced in special workshops for several different classes of Roman sarcophagi, as demonstrated by the griffins on the lid of an Endymion sarcophagus also in the Museo Capitolino;[5] Erotes on sea beasts, including griffins, Tritons, dolphins, etc., decorate the huge sandaled foot in the Museo Capitolino.[6] A Roman relief in Stockholm adds the hippocamp to the repertory,[7] and a lid dating to the end of the third century, in Zurich in 1962, shows seasonal genii driving a variety of animals of the type considered here. All such designs of the Antonine and Severan periods

must go back to famous architectural decoration, such as the carvings in Hadrian's Villa at Tivoli.[8] The Lansdowne relief in dark stone typifies these sources.[9]

1. Toynbee, *Hadrianic School*, pp. 206–207, pl. XLV, fig. 2.

2. The sarcophagus includes figures of a Muse, Apollo, and Marsyas; see Reinach, *Rép. rel.*, vol. 3, p. 232, nos. 3–5.

3. See A. Rumpf, *Die Meerwesen (Die Antiken Sarkophagreliefs*, vol. 5, pt. 1) (Berlin, 1939), p. 20, no. 56, pl. 19.

4. Stuart Jones, *Museo Capitolino*, Galleria, pl. 24, no. 46A.

5. Ibid., Sala delle Colombe, pl. 35, no. 37.

6. Reinach, *Rép. rel.*, vol. 3, p. 197, nos. 1–3.

7. Ibid., p. 522, no. 1.

8. P. Pensabene, *ArchCl* 28 (1976), pp. 126–160, pls. 44–57.

9. Ibid., pl. 44, no. 1.

36 (S278)

FUNERARY STELE

Greek Imperial, probably ca. A.D. 175 or later

Limestone; H: 0.35 m.

Gift of Paul E. Manheim

Provenance: from Egypt

Neg. No. C40872

Condition: The edges of the block have been chipped, particularly along the right side, behind the figure's left shoulder. The sunken relief of the figure, suggesting traditional Pharaonic Egyptian methods of representation, has gathered areas of dark patina where there was once paint and there is other surface discoloration.

36

37

37 (S278)
FUNERARY STELE
Greek Imperial, probably ca. A.D. 300 or earlier

Limestone; H: 0.333 m. W: 0.255 m.
William K. and Marilyn Simpson Fund. 1984.256

Provenance: from Egypt; once, perhaps, set into the façade of a tomb

References: Museum Year: 1983–1984, p. 43; P. Lacovara, in *Offerings*, pp. 82–83, illus. (beginning of inscription quoted).

Neg. No. C41624

Condition: The diagonal crack at the top is associated with some loss of stone. The right edge and the base are chipped.

Framed between two lotus columns in an aedicula, a man dressed in an Ionic chiton and himation is reclining on a couch, holding a skyphos in his extended right hand. To his right, a figure of Anubis, the jackal-headed god of death, sits on a standard next to one lotus-bud capital and turns his head toward the viewer. Offerings, shown in incised relief, are grouped beneath the couch. The horizontal fillet moldings at the bottom contain two lines of Greek text, lightly incised, beginning: "Heraklides, devoted to his brothers, and devoted to his children. . . ."

38 (S286)
VOTIVE RELIEF TO THE DIOSKOUROI
Greek Imperial, 1st or 2nd century A.D.

Marble from western Asia Minor; H: 0.42 m. W: 0.44 m.
Collection of Cornelius Adrian Comstock Vermeule. 153.1973

Provenance: from the art market in London and Switzerland; said to be of Anatolian provenance, from a shrine in Pisidia, according to Louis Robert (see below)

References: H. Seyrig, *Syria* 47 (1970), pp. 99–100, fig. 22, n. 1; Sotheby's sale, London, 10 July 1972, p. 27, no. 99, pl. 17, illus.; L. Robert, *BCH* 107 (1983), pp. 575–576, 577, fig. 5; Vermeule, *Numismatic Art*, p. 136, fig. H.

Condition: The relief is in virtually perfect state, with only slight wear and a yellowish patina, light in shade, to the marble.

The monument takes the form of a temple front, with an eagle of Zeus in the pediment (see no. 80, below) and akroteria above. Helen (or a Graeco-Roman lady as Helen) wears her chiton and himation in the Pudicitia pose, that is, wrapped around her head, neck, and shoulders and with the right hand touching the left edge of the "veil." She is flanked by the cuirassed Dioskouroi (who could be her brothers), their horses' bridles held in their inner hands and their parazonia, or sheathed short swords, in the hands closest to the viewer.

The inscription, running across the horizontal architectural frames, records (on the architrave) the dedication to the Dioskouroi in the name (on the base molding) of Lucius Velius Fronto, who may have lived in the territory of the Roman colony of Comama.

39 (S298)
TRIANGULAR SUPPORT FOR CANDELABRUM SHAFT, DECORATIVE COLONNETTE, OR SMALL BASIN
Early Roman Imperial, possibly A.D. 20 to 60

Low-grade Pentelic marble; H: 0.41 m.
Collection of Cornelius Adrian Comstock Vermeule. 213.1980

Reference: Picón, *Antiquities*, p. 56.

Exhibitions: Greek Sculpture in Transition, ca. 450 B.C.–200 A.D. (Ann Arbor: Kelsey Museum of Archaeology, University of Michigan, 30 January–19 April 1981), no. 19; *Figures from Greek Mythology in the Decorative Arts of the Roman Empire* (Concord, N.H.: Art Center in Hargate, St. Paul's School, 5 February–2 March 1985), pp. 1–3, illus.

Neg. Nos. C42134 (Hermes), C42133 (Dionysos), and C42132 (Artemis)

Condition: The monument has been mutilated on top and bottom, with a scrape running diagonally through Hermes and additional chipping. What remains is fresh, retaining the original delicacy of carving.

Within rectangular moldings, three divinities are shown walking to the left. They

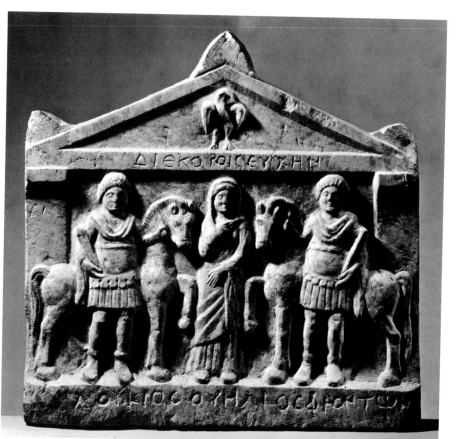

38

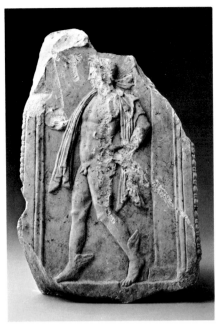

39

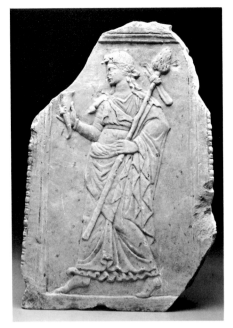

39

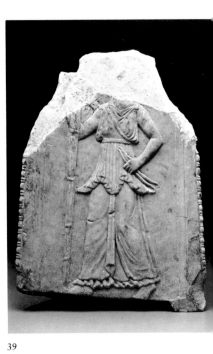

39

are Hermes with purse or ram's head, herald's staff, and winged sandals; Dionysos with rhyton and pine-cone-topped staff; and Artemis with a long torch. The style is a mixture of Archaistic and Neo-Attic, Hermes and Dionysos being depicted with young, wreathed heads and faces of the fourth century B.C. rather than with the heads of Archaic type often associated with this form of decorative art.

These figures appear in the Archaistic taste, with minor variations and in various combinations with other Olympians and their friends, on a variety of Graeco-Roman decorative monuments. The following are typical: a relief in the Villa Torlonia-Albani in Rome,[1] a relief in The Hermitage in Leningrad,[2] and the now-unlocated Guilford puteal from Corinth showing Hermes to the right.[3]

The rarest of the divinities on this support is the Artemis; she can be visualized in complete form by comparison with a relief of Apollo and Artemis in The Walters Art Gallery, Baltimore.[4]

1. Reinach, *Rép. rel.*, vol. 3, p. 129, no. 2.

2. Ibid., p. 490, no. 1.

3. Ibid., vol. 2, p. 518, no. 1. Further general comparisons are to be found in E.B. Harrison, *The Athenian Agora*, vol. 11: *Archaic and Archaistic Sculpture* (Princeton, 1965), pp. 81–84, no. 129, pl. 29; C.M. Havelock, *AJA* 68 (1964), pp. 47, 48, pl. 19; F. Poulsen, *Catalogue of Ancient Sculpture in the Ny Carlsberg Glyptotek* (Copenhagen, 1951), p. 356, no. 504, pl. 38 (Archaistic Dionysos).

4. No. 23.7; see Vermeule, *Sculpture in America*, p. 196, no. 162.

40 (S310)

ARCHITECTURAL RELIEF: LEAPING LION

Late Graeco-Roman ("Coptic"), 5th or 6th century A.D.

Rough limestone; H: 0.28m. W (as preserved): 0.343m.

Gift of Paul E. Manheim

Provenance: from Egypt

References: Eisenberg, *Late Egyptian and Coptic*, p. 28, no. 46, pl. 21; C. Vermeule, in *Festschrift Avi-Yonah*, pp. 58–59 (fig. 2), 61, n. 3.

Neg. No. c28608

Condition: The surfaces are chipped and patinated and the lion's lower jaw has been broken away. It appears that the left part of the scene had been completed by another slab or slabs.

Within flat fillet moldings above, below, and on the right, the feline leaps over a stylized plant toward a large, round object. Parallels in Roman sepulchral sculpture (see no. 35) and a Hellenistic bronze bracelet with lions biting a ball (see no. 88) show the popularity of the fierce yet playful feline in Hellenistic and Graeco-Roman art. The sculptor of this relief could have copied the subject from a North African mosaic of somewhat earlier times in the Roman Empire.

41 (S315)

SIX DECORATIVE SCULPTURES

Graeco-Roman, before A.D. 79 and probably before the earthquake of A.D. 62

Medium-grade Attic marble

Classical Department Exchange Fund. 1980.201–206

40

Provenance: from the collection of The Cleveland Museum of Art and previously from the Villa of the Contrada Bottaro, near Pompeii (see no. 29)

References: Museum Year: 1979–1980, p. 40; L.G. Eldridge, in *Bulletin of The Cleveland Museum of Art*, 1919, p. 73; F.A. Whiting, in idem, pp. 102–103, illus.; G.H. Chase, *Greek and Roman Sculpture in American Collections* (Cambridge, Mass., 1924), p. 183, fig. 227; Vermeule, *Egypt*, p. 186, no. 4A.

Condition: The surfaces of all pieces are worn. The damage seems to have resulted both from weathering when the sculptures stood in the courtyard of the villa and from the rise of the water table after they were buried. Extensive evidence of ancient repairs suggests that the ensemble suffered in the earthquake of A.D. 62 and was reconstituted in the villa's garden court yard in time for the eruption of Vesuvius in August of 79.[1] A small statue of a Hermaphrodite (no. 29) found in the same villa was repaired in the same fashion, probably as a result of the same disaster.

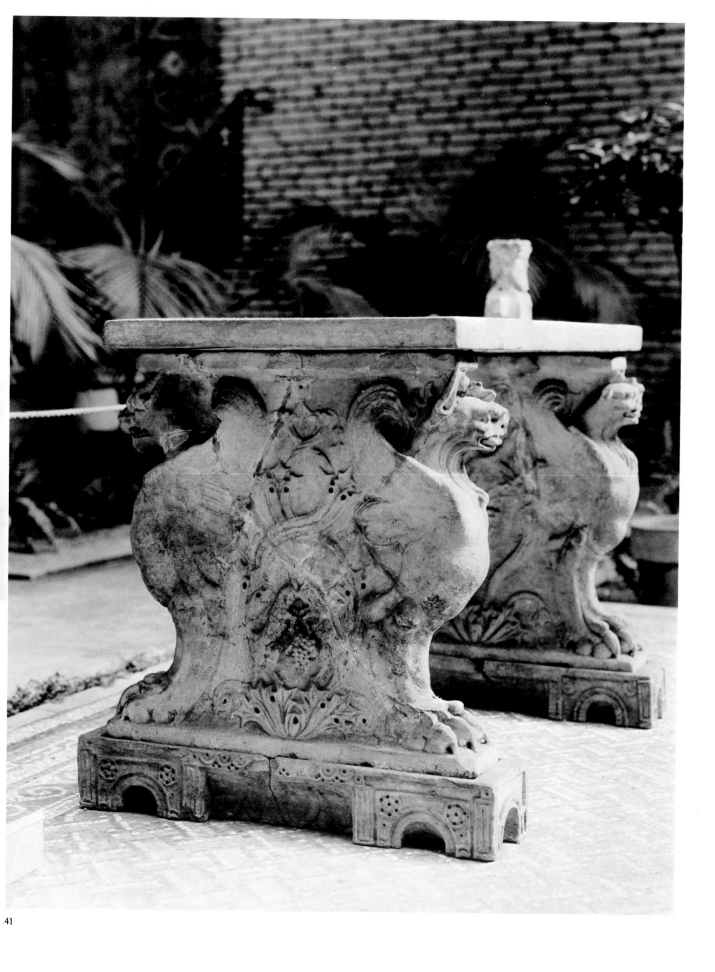

41

(201; CMA 16.892) Table with two supports decorated with "chimaeras," foliage in relief between the creatures, and a pair of fighting goats in the center of each side (The top of this ensemble may have come from another table.) H (with top): 0.711m. (top: 1.81m. by 0.62m.)

(202; CMA 16.893) Herm shaft with juxtaposed heads of a Bacchus and a Maenad; H (average of the herms here): 0.89m.

(203; CMA 16.891) Herm shaft with juxtaposed heads of a youthful Bacchus and a child (The child's head is large in scale and of different workmanship. It seems to reflect a restoration, perhaps after the earthquake of A.D. 62.)

(204; CMA 16.895) Herm shaft with juxtaposed heads of a Silenus and a Maenad

(205; CMA 16.896) Herm shaft with juxtaposed heads of Hermes and a bearded Bacchus

(206; CMA 16.897) Fountain basin supported by a kneeling satyr; H (max.): 1.067m.

This group of decorative marbles was greatly admired, earlier in this century, for its monumentality and imagery with sacred and mythological connotations. The table has been cited as one of the few examples in America of foliate ornament in the tradition of the Augustan *Ara Pacis* and one of the most complete examples of its kind on this side of the Atlantic (another being in the Villa Vizcaya in Miami).[2] The fountain, too, is remarkably complete, and the very unusual supporting figure below the basin gives the piece a special interest.[3]

The sculptures, long in The Cleveland Museum of Art, came from the Roman villa outside Pompeii where frescoes now in Boston were found.[4] The villa, in the Contrada Bottaro near the ancient seashore along the Bay of Naples, was excavated between 1900 and 1901.[5]

1. Robert Cohon made this observation.

2. Vermeule, *Sculpture in America*, p. 269, no. 227.

3. Compare Vermeule, Cahn, and Hadley, *Gardner Museum*, pp. 22–23, no. 28.

4. J. Herrmann, in J. Ward-Perkins and A. Claridge, *Pompeii A.D. 79* (Boston: Museum of Fine Arts, 1978), pp. 150–152, no. 87, illus. The sculptures were acquired when it became known that they were from the Villa of the Contrada Bottaro (see also no. 29, n. 1).

5. Published in R. Paribeni, *NSc*, 1902, pp. 568–578. The Cleveland-Boston marbles are listed without illustrations, and the rather worn surfaces are described.

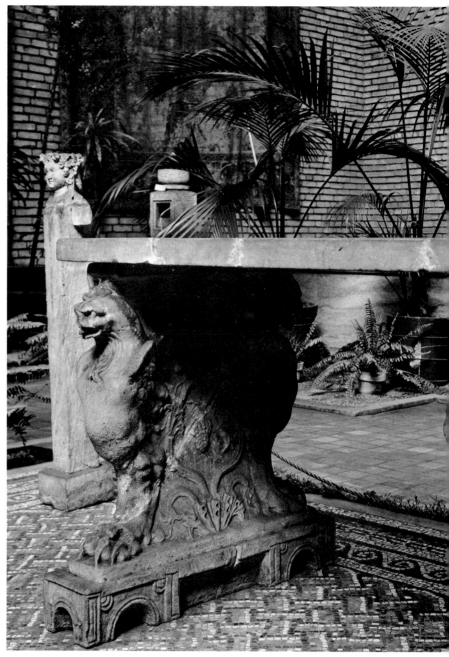

41

41

41

41

41

41

51

42

42 (S317)

SUPPORT FOR BENCH, LOW TABLE,
OR SARCOPHAGUS: SKIN OF
NEMEAN LION

Roman Imperial, probably 2nd century
A.D.

Italian marble, somewhat like limestone;
H: 0.218m.

Nuffler Foundation Loan

Provenance: from the vicinity of Rome

References: Ancient Art, Summa Galleries,
Beverly Hills, Calif., Catalogue 3, December
1977, back cover in color and p. 2, no. 2; Ver-
meule, *Egypt,* pp. 180, 189, fig. 1

Exhibition: Edith C. Blum Art Institute, Bard
College, Annandale-on-Hudson (C. Vermeule,
in Uhlenbrock, *Herakles,* pp. 110–111, no. 48,
pl. 48).

Neg. Nos. C33985 (front view), C33986 (profile
to left)

Condition: The marble has been broken across
the middle of the pillar or rectangular support,
and there is chipping around the lion's head and
the knotted skin, including the paw at the view-
er's left.

The back is cut roughly flat, sculpted at the
top and with a rectangular wedge at the
upper rear, as if for fitting a table or bench
support. Such features can be visualized in
complete form by comparison with a pair
of similar sculptures terminating in large
feline paws on their plinths. The two mar-
bles are currently beneath a Nereid sar-
cophagus in the Belvedere of the Vatican
Museums.[1]

1. W. Amelung, *Die Sculpturen des Vaticanischen
Museums,* vol. 2 (Berlin, 1908), p. 253, nos.
91a and b, pl. 23. See also Vermeule, *Egypt,* pp.
180, 189, fig. 2.

Roman Portraits

43 (S341)

FRAGMENT OF COMMEMORATIVE
RELIEF: HEAD
OF YOUNG NERO (?)

Roman Imperial, ca. A.D. 42

Greek island marble (Naxos); H: 0.16m. W
(including joining strut behind right ear):
0.15m.

Anonymous Loan. 214.1980

Provenance: from a private collection in New
York (originally from Rome)

Reference: C. Vermeule, *AJA* 86 (1982), pp.
242–244, pl. 38.

Neg. Nos. C35529 (front view), C35530 (profile
to left)

Condition: There are so-called fresh breaks at
the left ear, in the hair, above the right eye, and
on the edges of the old patinated break at the
neck.

The subject has been identified as the child
Nero from an early Julio-Claudian proces-
sional relief like those of the *Ara Pacis* or
the *Ara Pietatis Augustae.*[1] The princely
child was doubtless marching determinedly
along beside his elders, notably his mother
Agrippina the Younger, just as do the two
little boys and the slightly larger girl in the
two family groups with children on the
south frieze of the *Ara Pacis.* The future
emperor Nero was born at Antium on 15
December in the year 37 and was adopted
by Claudius in the year 50, becoming
consul in 51 at the age of fourteen. Nero's
famous pedigree gave him a place in Julio-
Claudian public processions in the early
forties of the first century A.D., before his
great-uncle Claudius married his mother
Agrippina.

1. Bonanno, *Portraits,* pp. 23–40.

43

43

44 (S342)
HEAD OF YOUNG MAN FROM
HISTORICAL RELIEF
Roman Imperial, ca. A.D. 60–65
Probably Attic (low-grade Pentelic) marble;
H: 0.30m.
Gift of Ariel and John Herrmann.
1983.681

Provenance: from the art markets in Basel and
London and from a British collection

References: MFA Preview, April 1985, illus.;
Museum Year: 1983–1984, p. 42; Münzen und
Medaillen A.G., Basel, Auktion 51, 14–15
March 1975, p. 119, no. 278, pl. 74.

Condition: The head and neck are broken
diagonally from left rear to right front. The nose
is mostly broken away, and there is chipping
over the right eyebrow.

The slightly over-life-sized head reveals a
man of haughty appearance, with hair
arranged in two rows of curling locks
around the broad forehead, smallish eyes
(the pupils unexpressed), and an open
mouth. He was looking three-quarters to
his left.

 The high quality of carving, the size, and
the subject's courtly appearance suggest
that the monument from which this head
came belonged to the years when Nero
was consolidating his power. An unbal-
anced, egocentric ruler, he was still, how-
ever, being served by strong generals in the
field. The subject here could be one of
Nero's companions, perhaps Marcus Sal-
vius Otho, who became emperor briefly in
the year after the last Julio-Claudian's
death. This ideal likeness shows how Otho
might have appeared in the early sixties of
the first century, a period when he served
as a governor in Spain, sent there by Nero
to make it easier for the emperor to marry
Otho's wife, Poppaea Sabina.

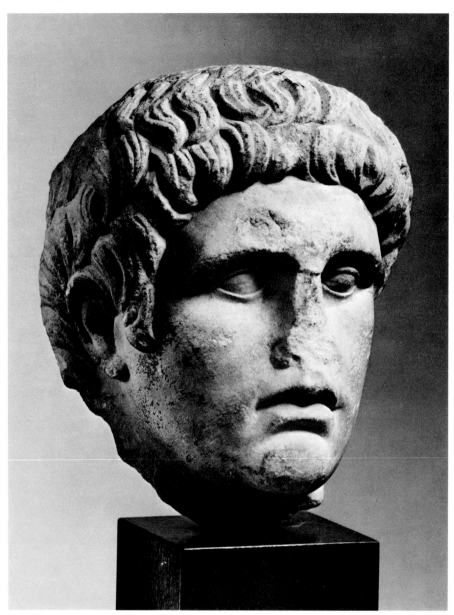

44

 In the heart of the Eternal City, the mid-
sixties saw construction of an arch with
reliefs to commemorate victory over the
Parthians in Armenia.[1] A head of Nero on
a fragment thought to have come from the
arch[2] is similar in scale to the Boston head,
yet something in the style of the latter
suggests a monument in Greece (where
Nero, the artist, who put his name and
titles on the front of the Parthenon, was
viewed with mixed emotions) rather than
in Rome. Alternatively, both heads could
have come from Roman monuments, on
the evidence of later reliefs such as the
Domitianic scenes from the stoneyard
under the Cancelleria Palace, which show
the emperor as very Roman (with his image
carved by a special portraitist), while the
followers were shown, by contrast, as
more ideal and Greek.[3]

1. See F.S. Kleiner, "Searching for the Lost Arch
of Nero in Rome," *Context* 2, no. 4 (Winter
1983; Boston University Center for Archaeologi-
cal Studies), pp. 4–5, illus.

2. Compare H. von Heintze, *Die antiken por-
träts in Schloss Fasanerie bei Fulda* (Mainz,
1968), pp. 40, 101–102, pls. 46–47, 119a (the
fragment showing the undisputed, very numis-
matic head of Nero).

3. Andreae, *Rome,* figs. 389–390.

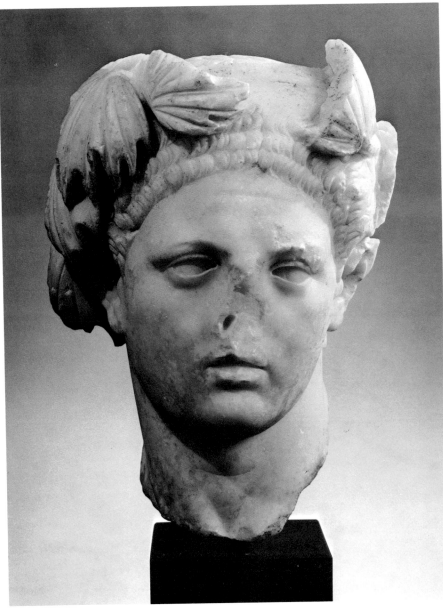

45

Carved at the height of Domitian's autocratic career, about six years before his murder by outraged senators, this precisely treated yet emotional head presents the last Flavian as the godly Herakles. The complete statue, showing him standing with club, lion skin, and the Apples of the Hesperides in hand, was undoubtedly designed for a shrine of the emperor in the region of Rome. There were similar, larger statues in the audience hall of Domitian's palace on the Palatine Hill and in the Flavian family temple at Ephesus in western Asia Minor.[1] The poet Martial saw Domitian's features in the cult statue of Herakles in a temple founded by the emperor on the Via Appia in the year 91.[2]

1. G. Daltrop, U. Hausmann, and M. Wegner, *Die Flavier* (Berlin, 1966), pp. 25–26, pl. 15a,b.
2. Ibid., p. 30.

46 (S354)
FUNERARY RELIEF
Northern Greek Imperial, ca. A.D. 120–130
Thasian marble; Radius (max., as preserved): 0.47 m. H (as preserved): 0.35 m.
D: 0.16 m.
Classical Department Exchange Fund.
1980.212

Provenance: acquired from a private collector in Bavaria; said to have been brought from Salonika during the Balkan Wars
Reference: Museum Year: 1979–1980, p. 40.
Condition: The noses have been broken; otherwise, the piece is in excellent condition. There are patches of a brown patina on the surface.

45

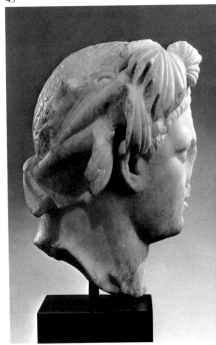

45 (S346)
FRAGMENT OF STATUE: HEAD OF
DOMITIAN IDEALIZED AS HERCULES
(HERAKLES)
Roman Imperial, ca. A.D. 90
Mainland Greek marble; H: 0.205 m.
Frank B. Bemis Fund. 1978.227

Provenance: from the art market in New York by way of a private collection in Chicago (originally from Rome)
References: Museum Year: 1978–1979, pp. 21 (illus.), 39; Vermeule, *Iconographic Studies,* pp. 7–9, 12, figs. 6–7; idem, *Sculpture in America,* pp. 300–301, no. 257; D. Buitron-Oliver, in *Bastis Collection,* p. 146.
Neg. Nos. C33322, C33394 (front view), C33321, C33393 (profile to right)
Condition: The head and neck were broken off at the base of the neck. The head is chipped on the left cheek, ear, and eyebrow and on the hair

near the right ear. Portions of the leaves in the crown are missing, and the nose is entirely broken away. Otherwise, the head is in excellent condition with a smooth surface and only a slight encrustation at the back.

Crowned by a heavy wreath of acanthus, poplar, or grape leaves tied with a broad fillet, the head has the cauliflower ears of a young beardless Herakles of the Genzano type. The hair, neatly clipped and combed into several tiers, is high Flavian in style.

Titus Flavius Domitianus (emperor from 81 to 96) spent the years 69 to 81 in the shadow of his forceful father Vespasian and his talented elder brother Titus, "darling of the human race" and conqueror of Jerusalem. Some say Domitian hastened Titus' death and, once in sole possession of the Roman Empire, he behaved like a semi-divine ruler in the tradition of successors of Alexander the Great in Asia and Egypt.

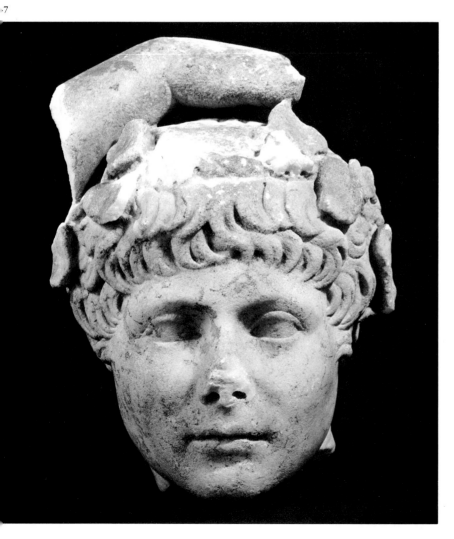

The positions of the heads, carved in deep relief in the upper right quadrant of a tondo the size of a large shield, show that they were a father and daughter. The wife and mother was undoubtedly in the missing area at the left. The lower part of the interior of the circle either terminated in their busts or there could have been up to four more heads and truncated shoulders crowded onto the field, like an example long exhibited on the wall of the new mosque (the old Archaeological Museum) in Salonika, or like other complete and fragmentary funerary tondi in the modern Archaeological Museum near the university and the trade fair grounds (the old Sephardic cemetery).[1]

Tombstones in the form of a tondo with ideal portraits of the deceased (usually a family group) within a fillet molding, were popular in Macedonia and Thrace in the second and third centuries of the Roman Empire, a time of prosperity around the northern coasts of the Aegean. The example seen here is one of the finest in quality of carving to have survived from ancient times. It dates early in the sequence, in the reign of the emperor Hadrian (117 to 138), who gave his name to the city of Hadrianopolis in Thrace (modern Erdine), still one of the centers of the region.

Such tombstones have their origin in the similar multifigured reliefs of Rome from the Julio-Claudian to Trajanic periods, as demonstrated by examples in the old collections of the Louvre.[2]

1. Compare also the various examples in Istanbul, from the old Ottoman vilayet of Salonika; see G. Mendel, *Catalogue des sculptures grecques, romaines et byzantines*, vol. 3 (Constantinople, 1914), pp. 167–173, especially nos. 953, 958, and 960.

2. Reinach, *Rép. stat.*, vol. 1, p. 52.

47 (S355)

FRAGMENT OF STATUE: HEAD OF BOY AS RESTING DIONYSOS
Roman Imperial, ca. A.D. 120
Crystalline marble from Greek islands (Naxos?) or possibly western Asia Minor;
H: 0.205 m. H (with hand): 0.245 m.
Classical Department Exchange Fund.
1980.30 (The head has been deaccessioned and returned to Rome.)

Provenance: from Rome via the European and American art markets

References: Museum Year: 1979–1980, pp. 21 (illus.), 40; Vermeule, *Sculpture in America*, p. 312, no. 268.

Neg. Nos. C35288 (front), C35289 (profile to left), and C35290 (profile to right)

Condition: Damage to the nose and wreath probably occurred when the head and forearm with hand were broken in modern times from a statue then in the open storage area of the Museo (Nuovo) Capitolino in Rome.

47

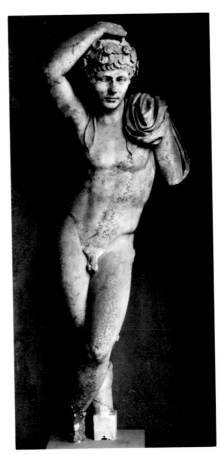

47

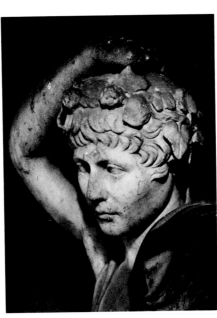

47

This vine-wreathed portrait was once part of a statue showing the young man leaning languidly on a symbolic support, his right hand placed on top of his head. The inspiration was a statue created by Praxiteles in the fourth century B.C., a type used in subsequent centuries for young gods such as Apollo (the original subject) or Dionysos and for Roman youths represented in their heroic image. Here the careful combing of the layers of locks around the forehead suits court fashions of the early to middle part of the reign of Hadrian (117 to 138).

The statue must have suffered in Antiquity as well as in modern times, for the fingers of the hand resting on the head were broken and repaired with an iron dowel. They are missing again. The similar, slightly later Antinous from the Hadrianic Baths at Lepcis Magna was also repaired in ancient times, the Bithynian youth's head being a substitution made in the early 130s.[1] Like Antinous, this young man may have died prematurely, and the statue may have been created to elevate him to the ranks of the Olympians.

The Roman youth as Dionysos is one of the last portraits in the second century A.D. to express timeless divinity, even if the eyes were made more lifelike with the addition of paint. Roman men and women in marble, including those arrayed as divinities, soon acquired incised pupils of the eyes and took on the various expressions of concern that foretold the eventual coming of the Middle Ages.

1. Compare C.W. Clairmont, *Die Bildnisse des Antinous* (Rome, 1966), p. 51, no. 38, pl. 29; and C. Picard, *Manuel d'archéologie grecque: La sculpture*, vol. 4: *Période classique—IVe Siècle*, pt. 2 (Paris, 1954), pp. 327–342, especially p. 342, n. 2 (showing that the Lepcis Magna statue now has a head of Antinous-Dionysos on a body that has Apollo's tripod for a support).

48 (S356)
STATUE: VIBIA SABINA, WIFE OF EMPEROR HADRIAN
Roman Imperial, ca. A.D. 136
Greek island marble; H: 2.02m.
Classical Department Exchange Fund.
1979.556

Provenance: formerly in an aristocratic family collection in Bavaria, later in Switzerland

References: Museum Year: 1979–1980, p. 40; *Masterpieces*, no. 23, color illus.; Vermeule, *Sculpture in America*, pp. 314–315, no. 270, illus., color pl. 23; idem, in MFA *Art in Bloom* (Boston, 1983), p. 85, illus.; M. Wegner and R. Unger, *Boreas* 7 (1984), p. 146 (listed as not Sabina).

Condition: The statue is in an excellent state of preservation with only several minor chips and discolorations, which are partly a light patina and partly metallic stains.

Plotina, wife of the great emperor Trajan, arranged Sabina's marriage to the young Hadrian about A.D. 100. Sabina was the granddaughter of Trajan's sister and Hadrian, like Trajan, was a Roman from Spain. This statue, noteworthy for its completeness, was carved for a public monument, such as a temple to the imperial family or a shrine in a forum or theater. The portrait was drawn from observation of the empress, but the ideal presentation was created within about a year after her death. Hadrian thus elevated Sabina to the ranks of the gods—an act of piety, if not of deep love, that was reflected in monumental sculptures and on the imperial coinage.

Sabina appears here with her hair pulled back and twisted into a coil wrapped about her head and into a topknot in front. She is clad in a long chiton and with an ample himation or cloak around her body and arms, part of the garment being drawn over her head as a veil. The arrangement of clothing is copied from a famous lost statue attributed to Lysippos about 325 B.C. showing Demeter standing with her daughter Persephone. Romans used the two types for their statues of older and younger women of imperial or lofty rank, the most famous pair being the large and small Herculaneum Women in Dresden.[1] Sabina's longish, narrow face, her bumpy nose (so well preserved here), and her knotted hair all reflect the solemn, cold, almost-depressed personality that, while it led Hadrian to seek comfort elsewhere during her lifetime, won the respect of all Romans, including the phil-Hellene emperor.[2]

1. P. Herrmann, *Verzeichnis der Antiken Originalbildwerke der Staatlichen Skulpturensammlung zu Dresden* (Berlin, 1925), pp. 77–78, nos. 326 (the large woman; illus.) and 327 (the small woman).

2. Compare A. Carandini, *Vibia Sabina* (Florence, 1969), pp. 171–172, figs. 173, 175 (in the Museo Nazionale, Rome, from Hadrian's Villa at Tivoli); also Andreae, *Rome*, p. 415, fig. 435;

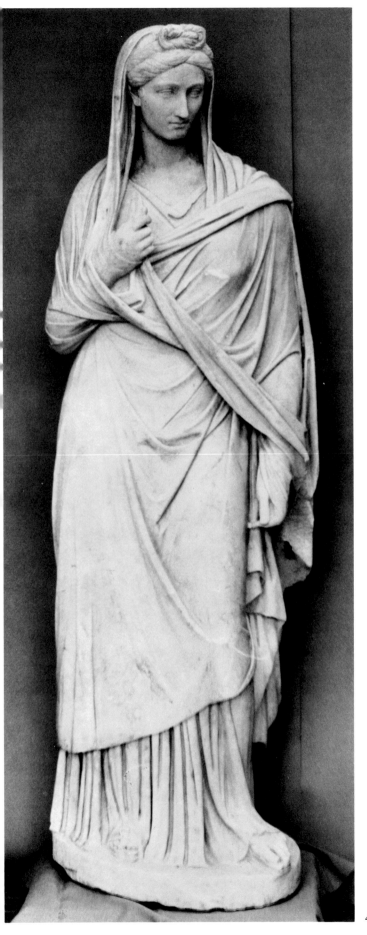

48

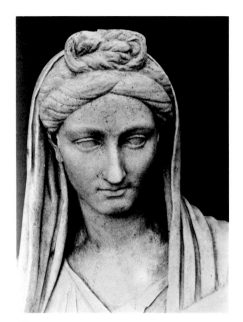

48

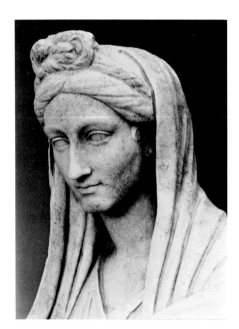

48

M. Wegner, *Das Römische Herrscherbild*, pt. 2, vol. 3 (Berlin, 1956), Sabina, p. 129, pls. 44b, 46b (in the Musei Vaticani, from the Villa of Antoninus Pius at Lanuvium). The head of the Boston Sabina combines the hair knot of the Villa Adriana head with the long nose of the bust from Lanuvium.

49 (S364)
STATUE: LADY FROM FUNERARY NICHE
Greek Imperial, probably ca. A.D. 200
Limestone; H (as preserved): 1.41 m.
Mary S. and Edward J. Holmes Fund.
1972.875

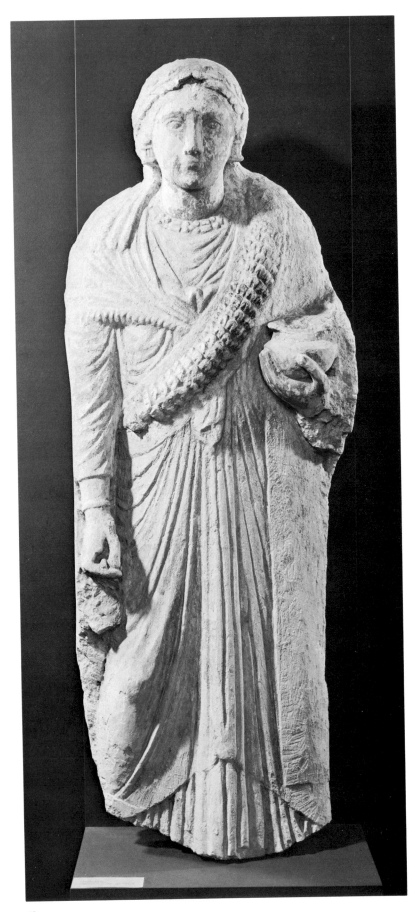

49

Provenance: from Egypt

References: Museum Year: 1972–1973, p. 49;
K. Parlasca, *Enchoria* 8 (reprint ed., 1978), p.
116, pl. 41; E. Brovarski, in *Offerings*, pp.
78–79, illus.

Exhibition: Romans and Barbarians, p. 27, no.
32, illus.

Neg. No. C28889

Condition: Of the carved surfaces, the left
forearm and the attribute in the lowered right
hand have been damaged. The lower edges of
the long tunic and the feet are broken away.
There are extensive remains of color on the
lady's face and neck, on the floral wreath around
her left shoulder, and under her right arm. The
back of the figure indicates that it was removed
from a larger surface. The limestone was stuc-
coed.

The lady, her hair dressed in long braids,
wears a wreath on her head, triple-pendant
earrings, and an elaborate necklace. Her
fringed cloak is gathered in an Isiac knot
underneath a stole or mantle, part of which
is wrapped around under the right arm as
a backing for the floral wreath.

 This figure in high relief is said to be
from the Behnessa-Oxyrhynchos region. A
nearly identical half-figure of a lady comes
from Sheikh Abada-Antinoopolis and has
been dated in the third century A.D.[1]

1. Eisenberg, *Late Egyptian and Coptic*, pp.
6–7, no. 5.

50 (S364)

STATUE OF SEATED CHILD

Graeco-Roman (possibly Hadrianic to
early Antonine)
Limestone; H: 0.545m.
Gift of Paul E. Manheim

Provenance: from Egypt

Neg. No. C40871

Condition: The right arm has been broken and
rejoined. The surfaces have suffered from chip-
ping and flaking.

Wearing a tunic with short sleeves and an
ample cloak around the lower body and
limbs, and also around the left arm, the
child sits on a rectangular block set on a
thick plinth.

 From the late fourth century B.C.,[1] most
such young funerary figures are in seated
poses of obvious mourning. The examples
in late Attic and Hellenistic funerary
sculpture are usually nude children, little
boy slaves, although some have the wings
of Erotes. The source for this clothed
figure, clearly a provincial work, must be
in the realm of pensive provincial personifi-
cations or defeated "barbarians" in Roman
triumphal art, such as the "Judaea" on the
coins of the Flavians or the "Dacia" on the
keystone of a Trajanic triumphal arch now
in the courtyard of the Palazzo dei Conser-
vatori in Rome.[2]

50

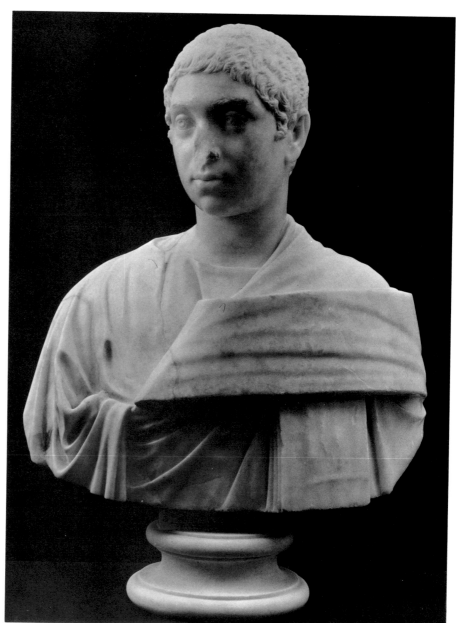

51

1. See the stele from the Ilissos River in Athens of the 320s, cited in Bieber, *Sculpture*, p. 29, fig. 69.

2. See Toynbee, *Hadrianic School*, pp. 77 (pl. xxv.1) and 117–121.

51 (S371)

BUST OF EMPEROR ELAGABALUS
(218–222)
Carved in August-September 219, probably in a workshop in Rome
Cloudy, crystalline marble (primarily white with grayish areas), probably from southwest Asia Minor; H (max.): 0.71 m. H (of face): 0.23 m.
Mary S. and Edward J. Holmes Fund.
1977.337

Provenance: from a private collection in Germany, thought to have come originally from Rome

References: Masterpieces, no. 22, color illus.; Vermeule, *Roman Art*, covers; idem, *Iconographic Studies*, pp. 35–41, 49–51, illus. (here the young Elagabalus is distinguished from his first cousin and successor, the young Severus Alexander [222–235]); idem, *Sculpture in America*, p. 354, no. 305 (illus.), color pl. 29; H.R. Goette, "Antike Skulpturen in Braunschweig," *AA* (1986), pt. 4, p. 728, n. 53; Wood, *Portrait Sculpture*, p. 124; idem, in *Ancient Portraits in the J. Paul Getty Museum*, vol. 1 (Malibu, 1987), pp. 118 (nn. 5–6), 132; . Herrmann, in *Art for Boston*, pp. 84–85, color illus.

Condition: The nose is mostly broken away. The togate bust has a section of old nineteenth-century type of restoration, and the turned pedestal is a similar addition. Face and neck have a delicate polish, and the hair has been carved with softness, sensitivity, and considerable attention to detail.

The subject has been identified through comparison with contemporary coins from the mint of Rome. Marcus Aurelius Antoninus, called Elagabalus, ascended to the throne at Emesa (modern Homs) in Syria on 15 May 218. In July of 219, the young emperor, his maternal protectors, and his then-loyal legions, reached Rome from the East. A month or so later this likeness was carved, not long after his fifteenth birthday.

A hereditary priest of the Syrian sun god, Elah Gabal, from whom he took his name, Elagabalus was interested chiefly in practicing his religion with ceremonies sometimes ludicrous and obscene, while the real power was wielded by his mother and her servants. In 222, he met his death at the hands of the Praetorian Guard, who were offended by the youthful emperor's self-indulgences—tendencies hinted at in this remarkable portrait by the dreamy sensuous look about the eyes and the curves of the soft, fleshy mouth.

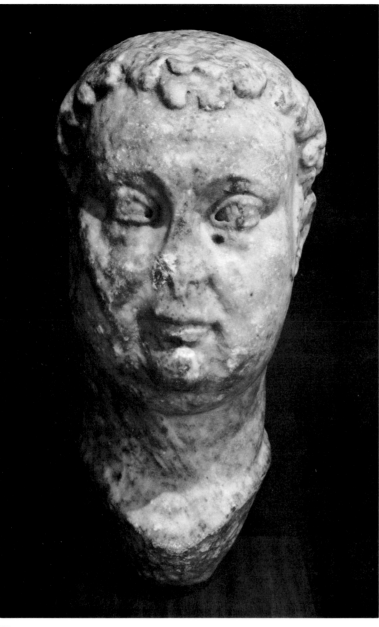

52

52 (S382)

FRAGMENT OF STATUE:
HEAD OF HIGH OFFICIAL
Roman Imperial, ca. A.D. 450 to 500
Marble from Proconnesus or northwestern
Asia Minor; H: 0.43 m.
Gift of Heinz Herzer. 1977.656

Provenance: from a private collection in Germany

References: Museum Year: 1977–1978, pp. 23 (illus.), 40; Vermeule, *Iconographic Studies*, pp. 3–7, figs. 1, 3.

Exhibition: Romans and Barbarians, p. 154, no. 191.

Neg. Nos. C33022 (front view), C33023 (profile to left)

Condition: The surfaces, especially the nose and ears, have been damaged and heavily weathered in Antiquity and post-Classical times.

This head provides the perfect portrait of a magistrate who witnessed the fall of the Roman Empire in the West. His plump face is framed by stylized curls around the forehead and the shadow of a beard. His eyes stare up and out in an apprehensive look, one doubtless of anticipated disaster. Head and neck were inserted in a draped statue, the subject thus being shown in the Late Antique form of the Roman toga.

The portrait may be that of a contemporary Roman, a magistrate of the time of Romulus Augustulus (475 to 476), or perhaps it was a retrospective likeness of a famous emperor of earlier, happier days. The public areas of Roman cities, such as the Forum of Augustus in Rome, continued to be populated with statues of magistrates and men of intellect at a time when military power was passing to barbarian generals. As Late Antique contorniates (ceremonial tokens struck in bronze), reliefs, and illuminated manuscripts prove, great worthies of the past were also honored, from the early kings to mythical heroes to great emperors. Comparison with a head of about A.D. 75[1] suggests that this portrait of the time of Rome's "fall" might be the emperor Titus (ruled 79 to 81), who conquered Jerusalem, completed the Colosseum in Rome, and had to deal with the volcanic destruction of the cities around the Bay of Naples. Since Titus had been styled "the darling of the human race," he merited being remembered in Italy at a time when civilization seemed so threatened.

1. Comstock and Vermeule, *Stone*, no. 344.

Early Imperial and Late Antique Architectural Sculpture

53 (S307)

CORINTHIANIZING CAPITAL

Roman, Early Imperial, 31 B.C. to A.D. 69
Marble; H: 0.189m. w. (max., at top):
0.227m.
Edwin E. Jack Fund. 1987.187
Provenance: probably from Latium
Reference: Museum Year: 1986–1987, p. 52.
Neg. No. E2186
Condition: There are breaks at the corners of
the abacus and encrustation in the background
areas. Otherwise, the state of preservation is
excellent.

In both material and workmanship this
capital is one of the most elegant of all
pieces of Roman architectural decoration.
It is notable for the sensitivity of its foliage,
with different kinds of vegetation being
contrasted with great skill. Relatively large
areas of background were left bare to set
off the projecting elements.

Known to Antiquity as "marmor
Lacedaemonius," the red marble came
from the Peloponnesus and was used exten-
sively for small-scale decorative works,
particularly wall revetment. Of the few
capitals surviving from these projects,
almost all are of fine quality.

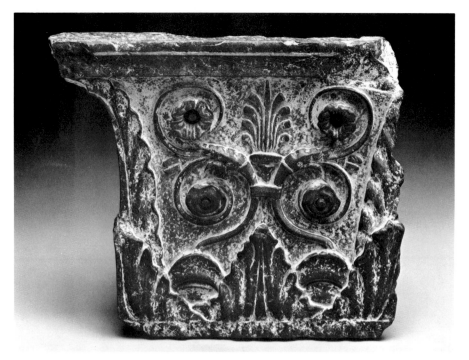

53

54 (S311)

SLAB FROM PARAPET

North Syrian, 5th century A.D.
Limestone; H: 0.70m. W: 0.70m.
Gift in Honor of M. Trophime Dahda.
1978.499
Provenance: acquired years ago from the collec-
tion of a Lebanese diplomat in Geneva
*Reference: Museum Year: 1978–1979, pp. 21
(illus.), 39.*
*Exhibition: Romans and Barbarians, p. 192,
no. 222.*
Neg. No. C33516
Condition: The lower left corner is broken off.
The edges are chipped, and the patina is reddish-
yellow.

Carved slabs of this type were used to
fence in porticoes or terraces and, most
often, to enclose the altar area in church
buildings. This elaborately decorated
example is covered with a network of
knots around rosettes. Knotted ornament,
which creates a paradoxically loose, insub-
stantial effect when applied to architecture,
appears on Syrian parapets as early as the
fourth century, when it was used to form a
ring enclosing a cross. Here the network
seems borrowed from mosaic pavements
of the fifth century. The ornament is denser
and lusher than in the mosaics, but the

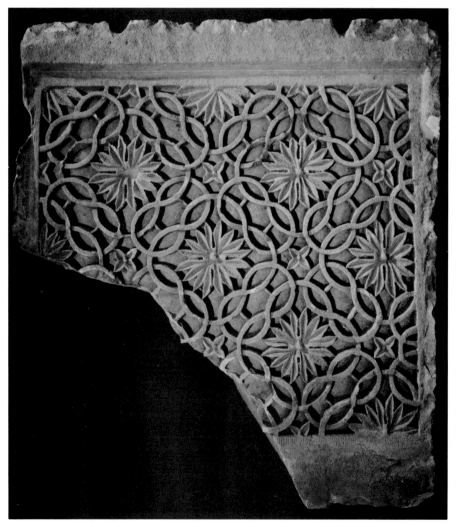

54

effect is drier than that of sixth-century capitals, where the foliage is packed in front of a background lost in shadow.

55 (S311)
CORINTHIAN PIER CAPITAL
Syrian, ca. A.D. 500
Limestone; H: 0.50m.
Gift in Honor of M. Trophime Dahda.
1978.500

Provenance: acquired years ago from the collection of a Lebanese diplomat in Geneva
Reference: Museum Year: 1978–1979, pp. 21 (illus.), 39.
Exhibition: Romans and Barbarians, pp. 192–193, no. 223.
Neg. Nos. C33517, C33518, and C33519
Condition: There is some ancient damage to the tips of the leaves. The patina is reddish-yellow.

The capital derives from the decorative style developed in the great pilgrimage church built around the column of Saint Simeon Stylites by the emperor Zeno (474 to 491). On this kind of Corinthian capital, the foliage is a dense mass that covers the surface completely; scrolls and moldings that traditionally ride above the foliage have been suppressed. A rich play of light and shadow is created by the modeling of the leaves, with deeply drilled grooves and spaces between their points. This capital has been made Christian by carving a Christogram (the Greek letters "Chi" and "Rho") arbitrarily into the center leaf, a practice common in the sixth century.

56 (S311)
CORINTHIAN CAPITAL
North Syrian, ca. A.D. 550
Limestone; H: 0.47m.
Gift of Dr. and Mrs. John J. Herrmann, Jr.
1980.469

Reference: Museum Year: 1980–1981, p. 36.
Exhibition: Romans and Barbarians, p. 193, no. 224.
Neg. Nos. C33520, C33521
Condition: There is some modern damage to the tips of the leaves.

The foliage of this carved capital, more stylized than that of no. 55, is composed of curling vines attached to a central stem. Deep perforations set off the smooth, almost unmodeled surfaces of the leafage. While the basic arrangement is traditional in Syria, the new lacy effect must have been inspired by the vine-covered, interwoven surfaces of architectural enrichment in churches in Constantinople built during the reign of the emperor Justinianus (527 to 565). Other capitals like this one are to be found in the northern Syrian church of Der Seta.

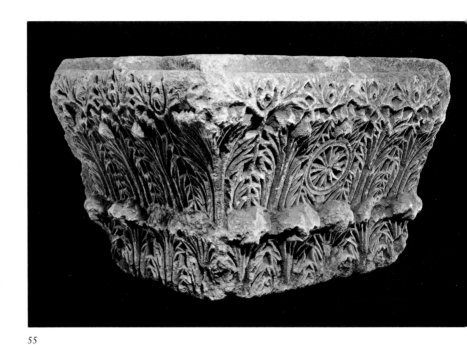

55

55

56

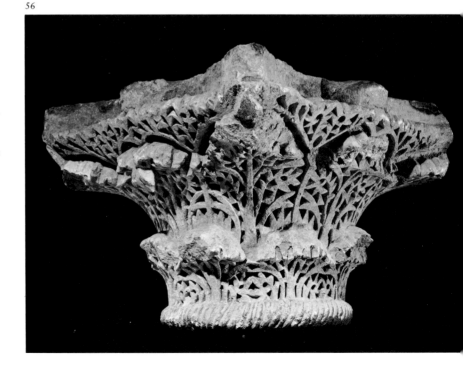

57 (S311)

SECTION OF CURVED FRIEZE
OR LINTEL
Late Roman Egyptian ("Coptic"), A.D.
400 to 550
Limestone; L (max.): 0.29 m.
Anonymous Loan. 146.1973

Provenance: from El Bahnassa

References: Eisenberg, *Late Egyptian and Coptic*, pp. 24 (no. 40), 27 (illus.); C. Vermeule, in *Festschrift Avi-Yonah*, pp. 58–59 (fig. 5), 61, n. 5.

Neg. No. C28403

Condition: There is considerable wear on the surfaces, especially at the upper right and the lower left.

A broad fillet surmounts a course of curved waterleaf molding, all leading downward to a thin, straight fillet. In the main area below, between stylized acanthus foliage, a feline crouches to the left, its head turned around to the right.

Post-Classical Sculpture

58 (S466)

FRAGMENT OF STATUE:
FACE OF YOUTH
Style of late Archaic sculpture from Aegina;
ca. 1901
Crystalline marble from Greek islands;
H: 0.168 m.
Anonymous Gift. 02.388

References: C. Vermeule, *CJ* 65 (1969), pp. 49, 51–52, fig. 2; M. Maass, *AM* 99 (1984), p. 174, n. 43; Türr, *Fälschungen*, pp. 9, 25, 33, 38–39, 88–90 (no. A27, illus.), 92, 229.

Neg. Nos. C26195 (front view), C26196 (side view)

Condition: The top and back of the head are missing, the latter from a point just behind the cap-like helmet and the backs of the ears. The face has been treated to give the appearance of weathering and a crusty brown "iron" deposit.

The "forger's" inspiration for this sculpture may have come from heads found in the excavations at Aegina in 1901. They had apparently belonged to the first east and west pediments of the temple and had been removed, buried under the building, and replaced by sculptures that later were among those brought to Munich after the Napoleonic Wars.

Comparison with other warriors in various poses from the pediments of the main temple at Aegina shows that this sculptor may have been trying to copy a pushed-back Corinthian helmet and misunderstood its shape, as well as carving hair in bold striations where a cloth cap or liner should have shown beneath the helmet, or possibly he was attempting a variation of the lion-skin cap worn by the kneeling Herakles.

Around the time of the 1901 excavations, and under the influence of revived European and American awareness of Greek art of the period before the battle of Marathon, the Italian sculptor Alceo Dossena (1878–1937) began his career as a sculptor imitating the late Archaic style;[1] he could have produced the present work.

1. See Vermeule, Cahn, and Hadley, *Gardner Museum*, p. 27, no. 34 (a recut Classical male head made into the likeness of an Archaistic goddess).

59

FRAGMENT OF STATUE: HEAD
OF MENELAOS
Graeco-Roman or Italian baroque
Pentelic marble; H: 0.275 m. L (of face):
0.105 m.
Benjamin Pierce Cheney Fund. *88.644*
Provenance: from the area of Rome

58

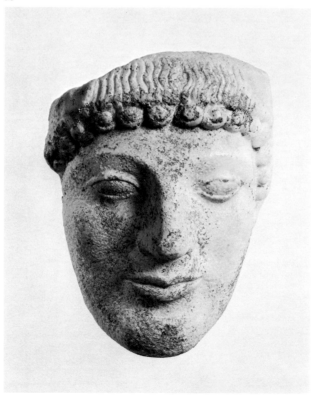

Reference: C.A. Picon, in *Bartolomeo Cavaceppi: Eighteenth-Century Restorations of Ancient Marble Sculpture from English Private Collections* (London: Clarendon Gallery, 1983), p. 46.

Exhibition: K.E. Dohan, in *Ancient Greece* (Allentown: Allentown Art Museum, 1979), pp. 174–175, no. 85, illus.; also G.F. Pinney and B.S. Ridgway, in the same volume, p. 7.

Neg. Nos. C33660 (front view), C33661 (profile to right), and C33662 (profile to left)

Condition: The edges of the helmet, including parts of the flaps over the ears, have been restored in plaster. The marble has a yellowish patina.

This small head, possibly made more "baroque" by the enthusiasm of the plaster restorations to the helmet, belongs with a figure of the type called "Ajax" (in a group with the body of Achilles) from the Renaissance to the nineteenth century, until it was recognized that the dead hero being carried by the bearded warrior had wounds in the body rather than an arrow in the heel. The head has been published in full detail[1] as a reduced version of the famous Pergamene group, surviving in Graeco-Roman copies such as the famous "Pasquino." The use of the drill in hair and beard has suggested a date for this copy in the Flavian period, the last thirty years of the first century.

There remain questions about the general style of the present work, however, as to whether it is complete in itself or was part of a small group. The emotional face seems exaggerated, and the head is turned more decidedly than that of the Pergamene prototype. Decorations in relief on the sides of the helmet (particularly the combats with centaurs) appear too large and showy for this marble to have been carved in Antiquity. The uniqueness of such a subject in miniature also comes to mind, but this is not an essential objection. The Romans did not like "heavy" subjects for their small marble groups; they preferred "rococo" creations, especially Dionysiac or rustic subjects (as no. 27 above). Without ruling out further speculation, the present judgment is that this head would seem to have been carved from about 1625 to 1725, at a time when replication of famous antiquities on "tabletop" scale was becoming popular in Europe.

1. See K.E. Dohan in *Ancient Greece*.

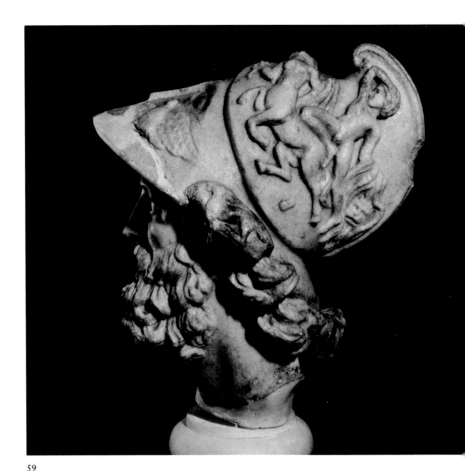

59

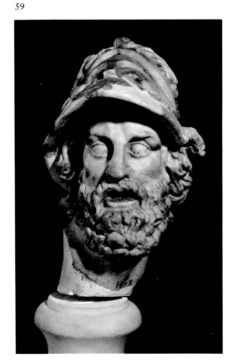

59

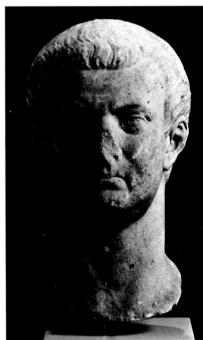

60

60
HEAD OF MAN

19th or early 20th century
Grayish streaked marble, possibly from around the Sea of Marmara; H: 0.305 m.
Gift of Paul E. Manheim. 68.769

References: Museum Year: 1968, p. 33; C. Vermeule, *CJ* 65 (1969), pp. 71–73, fig. 21; Türr, *Fälschungen*, pp. 213, 215, 229, no. RK 19, illus.

Exhibition: Fakes and Forgeries (Minneapolis: Minneapolis Institute of Arts, 1973), no. 19, illus.

Neg. Nos. C26277 (front view), C26278 (profile to right)

Condition: The nose and the base of the neck are damaged. There is chipping on the surfaces.

The head, resembling the emperor Licinius I (307–324), was probably fashioned as part of a gallery of the Caesars in the nineteenth century, perhaps as early as the decades just after the Napoleonic Wars. English country houses such as Lowther Castle had sets of heads of this general type. The portrait's appeal centered around the combination of the Late Antique look with the memory of austere male portraits going back to the last generation of the Roman Republic. The combing of the hair forward on the forehead and the relatively shallow incision of the eyes are found in portraits of about A.D. 240 and again in the Augustan classical revival in the age of Constantine the Great; for example, in heads of the emperor Licinius inserted in the Hadrianic tondi of the Arch of Constantine in Rome around 315.

61
SCULPTURE OF HAWK OR FALCON

Modern work in late Greek Imperial or Byzantine style
Marble from western Asia Minor; H: 0.23 m.
Gift of Richard R. Wagner. 65.1704

Provenance: from Istanbul

References: Museum Year: 1965, p. 68; C. Vermeule, *CJ* 63 (1967), pp. 67–69, fig. 21 (2 views).

Neg. Nos. C23932 (three-quarter view to left), C23933 (left profile), and C23934 (rear)

Condition: The figure has been broken and mended above the base across the ankles and tail. On the surface are two substances that are not natural: a yellow patina and brown stain around the feathers, the latter designed to give the illusion of age.

This creature is a modern Anatolian rustic version of Roman Imperial birds created in the traditions of Ptolemaic Egypt and beyond to the royalty and religion of the late Dynastic Nile. The bird does not have the brooding forcefulness of Horus hawks or falcons in dark green or black stone. This is probably because the local sculptor in Asia Minor knew only of those Hellenistic Egyptian arts associated with the cults of Isis and Serapis.[1]

In Graeco-Roman times, as is well known, Egyptian divinities were widely worshiped on Cyprus, in western Asia Minor, and even in Athens. The excavations at Salamis on the eastern coast of Cyprus have yielded statues of all the Graeco-Egyptian divinities in the ruins of Trajanic, Hadrianic, and later Imperial times. In Asia Minor their worship, as attested by coins and inscriptions, was commemorated in every conceivable form.

The craftsman who fashioned this bird in a kind of linear, neo-Byzantine style also had models in Roman reliefs from the second to the fourth century of the empire, notably those with the Lydian Zeus, Sabazios, and Anatolian rider-gods holding or accompanied by birds.

1. Compare Bieber, *Antiken Skulpturen*, p. 36, no. 71, pl. XXXV (a late "Egyptian" falcon made out of wood).

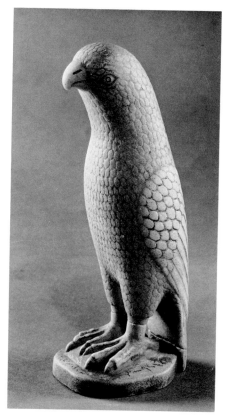

61

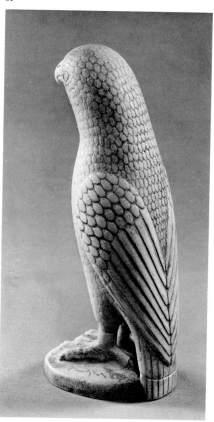

61

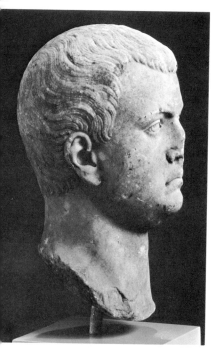

60

Sculpture in Bronze

Greek and Graeco-Roman Statuettes

62 (B11)

STATUETTE OF GOOSE
Geometric, ca. 750 B.C.
H: 0.05 m. W: 0.083 m.
Anonymous Loan

Provenance: from private collections in Germany and Switzerland; said to have come from Olynthus

Reference: G. Hafner, in Ars Antiqua A.G., Lucerne, Auktion III, 29 April 1961, p. 29, mentioned under no. 66.

Condition: The sculpture has a light green patina with brown spots.

The profiles and volume are rendered in simple terms, with bending head, curling tiny feet, and a large loop for suspension on the back.

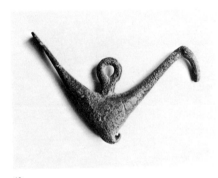

62

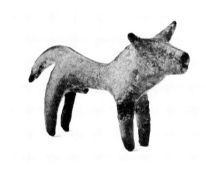

63

63 (B18)

STATUETTE OF BULL
Archaic, ca. 600 B.C. or slightly later
L: 0.06 m.
Anonymous Loan. 110.64

Provenance: from the Hugo Weissmann Collection, Boston (1958) and Vienna

Neg. No. C42922

Condition: There is a green patina, with black on the legs.

The statuette is somewhat Geometric in form, having a pig snout, pointed ears, and a heavy tail. There are, of course, many similar votive bronzes, varying in details such as the length of the horns and legs.[1] A close parallel, identical in length, is postulated as having come from Olympia,[2] as does the prototype bull in this group, the true example from the Geometric period of Greek art and dated 800 to 750 B.C.[3]

1. See, for example, *Bedeutende Kunstwerke aus dem Nachlass Dr. Jacob Hirsch* (Lucerne, 7 December 1957), p. 21, no. 43, pl. 21.
2. Sotheby Parke Bernet, New York, sale no. 4380, 16 May 1980, no. 207.
3. Rolley, *Bronzes Grecs*, p. 228, fig. 215; see also Sotheby Parke Bernet, New York, sale no. 3811, 21 November 1975, no. 629.

64 (B99)

STATUETTE OF ATHENA (MINERVA)
Roman, 2nd to 3rd century A.D.
H: 0.116 m.
Gift of Mrs. Jamileh Yeganeh Alavi.
1986.268

Provenance: from a private collection in Germany, and possibly from Asia Minor or nearby lands

Reference: Museum Year: 1985–1986, p. 48.

Neg. Nos. E942, E943

Condition: The patina is an even green. The top of the crest has been damaged, the spear in the right hand is missing, and the left arm is broken off above the elbow. (This arm and hand probably supported and held a shield.) The pupils of the eyes may have been inlaid.

The goddess runs from the viewer's right to the left, head tilted back and right leg, advancing, bared at the parting of the drapery. She wears the crested Corinthian helmet pushed back above her brow, an Ionic chiton pinned on both shoulders and tied high up around the waist, and panther-skin boots. The garment has a sleeveless tunic falling to the lower middle of the body and long skirts that flow in folds and zigzags to the ankles.

Small statues in marble or statuettes in bronze of Athena moving in an open motion to the side derive ultimately from the Athena moving to the left in a contest with Poseidon in the west pediment of the Parthenon or the same goddess moving to the right (in the scene of her birth from the forehead of Zeus) in the Parthenon's east pediment. The representation of Athena-Minerva running to the right received great stimulus from an appearance in a sacral landscape setting on a big bronze medallion of Commodus in 191.[1] The type as seen in the present work survived as late as 270 to 275—the reign of the emperor Aurelian—on bronze coins of Selge in Pisidia (in connection with cultivation of the styrax tree).[2]

1. See F. Gnecchi, *I Medaglioni Romani*, vol. 2 (Milan, 1912), p. 57 (no. 47), pl. 81 (no. 6).
2. See E.J. Waddell, New York and Washington, Auction 1, December 1982, no. 467.

65 (B100)

STATUETTE OF DISPATER

Roman, 1st to 2nd century A.D.
H: 0.182m.
Classical Department Exchange Fund.
1980.174

Provenance: Anna and Edward Smith Collection; from Gaul

Reference: Museum Year: 1979–1980, p. 39.

Exhibition: Romans and Barbarians, pp. 70–71, no. 96.

Neg. No. B20858 (front view)

Condition: The hands, now missing, were made separately and attached. (The raised left hand held a mallet—the sounder of thunder—and the extended right hand held a jar with the water of life.) Surfaces are covered with dark green to black patina.

This statuette is one of the finest representations of the Gallic god that has survived, based on a late Hellenistic model of Zeus, the appearance and details of the head being like those of the marble Zeus from Otricoli in the Vatican Museums. Similar Dispaters have been collected in Paris.[1]

1. Babelon and Blanchet, *Bronzes Antiques*, pp. 305–307, nos. 694–696.

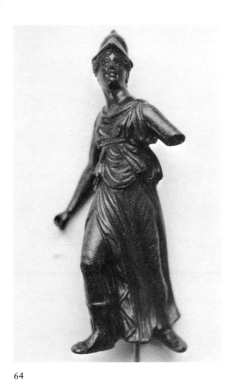

64

66

66 (B102)

STATUETTE OF FLYING EROS

Graeco-Roman, 1st to 2nd century A.D.
H (as preserved): 0.145m. W (max.): 0.10m.
Gift of the Estate of Alfred Greenough.
85.244
Neg. No. C42923

64

65

Condition: Patches of corrosion cover most of the body. The lower part of the fillet in the left hand, which may have extended across to the right hand, is broken away, as are the fingers of the right hand, the edges of the wings, and the right foot and much of the left. The patina ranges from black to a metallic yellow.

This is a relatively large version of a type of Eros that was popular in bronze in the Graeco-Roman era, having originated in terracotta in the fourth century B.C. and the Hellenistic period. While most parallels in bronze are much smaller,[1] there are two other known figures comparable in size to the Boston example: one holding a mirror with open cover in his raised left hand,[2] as is the case in many Hellenistic terracottas, and another with the right arm raised.[3]

1. E.g., Münzen und Medaillen A.G., Basel, Sonderliste P, February 1976, pp. 28–29, no. 60, illus.; *Hesperia Art Bulletin* 43 (Philadelphia, n.d.), p. 4, no. A31, illus. (0.08m high).
2. E.g., Münzen und Medaillen A.G., Basel, Auktion 60, 21 September 1982, p. 65, no. 132, pl. 42.
3. Williams, *Johns Hopkins*, pp. 88–89, no. 60.

67 (B103)

STATUETTE OF HORUS IN ARMOR

Roman, ca. A.D. 150 to 200 or later
H: 0.102m.
Arthur Mason Knapp Fund. 1974.415

Provenance: brought by the late Michael Abemayor from Cairo and acquired in New York

Reference: Museum Year: 1973–1974, p. 13.

Exhibitions: Romans and Barbarians, p. 18, no. 22; Morgan, *Ancient Mediterranean*, p. 59, no.

67

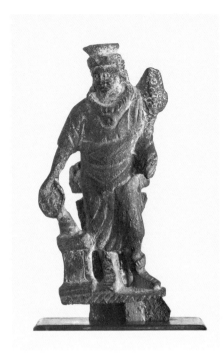

69

He probably once held a club in his lowered left hand, either pointed toward the ground or with the end resting on his shoulder.[1] The right hand, extended and with palm partly open, may have grasped a kantharos, a skyphos, or a libation bowl. The probability that this popular hero was shown in other statuettes holding a club toward the ground in his right hand is attested by a version of the type on a bronze jeweler's core in the Art Museum of Princeton University.[2]

1. For another statuette with the club in the left hand, see Uhlenbrock, *Herakles*, fig. 46.

2. Amyx and Forbes, *Echoes*, pp. 77, 83, no. 27, illus.; see also Vermeule, *Sculpture and Taste*, p. 29, fig. 19.

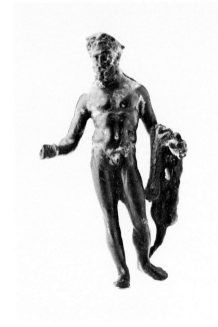

68

91, fig. 30; and "The Mediterranean World" (Danforth Museum, Framingham, September 1977–March 1978).

Neg. No. B20641 (front view)

Condition: Ankles and feet are missing; the surfaces have a black patina.

Horus, wearing the crowns of upper and lower Egypt, stands with left arm raised, finger pointing toward heaven, and patera in the extended right hand. He also wears a short field cloak around the shoulders and down the back, and Greek Imperial ceremonial field armor consisting of an articulated breastplate, three rows of short leather straps (pteryges), a double cingulum knotted in the center, and a tunic beneath.

Horus appears not only as a Hellenistic or Greek Imperial soldier, as here, but also as a Roman emperor or general.[1] Coins of the Nomes of Egypt in the Antonine period show the popularity of this armored Horus in the hinterlands.[2]

1. In a large bronze bust from the Edward Smith collection; see Sotheby Parke Bernet, New York, sale no. 3581, 7 December 1973, no. 82.

2. See H. Seyrig, *Syria* 47 (1970), pp. 101–107, fig. 24.

68 (B106)

STATUETTE OF HERAKLES

Graeco-Roman, ca. 50 B.C. to A.D. 125

H: 0.09 m.

Collection of the Late Sir Charles Nuffler

Neg. No. C42939

Condition: The surfaces have a rich, black patina.

The athletic figure of Herakles is wreathed, with fillets falling down on his neck and shoulders and a lion skin on his left arm.

69 (B116)

STATUETTE OF TYCHE FROM ROMAN EGYPT

Late Roman, ca. A.D. 200 to 300

H: 0.085 m.

Anonymous Gift. 1972.374

Provenance: from Spink and Son, London, and Blanchard's Museum, Cairo; found at Faijorum Oasis

References: Museum Year: 1971–1972, p. 45; True and Vermeule, *Bulletin*, pp. 128–129, no. 9.

Neg. No. B20216 (full view)

Condition: The statuette has a metal ring at the back and is mounted on a spearpoint, probably for installation in a shrine. The surfaces are rough with brown areas and encrustation.

This figure is a conventional version of the Isis-Fortuna "Tyche" of widely found Greek Imperial type. She is pouring a liba-

tion from a patera or phiale at an altar. The wreath and bulla around her neck, the high boots with fringes, and the crisscross enrichment on the front of the plinth contribute to a very Romano-Egyptian to proto-Coptic appearance.

The Antonine coin reverses of Alexandria show figures similar to this statuette as representations of major divinities such as Demeter and variations of Isis or Tyche-Fortuna.[1] Dikaiosyne-Justitia appears in this fashion as late as the series of Alexandrine tetradrachms survived, through the period of the Tetrarchs; an earlier example is the coin of the empress Orbiana (A.D. 227), and there are similar figures of Homonoia-Concordia on coins such as that of Pupienus in A.D. 238.[2]

1. See *Sammlung Walter Niggeler*, pt. 2, Münzen und Medaillen A.G., Basel, 1966, p. 27, no. 735, pl. 12.

2. Ibid., p. 30, nos. 772 and 774, pl. 15.

70 (B117)

STATUETTE OF NIKE-VICTORIA ON TWISTED COLUMN WITH CORINTHIAN CAPITAL

Roman Imperial, 1st to 2nd century A.D.

H: 0.138 m.

Morris and Louise Rosenthal Fund. 1976.150

Provenance: from the collection of Dr. Robert Friedinger-Prantner, Ambassador of Austria in Cairo and Athens

References: Museum Year: 1975–1976, p. 22; Münzen und Medaillen A.G., Basel, Sonderliste P, February 1976, pp. 27–28, no. 56, illus.; Noelke, *Iupitersäulen*, p. 355, n. 478.

70

70

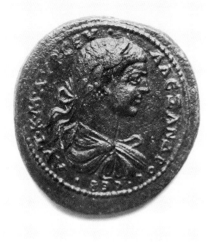

70

Exhibition: *Romans and Barbarians*, p. 114, no. 122.

Neg. No. B20819 (full view)

Condition: The column has been cracked and mended in the middle. The orb is attached loosely to the capital. There is a brown and blackish patina.

This conventional image suggests a copy in miniature of statues seen on the reverses of Greek Imperial coins in architectural settings, as in front of the shrine on a bronze of Selge in Pisidia under the emperor Severus Alexander (222 to 235).[1] The Victoria was based on an image from Tarentum, which was set up in the Senate House of Rome at the beginning of the Empire.

1. F. Imhoof-Blumer, *Kleinasiatische Münzen*, vol. 2 (Vienna, 1902), p. 406, no. 27, pl. 15, fig. 2; MFA no. 1984.104 (see Münzen und Medaillen A.G., Basel, Auktion 64, 30 January 1984, no. 180).

71 (B117)
STATUETTE: OCEANUS
Roman Imperial (Severan), early 3rd century A.D.
H: 0.08m. L: 0.08m. W: 0.06m.
Edwin E. Jack Fund. 1986.340

Provenance: said to have come from Spain
Reference: Museum Year: 1986–1987, p. 51.
Neg. Nos. E1244 (front view), E1245 (three-quarter view to left), E1246 (back)
Condition: The sculpture, covered with a dark green patina, has an upturned flange at one end and two holes for attachment at the back. (It appears that a third hole for attachment was broken when the ensemble was removed from whatever it joined.) The front and rear edges of the base are chipped.

Oceanus, a sea monster (ketos), and an urn are set on a rectangular base that is shaped somewhat like the pedimental lid of a Greek sarcophagus. The personification of the seas reclines partly on the back of the animal, grasping its snaky neck with his extended right hand. His other hand is placed on a large urn (of arbyallos shape)

71

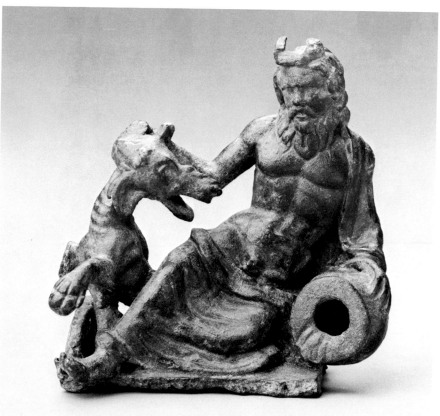

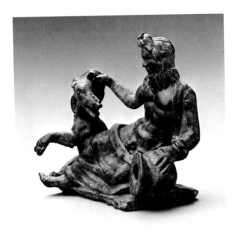

71

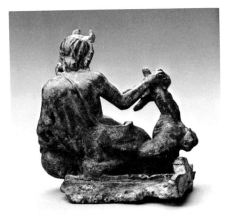

71

that lies on its side, the mouth and the engraved rim toward the viewer. Oceanus wears an ample himation around his lower limbs and over his left shoulder. He has hair and a full beard like seaweed and two crab's claws as horns on his forehead above the brow line. The ketos has a lupine head with fin-like dewlaps, a long right ear, canine paws, and similar marine "horns," one of which is missing. His left paw is extended, the other is broken away.

Oceanus and his mother, Tellus-Ge (Earth), were popular as a symbolic geographical pair in Roman art, from the breastplate of the Primaporta Augustus of the late first century B.C. to a host of sarcophagi in the second and third centuries A.D. The present sculpture, perhaps the ornament of a cart or a piece of symbolic furniture, goes back ultimately to Pergamene Hellenistic art of the second century B.C.[1]

1. See G.M.A. Hanfmann, in Mitten and Doeringer, *Master Bronzes*, p. 254, no. 244.

72 (B118)

STATUETTE OF PAN
Graeco-Roman, ca. 50 B.C. to A.D. 200
H: 0.10m.
Private Collection. 114.<u>64</u>

Provenance: from the Hugo Weissmann Collection, Boston (1957) and Vienna; previously from Asia Minor

Neg. No. C42940

Condition: The piece has a crusty green patina.

The god of herders and rustic settings stands with pipes in his left hand and a pedum in the crook of his right arm. This statuette copies a work of the fourth century B.C. or of Hellenistic origin, of which small marble versions exist. One such figure appears to have been grouped with Eros or Dionysos in an "erotic" contest.[1] A related seated Hellenistic Pan in bronze, holding a syrinx in one hand and a lagobolon ("throwing stick") in the crook of the other arm, is attached to a fitting for furniture or a cart.[2]

1. See E. Strong and B. Ashmole, in *Catalogue of the Greek and Roman Antiques in the Possession of . . . Lord Melchett . . .* (Oxford, 1928), p. 25, no. 19, pl. XXVII.

2. *Classical Antiquity* (Zurich: André Emmerich Gallery, 1975), no. 59.

72

73

73 (B122)

STATUETTE OF ZEUS OF CAPPADOCIA
Greek Imperial, ca. A.D. 100 to 230
H: 0.192m.
Edwin E. Jack Fund. 1972.920

References: Museum Year: 1972—1973, pp. 40, 42, illus.; True and Vermeule, *Bulletin*, pp. 124–125, no. 6; C. Vermeule, *Hesperia* 45, no. 1 (1976), p. 71, pl. 12d; idem, *Numismatic Art*, pp. 125, 148 (fig. I), fig. 116.

Condition: The small figure has a rich brown patina.

With its waves of hair over the forehead, the articulation of the himation around the left shoulder, the weighted end of the cloth at the figure's left side, and the feet on tiptoes in sandals, this large statuette is an elegant expression of a particular Zeus. The traditions are early Hellenistic, a modernization of the cult statues of the Galatians or the Seleucids in a restyling of the Pheidian tradition. The raised left hand must have held a scepter-staff. On the extended right hand is a stylized symbol of Cappadocia's sacred mountain, Mount Argaios—a form identical to the pyramid on reverses of bronze coins of Caesarea in Cappadocia in the reign of the emperor Trajan (98 to 117).[1] Since Trajan was much in the Greek East as a Jovian savior in the last several years of his life, the monumental prototype for this bronze figure may have been created in his reign or in that of his successor, Hadrian (117 to 138).

1. MFA 1984.10 (see F. Sternberg, Zurich, Sale XIII, 17 November 1983, no. 245).

74

1. *EA*, 5055.

2. E.F. von Sacken, *Die Antiken Bronzen des K. K. Münz-und Antiken-Cabinetes in Wien* (Vienna, 1871), p. 16, pl. VII, fig. 5.

3. *Spätantike und frühes Christentum* (Frankfurt-am-Main: Liebieghaus, Museum alter Plastik, 16 December 1983 to 11 March 1984), pp. 544–545, no. 151; also, generally, M.P. Speidel, *The Religion of Iuppiter Dolichenus in the Roman Army* (Leiden, 1978).

75 (B126)

STATUETTE OF YOUTHFUL MÊN

Greek Imperial, ca. A.D. 150 to 220

H: 0.10m.

Gift of Mrs. E. Ross Anderson and Classical Department Publication Fund.

1984.234

Provenance: presumably from Asia Minor

Reference: Museum Year: 1983–1984, p. 42.

Neg. No. C41823

Condition: A scepter-staff, originally in the right hand, is missing.[1] The top of the Phrygian bonnet has been bent toward the divinity's left. The patina is a deep sea-green to black.

Without the addition of the large crescent, cap, cloak, belted tunic, trousers, and boots, this figure is simply an "Alexander with the Lance" after Lysippos. The idealized features are such that one could call it an Alexander-Mên, a fusion of the Macedonian hero and the young divinity, which was an appropriate concept in the heartlands of Asia Minor (Anatolia), where the former was remembered as the founder of new cities and the latter was worshiped in Greek Imperial times as a moon god.

A bronze statuette of Mên in the Sackler Museum,[2] although posed differently, with pine cone in the extended right hand, has the facial features of the marble Alexanders of the Severan period from Asia Minor, Syria, and, especially, Egypt, as seen in an example from Ptolemais Hermiu (El Menschiye).[3]

75

76

1. As is typical in representations of Mên, the scepter may have been topped with a pine cone.

2. Harvard University Art Museums no. 1964.126. See also D. Salzmann, "Neue Denkmäler des Mondgottes Men," in *IstMitt* 30 (1980), p. 280, pl. 109, figs. 2–4.

3. This heroic marble head has a rolled diadem; see Comstock and Vermeule, *Stone*, no. 127; A. Herrmann, in *Search for Alexander*, p. 102, no. 8.

76 (B126)

STATUETTE OF YOUTHFUL MÊN

Greek Imperial, ca. A.D. 200 to 240

H: 0.062m.

Gift of Mr. and Mrs. Abram T. Collier.

1985.15

Reference: Museum Year: 1984–1985, p. 47.

Neg. No. C42925

Condition: Some surfaces are slightly rubbed, revealing a brassy color; otherwise there is a deep brown to black patina.

The garment of Mên is arranged in a series of folds. At the back of the cloak, smoothed along the contours of the body between two heavy vertical folds, are small circles with dots in the centers suggesting embroidery or a starry firmament. The figure has baggy trousers and boots with turned-up toes.

This image is clearly a minor work of art, a small votive object. The style, however, is vigorous, and the details of the costume reinforce the uncommon choice of attributes: a phiale (patera) in the lowered right hand and a jar (pyxis) without a lid in the extended left hand. The jar resembles a truncated version of pine cones held by Mên in other bronze statuettes and marble reliefs.[1]

1. Lane, *Corpus*, 4 vols.

74 (B124)

STATUETTE OF ZEUS (JUPITER) DOLICHENUS-SABAZIOS

Greek Imperial, ca. A.D. 150 to 300

H: 0.07m.

Gift of Mr. and Mrs. Richard R. Wagner.

1973.163

Provenance: presumably from Asia Minor

Reference: Museum Year: 1972–1973, p. 43.

Exhibition: "The Mediterranean World" (Danforth Museum, Framingham, September 1977– March 1978).

Condition: A black patina covers the figure, whose right arm is missing from the elbow. Sticking out from the middle of the back, between the shoulder blades, is a long round dowel, or puntello.

The bearded god is dressed in a Roman military costume, with trousers and a Phrygian cap. In his left hand he clutches the bolts of lightning of the thunder god and in his right he probably held a double ax.

This manifestation of Zeus originated in Syria and traveled through Cilicia and Cappadocia northwest toward Phrygia. There the legionary god was amalgamated with Dionysos Sabazios to create the cult image seen here. A famous bronze bust in the Victoria and Albert Museum in London shows the emperor Commodus (180 to 192) in the cap and cloak of Sabazios, providing a good date for such small figures.[1] A similar statuette is in Vienna[2] and another, in the Antiquario Comunale, Rome—with pose and costume identical to those of the Boston statuette—stands on a bull in a relief for Jupiter Dolichenus, dated to the third century A.D.[3]

77

77 (B136)
STATUETTE OF SEATED CHILD
Graeco-Roman, ca. 50 B.C. to A.D. 75
H: 0.067m.
Bequest of Mrs. Edward Jackson Holmes

Neg. No. E2095

Condition: The figure has a black patina, with earthy deposits between the arms and legs.

The child—seated with feet together and hands placed on enlarged hips—has facial features like those of Cypriote temple babies of the late Hellenistic to Roman Imperial period. Given grosser characteristics, such seated children are associated with the art of urban centers from Smyrna to Alexandria.[1] A similar bronze statuette of a baby boy (possibly Opheltes himself) has been found in the disturbed fill of the surroundings of the Tomb of Opheltes at Nemea.[2]

1. See, for example, Münzen und Medaillen A.G., Basel, Auktion 51, 14 and 15 March 1975, p. 105, no. 238, pl. 64.
2. H.W. Catling, in *Archaeological Reports for 1979–80* (London, 1980), p. 25, fig. 43.

78 (B146)
STATUETTE OF OLD RUSTIC WITH GOAT
Graeco-Roman, 2nd or 3rd century A.D.
H: 0.065m.
John Michael Rodocanachi Fund.
1983.412

Provenance: from the art market in New York
Reference: Museum Year: 1983–1984, p. 42.

Neg. No. E425

Condition: The surfaces have some slight pitting and a varied light to dark green patina. There is an ancient hole in the top of the head.

The bald, bearded old man with ears somewhat like those of Silenus (rounded rather than equine) wears an ample cloak with an extra section over the left shoulder like a Mexican blanket. The cloak has fringes on its squared-off edges.

Similar to this work is the figure of an old man wearing the animal-skin cloak of Silenus around the lower body and carrying an ibex across his shoulders and an oinochoe in his right hand.[1] These figures—possibly famous neo-Socratic philosophers posed as rustics—are the Roman Imperial to Late Antique equivalents of Archaic Greek gods and votaries bearing rams and bovines. They have a continuous history in Hellenistic and Roman art, as is demonstrated by a young rustic with Boeotian cap and a ram on his shoulders from Tarragona in Spain.[2] Another version of the old rustic studied here has the ears of Silenus in more pronounced fashion.[3]

1. Sotheby Parke Bernet, New York, sale no. 3697, 22 November 1974, no. 258, illus.
2. The work is in the Louvre; see de Ridder, *Bronzes Antiques*, vol. 1, p. 98, no. 711, pl. 49.
3. In the Bibliothèque Nationale; see Babelon and Blanchet, *Bronzes Antiques*, p. 173, no. 383.

78

79 (B155)
STATUETTE OF VOTARY, PROBABLY PRIEST OF DIANA
Italic (late Roman Republican), probably ca. 50 B.C.
H: 0.194m.
Gift of Mrs. Horace L. Mayer. 1974.582

Provenance: Horace L. Mayer Collection; Collection of Captain E.G. Spencer-Churchill, Northwick Park, near Oxford; Spink and Son, London; originally from the Shrine of Diana at Lake Nemi
References: Museum Year: 1974–1975, p. 12; True and Vermeule, *Bulletin*, pp. 126–127, no. 8; Christie's Sale, London, 23 June 1965, p. 129, no. 506.
Exhibition: Ackland Memorial Art Center, Chapel Hill (F. Heumer, in Sams, *Small Sculptures*, no. 69).

Neg. No. C24368 (front view)

Condition: The statuette has a rich brown patina.

The votary holds a patera in the extended right hand and a pyxis or jar in the left. He wears a stylized floral or radiate crown and an ample cloak on his left shoulder and around his waist, an end over his left arm.

This is one of eight Nemi votaries that included a larger goddess, three priests,[1] and four priestesses, shown by the firm of Spink and Son to H.M. King Edward VII. (His death in 1910 prevented acquisition of the entire group for the British nation.) The votaries are larger and finer specimens of a conventional late Etruscan to Italic figure known in many smaller versions.[2]

1. Another of the priests is also in the MFA collection (59.10); see Comstock and Vermeule, *Bronzes*, no. 155.
2. For a recent bibliography of the group and its history, see Sotheby's sale, New York, 22 May 1981, no. 100 (a priestess).

80 (B166)
STATUETTE OF EAGLE WITH WINGS HALF SPREAD
Roman, 3rd to 5th century A.D.
H: 0.109m. W (wing to wing): 0.106m.
Gift of David Bacon, Alice Bacon Hallett, and Leonard Lee Bacon in Memory of the Rev. Dr. Leonard Bacon (1802–1881).
1977.657

Provenance: found by an Armenian farmer in his vineyard a few miles northeast of Aintab (Gaziantep), on the way to Doliche in the Syrian Commagene. In 1868 the eagle was given to George R. Nutting, an American missionary in southeast Asia Minor and northwest Syria, by a Dr. Nersis, an American Protestant physician in Aintab. George Nutting gave it to Rev. Dr. Leonard Bacon and it remained in the possession of the Bacon family for about a century.
References: Museum Year: 1977–1978, pp. 23 (illus.), 40; C. Hoeing, *AJA* 29 (1925), pp. 172–179, illus.

79

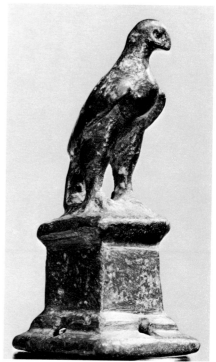

81

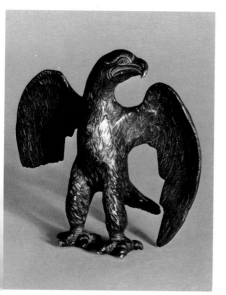

80

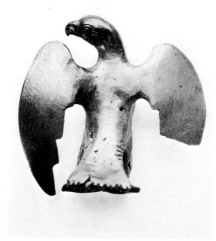

80

Neg. No. c33019 (full view)

Condition: The bird was cleaned and filed on the back and the end of the right wing is broken away. There are grooves for a wreath and a fulmen (thunderbolt) on top of each of the three outer talons. The color is dark green to black.

This eagle, symbol of Jupiter, was designed to be set in a shrine or possibly on top of a standard. The bird with wings half spread occurs on the reverses of Greek Imperial coins in Syria and Alexandria in Egypt during the century from Antoninus Pius (138 to 161) through Diocletian (284 to 305), who, as senior Tetrarch, was given the title "Jovius" (Jupiter). His junior partner Galerius campaigned against the Persians in the general area where this eagle was found. It may thus have been an emblem of that time, symbolizing the emperor, or it may have been fashioned in connection with a later campaign against the Persians, perhaps under Julian the Apostate in 363.

81 (B166)
STATUETTE OF EAGLE ON ALTAR
Roman Imperial
H: 0.058 m.
Anonymous Loan. 157.<u>64</u>

Provenance: brought from Athens shortly after World War II and said to have come from northern Asia Minor, where it passed to a Pontic Greek collection

Exhibition: Romans and Barbarians, p. 52, no. 68.

Neg. No. B20815 (three-quarter view to right)

Condition: The patina is blackish, with a crusty, earthy surface.

A number of similar bronzes have been found in shrines patronized by Roman legionaries, especially in northern Asia Minor, where such eagles also appear on Greek Imperial coins and on stelai carved in stone. Several related examples have been seen in public and private collections in the past three decades.[1]

1. E.g., Ars Antiqua A.G., Lucerne, Auktion IV, 7 December 1962, no. 115, pl. 38; also (an owl) Auktion I, 2 May 1959, no. 75.

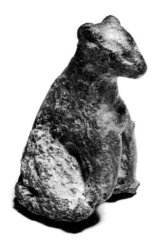

82

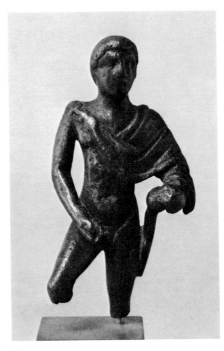

83

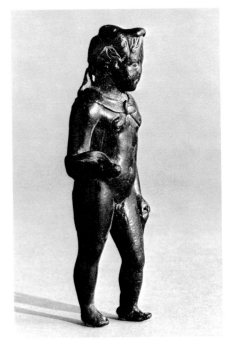

84

82 (B171)
STATUETTE OF SEATED BEAR
Roman Imperial
H: 0.037m.
Private Collection. 173.1970

Provenance: acquired in Beirut after World War II

Neg. No. C43530

Condition: The patina is crusty green, with areas of brown.

The animal is seated on a base that has been broken irregularly, suggesting that the little figure was once mounted on an object that might have been the top of a pyxis or a bar or strip of metal with other figures arranged in a votive ensemble, perhaps for presentation at a shrine dedicated to a bear cult.

Bears appear on at least two reliefs in the area from which this work was brought in the 1940s: a rock-cut hunting scene at Byblos and a chase on the east side of the mausoleum at Hermel.[1]

1. J.M.C. Toynbee, *Animals in Roman Life and Art* (Ithaca, N.Y., 1982), pp. 93–95 and fig. 34 (cites bears frolicking on a mosaic in the Bardo Museum, Tunis). Lebanese and Syrian bears were the color of straw, a hue well simulated in freshly worked bronze.

83 (B174)
STATUETTE OF RULER FROM ROMAN BRITAIN
Ca. A.D. 65 or later
H: 0.10m.
Anonymous Gift. 1972.375

Provenance: said to have been found near Chester

Reference: True and Vermeule, *Bulletin*, p. 129, no. 10.

Exhibition: Romans and Barbarians, p. 68, no. 93.

Neg. Nos. 20214 (front), 20215 (one-quarter view to left)

Condition: The lower legs and feet are missing. The surfaces are worn and now have a brown patina.

This statuette represents a Roman emperor, perhaps Nero (ruled 54 to 68) as the Lysippic Poseidon (lord of the seas), best known from the marble version in the Lateran collection of the Vatican Museums.[1] He wears a cloak pinned on the right shoulder and wrapped around the left arm. The right hand held an attribute, perhaps a symbolic wave, and the left rests on the remains of a steering oar or rudder. Octavian or Augustus, as hero of Actium and conqueror of Egypt, was represented in this fashion on coins[2] about one hundred years before this statuette is thought to have been made. Thus, it would not be surprising to find Nero being identified as the new Octavian in a cult image in miniature.

1. Vermeule, *Sculpture and Taste*, fig. 33.
2. H. Mattingly, *Coins of the Roman Empire in the British Museum* (London, 1923), vol. 1, p. 100, pl. 15, no. 5.

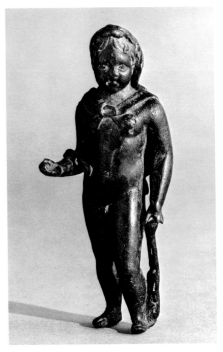

84

84 (B174)
STATUETTE OF YOUNG CARACALLA AS INFANT HERCULES
Roman Imperial, ca. A.D. 190 to 200
H: 0.094m.
Edwin E. Jack Fund. 1972.358

References: Museum Year: 1971–1972, p. 41; True and Vermeule, *Bulletin*, p. 123, no. 5; C. Vermeule, in *Festschrift Brommer*, p. 292, pl. 77, figs. 2, 3; M. Wegner, *Boreas* 3 (1980), p. 77; Uhlenbrock, *Herakles*, p. 15, pl. 46.

Exhibition: Edith C. Blum Art Institute, Bard

College, Annandale-on-Hudson, N.Y., 1 March–
31 May 1986.

Neg. Nos. B20301 (front), B20302 (back), and
B20303 (three-quarter view to right)

Condition: The extended right hand is slightly
damaged and has lost its attributes, which were
probably the Apples of the Hesperides. The
patina is deep green to nearly black.

The statuette is based on the popular image
of a child Hercules derived from a well-
known Roman Imperial cult statue that
probably stood in a temple or shrine on
the Aventine Hill in Rome.[1] Coins and
portraits in marble at the outset of the
reign of the emperor Septimius Severus
(193 to 211) identify this figure as the
child heir-apparent Caracalla, who was
portrayed as Hercules throughout his life
(emperor with his father 198 to 211, with
his brother 211 to 212, and sole emperor
212 to 217).[2]

1. C. Vermeule, *The Cult Images of Imperial
Rome* (Rome, 1987), p. 52, fig. 15A.

2. The emperor Commodus (180 to 192) had
shown the Severans how to identify the cults of
the ruler with those of Hercules, although the
last of the Antonines carried the process to an
unfortunate extreme.

85 (B176)
Right Hand from Statue
of Gladiator
Roman Imperial, ca. A.D. 150 to 220
L (overall): 0.02 m. L (end of thumb to end
of wrist): 0.162 m.
Anonymous Gift. 1972.900

Provenance: from a private collection in Switzer-
land (thought to be from Asia Minor)

References: Museum Year: 1972–1973, p. 41;
True and Vermeule, *Bulletin*, p. 130, no. 11.

Neg. Nos. C28365 (palm), C28366 (top), and
C28367 (side)

Condition: The hand is well preserved. It had at
least one rectangular patch characteristic of
Roman Imperial bronze statues (the group from
Bubon in Lycia for instance); this small surface
patch is now missing. The patina is black or very
dark green, and there is evidence of burial in
earth or debris.

This hand with its elaborate covering must
belong to a commemorative statue of a
famous gladiator set up in his home city or
in a metropolis where games were cele-
brated, probably in Asia Minor. Known as
a caestus, the gladiator's "glove" represents
the most complex, sophisticated form of
brutal boxing equipment developed by the
Romans of the empire. A heavy sheepskin
collar surrounds the wrist and thongs run
crisscross over the palm and down the
back of the hand, forming a harness
around the knuckles of the clenched fist.
Over this is tied a three-pronged "knuckle-
duster," and into the hand, fitted over the
fingers and grasped by the thumb, is a
semicircular metal weapon like a half-
section of pipe, presumably to heighten the
brutality of fighting.

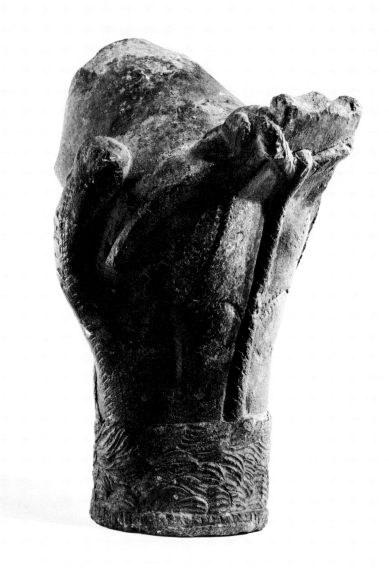

85

Etruscan and Italian Statuettes

86 (B191)

STATUETTE OF RIDER
Central Italian (late Archaic), 520–500
B.C.
H: 0.075 m.
Anonymous Loan. 109.<u>64</u>
Reference: True and Vermeule, *Bulletin*, p. 122,
no. 4.
Neg. No. B16985 (profile to right)
Condition: The rider's left arm and attributes
are missing. His feet are also broken away, as are
the animal's lower legs and hooves.

Since this figure's mount appears to be a
horse, he might be a warrior, perhaps even
a warrior-god. He seems to be wearing a
helmet and a short tunic. If, however, his
mount is a ram, he would represent
Hermes or a local forerunner of the pas-
toral god.

A more primitive, stylized version of this
type of figure, Italic but of indefinite origin,
is in the Musée du Louvre.[1]

1. See De Ridder, *Bronzes Antiques*, vol. 1, p.
38, no. 210, pl. 21.

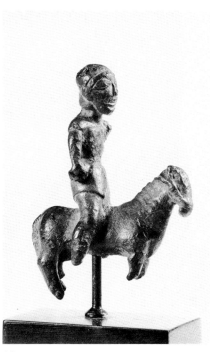

86

87 (B196)

FINIAL: KOUROS OR YOUTH
Etruscan, ca. 500 B.C. or slightly later
H: 0.11 m. H (with tangs): 0.133 m.
*Gift of Dr. Ernest and Virginia Lewisohn
Kahn.* 1976.789
Reference: Museum Year: 1976–1977, pp. 24
(illus.), 40.
Neg. No. B20940 (front view)
Condition: Tangs projecting from the feet are
heavily encrusted with lead. The body is deep
green, with a lighter green patina on the arms.

The nude figure steps forward with his
large hands outstretched, palms flat and
downward, in a most expressive gesture of
dance, perhaps at one of the elaborate
banquets held at the height of the Etrus-
cans' artistic power. The tangs, shaped like
spearheads, suggest that this vigorous late
Archaic youth had been designed as the
finial of a candelabrum or a stand used at
banquets in a game known as *kottabos*, in
which the participants flipped dregs of
wine from cups. The object of the contest
was to hit a dish below the figure at the top
of a long bronze shaft on tripod legs with
animal-feet supports.

The value of the Etruscan youth to the
Boston collections is enhanced by his re-
lationship to two famous "dancing"
females of the same period, which have
long been on display amid the bronzes of
early Italy.[1]

1. See Comstock and Vermeule, *Bronzes*, nos.
197 and 198.

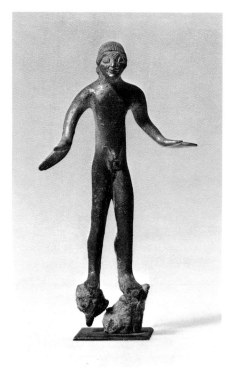

87

Greek and Graeco-Roman Jewelry

88 (B258)

BRACELET WITH LION PROTOMES
Greek, from the Near East (Hellenistic)
L (as preserved): 0.075 m.
John Michael Rodocanachi Fund.
1976.103
Reference: Museum Year: 1975–1976, p. 22.
Neg. No. E940
Condition: The end of one protome has a verti-
cal tang for attachment, while the opposite end
has a shallow groove cut in the corresponding
place. The rest of the circular bracelet was made
separately, probably in another material. The
patina is dark green with reddish areas.

The carefully defined heads of these lion
protomes are represented as chewing on a
ball. Such activity may be related to the
capture and training of lions in Hellenistic
and Roman Africa, for example, as shown
on the lid of a Roman late-third-century
sarcophagus set into the garden façade of
the Villa Medici in Rome: a Roman hunter
distracts a lion with a ball while his com-
panions load other felines onto a ship
bound from Africa to Ostia.[1]

1. See *TAPS* 56, pt. 2 (1960), pp. 34 (no. 8519),
120 (figs. 114, 113: Dal Pozzo-Albani drawings
at Windsor Castle).

89 (B267)

PAIR OF GEOMETRIC FIBULAE
Greek, ca. 750 to 700 B.C.
L: 0.11 m. and 0.145 m.
Anonymous Gift. 1972.372, 373
Provenance: brought to Basel from Macedonia
or Thrace via Athens
References: Museum Year: 1971–1972, p. 45;
True and Vermeule, *Bulletin*, p. 118, no. 1.
Neg. Nos. B20218, B20217 (the broken fibula)
Condition: Both fibulae have deep green patinas.
The second example is broken and lacks the pin.
On this one the patina has a bluish cast, increas-
ing its richness.

These early Greek funerary pins take the
form of two joined spirals of wire with pin
and hook riveted on the back. All recorded
examples of this particular type, which is
called "northern Greek," appear to come
from Macedonia—many from tombs in
the Vergina region, where they have been
found with spiral bracelets.[1]

In a discussion of a similar but slightly
more refined example, more like machined
wire, one source provides a list of sites in
mainland Greece, the central to eastern
Aegean islands, and the lower half of Italy,
where the passion for these pins spread.[2]
Examples seen in Istanbul in recent years
confirm discoveries of such fibulae in tombs
in Turkish or Bulgarian Thrace.

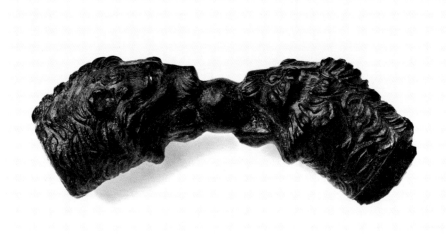

88

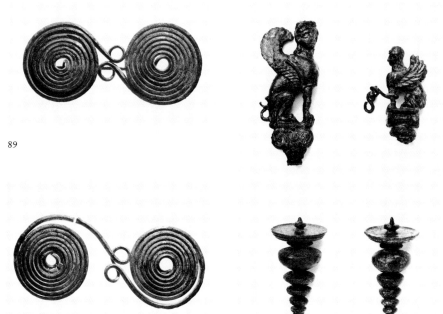

89

89 90

1. A photograph of early Greek jewelry in situ appears in Rolley, *Bronzes Grecs*, pp. 64–65, fig. 44 (Vergina, tomb I of tumulus Y).

2. See De Ridder, *Bronzes Antiques*, vol. 2, p. 64, no. 1867, pl. 89; see also Rolley, *Bronzes Grecs*, p. 229, fig. 222 (Vergina, tomb AII).

90 (B274)
FOUR PINS: TWO SPHINXES AND TWO FINIALS

Greek, 500 B.C. (larger sphinx), 525 B.C. (smaller sphinx), and 600 to 500 B.C. (finial pins)

(364) H (max.): 0.040 m. (365) H (max.): 0.028 m. (811) H (max.): 0.0295 m. (812) H (max.): 0.0305 m.

Frank Bemis Fund. 1975.364, 365, 811, 812

Provenance: The group came into the collection together and they appear to have been found together. The area on the road from Boeotia to Delphi has been mentioned as a possible provenance.

Reference: Museum Year: 1975–1976, p. 21. Neg. No. E939

Condition: Rusty traces remain of the iron pins once attached to each piece. The patinas are deep green and the right wing of the first sphinx is broken away above the shoulder.

The first sphinx looks to the right from her perch on the capital; the second faces to the front with three links of bronze chain attached to her left foreleg. A sphinx pin in Princeton[1] may have belonged to the group.

A small pointed knob tops each finial, which is composed of a group of disks (the largest with turned edges) over five compressed globes of decreasing size surmounting a (now-missing) shaft.

1. No. 57.59. See F.F. Jones, in *Record of The Art Museum, Princeton University* 17 (1958), no. 2, pp. 46–48, fig. 1.

91 (B294)
RING WITH TONDO BUST OF SERAPIS

Roman Imperial, probably 2nd century A.D.

H (max.): 0.045 m.

Edwin E. Jack Fund. 1978.56

Provenance: from private collections in New York and, earlier (before World War II), in Germany

Reference: Museum Year: 1977–1978, p. 40. Neg. Nos. E1883 (front), E1884 (profile to right)

Condition: The piece has a dark patina with some pitting.

The form of the bust, paralleling representations of the emperor Trajan (98–117) on certain Roman Imperial sestertii, suggests a date for the ring. Clad with drapery and a himation on the left shoulder, the bust is

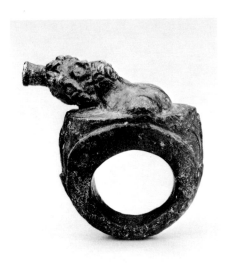

91

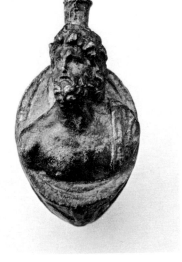

91

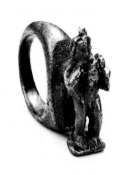

92

Provenance: from a private collection in New York
Reference: Museum Year: 1977–1978, p. 40.
Neg. No. E2167
Condition: The piece has a blackish patina.

On a small plinth attached to the hoop of this ring,[1] Eros-Harpocrates stands nude in a canonical pose with a finger to his mouth and his hair in a topknot from which falls the Egyptian sidelock of youth.

As an Egyptian deity whose name signified "Horus the Child," Harpocrates also appeared as an infant in the lap of his mother Isis. During the wave of religious syncretism of the Hellenistic period he was identified with Eros and became popular in the Graeco-Roman world.[2]

1. Compare Marshall, *Finger Rings,* p. 204, pl. XXXI, nos. 1298–1302.

2. *EAA,* vol. 1, pp. 671–672, fig. 859.

bare on the chest and right side to the rib cage, making this spirited Serapis a variant of the canonical Alexandrine and Roman cult images. Bronze rings in the British Museum have smaller busts of Serapis or Isis or the two together (as on Alexandrine coins), applied directly to the hoop.[1] In this case, the bezel of the ring as background to the bust serves as a tondo, symbol of divinity.

1. Marshall, *Finger Rings,* p. 204, pl. XXXI, nos. 1298 and 1302.

92 (B294)
RING DEPICTING EROS-
HARPOCRATES
Roman Imperial, probably 2nd century
A.D.
H (max.): 0.025 m.
Arthur M. Knapp Fund. 1978.63

Etruscan, Italic, and Roman Mirrors

93 (B390)
MIRROR DEPICTING DIOSCURI
AS LASAS
Etruscan, 4th century B.C. or slightly later
DIAM (of disk): 0.175 m. L (max.):
0.255 m.
Alice Bartlett Fund. 1973.191

Provenance: from the Matthews Collection, New York
Reference: Museum Year: 1972–1973, p. 40.
Neg. No. C30039
Condition: The mirror, with a tang for insertion into a handle, is very well preserved. A dark patina covers most of the surface, some areas being in lighter green.

The twin sons of Zeus, Castor (in some legends the son of a mortal) and Polydeukes (see no. 16), are represented as winged youths, armed with shields and spears. They wear only helmets and boots.[1]

1. There are a number of smaller mirrors that relate to this one; see E. Gerhard, *Etruskische Spiegel* (Berlin, 1843), pt. 1, pl. LIV; and Münzen und Medaillen A.G., Basel, Sonderliste J, March 1968, p. 15, nos. 34 and 35, with references.

94 (B400)
MIRROR DEPICTING WOMEN AT
BATH OF APHRODITE
Graeco-Roman, ca. A.D. 100 to 120
DIAM (max.): 0.13 m.
Gift of Dr. Ernest and Virginia Lewisohn Kahn. 1978.158

References: Museum Year: 1977–1978, pp. 22 (illus.), 40; Vermeule, *North Carolina Bulletin,* pp. 30, 32 (fig. 4), 33, 39 (n. 4); A. Delivorrias et al., in *LIMC,* vol. 2, pt. 1, p. 56, no. 452; pt. 2, pl. 43.
Neg. No. C32719
Condition: The front is silvered and the back is gilded. There is damage to the *repoussé* relief and to the surfaces, especially around the edges. The patina is green.

The scene, encircled by a rolled fillet molding, depicts two nude women bathing in front of a Tuscan column surmounted by a figure of Aphrodite Anadyomene.[1] A large basin resembling a birdbath appears in the center, a kalpis to the left. Both containers are on stands, and all, including the figures, are set on a base. The ladies, wearing their hair tied up in elaborate bands, appear to be taking sponge baths.

This mirror belongs to a group of Roman Imperial mirrors with mythological, allegorical, genre, or even semihistorical scenes.[2] They appear to have been circulated in northern Greece and Asia Minor at the height of the Roman Empire, since they influenced coin designs in these regions. Over thirteen hundred years later,

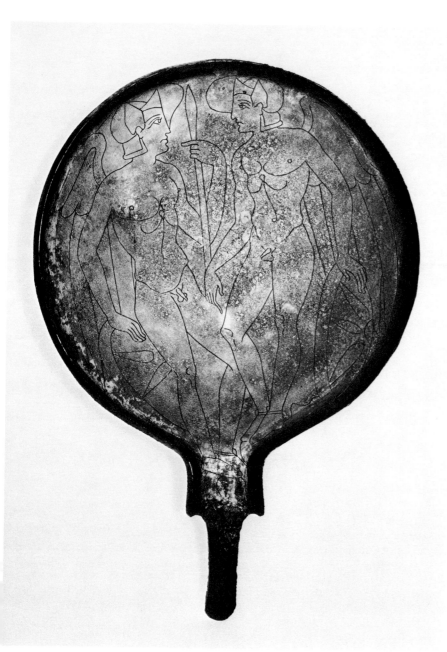

93

they inspired Italian medalists of the Renaissance who voyaged to Greek lands or saw what the Venetians and others had brought back to Italy.

1. Compare no. 24.
2. There is a duplicate in the Virginia Museum of Fine Arts in Richmond (no. 80.28).

95 (B400)
MIRROR DEPICTING SCENE OF PUNISHMENT

Graeco-Roman, ca. A.D. 100 to 150
DIAM (max.): 0.107m.
William E. Nickerson Fund. 1986.750

Provenance: from the Roger Peyrefitte Collection, Paris

References: R. Peyrefitte, *Un Musée de l'Amour* (Paris, 1972), p. 38; H. Cahn, in *"Le Musée Secret" de Roger Peyrefitte*, auction in Paris, 11–12 December 1978, no. 434; Eisenberg, *Ancient World*, p. 110, no. 324, and further parallels; C. Vermeule, *Museum Year: 1986–1987*, pp. 31 (illus.), 51.

Condition: The front is polished, and the back is gilded.

The scene, in *repoussé* relief encircled by a rolled fillet molding, shows a woman being flogged by an elderly bald and bearded man in the rear center behind a table. He wears a himation wrapped around the waist, one end over his left shoulder. While one plump Eros supports the woman and another holds her feet together, a third, standing on a bench at the extreme right, writes on a rectangular tablet set on a slender column, perhaps recording the number of whippings. An object resembling a tympanum rests on the table or bench to the left. In the upper background appears a tiny rectangular shrine with its doors open and an image of Athena inside, spear in her raised right hand and shield in the lower left hand, facing the viewer. A multileaved tablet of codex shape and two styluses appear below the ground line in the "exergue."

This composition derives from a late Hellenistic or early Imperial Romano-Campanian painting from Pompeii showing a school in front of a portico with a student being flogged.[1] As the teacher deals out the punishment, an assistant writes the tally on the column at the extreme right. A small bearded old man witnessing the scene from the extreme left may be the headmaster or, more likely, a tutor who accompanied one of the pupils to school.[2]

Certain academic touches from the original composition are retained on the mirror: the "schoolmaster" in the center is a heroic Socrates, not unlike a statuette in the British Museum,[3] and Athena, goddess of wisdom, presides over the scene. The resemblance of Socrates to Silenus, along with the fact that the attendant figures have become Erotes and that the one being

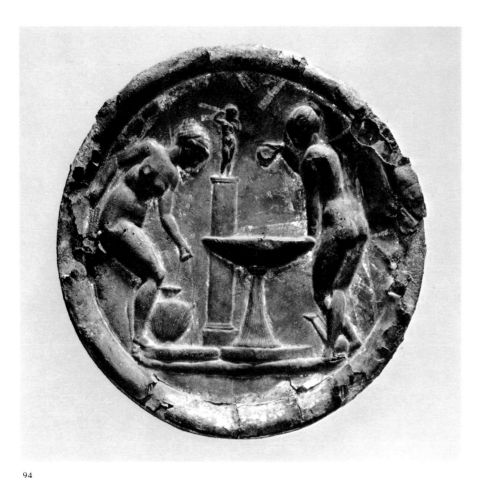

94

wings. The figure at the left pours a libation from an oinochoe in his raised left hand and holds a thyrsos in the crook of his right arm. The center figure appears to be supporting his companion to the right,[1] who holds out a wreath in his left hand and a reversed torch in the other.

1. A version of the subject appears in a section of a Roman sarcophagus relief in the MFA collection, a carving dated about A.D. 200–225. See Comstock and Vermeule, *Stone*, pp. 156–157, no. 246.

whipped is female, however, gives the scene erotic rather than pedagogical implications. These may link it to the tradition of a cup by the Brygos Painter (first quarter of the fifth century) with its vignette of a man battering a bent-over prostitute.[4]

1. See S. Reinach, *Répertoire de Peintures: Grecques et Romaines* (Paris, 1922), p. 255, no. 3, and further bibliography. At Pompeii also, on the frescoed walls of a cult room in the Villa of the Mysteries, are scenes of initiation in which a winged attendant brandishes a whip above the shrinking form of a young woman; see Brilliant, *Pompeii*, illus. pp. 242–243.

2. Such punishment was all too common in Roman schools, Quintilian noting the misery visited upon the pupils and the hypocrisy and cowardice that an abuse of corporal punishment by a brutal teacher was apt to call forth. See J. Carcopino, *Daily Life in Ancient Rome* (New Haven, 1951), pp. 105, 298, n. 22 (Quintilian, 1,3,16–17). Compare a Graeco-Roman gem (no. 6918 in the Staatliche Museen of East Berlin) on which a young person, held in the air by two playmates, receives a whipping; see F.A. G. Beck, *Album of Greek Education* (Sydney, 1979), pl. 53, no. 275.

3. Bieber, *Sculpture*, figs. 138–139.

4. In the Museo Archeologico, Florence (3921). See M. Wegner, *Brygosmaler* (Berlin, 1973), pl. 4b; and E.C. Keuls, *The Reign of the Phallus: Sexual Politics in Ancient Athens* (New York, 1985), pp. 186 (fig. 170), 439 (where the museum numbers are transposed).

96 (B400)

MIRROR WITH REVELING EROTES
Graeco-Roman, ca. A.D. 200
DIAM (max.): 0.089m.
Gift of Esther D. Anderson, Nancy A. Claflin, Suzanne R. Dworsky, and Dr. Josephine L. Murray. 1988.232

Provenance: from the Joseph Ternbach Collection, New York

References: Sotheby's sale, New York, 24 November 1987, no. 168; *A Glimpse into the Past: The Joseph Ternbach Collection* (Jerusalem: Israel Museum, 1981–1982), no. 162, illus.

Neg. No. E2524

Condition: The patina is brown and black with some gilding remaining on the back. The front, or reflecting side, was silvered and polished and still retains some shine although there are patches of green and brown corrosion. There is some crumbling at the edges of restored areas of the rim.

Bacchic and funerary motifs are mingled in this example of a composition popular in Roman art. The scene, in *repoussé* relief encircled by a rolled fillet molding, shows three Erotes tripping from left to right beneath a garland. Below the groundline are ears of wheat and ivy leaves or fruit. Although all three figures are wearing cloaks, only the one at the center has

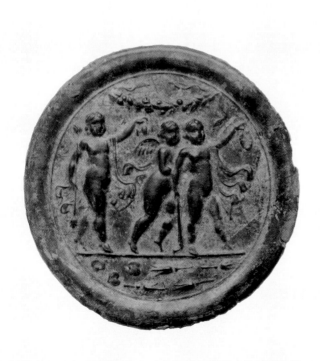

95

Greek and Graeco-Roman Vessels and Attachments

97 (B405)
HANDLE OR PENDANT: BULL PROTOME
Anatolian, probably Hellenistic (or Graeco-Roman), ca. 200 B.C.
H (max.): 0.095 m. W (max.): 0.085 m. D. (max.): 0.035 m.
Gift of Mr. and Mrs. Richard R. Wagner. 1977.728

Provenance: from near Diyarbakir (Amida), southeast Asia Minor
Reference: Museum Year: 1977–1978, p. 40. Neg. No. E2094
Condition: The piece has a green patina with black areas. The ensemble was once mounted on a door (modern), removed, and cleaned.

97

The bull protome is set above and partly within three interconnected rings that join the hollowed back of the head at a trapezoidal fillet molding (0.01 m. thick). The rings are enriched with engraved circles and the bull's ears are pierced for suspension. Stylized channels and crisscross lines represent the hair on the bull's head and face, while a rolled fillet of parallel lines divides the snout from the length of the nose.

This protome is Anatolian within the Hellenistic or Graeco-Roman milieu, and the stylistic connections are with the bull-protome architectural monuments of Delos, Ephesus, and Cypriote Salamis in the age of the later Seleucids and Ptolemies. A truly Hellenistic, very Greek bull protome, by contrast, may be seen in the Harvard University Art Museums (Sackler).[1]

1. D. Mitten, in Mitten and Doeringer, *Master Bronzes*, p. 141, no. 145.

96

98

98 (B405)
HANDLE OR PENDANT: BULL
PROTOME WITH CROSSES
Greek Imperial, probably 3rd century A.D.
H: 0.115m. W: 0.10m.
Gift of Mr. Richard R. Wagner. 1973.164

Reference: *Museum Year: 1972–1973*, p. 43.
Neg. No. B20798

Condition: The ring on the left side of the head
has been broken away. The entire surface is
covered with a pale green patina.

This attachment or pendant consists of a
stylized bull protome surrounded on three
sides by flattened rings with incised circular
decorations. Within the ring below the
animal's snout is set a Greek cross, a motif
echoed by a smaller cross engraved on the
forehead.

There are other examples of these bull-
protome plaques with "Christian" sym-
bols, the cross occasionally in relief on the
forehead or, in more plastic Hellenistic
examples, as a freestanding element above
the head.[1]

1. Sotheby Parke Bernet, New York, sale no.
3994, 21 May 1977, no. 47; Münzen und
Medaillen A.G., Basel, Sonderliste Q, November
1976, pp. 21, 41, no. 114 (illus.). In the first of
these parallels, the bull's horns form a lunar
crescent, confirming traditional associations
with Selene and/or Mên (see above, nos. 75 and
76). An inscribed example appeared at
Sotheby's, New York (22 November 1974, no.
357); see Comstock and Vermeule, *Bronzes*, no.
405.

99 (B419)
HANDLE OF HYDRIA: SIREN ON
INVERTED PALMETTE
Greek, ca. 450 B.C.
L: 0.14m.
Sir Charles Nuffler Foundation. 112.64

Provenance: from Spink and Son, London, 1950
References: S. Doeringer, in Mitten and
Doeringer, *Master Bronzes*, p. 107 (cited as a
parallel to no. 106 in the Edward Perry Warren
Collection at Bowdoin College, Brunswick,
Maine).
Condition: The piece has a green patina.

A Siren with wings spread, her feet together
on an inverted palmette, decorates the
lower part of the back handle of a large
water jug (hydria or kalpis).

Most Sirens so located on Classical
Greek water jugs have their wings curving
upward, but, as here, there are examples
with wings in the downward position, like
the wings of owls on silver dekadrachms of
Athens.[1]

1. See Diehl, *Hydria*, p. 220, no. B 166, pl. 18
(Istanbul Museum no. 7, from Myrina).

99

100 (B419)
FUNERARY VASE (HYDRIA-KALPIS)
Greek, ca. 350–330 B.C.
H (max.): 0.45m. W (with handles):
0.38m.
*Mary S. and Edward J. Holmes Fund.
1984.750*

References: Museum Year: 1984–1985, pp. 27
(illus.), 47; C. Vermeule, in *Art for Boston*, pp.
68–69, illus.
Neg. Nos. C42472 (full view with Eros), C42473
(full view of side), C42474 (detail of Eros)
Condition: Silver inlay appears on the lip, the
bases of the handles and the foot, and as
bracelets on the two figures. The patina is rich

green. Restored areas include a section of hair
and a bit of the head above the right eye of Eros,
as well as possibly the two middle fingers of his
left hand and the upper tips of his wings. The
surface is pitted in places.

Elegant ceremonial vessels of this type
were used as containers for the ashes of the
deceased not only in ancient Greek lands,
from near Athens to western Asia Minor,
but also among the Macedonians and
Thracians, extending as far as the Black
Sea coasts and northwestward into Epirus
(northern Albania). They were created
originally in metalworkers' studios in
Athens, but examples were certainly made
also in cities such as royal Aegae or Greek
Amphipolis in Macedonia and Byzantium
or ancient Odessa (modern Varna, Bul-
garia) in Thrace.

The larger winged figure standing on the
base of the handle, holding a mirror in his
left hand, is Eros. His mother, Aphrodite,
goddess of love, beauty, and physical regen-
eration, is the small figure in the Archaic
style. The presence of Eros and Aphrodite
on such a funerary urn might suggest that
it contained the ashes of a lady of impor-
tance, such as a magistrate's or merchant's
wife in central Greece, or a Macedonian
queen or Thracian princess in the north.
Eros with Aphrodite might also allude to
maternal love for a young man. Thus, the
deceased could have been a prince (like
numerous members of the family of Alex-
ander the Great who died at an early age
and were given elaborate burials in big
vaulted tombs) or an older man of royalty
(such as Philip of Macedon, wishing to be
remembered as in his eternal youth).

A comparable example, the famous
bronze and silver hydria-kalpis, now in the
collection of the National Museum at
Athens,[1] was found in the nineteenth cen-
tury in a tomb at Pharsalos in Thessaly
(east central Greece). Also an outstanding
work of Greek metallic art in the ages of
Philip II and Alexander the Great, it depicts
on the base of its rear handle Boreas, the
North Wind, carrying off the royal Athe-
nian maiden Oreithyia.[2] The Boston vase,
of the finest quality in its details and identi-
cal in the enrichment of lip, handle bases,
and foot with the hydria from Thessaly,
must have been made in the same work-
shop.[3]

1. *Search for Alexander*, p. 127, no. 50A; Boston
Supplement (1981), p. 34, illus.

2. Diehl, *Hydria*, p. 222, no. B201.

3. A hydria-kalpis with figured back handle in
the Metropolitan Museum of Art has the same
subject as the Boston vase. See ibid., p. 221, no.
B182; and *Search for Alexander*, New York
Supplement (27 October 1982 to 3 January
1983), cover (in color), p. 14, no. S50, illus.

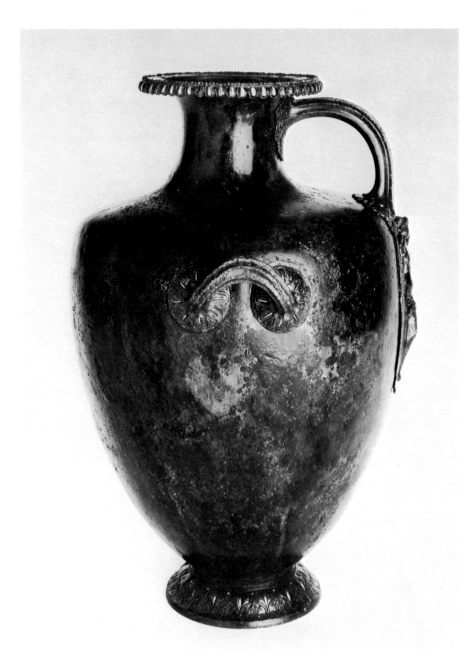

100

101

101

101 (B420)

HANDLES OF AMPHORA

East Greek (Ionian), ca. 500 B.C.

L: 0.185m. W: 0.118m.

Gift of Richard R. Wagner. 1971.264, 265

Provenance: from Asia Minor, probably the Hermos Valley

References: Museum Year: 1970–1971, p. 37; True and Vermeule, *Bulletin* 72 (1974), p. 121, no. 3.

Neg. Nos. B20070 (full view), B20071 (profile)

Condition: In the leaf at the base of each handle are four holes for attachment to the body of the amphora. The surfaces have an even light green patina.

These handles have a double ribbed molding. The side terminals at the top are in the shape of ducks' heads, and the lower end has been fashioned as a grape leaf with veins incised. The handles, attached to the neck and body of the amphora on opposite sides, have the simplicity of form expected of Greek functional decoration during the transition from Archaic to early Classical art, with the touch of extra elegance found in the parts of the Greek world under Persian domination.

Attic black-figured amphoras of around 520 to 500 B.C., of which there are examples in all major collections of ancient ceramic art, convey an excellent idea of this type of vessel in its entirety.

102

1. E. von Mercklin, *Antike Figuralkapitelle* (Berlin, 1962), no. 180, figs. 338–339.

2. Ibid., no. 181, fig. 336.

3. See, for example, ibid., nos. 159 and 164, figs. 261 and 271.

4. W. Lamb, *Greek and Roman Bronzes* (London, 1929), p. 188, pl. 73b.

102 (B430)

HANDLE OF LARGE BASIN OR FOOT-BATH

South Italian Greek, ca. 250 B.C.

W (max.): 0.235 m.

Private Collection

Provenance: acquired in Rome about 1949

Neg. No. E2214

Condition: There is an overall green patina, with earth encrustation and traces of iron pins on the reverse sides of the palmette-like stylized acanthus plants at the points of attachment to the curved side of the basin.

The functional part of the handle, ridged on its upper surface, ends in circular plaques that open up into a calyx of simple leaves and volutes and a large acanthus palmette; a leaf between the volutes is textured (inorganically) with v-shaped incisions. The jagged, loose quality of the ornament has much in common with early Hellenistic architectural decoration in southern Italy. Similar volutes appear in corinthianizing capitals in a tomb at Lecce of the first half of the third century,[1] while the sharply ridged petals of the palmettes resemble those in Italic Ionic capitals, like one made of Tarentine limestone in the storerooms at Pompeii.[2] The palmettes have been conflated with a kind of acanthus leaf with scalloped borders seen frequently in Tarentine corinthianizing capitals of the late fourth or early third century.[3]

Handles of this general type had long been used on the sides of bronze hydriae (water jars), as in an Italic hydria-kalpis from Lokri in the Museo Nazionale of Naples, dated in the second half of the fourth century B.C.[4] In Classical hydriae, however, the vegetal forms are stylized much more abstractly.

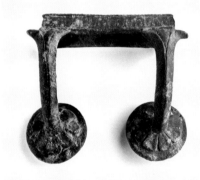

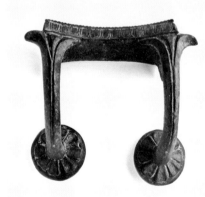

103

103 (B432)

PAIR OF HANDLES FOR FLAT BASIN (LEKANIS)

Hellenistic to Graeco-Roman, ca. 200 B.C. to A.D. 50

W (AV.): 0.09 m.

Anonymous Loan. 115.64

Provenance: acquired in Rome shortly after World War II

Neg. No. E2190

Condition: The patinas are a rich green with earthy encrustation.

Ovolo moldings surround the outside rims of the uppermost surfaces, which are flat; attachments to the body are in the form of rosettes. Similar handles have been found on basins of the type preserved in the houses and villas buried by the eruptions of Mount Vesuvius in A.D. 79.[1]

1. Compare E. Pernice, *Die Hellenistische Kunst in Pompeji*, vol. 4: *Gefässe und Geräte aus Bronze* (Berlin and Leipzig, 1925), pp. 12–13, fig. 17 (on a bowl).

104 (B452)

HANDLE OF PATERA: BOAR'S-HEAD TERMINAL

Late Republican or early Roman Imperial

L (max.): 0.16 m.

Sir Charles Nuffler Foundation Loan

Provenance: from the art market in Cambridge, Mass., by way of a private collection in the United Kingdom

Neg. Nos. E2188 (right profile), E2187 (three-quarter view to right)

Condition: There is a black patina with earthy encrustation in the fluting of the handle and around the animal's head.

The boar's head leads to a round collar, then to the fluting, a diagonal joining element, and a tang for insertion in the body of the dish.

A similar patera-handle with the head of a dog or wolf is in The Metropolitan Museum of Art in New York.[1] Like most of the bosses on cuirassed statues and the spouts on buckets, basins, and heaters, the animal's head at the outer end of these handles was often purely decorative. In some cases the choice of a dog could refer to Diana, the wolf to Roma, and the boar to Hercules or Meleager.

1. Richter, *Bronzes*, pp. 172–173, no. 444.

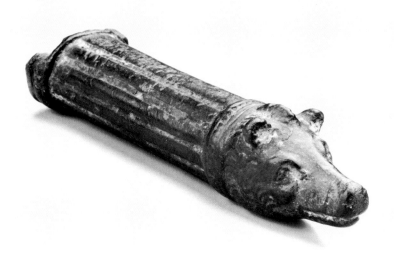

104

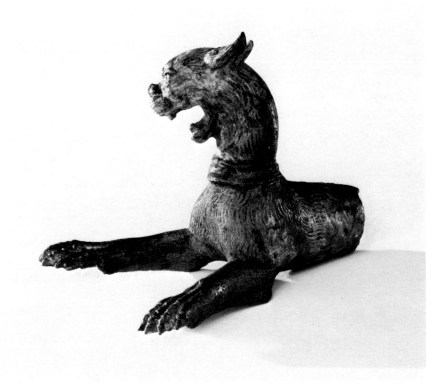

105

105 (B452)

HANDLE OF PATERA OR LAMP: PANTHER WITH FORELEGS SPREAD
Greek Imperial (perhaps Syria), ca. 50 B.C.
to A.D. 150
L (as preserved): 0.115 m.
Mary S. and Edward J. Holmes Fund.
67.636
References: Museum Year: 1967, pp. 62–63,
illus.; True and Vermeule, *Bulletin*, p. 131, no.
12.
Neg. No. B20495
Condition: The core and part of the lead attachment for this hollow-cast bronze object remain. The patina varies from green to brown, with some surface penetration.

The forepart of a reclining panther is represented in loving detail. With paws outspread, open jaws, and head turned to the right, the animal wears a wide collar crossed over in the back. Fur is indicated by incised lines. On the analogy of similar bronzes in the form of animal protomes,[1] the rear part was attached directly, or through an intermediate section, to the body of a vessel or lamp. The workmanship is very precise, including the divisions of the face and the bone structure of the legs and paws. At the same time, there is an overall feeling for an animal with latent power and a visible surplus of feline grace.

A number of such objects, usually more Graeco-Roman in form, have been identified with cities around the Bay of Naples in the Augustan age.[2]

1. See Comstock and Vermeule, *Bronzes*, pp. 340 (no. 478), 349 (no. 490).
2. See G. Hafner, in Ars Antiqua A.G., Lucerne, Auktion I, 2 May 1959, p. 35, no. 89, pl. 43; compare also Sotheby Parke Bernet, New York, sale no. 4253, 19 May 1979, no. 216 (a patera).

106 (B466)

HANDLE OF OINOCHOE
Graeco-Roman, 1st century A.D.
H (max.): 0.167 m. W (at top): 0.085 m.
Anonymous Loan

Neg. No. E2189
Condition: The patina is light greenish gray with encrustation, especially at the upper and lower ends. The attachment at the top has been slightly damaged.

At the point of attachment the upper end of the handle terminates in a stylized flower resembling an animal's paw; the lower end becomes a theater mask—that of a tragic female, matron, or slave—which forms the plate for attachment to the body of the vase. Based on comparisons with marble and fresco examples found at Pompeii, Herculaneum, and elsewhere in the early Roman Empire, the mask is probably that of a young heroine of tragedy.[1] It is tempting to speculate that the owner of this vase was a lover of the Roman theater.

1. See M. Bieber, *The History of the Greek and Roman Theater* (Princeton, 1961), pp. 157 (fig. 568), 243 (figs. 801, 802).

107 (B480)
BOTTLE (BALSAMARIUM)
Roman Imperial, 1st or early 2nd century A.D.
H (max.): 0.140m. W (dolphin's mouth to dolphin's mouth): 0.08m.
William E. Nickerson Fund. 1986.584

Reference: J. Herrmann, *Museum Year: 1986–1987*, pp. 31 (illus.), 51.

Neg. No. E1852

Condition: Surfaces have a rich green patina with black and brown areas and places where the surface is very slightly corroded. The condition is excellent except for a few missing parts: the chain must once have had a loop for attachment above the tail of the second dolphin; the right flipper of the tail of the first dolphin is broken away; and the lid or stopper has disappeared.

The body of the bottle is of hexagonal shape with stylized Egyptian lotus leaves rising from the molded base. Correspondingly, the top of the neck below the rounded lip is also in the form of a strict hexagonal molding. Dolphins' tails join two of these hexagonal sections, and their heads rest on two ridges of the body, which

are also the center ridges of the outside lotus leaves. On the bottom are inset concentric-relief circles characteristic of bronze utensils in the Roman Imperial period.

A rounded flacon of the same period, with unornamented surfaces,[1] has an elaborate stopper attached by a chain to one of the floret-decorated handles. Such bottles are found from Asia Minor to North Africa.

1. De Ridder, *Bronzes Antiques*, vol. 2, pp. 126–127, no. 2912, pl. 102.

108 (B482)
JAR (PYXIS) DEPICTING PHILOSOPHERS, AUTHORS, AND MUSES
Graeco-Roman (Imperial)
H: 0.083m.
Edwin L. Jack Fund. 1977.145

References: Museum Year: 1976–1977, pp. 24 (illus.), 40; Vermeule, *Socrates to Sulla*, pp. 108, 310, fig. 152.

Neg. Nos. C32061–C32064

Condition: The black and greenish patina has encrustation and there are several missing sections, cracks, and a break at the lip. Slots pierce the jar behind the philosopher on the right and the Muse on the left.

107

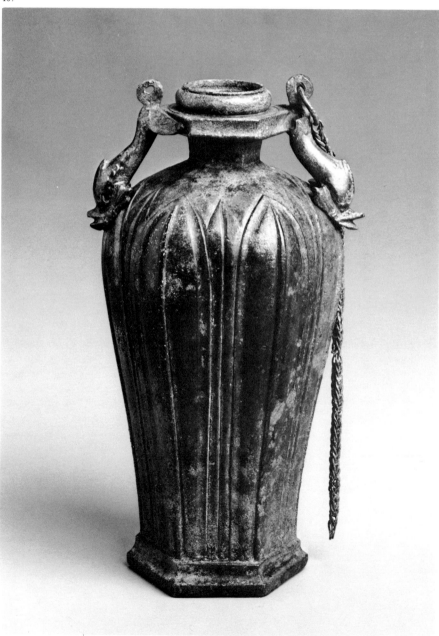

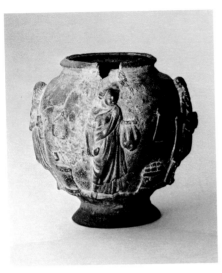

108

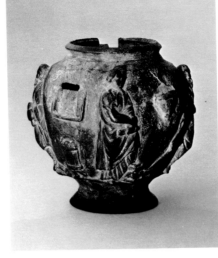

108

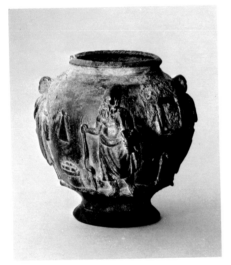

108

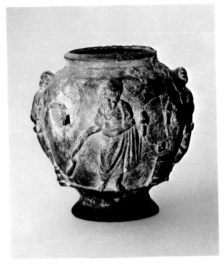

108

1. Larger bronze supports for tables, with feline heads of Near Eastern appearance but belonging to the Greek Imperial period (in aspect like no. 105, a panther-protome handle), have been found in Egypt; see G.M.A. Hanfmann, in Mitten and Doeringer, *Master Bronzes*, p. 309, no. 311.

2. See Vermeule, *Egypt*, pp. 187 (nos. 21–24, fig. 14), 188–189 (no. 49, fig. 14A); complete tables are in Herculaneum, Pompeii, and the Museo Nazionale, Naples.

110 (B485)

SUPPORT FOR MINIATURE TABLE

Hellenistic to Roman Imperial
H: 0.195 m. W (max.): 0.021 m. L (front to back): 0.037 m.
John Michael Rodocanachi Fund.
1984.437
Reference: Museum Year: 1984–1985, p. 47.
Neg. No. C43283 (profile to right)
Condition: The surfaces are in an excellent state of preservation. The patina is mostly brown, blending into areas of green.

This delicate leg takes the form of a goat's head springing from a sheath of acanthus and, below, the animal's lower leg, hock, and hoof.

A more elaborate counterpart in marble is a double-ended support in the form of winged goats' heads and lower legs, back to back.[1] The type of three-legged bronze table from which this leg could derive is

109

The figural references to writing and poetry indicate that this pyxis might be an inkwell produced for use by an intellectual of the Greek Imperial age. An elderly historian, who may be Herodotus of Halicarnassus, faces a scroll-bearing Muse and appears to be sketching on the ground with his staff. On the other side, a similar man of intellect—possibly the historian's cousin Panyassis, also a Halicarnassian—is facing a Muse with a large stringed instrument.

This jar, with its literary overtones, would have been the perfect work of art to sell a visitor from anywhere in the ancient world who had come to view the Mausoleum, the temple of Ares, and the handsome, theater-shaped harbor at the end of a peninsula on the Aegean coast of Caria.

109 (B485)

SUPPORT FOR MINIATURE TABLE

Hellenistic to Roman Imperial
H: 0.056 m. W (max.): 0.012 m.
Anonymous Loan. 55.68

Condition: There is some green corrosion on surfaces partly patinated brown.

The leg is a miniature version of full-sized prototypes in marble, colored stones, and bronze. Below the rectangular support, the head of a lion blends into a powerful feline leg and paw. A small votive or funerary table stood on three such ensembles, as did larger counterparts, also with circular tops.[1] There are complete tables of this type in marble from the cities on the Bay of Naples and many single surviving legs or fragments thereof.[2]

112

Condition: There is silver inlay on the head and the body of the feline. The condition, as preserved, is perfect, with a pleasing even brown patina.

This is a canonical form for a table leg, whether carved in marble on a life-sized scale or reproduced in bronze for a tiny votive or household table—one perhaps used as a small tray for sweetmeats or an ornament in a lararium. The feline head is that of a leopard (the silver inlay being the spots), while the relatively large lower leg and paw below the conventional "flame" of acanthus is that of a huge lion.

The "damascening" of the smooth bronze surfaces with silver plugs is a feature attesting to an "oriental" origin.[1] Iran in the centuries of Parthian rule is a likely source for this perfect survivor of a larger ensemble, but inlay was also a feature of decorative bronzes in northern Greece, Thrace, and western Asia Minor (see no. 100). The tiny three-legged table from which the leg probably derives could have traveled in the baggage of a Hellenistic official or a Roman magistrate from Bithynia to Syria and beyond.

1. *Museum Year: 1985–1986,* p. 30.

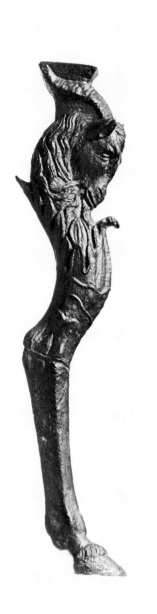

110

well represented around the Bay of Naples, from Pompeii, Herculaneum, and elsewhere.[2]

1. MFA no. 28.893; see Comstock and Vermeule, *Stone,* no. 318.

2. See V. Spinazzola, *Le arti decorative in Pompei e nel Museo Nazionale di Napoli* (Milan, 1928), p. 263 (with hounds leaping upward as the upper element and a big feline paw at the bottom).

111 (B485)
SUPPORT FOR MINIATURE TABLE
Hellenistic to Roman Imperial
H: 0.127m.
Morris and Louise Rosenthal Fund.
1986.141

Reference: Museum Year: 1985–1986, pp. 30 (illus.), 49.
Neg. No. E993 (profile to right)

111

112 (B489)
"POMPEIIAN" LAMP WITH ACANTHUS-STEM DOUBLE HANDLE
Roman Imperial, 1st century A.D.
H (max.): 0.115m. L (max.): 0.22m.
John Michael Rodocanachi Fund.
1978.275

Reference: Museum Year: 1978–1979, p. 39.
Condition: The surface is corroded in spots; otherwise, the piece is well preserved.

The handle is decorated with leaves from which a goat's head emerges as the connection with the body of the lamp. The filler hole is trilobed, and the spout is covered by an unattached stopper. Lamps such as this, identified from numerous examples from Pompeii and Herculaneum in the Museo Nazionale in Naples, are also found all over the Roman Empire and beyond the imperial frontiers.[1] They were hung by chains from large lampstands, set on trays and tables, or carried by their handles. An example in the Denver Art Museum has a theatrical mask at the upper end of the handle, like the mask at the lower end of the handle of an oinochoe discussed in the text of no. 106.[2]

1. An example in the collections of The Metropolitan Museum of Art in New York is of truly "Pompeiian" type but is said to have been found in The Hauran, Syria; see Richter, *Bronzes,* p. 381, no. 1340.

2. J.A. Scott, in Mitten and Doeringer, *Master Bronzes,* pp. 298–299, no. 297; see also Sotheby's sale, New York, 11 December 1980, no. 209, and Sotheby's sale, London, 10–11 December 1984, no. 266.

113

114 (B501)

LAMP: STYLIZED LION
Medieval Egyptian, Coptic, or Islamic
H (max., including tang and small loop at
the top of the head): 0.11 m. L (max.):
0.143 m.
Private Collection. 5.1976

Provenance: from London and Egypt, via Blanchard's Museum in Cairo

Condition: The surfaces have an even brown patina.

The lion turns his head upward and curls his tail between his legs and onto his back. There are tangs under the forefeet. The spout extends from the chest outward with a circular hole on the horizontal upper surface, just as was the case in late Roman and Byzantine bronzes of the sixth and seventh centuries A.D.

Comparable examples include an Islamic "dog" dated in the twelfth century A.D. (0.07 m. long)[1] and part of a bronze censer that has been termed Egyptian of the fifth to sixth century.[2] The form of this lion lamp derives from late Classical to early Byzantine examples of Graeco-Roman proportions.[3]

1. Christie's sale, London, 14 June 1978, p. 9, no. 25, pl. 4.

2. *Early Christian and Byzantine Art* (Baltimore: Baltimore Museum of Art, 1947), p. 67, no. 273, pl. XL.

3. Such as a lion lamp found in 1967 in a shop against the southern wall of the synagogue at Sardis; see M.J. Mellink, in *AJA* 72 (1968), p. 141, pl. 56, fig. 11.

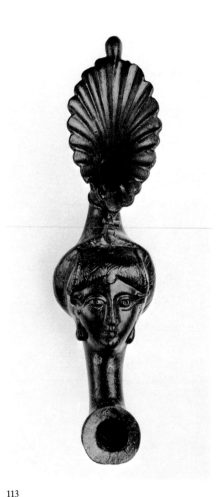

113

113 (B498)

LAMP

Late Roman or Byzantine, 5th or 6th century A.D.
H (max.): 0.07 m. L (max.) 0.224 m.
Otis Norcross Fund. 1984.222

Reference: Museum Year: 1983–1984, p. 42. Neg. Nos. C43287 (top), C43098 (left profile), C43097 (three-quarter view to right)

Condition: The surface is very well preserved, with a rich green patina.

The lamp, of a traditional Roman design, has a scallop shell forming the opening at the handle, the stylized head of an eastern Roman empress on the top of the body (above the turned foot), and the usual long spout with smaller round opening on the top.

Earlier Roman bronze lamps had heads of pagan divinities, such as Mercury-Hermes, god of commerce.[1] This portrait must be of an empress, an Augusta of major importance, perhaps represented elsewhere in the arts. Ariadne, consort of the emperor Anastasius, comes to mind, as she appears with full regalia on Imperial ivory diptychs from Constantinople.[2]

The early Byzantines were very imaginative in shaping their bronze lamps; some have pygmy heads on top while others are in the form of a sandaled foot.[3]

1. See, for example, Sotheby's sale, New York, 11 December 1980, no. 208 (dated in the second century A.D.).

2. Ariadne died in A.D. 515. See J. Beckwith, *The Art of Constantinople* (London, 1961), p. 37, figs. 47, 48.

3. Sotheby Parke Bernet, New York, sale no. 4196, 14 December 1978, nos. 285, 284.

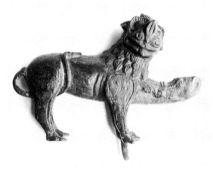

114

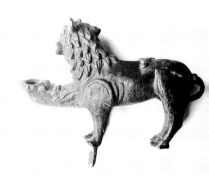

114

Sardinian and Etruscan Vessels and Attachment

115 (B504)

VOTIVE BOAT

Sardinian, ca. 675 to 650 B.C.

H (at right horn): 0.085 m. L (max.): 0.165 m.

John Wheelock Elliot and John Morse Elliot Fund. 1976.67

Reference: Museum Year: 1975–1976, p. 21.

Neg. No. B20892 (profile to left)

Condition: The tips of both horns are broken off and the ears are damaged. The object has a very dark green-black patina, with earth inside.

This votive boat has a long-horned animal, perhaps a wild creature of the bovine family, as its "figurehead" and a relief fillet covers the area of the gunwale. On top of a broad band curving from one side to the other just forward of the middle is a loop for suspension.

Nearly identical to this example is one in Cagliari called "Barchetta con testa bovina (o d'antilope?)."[1] A slightly more elaborate version displays an animal figurehead with longer horns (a stag, not a bovine creature) and fenestrated panels between the sides of the boat and the handle.[2]

Forgeries of this type are recorded.

1. In the Museo Archeologico; see G. Lilliu, *Sculture della Sardegna Nuragica* (Cagliari, 1956), p. 67, no. 130 (illus.; pl. nos. 126 to 144 include other boats, some simpler and many more elaborate); compare also Christie's sale, London, 11 July 1973, p. 50, no. 201, pl. 29, and bibliography; Sotheby's sale, London, 13 December 1982, p. 66, no. 224 (a bull in a boat).

2. See N. Dessy, *I Bronzetti Nuragici* (Milan, 1955), pl. III.

116 (B508)

STAMNOS

Etruscan, late 6th to 5th century B.C.

H (max.): 0.37 m.

Helen and Alice Colburn Fund. 1976.146

Reference: Museum Year: 1975–1976, p. 22.

Neg. No. C30693 (full view)

Condition: The body of the stamnos—with one lug remaining on the side—is heavily corroded, undoubtedly from use in a cremation burial. Its surfaces have been partly cleaned and restored in places with plaster and green paint. The ancient patina is pea green.

The urn or vessel is enriched with a series of complex moldings and floral friezes, top to bottom. Above a wave pattern near the base, there is a frieze of animals in combat in the traditional Late Archaic poses. A long inscription appears below the neck, beneath what appears to be a palmette-and-lotus border.

There are other bronze vessels or buckets comparable for the shape and for the pat-

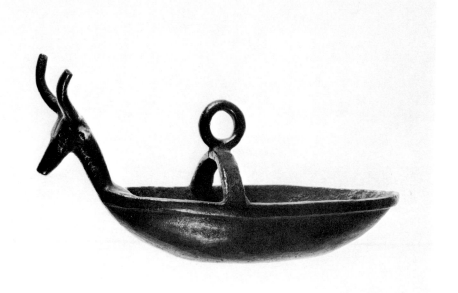

115

116

ꓥⱯꓘＣ｜·ꓘⵓꓐⱯ·ＣꓯꓘꟼⵕⱯⵕ｜ＳⱯ·ⵕⱯꟼＳ·ꓯꟼＺꓯ

116

116

terns of the body.[1] One such stamnos, now in Karlsruhe, was found at San Ginesio near Tolentino; its handles with end-plates in the form of triton-protomes are preserved in the local Italian museum.[2]

1. See G.Q. Giglioli, *L'Arte etrusca* (Milan, 1935), pl. CV, no. 2; Walters, *Bronzes*, p. 107, no. 650.

2. K. Schumacher, *Beschreibung der Sammlung antiker Bronzen* (Karlsruhe, 1890), p. 119, no. 632, pl. XVIII.

117 (B516)
HANDLE OF JUG OR PITCHER (OINOCHOE)
Etruscan (Archaic to Classical), ca. 500 to 450 B.C.
L: 0.15 m.
Anonymous Loan. 108.<u>64</u>

Provenance: from the collection of Piero Tozzi, New York

Neg. No. E2192

Condition: The patina is the bright green characteristic of the best Etruscan Archaic bronzes.

The upper end of this curving handle terminates in a ram's head, and the lower end is completed by the head or mask of a Silenus. Beading and a tiny palmette appear above the Silenus.

 A similar handle, attached to the upper part of a spouted jug, has an older Silenus (or satyr) with a fuller beard and a bald companion instead of the ram at the upper end.[1]

1. 1972.51. See S. Doeringer, in *The Frederick M. Watkins Collection* (Cambridge, Mass.: Fogg Art Museum, 1973), pp. 77–79, no. 32 and extensive bibliography.

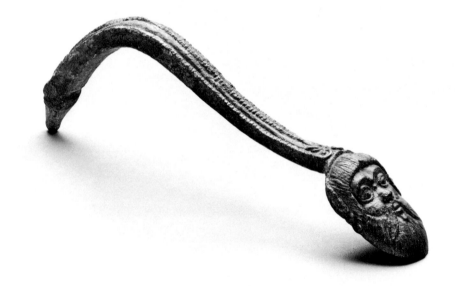

117

117

Greek, Etruscan, and Roman Arms and Armor

118 (B584)

Sᴴɪᴇʟᴅ

Archaic Greek, ca. 520 B.C.

ᴅɪᴀᴍ: 0.815 m. ᴡ: 0.115 m.

Helen and Alice Colburn Fund. 1971.285

References: Museum Year: 1971–1972, p. 41; True and Vermeule, *Bulletin*, pp. 119–120, no. 2; *Biblical Illustrator*, Summer 1982, p. 79 (view of reverse); G. Seiterle, in *Antike Kunstwerke aus der Sammlung Ludwig*, vol. 2: *Terrakotten und Bronzen* (Mainz, 1982), p. 258, n. 18.

Condition: Inside the shield, fastening rivets and sections of the bronze strap with relief decoration are preserved. All the remaining pieces inside were added during restoration and mounted on a modern surface of wood. The rim of the outer surface, composed of sheet bronze, is decorated with a multiple running *guilloche* pattern. The patina is a rich green.

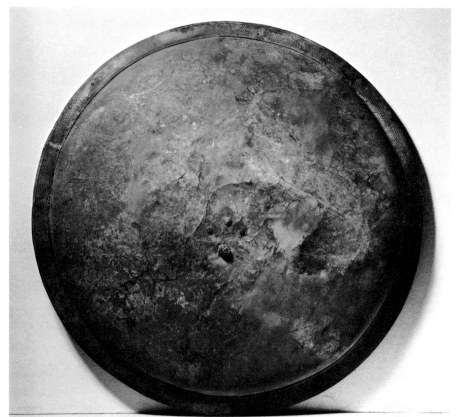

118

118

118

118

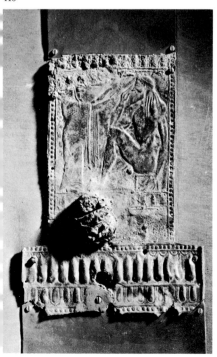

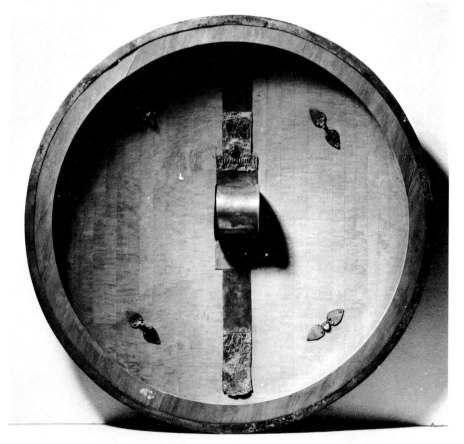

The style of the figures in the relief panels on the strap parallels that of the painter known as "The Affecter" on Attic black-figure vases of around 540 B.C. When all the scenes were present, this votive or funerary work may have been a Late Archaic "Shield of Achilles," with various episodes from the hero's life on the strap in a series of about eight panels. Of the three panels preserved here, the first appears to show two heroes confronting each other, perhaps in combat. On the panel below, a youth holding two wreaths advances toward a larger figure, possibly a divinity with attributes, standing at the left. The remaining scene, on the opposite side of the arm loop, has been named tentatively "Thetis before Zeus"; it shows a woman in a long garment standing in a gesture of supplication before a nude bearded man (seated on an altar-like stool) who seems to have the presence of a major divinity.

119 (B586)
SHOULDER PLATE OF CUIRASS WITH FACING HEAD OF AMAZON
Greek, ca. 300 B.C.

H: 0.16m.

Frank B. Bemis Fund. 1986.242

References: Museum Year: 1985–1986, pp. 28 (illus.), 48; *MFA Preview*, April 1987, illus.; F. Wolsky, in *Art for Boston*, pp. 74–75, illus.; C. Vermeule, in *GettyMusJ* 15 (1987), p. 34, fig. 6, nn. 19–20.

Neg. No. E918

Condition: A section is broken off at the upper left. Below this area, at the left edge, a small section has been rejoined. The surfaces have an even dark green to black patina with slight areas of corrosion on the face.

The face of a woman in high relief decorates one of two hinged flaps that covered the shoulder straps of a cuirass.[1] Wearing a "Phrygian" cap, elaborate earrings, and a necklace with rosette pendant, she may represent Penthesilea, the warrior queen of the Amazons.

In a furious battle of the Trojan War, Penthesilea, an ally of the Trojans, was killed by Achilles, who upon removing her helmet was overwhelmed by her beauty and deeply grieved. The poignancy of this encounter made it an enduring theme in classical iconography from the sixth century B.C. on. Representations of the combatants were appropriate motifs for the decoration of armor, and it is likely that this image of a female warrior gazing to the right was matched on the opposite shoulder by the image of her opponent, looking left.

1. Compare the Siris Bronzes in the British Museum; see Walters, *Bronzes*, no. 285, pp. 39–40, pl. VIII.

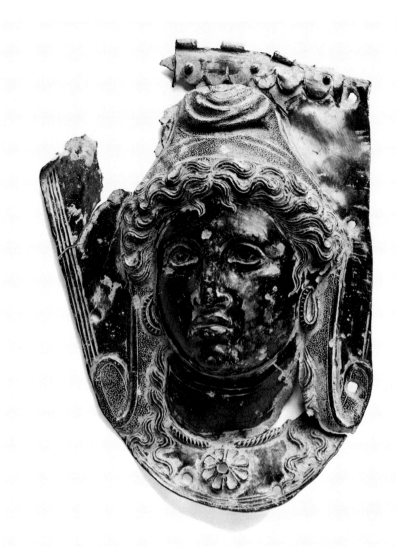

119

119

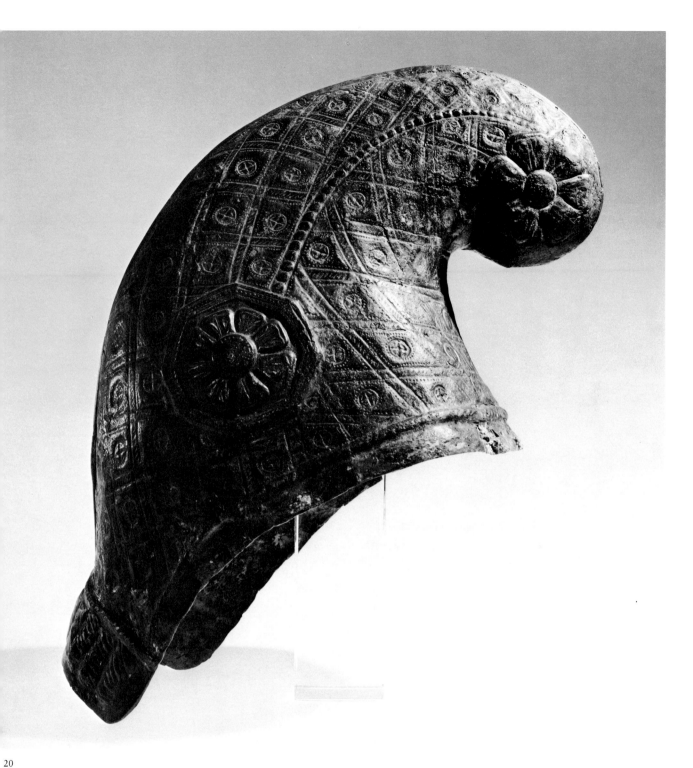

20

20 (B589)
HELMET
Late Hellenistic or Roman Imperial (Par-
thian or Kushan), ca. 100 B.C. to A.D. 300
H (max.): 0.33 m.
Morris and Louise Rosenthal Fund.
1979.41
References: MFA *Calendar*, June 1981, illus.;
Museum Year: 1978–1979, pp. 23 (illus.), 40,
entry by Timothy Kendall.
Neg. No. C33913

Condition: After careful cleaning and restora-
tion, the surfaces, with their deep green patina,
reveal some corrosion or encrustation from
within the helmet.

The elaborate chased patterns on this
helmet of traditional nomadic Eastern type
imitate a quilted fabric and also, possibly,
embossing in leather. Its closest parallels
are worn by figures among the sculptures
of the great tomb of Antiochus I of Com-
magene (69 to 34 B.C.) at Nimrud Dag
(Nemrut Dagh) in southeast Asia Minor,
by priests in the so-called fresco of Conon
(about A.D. 70) at Dura Europos on the
Roman frontier of Mesopotamia, and by
royal persons represented in statues of
second-century date from Hatra in Syria.
Surprisingly, perhaps the most remarkable
parallel appears on a sculpture of one of
the Indo-Scythian rulers of Kushan (first to
fourth century A.D.), now in the Mathura
Museum in India. It lacks rosettes on the
sides and peak; otherwise the patterning is
identical.

121

121 (B592)

BUTT END OF SPEAR
Greek, 5th century B.C.
L: 0.272m.
Sir Charles Nuffler Foundation

Provenance: from the collection of a Swiss hotel
owner
Reference: Münzen und Medaillen A.G., Basel,
Sonderliste J, March 1968, pp. 23–25, no. 62,
illus.
Condition: The patina is hard and green, with
some corrosion on surfaces and edges.

Two of the four sides, concave to make it
easier to plant the spear in the ground on
ceremonial occasions, are engraved with
the letter N, perhaps that of the owner.
Identical integral parts of military spears
or athletic javelins, dedicated at major
temples and sanctuaries, have been exca-
vated at Olympia, the Acropolis of Athens,
Delphi, and (among other sites on Cyprus)
at Idalion. A more elegant "Late Archaic"
example is in the Metropolitan Museum of
Art, New York.[1]

1. G.M.A. Richter, *Handbook of the Greek
Collection* (Cambridge, Mass., 1953), p. 209,
pl. 49h.

122 (B593)

HANDLE OF SHORT SWORD OR
LARGE KNIFE: GLADIATOR IN
ARMOR
Graeco-Roman (late Republican to early
Imperial)
L (max.): 0.132m. H (of base or handle
only): 0.042m.
Edwin E. Jack Fund. 1984.142

Reference: Museum Year: 1983–1984, p. 42.
Condition: The surfaces, once polished, now
have a rich green patina. Incised designs on the
shield and the face and shaft of a herm[1] bracing
the figure's right leg at the rear are worn by
repeated gripping.

The handle depicts a gladiator going
through his paces, holding a large rectangu-
lar shield. He wears a large helmet of tradi-
tional ("Samnite") type, a face mask, body
armor, a garment with heavy sleeves, a
skirt, and greaves.

Gladiator figures occur also on the han-
dle of another knife;[2] on the handle of a
folding knife;[3] and on a round base or
handle similar to the Boston example, with
the shield at the gladiator's left side and his
left hand on the edge of his helmet, all
designed to make a compact grip.[4] There is
also a slightly smaller gladiator figurine,
not an attachment in relief or a handle.[5]

1. The presence of the herm is an indication that
the scene takes place in a gymnasium or training
school.

2. In the Antiquarium in Berlin; see K.A.
Neugebauer, *Antike Bronzestatuetten* (Berlin,
1921), p. 110, fig. 60 (from Italy).

3. In the Ménil Foundation Collection; see
Hoffmann, *Ten Centuries*, pp. 231–232, no.
110.

4. In the Bibliothèque Nationale, Paris; see
Babelon and Blanchet, *Bronzes Antiques*, p.
417, no. 943.

5. D.K. Hill, *Catalogue of Classical Bronze
Sculpture* (Baltimore: Walters Art Gallery, 1949),
p. 60, no. 122, pl. 19.

122

Greek and Graeco-Roman Miscellaneous Objects

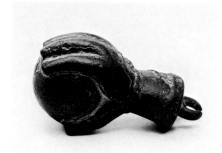

124

123 (B643)
Steelyard Weight:
Sacred Mountain
(Mount Argaios in Cappadocia)
Greek Imperial, ca. A.D. 150 to 250
H: 0.12m. W: 0.08m.
John Michael Rodocanachi Fund. 1972.79

Provenance: from an old collection (originally from Constantinople)
References: Museum Year: 1971–1972, p. 41; True and Vermeule, *Bulletin*, p. 126, no. 7; Vermeule, *Numismatic Art*, pp. 55, 119, fig. 71.
Neg. No. B20233
Condition: The piece has a green patina with earthy encrustation.

A bust of Helios appears at the top of the mountain and an offering of fruit or pine cones is placed in a basket amid the flame-like pine trees on the lower slopes. A loop for suspension, reinforced from below, protrudes behind the god's head. Within the concave area of the back, hollowed for filling with lead, an iron pin remains.

The reverse designs of numerous Greek Imperial coins of Caesarea in Cappadocia show Mount Argaios in this stylized fashion, with Helios at the top.

124 (B644)
Steelyard Weight:
Hand with Orb
Late Greek Imperial or Byzantine
L: 0.08m.
Anonymous Gift. 1970.505

Provenance: from the art market in Philadelphia; brought from Constantinople
References: Museum Year: 1970–1971, p. 37; True and Vermeule, *Bulletin*, p. 132, no. 13.
Exhibitions: Morgan, *Ancient Mediterranean*, p. 68, no. 114, fig. 33; "The Mediterranean World," Danforth Museum, Framingham, September 1977—March 1978.
Neg. No. B16638
Condition: There is a dark green patina, with some corrosion on the surfaces.

This steelyard weight is in the form of a gloved hand, doubtless the hand of an emperor grasping the orb of universal power (*orbs domina*). The motif has a long history in the sculpture and on the coins of the Roman Empire and, especially in carved ivories, in the art of the eastern Roman or early Byzantine world. The symbolism moved from the major arts and from coins to functional bronzes such as this about the time the four tetrarchs in the Vatican Library[1] were carved (A.D. 303). These stocky Late Antique emperors in uniform likewise hold orbs.

1. Andreae, *Rome*, p. 458, nos. 605–606.

125 (B644)
Steelyard Weight: Bust
of a Byzantine Official
Late Roman or Byzantine, late 4th to 10th century A.D.
H: 0.095m.
Arthur Mason Knapp Fund. 61.106

Neg. No. C25499 (three-quarter view to right)
Condition: The lead filling is missing and the surfaces are worn, revealing brassy areas.

The subject wears a Late Antique chlamys attached with a brooch on his right shoulder. He has short, straight hair cut in the "barbarian" fashion. The embroidery of his garment is indicated by a pattern of circular punchmarks.

A jeweled diadem or crown would make the official an emperor. That he is a cour-

tier, perhaps a famous general like Belisarius under the emperor Justinianus (527 to 565), is evidenced by similarity to scenes in reliefs on the base of the Obelisk of Theodosius I (late fourth century A.D.): here rows of officials watch ceremonies, dancing girls, and races in the Hippodrome at Constantinople.

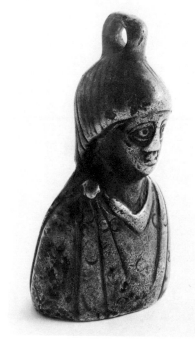

125

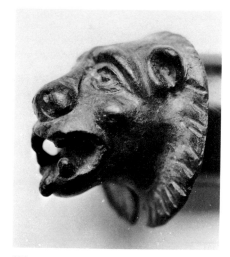

126

126 (B666)
Protome: Lion's Head
Roman Imperial
L: 0.034m. W: 0.045m.
Gift of Mr. and Mrs. Richard R. Wagner. 1972.1031

Reference: Museum Year: 1972–1973, p. 43.
Condition: The piece has a dark green patina.

The lion's head, represented in high relief,

123

is hollow, and the mane spreads around the neck to form a flange. This protome was probably a boss for a metal surface, such as a cuirass.

Compare the fittings represented in marble on the shoulder straps of certain Roman Imperial cuirassed statues. Examples include the torso of Domitian in Boston and the statue of Hadrian or Divus Augustus in the Cherchel Museum.[1]

1. Vermeule, *Cuirassed Statues*, pp. 33–34, 75 (pl. 36), 101 (pl. 58).

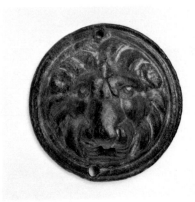

128

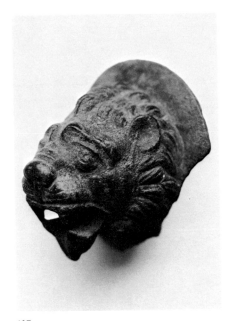

127

127 (B671)
PROTOME: LION'S HEAD
Graeco-Roman (probably Roman Imperial)
L: 0.067m. DIAM: 0.085m.
Gift of Mr. and Mrs. Richard R. Wagner.
1972.1032
Reference: Museum Year: 1972–1973, p. 43.
Condition: The lower left section of the protome is broken away irregularly. A very dark green patina covers the surface.

This lion's head is cast solid and, therefore, is heavy. The worn surface of the inside of the mouth, behind the front teeth, indicates that it once held a metal ring. The ensemble was probably an ornament for monumental furniture, very likely the enrichment of a chest.

Comparable protomes are to be found in a number of public and private collections. They include panthers as well as lions.[1]

1. See Münzen und Medaillen A.G., Basel, Sonderliste P, February 1976, pp. 37–38, nos. 91 and 92; Bieber, *Antiken Skulpturen*, p. 82, no. 325, pl. XLIX.

128 (B674)
PROTOME: LION'S HEAD
Roman Imperial
DIAM: 0.058m.
Gift of Mr. and Mrs. Richard R. Wagner.
1972.1030
Reference: Museum Year: 1972–1973, p. 43.
Neg. No. E2096
Condition: There are two holes at the edge of the tondo, probably for attachment to a wooden surface, such as a chest. The patina is black, with some encrustation in the ears and mane.

This impressive head is in lower relief than the previous examples, and the opening of the mouth goes straight through to the back. Here the style is like that of much larger Roman bronze lion's-head handles from wooden sarcophagi or chests of the second and third centuries A.D.[1]

1. See Sotheby Parke Bernet, New York, sale no. 4380, 16 May 1980, lot 226.

129

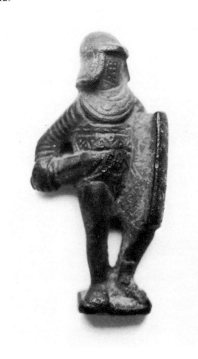

129

129 (B677)
PLAQUE: GLADIATOR IN ARMOR
Roman, 1st to 3rd century A.D.
H: 0.067m.
Classical Department Exchange Fund.
1982.323
Provenance: from a New York collection formed in Germany during the Weimar Republic
Reference: Museum Year: 1981–1982, p. 44.
Neg. No. E2093

The plaque, once applied to a large piece, has a hollow back, with the figure shown in three-quarter view. The gladiator holds a rectangular shield on the left arm and a sword in the right hand. His costume, traditional for Roman gladiators, derives from that of old Samnite warriors in the earlier days of the Roman Republic. Small bronze figures such as this example were often attached to a knife (as no. 122) or could be part of the enrichment of a gladiator's armor or equipment (the chest in which he kept his swords and knives, for example).

130 (B678)
HARNESS FITTING:
SEATED PARTHIAN
Easternmost Greek Imperial (Parthian), 1st to 3rd century A.D.
H: 0.035m.
Morris and Louise Rosenthal Fund and Horace and Florence Mayer Fund.
1983.504
Reference: Museum Year: 1983–1984, pp. 24 (illus.), 43.

Neg. No. C40991

Condition: The patina is a rich green.

The seated man, forming a figural fitting for a horse's harness, has a large moustache and a beard. Sitting cross-legged, elbows on thighs and arms brought up to his chin, he wears a high-peaked hat or helmet of Eastern type (compare no. 120) with a pattern stippled in the surfaces. From neck to boots he is wrapped in a heavy cloak, which has a rolled collar and envelops him in deep curving folds. All this makes a very expressive representation of an "Eastern barbarian" seated, watching his flocks or waiting for a ride to market.

Bronzes with "barbarians" in poses such as this and clad in "oriental" costumes found their way to Rome in Antiquity.[1]

1. See Babelon and Blanchet, *Bronzes Antiques*, p. 400, no. 914.

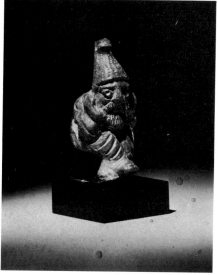

130

131 (B681)
VOTIVE PLAQUE TO APOLLO
Greek Imperial, 3rd century A.D.
H: 0.13 m. W: 0.234 m.
Edwin E. Jack Fund. 1983.222

Provenance: long in a private collection in Boston and, before that, in New York (originally from Asia Minor or Syria)

References: Museum Year: 1982–1983, p. 42; Vermeule, *Numismatic Art*, p. 125, fig. 118.

Condition: A rich black and green patina covers much of the engraved obverse surface, which has areas of pitting. There are remains of a heavy bronze loop for hanging.

In the upper center, Apollo as a rider-god carries a laurel branch in his lowered right hand and reins with their trappings in his left. Galloping to the right, he wears elaborate boots and a cloak that billows out behind. The horse has a bridle, an elabo-

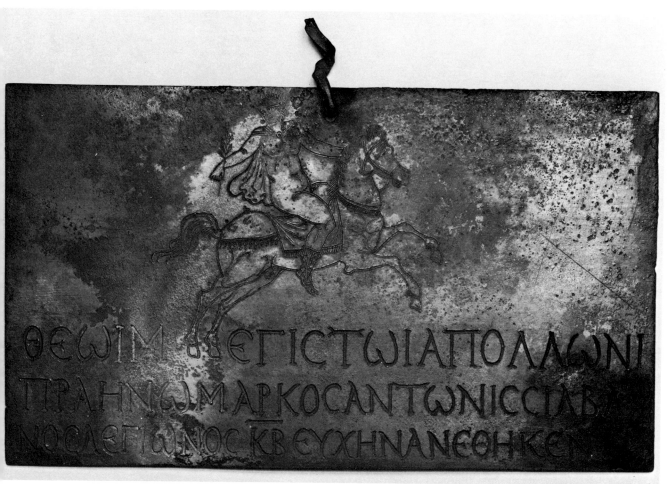

31

rate saddlecloth and martingale, and a decorated strap running around beneath his flowing tail.

A three-line inscription in Greek letters of the Imperial period reads: "Markos Antonis Silvanos of the 22nd. Legion dedicated [this plaque in fulfillment of] a vow to the greatest of the gods, Apollo of gentle mind."

132 (B686)

WHIP

Hellenistic, ca. 250 to 50 B.C.

L (max.): 1.17 m.

Private Collection. 18.1971

Provenance: from southeast Asia Minor or Syria

References: True and Vermeule, *Bulletin*, p. 133, no. 14; Vermeule, *Socrates to Sulla*, pp. 100, 137, 299, fig. 141.

Exhibition: Search for Alexander, Supplement (Toronto: Royal Ontario Museum, 5 March–10 July 1983), pp. 18–19, no. S-23.

Neg. No. E2467

Condition: The whip was reassembled in 1982 and 1983 in the Research Laboratory of the Museum of Fine Arts. Hearts and chains are now in their proper position at the end of the lash.

The long whip begins with a straight handle consisting of a ram's-head terminal and three heavy rings forming a collar, followed by a series of graduated rings diminishing in size to the end of the flexible lash, where flails are attached.

The best visual parallel for this rare object, which probably came from the tomb of a Hellenistic charioteer, is in the Alexander mosaic from Pompeii.[1] The driver of the great Persian King Darius III holds a whip of this type in his raised right hand as he attempts to speed his king away from impending defeat by the armies of Alexander the Great.

1. R.L. Fox, *The Search for Alexander* (Boston, 1980), pp. 176–177; B. Andreae, *Das Alexandermosaik aus Pompeji* (Recklinghausen, 1977).

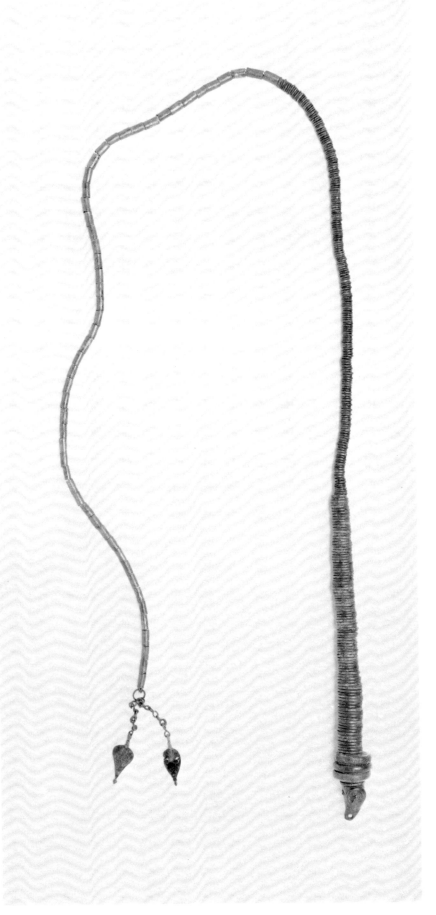

132

Concordance

Index

Bibliography

Supplementary Bibliography for *Sculpture in Stone*

Cycladic Sculpture

1. SCHEMATIC HUMAN IDOL (1972.868)
Vermeule, *Prehistoric through Perikles*, pp. 9, 207, 248, fig. 20.
Exhibited: Landesmuseum, Karlsruhe (Thimme, Getz-Preziosi, and Otto, *Cyclades*, pp. 229 [illus.], 433–434 [no. 54], 585, fig. 194); Virginia Museum of Fine Arts, Richmond; Kimbell Art Museum, Fort Worth; The Fine Arts Museums of San Francisco, California Palace of the Legion of Honor (Getz-Preziosi, *Early Cycladic Art*, pp. 129, 136–137 [no. 10, illus.], 260).

2. SCHEMATIC HUMAN IDOL (1972.869)
Vermeule, *Prehistoric through Perikles*, pp. 9, 207, 248, fig. 20.
Exhibited: Landesmuseum, Karlsruhe (Thimme, Getz-Preziosi, and Otto, *Cyclades*, pp. 229 [illus.], 433 [no. 53], 585, fig. 194); Virginia Museum of Fine Arts, Richmond; Kimbell Art Museum, Fort Worth; The Fine Arts Museums of San Francisco, California Palace of the Legion of Honor (Getz-Preziosi, *Early Cycladic Art*, pp. 129, 136 [no. 9, illus.], 137, 260).

3. STATUE OF A WOMAN (67.758)
Vermeule, *Prehistoric through Perikles*, pp. 9, 207, 249–250, figs. 21–22; Faison, *New England*, pp. 117, 156 (fig. 56), 344.

4. STATUETTE OF A WOMAN (35.60)
MFA *Handbook*, pp. 74–75, illus.
Exhibited: Landesmuseum, Karlsruhe (Thimme, Getz-Preziosi, and Otto, *Cyclades*, pp. 255 [illus.], 462 [no. 139]).

5. STATUETTE OF A WOMAN (61.1089)
Exhibited: Landesmuseum, Karlsruhe (Thimme, Getz-Preziosi, and Otto, *Cyclades*, pp. 289 [illus.], 484 [no. 228]).

Archaic Sculpture

8. KOUROS (88.734)
R.R. Holloway, *AJA* 90 (1986), p. 33.

10. YOUTH FROM A PEDIMENT OR RELIEF (00.312)
Wallenstein, *Korinthische Plastik*, pp. 51, 128, no. IV / B21, pl. 11, figs. 3–4.

11. MAN (17.598)
Vermeule, *Cyprus*, pp. 22–23, 39 (nn. 13–14), 43, fig. I.10; Hanhisalo, *Enjoying Art*, p. 49, fig. 22; U. Sinn, *AM* 98 (1983), p. 31, n. 33.

12. KOUROS (39.552)
Robertson, *History*, p. 96, pl. 27c; Bol, *Grossplastik*, p. 19.

13. KOUROS (34.169)
Robertson, *History*, pp. 98, 105; F. Johansen, *MedKøb* 34 (1977), pp. 123–124, fig. 24; G. Nicolini, in *Festschrift Bellido*, p. 33, n. 24; I.B. Romano, *Hesperia* 51 (1982), p. 401; U. Sinn, *AM* 98 (1983), pp. 45 (n. 3), 54; F. Eckstein, *AJA* 89 (1985), p. 617, n. 38; Hostetter, *Spina*, p. 63, under no. 33.

14. KORE (04.10)
Letta, *Coroplastica*, p. 27; Ridgway, *Archaic*, pp. 90, 115, 234, n. 16; Boardman, *Archaic*, pp. 89, 150, fig. 183; J. Floren, *Boreas* 2 (1979), p. 39; Congdon, *Caryatid Mirrors*, p. 60; J.M. Hemelrijk, *Caeretan Hydriae* (Mainz, 1984), p.

175; Walter-Karydi, *Bildhauerschule*, pp. 52, 155, n. 181.

15. LION (97.289)
L. Banti, in *EAA*, vol. 6, p. 31; Pedley, *Island Workshops*, p. 23; J.C. Wright, *Hesperia* 46 (1977), p. 251, n. 19; V.M. Strocka, *AA*, 1977, p. 508; Ridgway, *Archaic*, pp. 153, 155, 178, fig. 43; G.M.A. Hanfmann, in Hanfmann and Ramage, *Sculpture from Sardis*, pp. 48, 62–63; Boardman, *Archaic*, pp. 168, 238, fig. 267; L. Adams, *Orientalizing Sculpture in Soft Limestone from Crete and Mainland Greece* (BAR suppl. series, no. 42, Oxford, 1978), p. 2, n. 5; J. Floren, *Boreas* 2 (1979), pp. 41–42; *Greek Art of the Aegean Islands* (New York, 1979), p. 211, under no. 170; Vermeule, *Prehistoric through Perikles*, pp. 102–103, 144, 219, 399, fig. 159; M. Mertens-Horn, *RM* 93 (1986), pp. 24–25, pl. 14; Walter-Karydi, *Bildhauerschule*, p. 52.

16. GRAVE STELE OF A YOUTH (08.288)
Robertson, *History*, p. 113; A. Proukakis, *ArchEph* 1976 (1977), p. 97, n. 7; E.A. Mackay, *AJA* 83 (1979), p. 475, n. 10; A. Pasquier, in Amiet, *Handbook*, p. 395, no. 290, illus.; Vermeule, *Prehistoric through Perikles*, pp. 102, 219, 398, fig. 158.

17. UPPER PART OF A GRAVE STELE: SEATED SPHINX (40.576, 40.724)
Freyer-Schauenburg, *Bildwerke*, p. 203, under no. 132; MFA *Handbook*, pp. 84–85, illus.; *Second Greatest Show*, p. 12; M.-F. Billot, *BCH* 101 (1977), p. 398, n. 25; Boardman, *Archaic*, pp. 167, 218, fig. 228; Neumann, *Weihreliefs*, p. 10; Congdon, *Caryatid Mirrors*, p. 100 (as 40.57); Vermeule, *Prehistoric through Perikles*, pp. 101–102, 219, 397, fig. 157; W. Radt, *IstMitt* 33 (1983), p. 67; J. Boardman, in *The Cambridge Ancient History: Plates to Volume III* (Cambridge, 1984), p. 253, pl. 332b; J. Frel, *Death of a Hero* (Malibu, 1984), p. 69, n. 50; M. Mertens-Horn, *RM* 93 (1986), p. 13, n. 68; Walter-Karydi, *Bildhauerschule*, p. 77.

18. STELE OF A MOUNTED WARRIOR (99.339)
Hiller, *Grabreliefs*, p. 61, n. 212; MFA *Handbook*, pp. 96–97, illus.; Ridgway, *Archaic*, pp. 176, 183, fig. 54; M. Schleiermacher, *Boreas* 4 (1981), p. 74; G. Szeliga, *AJA* 87 (1983), p. 545, n. 7; Boardman, *Classical*, pp. 68, 78, 243, fig. 59.

19. RELIEF FROM THE TEMPLE AT ASSOS: HERAKLES AND THE CENTAURS (84.67)
Brommer, *Denkmälerlisten*, vol. 1, p. 140, no. 1; C. Laviosa, *Annuario* 50–51 (1972–1973), pp. 411–412; *EAA: Atlante*, pl. 13, fig. 5; Ridgway, *Archaic*, p. 264; *Second Greatest Show*, p. 12; P.S. Sheftel, *AJA* 83 (1979), p. 6; Brize, *Die Geryoneis des Stesichoros und die frühe griechische Kunst* (Beiträge zur Archäologie 12, Würzburg, 1980), pp. 53 (PHOL 2), 146; R.M. Cook, *Clazomenian Sarcophagi* (Mainz, 1981), p. 113, n. 24; *Masterpieces*, p. x; H.P. Isler, *JdI* 98 (1983), p. 32; F. Brommer, *Herakles II: Die unkanonischen Taten des Helden* (Darmstadt, 1984), p. 58; B.D. Wescoat, *AJA* 91 (1987), p. 568, n. 43.

20. RELIEF FROM THE TEMPLE AT ASSOS: FACING SPHINXES (84.68)
C. Laviosa, *Annuario* 50–51 (1972–73), pp. 411–412; *EAA: Atlante*, pl. 13, fig. 1; G.M.A. Hanfmann, in Hanfmann and Ramage, *Sculpture from Sardis*, p. 72, under no. 41; Ridgway, *Archaic*, pp. 157, 179, 259, 264;

Second Greatest Show, p. 12; P. S. Sheftel, *AJA* 83 (1979), p. 6.

23. TOP AND SHAFT OF A GRAVE STELE
(03.753)
Freyer-Schauenburg, *Bildwerke*, pp. 175–176, under no. 88; G. Bakalakis, in *Festschrift Homann-Wedeking*, p. 71; J. Vocotopoulou, *BCH* 99 (1975), p. 735, n. 17; Langlotz, *Nordostgriechischen Kunst*, p. 107; Hiller, *Grabreliefs*, p. 63, n. 221; G.M.A. Hanfmann, *RA*, 1976, p. 38; idem, in Hanfmann and Ramage, *Sculpture from Sardis*, pp. 24, 74; Neumann, *Weihreliefs*, p. 23; H. Philipp, *IstMitt* 31 (1981), p. 157; B. Jeske and C. Stein, *HASB* 8 (1982), p. 10; N. Nakayama, *Untersuchung der auf weissgrundigen Lekythen dargestellten Grabmaeler* (Freiburg im Breisgau, 1982), pp. 106–107, fig. 24; W. Radt, *IstMitt* 33 (1983), pp. 62 (n. 47), 64 (n. 55), 65 (n. 61), 66–67.

24. NOZZLE OF A LAMP (01.8212)
I. Scheibler, *Griechische Lampen* (Kerameikos, vol. 11, Berlin, 1976), p. 174; J.R. Mertens, *AntK* 22 (1979), p. 35, n. 70; Bruschetti, *Lampadario*, pp. 25–26; Vermeule, *Sculpture in America*, p. 29, no. 4, illus.
Exhibited: New York, thirty-year exchange loan to The Metropolitan Museum of Art, 1974 to 2004.

Fifth-Century Sculpture

25. KORE, PROBABLY FROM
A STATUE OF A SPHINX (1973.209)
Vermeule, *Cyprus*, pp. 17 (no. 3), 38, 43, fig. I.3; A. Hermary, *BCH* 107 (1983), p. 289; C.C. Lorber, in *Hunt Collections*, p. 282, under no. 64; Walter-Karydi, *Bildhauerschule*, pp. 80 (no. 47), 118, 158 (n. 316), pl. 37.
Exhibited: Indiana University Art Museum, Bloomington, "Of Gods and Mortals: Ancient Art from the V.G. Simkhovitch Collection," 16 September–20 December 1987.

26. FRAGMENTARY HEAD OF ATHENA
(00.307)
R.R. Holloway, *Influences and Styles in the Late Archaic and Early Classical Greek Sculpture of Sicily and Magna Graecia* (Louvain, 1975), pp. 3, 9, 51, fig. 16; P. Orlandini, in *Megale Hellas*, p. 369, fig. 363.
Exhibited: National Museum of Western Art, Tokyo (*Human Figures*, no. 10, illus.).

28. HERM-BUST OF A YOUTH (36.218)
Langlotz, *Nordostgriechischen Kunst*, p. 154; G. Siebert, *RA*, 1982, p. 275, n. 5.

29. BOY (22.593)
W. Fuchs, in *EAA*, vol. 4, pp. 414–415; Willers, *Archaistischen Plastik*, p. 17, n. 35; W.D.E. Coulson and D. Furmanik, *Antike Plastik* 17 (1978), p. 72, n. 4; E. Paribeni, in *MNR Sculture*, vol. 1, pt. 1, p. 61, under no. 50; Weski, *Antiquarium*, p. 265, under no. 151, n. 8.

30. THREE-SIDED RELIEF (08.205)
S. Aurigemma, *Le Terme di Diocleziano e Il Museo Nazionale Romano* (Rome, 1950), p. 105; ibid. (1955 ed. in English), p. 86; G. Bermond Montanari, in *EAA*, vol. 1, p. 704; G. Daux, *BCH* 93 (1969) pp. 947–948; G. Hafner, *Art of Rome, Etruria, and Magna Graecia* (New York, 1969), pp. 89, 91; F.L. Bastet, *BABesch* 45 (1970), p. 154, n. 37; L. Byvanck-Quarles van Ufford, in ibid., p. 210; M.W. Stoop, in ibid., p. 228; K. Schefold, *La Peinture pompéienne* (Collection Latomus, vol. 108, Brussels, 1972), p. 198; *BullComm* 83 (1972–1973), pp. 55–56; H. Plommer, *Antiquity* 47 (1973), p.

151; Robertson, *History*, pp. 203–209; Langlotz, *Nordostgriechischen Kunst*, p. 153, pl. 58, 2; Hiller, *Grabreliefs*, pp. 107–108, n. 55; MFA *Handbook*, pp. 70, 94–95, illus.; M.W. Frederiksen, *Archaeological Reports for 1976–77*, p. 62; Cristofani, *Civiltà Arcaica*, p. 98, n. 2; E. Berger, *AntK* 21 (1978), pp. 56 (n. 13), 59 (n. 28); E. Simon, *Gnomon* 50 (1978), p. 487; T. Fischer-Hansen, in ibid., p. 580; Devambez, *Great Sculpture*, illus. pp. 54, 120; A. Kossatz-Deissmann, *Dramen des Aischylos auf westgriechischen Vasen* (Mainz, 1978), p. 157; P.I. Coretti, in *XI International Congress of Classical Archaeology, Final Programme* (London, 1978), p. 84; idem, in *Greece and Italy*, p. 243; V.M. Strocka, *JdI* 94 (1979), p. 156, n. 64; A. Landi, *Dialetti e interazione sociale in Magna Grecia* (Naples, 1979), p. 162; Lullies, *Griechische Plastik*, p. 76; Loeb, *Geburt der Götter*, pp. 73, 77, 226 (n. 234), 229 (n. 245); Vermeule, *Death*, pp. 161–162 (fig. 15), 247 (nn. 23–24); Vierneisel-Schlörb, *Glyptothek: Skulpturen*, p. 43, n. 35; W. Burkert, *Structure and History in Greek Mythology and Ritual* (Berkeley, 1979), p. 197, n. 15; F.L. Bastet, in F.L. Bastet and M. de Vos, *Proposta per una classificazione del terzo stil pompeiano* (trans. A. de Vos) (The Hague, 1979), p. 83; D. Candilio, in *MNR Sculture*, vol. 1, pt. 1, pp. 56, 59, under no. 48; A. Stewart, *AntK* 23 (1980), p. 28, n. 14; W. Koenigs, *IstMitt* 30 (1980), pp. 87 (n. 52), 89; M. Guarducci, *Atti della Accademia Nazionale dei Lincei, Memorie*, ser. 8, vol. 24, fasc. 4 (Rome, 1980), pp. 506–507, 509, 512, 518, 521, 523, 529, 533; G. Schneider-Herrmann, *Red-Figured Lucanian and Apulian Nestorides and their Ancestors* (Amsterdam, 1980), p. 62, under no. 2; J. Dörig, in *Festschrift Jucker*, p. 92; A.E. Kalpaxis, in *Festschrift Hampe*, p. 292, n. 9; Ridgway, *Fifth Century*, p. 59, n. 23; Robertson, *Shorter History*, p. 58; M. Moltesen, *MedKøb* 37 (1981), p. 68, n. 13; Schefold, *Göttersage*, pp. 14, 79–82, 195, 280–281, 329, 334, 365, figs. 98–100; Vermeule, *Prehistoric through Perikles*, pp. 134–135, 150, 223, 439–441, fig. 191; M.C. Sturgeon, *AJA* 86 (1982), p. 140; G. Gullini, in *Festschrift Arias*, pp. 305, 309–317; M. Robertson, *Gnomon* 55 (1983), pp. 714, 716; D. Monna, P. Pensabene, and J.P. Sodini, in E. Dolci, ed., *Marmo restauro: Situazione e prospettive* (Atti del Convegno, Carrara, 31 May 1983), p. 50, n. 51; Ridgway, *Copies*, p. 29, n. 71; P. Orlandi, in *Megale Hellas*, pp. 428–429 (fig. 445), 441, 548 (n. 24); Herrmann, *Shadow*, p. 55, under no. 67; Barron, *Greek Sculpture*, pp. 64–65, illus.; *BullComm* 89 (1984), p. 378; J. Papadopoulos, *Le sculture della collezione Astarita* (Naples, 1984), pp. 2 (under no. 1), 4 (n. 3); Boardman, *Classical*, pp. 67, 72, 243, fig. 47; A. Bélis, *BCH* 109 (1985), pp. 207 (n. 18), 208–212 (figs. 8–9), 215; Scritti Paribeni, p. 124, no. 20; U. Knigge, *AM* 100 (1985), p. 291, n. 39; D. Monna, P. Pensabene, and J.P. Sodini, in P. Pensabene, ed., *Marmi antichi: Problemi d'impiego, di restauro e d'identificazione* (Studi Miscellanei 26, 1985), p. 25, n. 51; Armstrong, *Mediterranean Spirituality*, p. 257, fig. 20; A. Bélis, *RA*, 1986, p. 172 (citing D. Paquette, *L'Instrument de musique dans la céramique de la Grèce antique*, Lyon, 1984 [Université de Lyon II, Publications de la Bibliothèque Salomon Reinach], p. 164); R. Olmos, in *Festschrift Schauenburg*, p. 113, n. 33; Söldner, *Eroten*, p. 352; C. Weiss, in *LIMC*, vol. 3, pt. 1, pp. 775 (no. 288), 777; A. Hermary, in ibid., p. 920, no. 836.

31. LEFT HAND HOLDING ALABASTRON
(10.159)
V.M. Strocka, *JdI* 94 (1979), p. 151, n. 41.

32. HERO OR ATHLETE (51.1404)
Exhibited: Indiana University Art Museum, Bloomington, "Of Gods and Mortals: Ancient Art from the V.G. Simkhovitch Collection," 16 September–20 December 1987.

33. YOUTHFUL WARRIOR (95.66)
E. Raftopoulou, *Deltion* 26, pt. A (1971), p. 271, n. 27; K. Stähler, *Boreas* 2 (1979), pp. 186–187; Ridgway, *Fifth Century*, p. 88, n. 26.

34. WARRIOR'S HEAD IN RELIEF (18.431)
Ridgway, *Fifth Century*, p. 102.

35. GODDESS OR WOMAN (01.8201)
E. Raftopoulou, *Deltion* 26, pt. A (1971), p. 273, n. 36.

37. LEDA AND THE SWAN (04.14)
A. Andrén, *Opus Rom* 5 (1965), p. 93, under no. 9; Boardman and La Rocca, *Eros in Greece*, p. 123, color illus.; Brommer, *Denkmälerlisten*, vol. 3, p. 209, no. 2; Vierneisel-Schlörb, *Glyptothek: Skulpturen*, pp. 249–250, under no. 24; Ridgway, *Fifth Century*, pp. 67–68, figs. 41–42; Schefold, *Göttersage*, pp. 15, 242, 244, 372, fig. 341; Neumer-Pfau, *Aphrodite-Statuen*, pp. 105, 351, nn. 47–48; J. Chamay, *AntK* 26 (1983), pp. 45–46; K. Stähler, *Boreas* 6 (1983), p. 77, n. 15; C.A. Picon, *Classical Review* 33 (1983), p. 95; B.S. Ridgway, *GettyMusJ* 12 (1984), p. 49; Boardman, *Classical*, pp. 176, 181, 245, fig. 140.

38. MINIATURE HERM (08.537)
Exhibited: Danforth Museum, Framingham, "The Mediterranean World," September 1977–March 1978; Allentown Art Museum (E.B. Harnett, in *Ancient Greece*, pp. 182–183 [no. 88, illus.], 226, under no. 110); Kelsey Museum of Ancient and Mediaeval Archaeology, Ann Arbor, "Greek Sculpture in Transition," 20 January–8 May 1981.

39. RAM'S HEAD, FROM A STATUE
(01.8194)
Waywell, *Halicarnassus*, p. 72; M. Mertens-Horn, *RM* 93 (1986), p. 6, n. 19.

40. ATTIC GRAVE LEKYTHOS (38.1615)
Lohmann, *Grabmäler*, p. 73, n. 559; Kokula, *Marmorlutrophoren*, p. 18, n. 28.
Exhibited: Museum of Art, Rhode Island School of Design, Providence, "To Bid Farewell," 3 April–7 June 1987 (W.E. Mierse, exhibition brochure, fig. 4).

Fourth-Century Sculpture

42. MOUNTED AMAZON AND OPPONENT
IN COMBAT (03.751)
K. Stähler, *AA*, 1976, pp. 58–72, figs. 1–9; Sturgeon, *Corinth*, p. 66; C.W. Clairmont, in *Festschrift von Blanckenhagen*, p. 106, n. 12; Vierneisel-Schlörb, *Glyptothek: Skulpturen*, p. 403, n. 31; Ridgway, *Fifth Century*, pp. 59, 71; A. Kauffmann-Samaras, in *LIMC*, vol. 1, pt. 1, p. 613, no. 418; C.W. Clairmont, *Patrios Nomos: Public Burial in Athens during the Fifth and Fourth Centuries B.C.* (Oxford, 1983), p. 265, n. 59; Boardman, *Classical*, pp. 146, 157, 245, fig. 117; Morrow, *Greek Footwear*, pp. 87, 208, n. 39.

43. APHRODITE RIDING ON A GOOSE
(03.752)
L. Beschi, *Annuario* 50–51 (1972–1973), p. 491, n. 1; H.B. Jessen, in *Mélanges Mansel*, vol. 1, p. 626, n. 16; B. Palma, in Calza, *Villa Doria*

Pamphilj, p. 72, under no. 70; Loeb, *Geburt der Götter*, p. 315, Aph. 56; A. Pasquier, *RA*, 1980, p. 201 (as 63.752); Vermeule, *Socrates to Sulla*, pp. 9, 115, 145, fig. 4; O. Palagia, *Hesperia* 51 (1982), pp. 106, 108–109, n. 58; K. Stähler, *Boreas* 6 (1983), p. 77, n. 15; C.C. Lorber, in *Hunt Collections*, p. 284, under no. 80; A. Delivorrias et al., in *LIMC*, vol. 2, pt. 1, p. 96, no. 903; Weski, *Antiquarium*, p. 283, under no. 169, n. 3.

44. CARIAN ZEUS (04.12)
V.K. Müller, *Der Polos, die griechische Götterkrone* (Berlin, 1915), p. 92; G.M.A. Hanfmann, *Bulletin of the American Schools of Oriental Research*, October 1968, p. 33, n. 17; Letta, *Coroplastica*, p. 80; Fleischer, *Artemis*, p. 323; MFA *Handbook*, pp. 106–107, illus.; Hanfmann and Ramage, *Sculpture from Sardis*, p. 106, under no. 108; Waywell, *Halicarnassus*, pp. 76, 116; Vierneisel-Schlörb, *Glyptothek: Skulpturen*, p. 42, n. 17; Palagia, *Euphranor*, p. 56, n. 314; E. Paribeni, in *MNR Sculture*, vol. 1, pt. 2, p. 336, under no. 39; O. Palagia, *Hesperia* 51 (1982), p. 100, n. 4; Vermeule, *Prehistoric through Perikles*, pp. 156, 172–173, 227, 491–492, fig. 225; Dohrn, *Etruskische Kunst*, p. 56; Frischer, *Sculpted Word*, p. 234, n. 103; *Archéologia*, April 1983, p. 76, illus.; G.M.A. Hanfmann et al., *Sardis from Prehistoric to Roman Times* (Cambridge, Mass., 1983), p. 273, n. 7; C.C. Lorber, in *Hunt Collections*, pp. 200 (under no. 94), 286 (under no. 94); Knigge, *Griechische Plastik*, p. 146.

46. DIONYSOS (96.695)
G. Becatti, *Studi Miscellanei* 17 (1971), p. 55; Vierneisel-Schlörb, *Glyptothek: Skulpturen*, pp. 360 (under no. 32), 362 (n. 10a).

47. GODDESS (15.856)
B.M. Felletti Maj, in *EAA*, vol. 2, p. 575; Schneider, *Asymmetrie*, pp. 58 (table X), 126 (no. 198); B. Ashmole, in *Festschrift Brommer*, p. 15, n. 12; Weski, *Antiquarium*, pp. 157–158, under no. 31.

48. GODDESS, PERHAPS ATHENA (99.341)
G. Gualandi, *Annuario* 54 (1976), p. 34, n. 3; Weski, *Antiquarium*, p. 151, under no. 24.

50. GIRL (01.8198)
G. Gualandi, *Annuario* 54 (1976), p. 34, n. 3.

51. GODDESS OR WOMAN (99.122)
M.-A. Zagdoun, *BCH* 103 (1979), p. 398, n. 29.

52. WOMAN (00.305)
Linfert, *Kunstzentren*, p. 148, n. 587a; Vierneisel-Schlörb, *Glyptothek: Skulpturen*, p. 419, n. 7; C. Vermeule, in *Festschrift Trell*, p. 92; A. Delivorrias et al., in *LIMC*, vol. 2, pt. 1, p. 41, no. 287; vol. 2, pt. 2, pl. 30.

55. APHRODITE ("THE BARTLETT HEAD"; 03.743)
Abbate, *Art*, pp. 46, 48, fig. 24; Robertson, *History*, p. 395; Kyrieleis, *Bildnisse*, p. 89; MFA *Handbook*, pp. 106–107, illus.; B. Ashmole, in *Festschrift Brommer*, p. 15, n. 12; Brinkerhoff, *Aphrodite*, pp. 53, 119, 137 (n. 47), 160 (n. 41); Grigson, *Aphrodite*, p. 87, fig. 14; *Holosphere* 7, no. 12, December 1978, p. 3; M.-A. Zagdoun, *BCH* 103 (1979), p. 398, n. 29; MFA *Preview*, Summer 1979, illus.; Vierneisel-Schlörb, *Glyptothek: Skulpturen*, pp. 337 (n. 8), 342 (n. 28), 347 (n. 71); Vermeule, *Socrates to Sulla*, pp. 13, 116–117, 154, fig. 13; Faison, *New England*, p. 158, fig. 59; G. Rosada, in Ghedini and Rosada, *Torcello*, p. 106, under no. 34; Herrmann, *Shadow*, p. 16; A. Delivorrias et

al., in *LIMC*, vol. 2, pt. 1, p. 107, no. 1061; vol. 2, pt. 2, pl. 107; Del Chiaro, *Sculpture*, pp. 44 (under no. 13), 48 (under no. 15), fig. 13; Glover Memorial Hospital (Needham, Mass.), *Monitor* 9, no. 1 (1985), cover illus., p. 3, illus.; Koppel, *Tarraco*, p. 71, under no. 93; Weski, *Antiquarium*, pp. 139 (under no. 9), 143–144 (under no. 13).

56. YOUTHFUL GODDESS (?)
("THE MAIDEN FROM CHIOS"; 10.70)
Abbate, *Art*, pp. 46, 48, fig. 25; Fleischer, *Artemis*, p. 46; Kyrieleis, *Bildnisse*, p. 88; H.-G. Buchholz, *Methymna* (Mainz, 1975), p. 66, under B1; Robertson, *History*, p. 395; MFA *Handbook*, pp. 106–107, illus.; B.M. Kingsley, *The Terracottas of the Tarantine Greeks* (Malibu, 1976), p. 10; Stewart, *Skopas*, p. 83; idem, *RA*, 1977, pp. 200–202; B. Palma, in Calza, *Villa Doria Pamphilj*, p. 71, under no. 69; Brinkerhoff, *Aphrodite*, pp. 52, 89, 109–110, 137, n. 47; M.-A. Zagdoun, *BCH* 103 (1979), p. 398, n. 29; Lullies, *Griechische Plastik*, p. 123, no. 247, pl. 247; Vierneisel-Schlörb, *Glyptothek: Skulpturen*, pp. 330 (under no. 31), 343 (n. 38), 347 (n. 71); Biers, *Greece*, p. 264, fig. 9.30; Barron, *Greek Sculpture*, p. 134, illus.; Geominy, *Niobiden*, pp. 237, 242, 245–246, 444 (n. 505), 670 (fig. 259); Del Chiaro, *Sculpture*, p. 44, under no. 13; W. Fuchs, in J. Boardman and C.E. Vaphopoulou-Richardson, eds., *Chios, A Conference at the Homereion in Chios 1984* (Oxford, 1986), p. 292.
Exhibited: The National Museum of Western Art, Tokyo (*Human Figures*, no. 11, illus.).

57. STATUETTE OF ASKLEPIOS (18.440)
D. Candilio, in *MNR Sculture*, vol. 1, pt. 2, p. 324, under no. 31; V. Uhlmann, *HASB* 8 (1982), p. 37, no. 38; Galliazzo, *Treviso*, p. 61, under no. 11.
Exhibited: Kelsey Museum of Ancient and Mediaeval Archaeology, Ann Arbor, "Greek Sculpture in Transition," 20 January–8 May 1981.

59. ATTIC FUNERARY STATUE OF A YOUTH (04.283)
Süsserott, *Griechische Plastik*, pp. 168 (n. 144), 223; Schneider, *Asymmetrie*, pp. 50–51, 58 (table X), 115 (no. 135), pl. 7, figs. 18–19; K. Stähler, *AA*, 1976, p. 68, n. 43; L.M. Simon and B.S. Ridgway, in *Ancient Greece*, p. 186, under no. 90, n. 5; Vierneisel-Schlörb, *Glyptothek: Skulpturen*, p. 202, n. 15; Herrmann, *Shadow*, p. 15, n. 1; Geominy, *Niobiden*, p. 417, n. 380; Knigge, *Griechische Plastik*, p. 146; Weski, *Antiquarium*, p. 190, under no. 68, n. 3.

64. GRAVE STELE OF STRATOKLES (1971.129)
P. Demargne, *Fouilles de Xanthos*, vol. 5 (Paris, 1974), p. 78, n. 46; Vermeule, *Death*, p. 117, fig. 31; Vermeule, *Socrates to Sulla*, pp. 30, 121, 184, fig. 37; *Masterpieces*, no. 19, color illus.; Y. Papaoikonomou, *RA* 1983, pp. 322–324, fig. 6; Herrmann, *Shadow*, pp. 28–29, under no. 15; E.G. Pemberton, *AJA* 84 (1980), p. 542.

65. ATTIC GRAVE STELE: WOMAN WITH MIRROR (04.16)
Süsserott, *Griechische Plastik*, pp. 107 (n. 74), 220; MFA *Handbook*, pp. 100–101, illus.; V.M. Strocka, *JdI* 94 (1979), pp. 149 (n. 27), 161; B. Schmaltz, *MarbWPr*, 1979, p. 19 (n. 24), 25 (nn. 45, 50); Lohmann, *Grabmäler*, p. 73, n. 559; S. von Bockelberg, in *Antike Plastik* 18 (1979), pp. 44–45; Vierneisel-Schlörb,

Glyptothek: Skulpturen, p. 172, n. 13; Vermeule, *Prehistoric through Perikles*, pp. 173–174, 185, 227, 494, fig. 227.

66. ATTIC GRAVE STELE OF ARISTOMACHE (66.971)
B. Schmaltz, *MarbWPr*, 1979, p. 26, n. 54; Vermeule, *Socrates to Sulla*, pp. 31, 34, 123, 194, fig. 47; Geominy, *Niobiden*, p. 439, n. 452.

67. ATTIC STELE OF AN UNKNOWN YOUNG LADY (1973.169)
E.G. Pemberton, *AJA* 84 (1980), p. 542.
Exhibited: Danforth Museum, Framingham, "The Mediterranean World," September 1977–March 1978; Allentown Art Museum (B.S. Ridgway, in *Ancient Greece*, pp. 160–161, no. 78, illus.); Brockton Art Museum (Herrmann, *Shadow*, pp. 12, 18–19 [no. 5, illus.], 84).

68. ATTIC GRAVE RELIEF: SEATED WOMAN (59.845)
Exhibited: Birmingham Museum of Art, 1976–1979 (Farmer, *Festival*, no. 7); Allentown Art Museum (R. Lacy and B.S. Ridgway, in *Ancient Greece*, pp. 162–163, no. 79, illus.).

69. OLD WOMAN FROM AN ATTIC GRAVE STELE (01.8192)
F. Studniczka, *Neue Jahrbücher*, 1928, II, pl. 3b (ref. from J. Frel); Geominy, *Niobiden*, pp. 248–249, 472 (n. 720), 675 (fig. 281).

70. WOMAN FROM AN ATTIC FUNERARY MONUMENT (98.642)
M. Schmidt, *Der Dareiosmaler und sein Umkreis* (Münster, 1960), p. 68; M. Bonghi Jovino, *Capua preromana, Terrecotte votive*, vol. 2: *Le Statue* (Florence, 1971), p. 61, under no. 34; C. Vermeule, *GettyMusJ* 6/7 (1978–1979), p. 100; Vierneisel-Schlörb, *Glyptothek: Skulpturen*, p. 417, under no. 37; C. Cerchiai, in *Enea nel Lazio*, p. 37, under no. A70.

71. WEEPING SIREN (03.757)
E. Buschor, *Die Musen des Jenseits* (Munich, 1944), pp. 73–74, fig. 56; Mitten, *Classical Bronzes*, p. 59, under no. 17, n. 20; Alvarez, *Celestial*, pp. 137, 269, fig. 54; B.S. Ridgway, in *Ancient Greece*, p. 160, under no. 78, n. 4.

72. AKROTERION OF A GRAVE STELE (04.17)
U. Knigge, *AM* 99 (1984), p. 226.

74. ATTIC FUNERARY LEKYTHOS (1972.864)
Exhibited: Birmingham Museum of Art, 1976–1979 (Farmer, *Festival*, no. 6); Allentown Art Museum (A. Holden, in *Ancient Greece*, pp. 158–159, no. 77, illus.); Brockton Art Museum (Herrmann, *Shadow*, pp. 12, 18–19, no. 6, illus.).

75. ATTIC GRAVE LEKYTHOS (63.1040)
H. Jung, *MarbWPr*, 1986, p. 30, n. 121.

76. ATTIC FUNERARY LION (65.563)
Vermeule, *Socrates to Sulla*, pp. 36–37, 123, 197, fig. 50; idem, *Sculpture in America*, p. 97, under no. 66; J. Neils, in *Mildenberg Collection*, p. 160, under no. 139; *A Handbook of the Museum of Art* (Providence: Rhode Island School of Design, 1985), p. 108, under no. 20.

77. VOTIVE RELIEF TO HERAKLES ALEXIKAKOS (96.696)
MFA *Handbook*, pp. 106–107, illus.; A.D. Trendall and A. Cambitoglou, *The Red-Figured Vases of Apulia*, vol. 1 (Oxford, 1978), p. 403, under no. 41; M. Robertson, in *Festschrift von Blanckenhagen*, p. 78, n. 10; F.T. van Straten, *BABesch* 54 (1979), pp. 190, 195, figs. 2, 4; C. Bérard, *RA*, 1982, p. 143; Herrmann, *Shadow*,

pp. 32–33, under no. 20; O. Palagia, *OJA* 3, no. 1 (1984), pp. 121–122; Hostetter, *Spina*, p. 48, under no. 23.

78. VOTIVE RELIEF TO HELIOS AND MÊN (1972.78)
MFA *Handbook*, pp. 102–103, illus.; Lane, *Corpus*, vol. 2, p. 171; vol. 3, pp. 1–3, 13, 38, 92, 97 (n. 37), 101; Vermeule, *Socrates to Sulla*, pp. 16, 118, 161–162, figs. 19–20; D. Salzmann, *IstMitt* 30 (1980), pp. 275–276.
Exhibited: Brockton Art Museum (Herrmann, *Shadow*, pp. 11, 16, 19–20, no. 7, illus.).

79. FRAGMENT OF A VOTIVE RELIEF (18.436)
Exhibited: Brockton Art Museum (Herrmann, *Shadow*, pp. 20–21, no. 8, illus.).

81. FRAGMENT OF FUNERARY BANQUET RELIEF (19.318)
Exhibited: Kelsey Museum of Ancient and Mediaeval Archaeology, Ann Arbor, "Greek Sculpture in Transition," 20 January–8 May 1981; Brockton Art Museum (Herrmann, *Shadow*, pp. 20–21, no. 9, illus.).

82. SECTION OF FUNERARY BANQUET RELIEF (19.320)
E.D. Reeder, *AJA* 91 (1987), pp. 432 (n. 25), 435 (n. 44).
Exhibited: Brockton Art Museum (Herrmann, *Shadow*, pp. 18, 21, no. 10).

88. FRAGMENT OF RELIEF: NUDE YOUTH (18.442)
Exhibited: Kelsey Museum of Ancient and Mediaeval Archaeology, Ann Arbor, "Greek Sculpture in Transition," 20 January–8 May 1981.

89. SICILIAN GREEK ARTIST'S VOTIVE DISC (1972.391)
Exhibited: Danforth Museum, Framingham, "The Mediterranean World," September 1977–March 1978; Kelsey Museum of Ancient and Mediaeval Archaeology, Ann Arbor, "Greek Sculpture in Transition," 20 January–8 May 1981.

Hellenistic Sculpture

90. HEAD OF A MAJOR DIVINITY: A GODDESS (?) (89.152)
Exhibited: Birmingham Museum of Art, 1976–1987 (Farmer, *Festival*, no. 11, cover illus.).

91. TORSO OF A GODDESS (97.286)
Linfert, *Kunstzentren*, p. 85; G. Gualandi, *Annuario* 54 (1976), pp. 34 (n. 3), 238; Palagia, *Euphranor*, p. 31; idem, *Hesperia* 51 (1982), p. 103.

92. SEATED CYBELE (99.340)
H.W. Catling and G.B. Waywell, *BSA* 72 (1977), pp. 94–95; Hanfmann and Ramage, *Sculpture from Sardis*, p. 170, under no. 259; D. Candilio, in *MNR Sculture*, vol. 1, pt. 3, p. 160, under no. 408; L. de Lachenal, in ibid., vol. 1, pt. 5, p. 77, under no. 1; Ridgway, *Copies*, pp. 20, 27, n. 45, pl. 25; F. Naumann, *Die ikonographie der Kybele in der phrygischen und der griechischen Kunst* (IstMitt, suppl. 28, Tübingen, 1983), p. 360, no. 556.

93. SECTION OF DRAPED FEMALE (03.750)
G. Gualandi, *Annuario* 54 (1976), pp. 57–58, n. 5.

95. APHRODITE OR A NYMPH (13.4500)
M.-A. Zagdoun, *BCH* 103 (1979), p. 398, n. 29; D. Buitron-Oliver, in *Bastis Collection*, p. 142 (citing nos. 95–97).

98. APHRODITE OR A NYMPH (17.324)
Exhibited: Birmingham Museum of Art, 1976–1979 (Farmer, *Festival*, no. 5).

102. ATHENA OR POSSIBLY ARTEMIS (66.1076)
Exhibited: Birmingham Museum of Art, 1976–1987 (Farmer, *Festival*, no. 10).
Deaccessioned 1986 (*Museum Year: 1985–1986*, p. 49).

103. ARTEMIS "COLONNA" (88.351)
Eğilmez, *Artemis*, pp. 79, 344, no. III / 32; E. Simon, in *LIMC*, vol. 2, pt. 1, p. 801, no. 15g.
Exhibited: Danforth Museum, Framingham, "The Mediterranean World," September 1977–March 1978.

104. STATUETTE OF THE TRIPLE HEKATE (18.441)
B. Lichocka, in *Iconographie Classique*, p. 314.
Exhibited: Kelsey Museum of Ancient and Mediaeval Archaeology, Ann Arbor, "Greek Sculpture in Transition," 20 January–8 May 1981.

104A. HERAKLES, AFTER LYSIPPOS (1976.6)
C. Vermeule, in *Festschrift Schauenburg*, pp. 133, 135, pl. 23, fig. 1; Koppel, *Tarraco*, p. 101, under no. 143; Krull, *Herakles*, pp. 109–111 (no. 28), 302–303, 325–328, 330, 406 (n. 417), 407 (n. 428), 409 (nn. 452, 458), 410 (n. 460), 429.
Exhibited: Allentown Art Museum (E.B. Harnett, in *Ancient Greece*, pp. 166–167, no. 81, illus.); Edith C. Blum Art Institute, Bard College, Annandale-on-Hudson (Uhlenbrock, *Herakles*, p. 11, pl. 39; C. Vermeule, in ibid., p. 109).

105. POLYPHEMOS (63.120)
G. Säflund, *The Polyphemus and Scylla Groups at Sperlonga* (Stockholm, 1972), p. 22, fig. 10, p. 37; B. Fellmann, *Die antiken Darstellungen des Polyphemabenteuers* (Munich, 1972), pp. 45 (n. 98), 101, 131 (no. V7); Inan, *Side*, p. 176, under no. 106; MFA *Handbook*, pp. 118–119, illus.; MFA *Calendar of Events*, November 1976, illus.; R. Hampe, *Göttingische Gelehrte Anzeigen* 228 (1976), p. 220; Brommer, *Denkmälerlisten*, vol. 3, p. 417, no. 2; N. Bonacasa, *ArchCl* 29 (1977), p. 454; Vermeule, *Socrates to Sulla*, pp. 80–81, 131, 250, fig. 103; B. Schmaltz, *MarbWPr*, 1985, p. 26.

106. IO (63.2683)
Brommer, *Denkmälerlisten*, vol. 3, p. 177, no. 1 (as 62.2683); B. Freyer-Schauenburg, *RM* 90 (1983), pp. 41, 47, pl. 28, fig. 1.

107. FRAGMENT OF A STATUE OF EROS (72.732)
Waelkens, *Dokimeion*, p. 60, no. 2; Koch and Sichtermann, *Sarkophage*, p. 501, n. 41.

109. SECTION FROM A LARGE FUNERARY STELE OR COMMEMORATIVE ENSEMBLE: VEILED LADY OF IDEAL COUNTENANCE (1973.600)
Boston Herald American, 7 May 1976, p. 48, illus.; *Boston Globe*, 13 May 1976, *Calendar*, p. 17, illus.; MFA *Calendar of Events*, May 1976, illus.; C. Vermeule, *GettyMusJ* 6/7 (1978–1979), pp. 97–102, figs. 5–6; MFA *Art in Bloom*, 1982, p. 47, illus.

112. NEGRO BOY SEATED (01.8210)
Snowden, *Image*, p. 206; B.S. Ridgway, *Hesperia* 50 (1981), p. 429.
Exhibited: Allentown Art Museum (K.E. Dohan, in *Ancient Greece*, pp. 184–185, no. 89, illus.); National Museum of Western Art, Tokyo (*Human Figures*, no. 13, illus.); Walters Art Gallery, Baltimore, "African Image: Representa-

tions of the Black Throughout History," 17 February–30 March 1980.

113. DECORATIVE RELIEF (10.160)
B. Gossel, *Makedonische Kammergräber* (Berlin, 1980), p. 195; B. Van den Driessche, *Dossiers de l'archéologie* 40 (December 1979–January 1980), pp. 77–78; M. Pfrommer, *JdI* 97 (1982), pp. 144–145.

114. DISC WITH DIONYSIAC RELIEF (37.1152)
M. Anderson, in Houser, *Dionysos*, p. 105, MFA 18, illus.

115. OLD MAN AND WINGED FIGURE (Res. 08.34c)
Boardman and La Rocca, *Eros in Greece*, pp. 158–160, color illus.; Mulas, *Eros*, pp. 74–75, color illus.; Alvarez, *Celestial*, pp. 136, 268, fig. 51; Vermeule, *Death*, pp. 153–155, fig. 8; G. M.A. Richter and J.D. Breckenridge, in Temporini and Haase, *Aufstieg*, pt. 2, vol. 12, no. 1, pp. 15–16 (pl. 17, no. 20 is Ashmolean cast); Johns, *Sex or Symbol*, pp. 105–106, fig. 87 (as Res. 80.34c); A. Greifenhagen, *Gnomon* 56 (1984), p. 792; F.E. Brenk, in Temporini and Haase, *Aufstieg*, pt. 2, vol. 16, no. 3, pp. 2093 (n. 48: ref. to G. Devereux, *Dreams in Greek Tragedy: An Ethno-Psycho-Analytic Study* [Berkeley, 1976], frontispiece), 2113.

116. HERAKLES AND A NYMPH (Res. 08.34d)
Boardman and La Rocca, *Eros in Greece*, pp. 156–157, color illus.; Mulas, *Eros*, pp. 70–71, color illus.; Johns, *Sex or Symbol*, color illus. 15; A. Greifenhagen, *Gnomon* 56 (1984), p. 792.

Greek Portraits

118. STATESMAN OR PHILOSOPHER (67.1032)
G. Schwarz-Graz and J. Frel, *GettyMusJ* 5 (1977), pp. 166–168, figs. 9–10; Galliazzo, *Treviso*, pp. 50–51, under no. 7.

119. HOMER (04.13)
MFA *Handbook*, p. 114, illus.; Brinkerhoff, *Aphrodite*, p. 135, n. 40; Levi, *Atlas*, p. 52, illus.; Vermeule, *Socrates to Sulla*, pp. 56, 71, 87, 94–95, 136, 289, fig. 133; K. Morgenthaler, in Jucker and Willers, *Gesichter*, p. 49, under no. 16; H.P. Laubscher, *Fischer und Landleute* (Mainz, 1982), p. 20; Pollitt, *Hellenistic*, pp. 119–120 (fig. 122), 143; Barr-Sharrar, *Decorative Bust*, p. 86, n. 7.

120. SOCRATES (60.45)
MFA *Handbook*, p. 115, illus.; J. Frel, *GettyMusJ* 5 (1977), p. 20, n. 2; Vierneisel-Schlörb, *Glyptothek: Skulpturen*, p. 318, n. 4.
Exhibited: National Museum of Western Art, Tokyo (*Human Figures*, no. 12, illus.).

121. HERM-BUST OF MENANDER (?) (97.288)
Süsserott, *Griechische Plastik*, pp. 155 (n. 100), 225; H. Lattimore, in *The J. Paul Getty Museum* (Malibu, 1975), p. 20; Robertson, *History*, pp. 518–519, pl. 160b; MFA *Handbook*, pp. 116–117, illus.; Fittschen, *Schloss Erbach*, p. 26; R. Calza, in Calza, *Villa Doria Pamphilj*, p. 272, under no. 329; Devambez, *Great Sculpture*, p. 181; W. Stedman Sheard, *Antiquity in the Renaissance* (Northampton, Mass., 1979), under no. 69; P.G.P. Meyboom, *BABesch* 54 (1979), pp. 113, 115, fig. 2; R. Paris, in *MNR Sculture*, vol. 1, pt. 1, p. 20, under no. 22; D.L. Thompson, in *Pompeii and the Vesuvian Landscape* (Washington, D.C., 1979), p. 82, fig. 14; Vermeule, *Socrates to Sulla*, pp. 70–71, 129, 233,

fig. 89; C. Bossert-Radtke, *HASB* 7 (1981), p. 53; M.L. Morricone, *ArchCl* 34 (1982), p. 208; G. Hafner, *Rivista di Archeologia* 7 (1983), p. 44, fig. 18; R. Ling, in *The Cambridge Ancient History: Plates to Volume VII, Part I* (Cambridge, 1984), pp. 153–154, fig. 199; Rühfel, *Kind*, p. 351, n. 218; Pollitt, *Hellenistic*, p. 77, fig. 82.

122. HEAD OF DEMOSTHENES (1972.899)
E.D. Graz, *GettyMusJ* 1 (1974), pp. 39, 41–42, no. 6, figs. 6–7; Richter, *Portraits* (1984), p. 112.
Exhibited: Birmingham Museum of Art, 1976–1980 (Farmer, *Festival*, no. 13); Kelsey Museum of Ancient and Mediaeval Archaeology, Ann Arbor, "Greek Sculpture in Transition," 20 January–8 May 1981.

124. THE PHILOSOPHER METRODOROS (1986.885) (formerly 179.67)
Gift of Mr. and Mrs. Cornelius C. Vermeule III in the name of Cornelius Adrian Comstock Vermeule
V. Kruse-Berdoldt, *Kopienkritische untersuchungen zu den Porträts des Epikur, Metrodor und Hermarch* (Göttingen, 1975), pp. 58–61 (no. M7), 99–100, 157–175, nn. 355, 362; Fittschen, *Schloss Erbach*, p. 30; G.M.A. Richter, *The Portraits of the Greeks, Supplement* (London, 1972), pp. 20, 23, fig. 1244a–b; Vermeule, *Sculpture in America*, p. 137, no. 106, illus.; B. Schmaltz, *MarbWPr*, 1985, pp. 40, 45, 47, n. 118, pls. 11 (fig. 1), 12 (fig. 1); *Museum Year: 1986–1987*, p. 51.

125. HERMARCHOS OF MYTILENE (1972.971)
K. Morgenthaler, in Jucker and Willers, *Gesichter*, p. 43, under no. 13; Richter, *Portraits* (1984), pp. 129, 131.

126. ALEXANDER THE GREAT AS HERAKLES (52.1741)
E. Schwarzenberg, in *Festschrift Homann-Wedeking*, p. 181, n. 37; Stewart, *Skopas*, p. 124; C. Vermeule, in *Festschrift Brommer*, p. 289; A.F. Stewart, *JHS* 100 (1980), p. 278; W. Geominy and R. Özgan, *AA*, 1982, p. 120, n. 3; Frischer, *Sculpted Word*, pp. 270–271; G. Hübner, in M.N. Filgis and W. Radt et al., *Altertümer von Pergamon*, vol. 15: *Die Stadtgrabung*, pt. 1: *Das Heroon* (Berlin, 1986), p. 132, n. 43; O. Palagia, *Boreas* 9 (1986), p. 142.
Exhibited: *Search for Alexander*: The National Gallery of Art, Washington, D.C., 16 November 1980–5 April 1981; The Art Institute of Chicago, 14 May–7 September 1981; Museum of Fine Arts, Boston, 23 October 1981–10 January 1982; The Fine Arts Museums of San Francisco, M.H. de Young Memorial Museum, 19 February–16 May 1982; New Orleans Museum of Art, 27 June–19 September 1982; The Metropolitan Museum of Art, New York, 27 October 1982–3 January 1983; The Royal Ontario Museum, Toronto, 5 March–10 July 1983 (A. Herrmann, in op. cit., pp. 100–101, no. 5, illus.; C. Vermeule, in ibid., pp. 40–41, no. 1 [color illus.]; G. Kokkorou-Alevras, in ibid., p. 100, under no. 4).

127. ALEXANDER THE GREAT: A HELLENISTIC LIKENESS (95.68)
A. Adriani, in *EAA*, vol. 1, p. 226; M. Andronicos, in *Greece and Italy*, p. 46; idem, *Archaeology* 31, no. 5 (1978), p. 80; F. Rossi, *ArchCl* 32 (1980), p. 80; P.W. Lehmann, *AJA* 86 (1982), p. 437; M. Andronicos, *Vergina: The Royal Tombs and the Ancient City* (Athens, 1984), p. 175; Geominy, *Niobiden*, p. 467, n. 681; Koppel, *Tarraco*, p. 90, under no. 119; Pollitt, *Hellenistic*, p. 29; D. Buitron-Oliver, in *Bastis Collection*, p. 144.
Exhibited: "The Search for Alexander," Archaeological Museum of Thessalonike, 20 July–29 September 1980; *Search for Alexander:* The National Gallery of Art, Washington, D.C., 16 November 1980–5 April 1981; The Art Institute of Chicago, 14 May–7 September 1981; Museum of Fine Arts, Boston, 23 October 1981–10 January 1982; The Fine Arts Museums of San Francisco, M.H. de Young Memorial Museum, 19 February–16 May 1982; New Orleans Museum of Art, 27 June–19 September 1982; The Royal Ontario Museum, Toronto, 5 March–10 July 1983 (A. Herrmann, in op. cit., p. 102, no. 8, illus.).

127A. ALEXANDER THE GREAT OR GENIUS POPULI ROMANI (1974.581)
S.K. Morgan, *BMFA* 73 (1975), pp. 21–22, illus.
Exhibited: Danforth Museum, Framingham, "The Mediterranean World," September 1977–March 1978.

128. HELLENISTIC PRINCE: PTOLEMY III EUERGETES (1972.34)
Exhibited: Birmingham Museum of Art, 1976–1979 (Farmer, *Festival*, no. 12).

129. PTOLEMY IV PHILOPATOR (01.8208)
Kyrieleis, *Bildnisse*, pp. 44–45, 49, 55, 170–171, no. D1, pls. 31, 32, figs. 1–2; Robertson, *History*, p. 523, pl. 165b; Toynbee, *Historical Portraits*, p. 82, fig. 126; Vollenweider, *Catalogue Raisonné*, p. 49, under no. 46; H. Jucker, *JdI* 96 (1981), p. 242; Robertson, *Shorter History*, pp. 186–188, fig. 259; Bowder, *Who was Who*, p. 180, illus.; A. Houghton, *AntK* 27 (1984), p. 128, n. 16; Richter, *Portraits* (1984), p. 233, fig. 206; F. Queyrel, *BCH* 108 (1984), p. 285; Pollitt, *Hellenistic*, pp. 251, 253, fig. 270.

130. ARSINOË III (01.8207)
M.T. Marabini Moevs, in *EAA*, vol. 1, p. 688; Kyrieleis, *Bildnisse*, pp. 46, 104–108, 110–112, 129–130, 133–135, 181–182, no. L1, pl. 89, figs. 1–3; Robertson, *History*, p. 523, pl. 165a; Brinkerhoff, *Aphrodite*, p. 18; R.A. Lunsingh Scheurleer, in Maehler and Strocka, *Ptolemäische Ägypten*, p. 6; I. Jucker, *HASB* 5 (1979), p. 19, pls. 6 (fig. 3), 7 (fig. 1); Robertson, *Shorter History*, pp. 186–188, fig. 260; Bowder, *Who was Who*, p. 62, illus.; Richter, *Portraits* (1984), pp. 233–234, fig. 208; F. Queyrel, *BCH* 108 (1984), pp. 288–289; Pollitt, *Hellenistic*, pp. 251, 253, fig. 271; Barr-Sharrar, *Decorative Bust*, p. 68, under no. C138.

131. HELLENISTIC RULER (A PTOLEMY?) (59.51)
U.W. Hiesinger, *AJA* 79 (1975), p. 121, n. 36; Kyrieleis, *Bildnisse*, pp. 15, 69, 71–73, 120–121, 123, 127, 130 (n. 507), 133, 175–176, no. H 6, pls. 62, 64, figs. 1–3; A. Krug, in Maehler and Strocka, *Ptolemäische Ägypten*, pp. 13–15, 18, figs. 23–24; K. Parlasca, in ibid., pp. 25–26; Vollenweider, *Catalogue Raisonné*, p. 68, under no. 64; H. Philipp, *BonnJb* 179 (1979), pp. 773–775; H. Jucker, in Temporini and Haase, *Aufstieg*, pt. 2, vol. 12, no. 2, p. 697; I. Jucker-Scherrer, in Jucker and Willers, *Gesichter*, p. 23, under no. 4; H. Maehler, *BICS* 30 (1983), pp. 10, 18, n. 97; H. Jucker, in *Das römisch-byzantinische Ägypten: Aegyptiaca Treverensia: Trierer Studien zur griechisch-*

römischen Ägypten (Mainz, 1983), p. 141; Kiss, *Études*, pp. 86–87, figs. 222–223; *The Glory of the New Testament* (New York, 1984), p. 12, fig. 3; R.R.R. Smith, *GettyMusJ* 14 (1986), pp. 73–74, 76–78, fig. 9a–c.

Graeco-Roman Sculpture, Round

134. ATHLETE IN THE EARLY CLASSICAL STYLE (03.754)
B. Schmaltz, *Terrakotten aus dem Kabirenheiligtum bei Theben* (Berlin, 1974), p. 54, n. 261; J. Raeder, *JdI* 93 (1978), p. 266, n. 63, R. Thomas, *JdI* 97 (1982), p. 54; *Scritti Paribeni*, p. 75, pl. 47, fig. 122.

135. DEMETER OR KORE (16.62)
G. Traversari, *Sculture del V°–IV° secolo a.C. del Museo Archeologico di Venezia* (Venice, 1973), p. 26, under no. 7; Vermeule, Cahn, and Hadley, *Gardner Museum*, p. 24, under no. 30; J. Raeder, *JdI* 93 (1978), pp. 252–253, 257–259, 270, figs. 13–14; Vierneisel-Schlörb, *Glyptothek: Skulpturen*, pp. 126–127, n. 42; *Scritti Paribeni*, p. 62, n. 7.

136. GOD, PHILOSOPHER, OR POET (18.424)
Exhibited: Danforth Museum, Framingham, "The Mediterranean World," September 1977–March 1978; Allentown Art Museum (B.S. Ridgway, in *Ancient Greece*, pp. 142–143, no. 69, illus.).

139. HERAKLES (14.733)
H. Sichtermann, in *EAA*, vol. 3, p. 379, P.E. Arias, in *EAA*, vol. 5, p. 113; A. Andrén, *Opus Rom* 5 (1965), p. 126, under no. 6; Hammond, *Petra*, p. 70; P.C. Bol, *RM* 77 (1970), pp. 187–188, pl. 80, fig. 1; G. Horster, *Statuen auf Gemmen* (Bonn, 1970), pp. 91–92, 94, 96, 99–100, 108–110, illus.; Inan, *Side*, p. 147, under no. 75; S. Hiller, *AntK* 19 (1976), p. 30; MFA *Handbook*, pp. 118–119, illus.; G. Traversari, in Caputo and Traversari, *Leptis Magna*, p. 26, under no. 6; J. Dörig, *Onatas of Aegina* (Leiden, 1977), pp. 10, 12; Stewart, *Skopas*, p. 91; Sturgeon, *Corinth*, p. 112, n. 25; H. v. Heintze, *Gnomon* 49 (1977), p. 714; B. Palma, in Calza, *Villa Doria Pamphilj*, pp. 54 (under no. 29), 62 (n. 7); L. Marangou, in *Goulandris Collection*, p. 273, under no. 148; S. Howard, *The Lansdowne Herakles* (Malibu, 1978), pp. 25–26, 29–30, fig. 71; Bol, *Grossplastik*, p. 25; F.J. Henninger and A.U. Kossatz, *IstMitt* 29 (1979), p. 186; Vierneisel-Schlörb, *Glyptothek: Skulpturen*, pp. 123–124 (under no. 11), 126–127 (nn. 42, 44, 46); L. Todisco, *ArchCl* 31 (1979), pp. 142, 146–147, 150, pl. 50, fig. 1; B. Intzessiloglou, *AAA* 12, no. 1 (1979), pp. 95 (fig. 2), 97, 101–103; Schanz, *Sculptural Groups*, p. 88; Wrede, *Consecratio*, pp. 11, 54, 56–59, 63, 147, 204, 239, 241, 245, 250–253; D. Candilio, in *MNR Sculture*, vol. 1, pt. 2, p. 352, under no. 51; G. Touchais, *BCH* 105 (1981), p. 774; H. Wrede, *Die Antikengarten der del Bufalo bei der Fontana Trevi* (TrWPr 4, Mainz, 1982), p. 6; Bol, *Bildwerke*, p. 121, under no. 34; Hanhisalo, *Enjoying Art*, p. 55, fig. 27; B. Palma, in *MNR Sculture*, vol. 1, pt. 5, p. 159, under no. 66; P.C. Bol, *AM* 99 (1984), p. 302; O. Palagia, *OJA* 3, no. 1 (1984), p. 118; Boardman, *Classical*, p. 244, under no. 72; T. Boyd, *AM* 100 (1985), p. 328, n. 8; C. Landwehr and W.-H. Schuchhardt, *Die antiken Gipsabgüsse aus Baiae: griechische Bronzestatuen in Abgüssen römischer Zeit* (*Archäologische Forschungen* 14, Berlin, 1985), pp. 117 (n.

86), 128, 154; Uhlenbrock, *Herakles*, p. 9; C. Vermeule, in *Festschrift Schauenburg*, p. 136, n. 2; idem, *Numismatic Art*, endpiece II; idem, *Cult Images*, pp. 40, 51, fig. 12; Walter-Karydi, *Bildhauerschulen*, pp. 37, 154, n. 113; Weski, *Antiquarium*, p. 266, under no. 152.

140. ZEUS AMMON (59.715)
A. Grimm, in Maehler and Strocka, *Ptolemäische Ägypten*, p. 107, n. 49; Petit, *Dutuit*, p. 122, under no. 51, n. 1; J. Leclant and G. Clerc, in *LIMC*, vol. 1, pt. 1, p. 672, no. 7; vol. 1, pt. 2, pl. 537 (as Caskey, no. 66).
Exhibited: Allentown Art Museum (C.L. Lyons, in *Ancient Greece*, pp. 144–145, no. 70, illus.); Center for the Fine Arts, Miami, 14 January–22 April 1984 (J. van der Marck, *In Quest of Excellence: Civic Pride, Patronage, Connoisseurship* [Miami, 1983], pp. 56–57 [illus.], 236, no.).

141. ZEUS AMMON (03.755)
Petit, *Dutuit*, p. 122, under no. 51, n. 1.

142. POLYKLEITAN GOD OR ATHLETE (01.8190)
Hammond, *Petra*, p. 70; Herrmann, *Shadow*, p. 6, under no. 1; D. Candilio, in *MNR Sculpture*, vol. 1, pt. 7, p. 346, under no. 58638.

143. POLYKLEITAN GOD OR ATHLETE (1974.122)
Exhibited: Birmingham Museum of Art, 1976–1987 (Farmer, *Festival*, no. 3). Deaccessioned 1986 (*Museum Year: 1985–1986*, p. 49).

144. POLYKLEITAN HERMES (98.641)
Vierneisel-Schlörb, *Glyptothek: Skulpturen*, pp. 72–75 (under no. 8, no. 1), 84, 95 (under no. 9).

145. HERMES (95.67)
Zanker, *Klassizistische*, p. 39, no. 37, pls. 33 (fig. 6), 40 (figs. 3–4); MFA *Handbook*, pp. 118–119, illus.; S. Boucher, *BCH* 100 (1976), p. 100–101; Vermeule, *Sculpture and Taste*, p. 9–10; Weski, *Antiquarium*, p. 270, under no. 10.

146. YOUTH ("THE NELSON HEAD"; 03.746)
Stewart, *Skopas*, p. 173, n. 16, version 8; S. Lattimore, *AJA* 83 (1979), pp. 72–73, 76–77, no. 6, pl. 5, fig. 9; Vierneisel-Schlörb, *Glyptothek: Skulpturen*, pp. 425–426, under no. 38; B. Palma, in *MNR Sculpture*, vol. 1, pt. 5, p. 118, under no. 51; Beck, *Ares*, p. 121, n. 447c; E. Simon, in *LIMC*, vol. 2, pt. 1, p. 514, no. 23g.

148. POLYKLEITAN CULT STATUE ADAPTED AS A ROMAN PORTRAIT (03.749)
M. Bieber, in *Festschrift Renard*, p. 39, pl. 17, fig. 8; Mitten, *Classical Bronzes*, p. 182, under no. 60; Vierneisel-Schlörb, *Glyptothek: Skulpturen*, p. 212, n. 8; Del Chiaro, *Sculpture*, p. 35, under no. 10, n. 4; Vermeule, *Cult Images*, pp. 8, 58, fig. 33.

149. DIOMEDES (03.745)
L. Rocchetti, in *EAA*, vol. 3, pp. 108–109; Vierneisel-Schlörb, *Glyptothek: Skulpturen*, pp. 80–83 (under no. 9), 93 (n. 3).

150. HEAD OF THE ATHENA GIUSTINIANI TYPE (1971.782)
Exhibited: Birmingham Museum of Art, 1976–1979 (Farmer, *Festival*, no. 20); Allentown Art Museum (K.K. Albertson, in *Ancient Greece*, pp. 154–155, no. 75, illus.).

151. SEATED OR HALF-RECLINING FEMALE (01.8203)
E. Raftopoulou, *Études Argiennes* (*BCH*, suppl.

6, Paris, 1980), p. 130, n. 69; E.G. Pemberton, *AJA* 84 (1980), p. 541; A. Delivorrias et al., in *LIMC*, vol. 2, pt. 1, p. 32, no. 202.
Exhibited: Allentown Art Museum (B.K. Hamanaka, in *Ancient Greece*, pp. 150–151, no. 73, illus.); Kelsey Museum of Ancient and Mediaeval Archaeology, Ann Arbor, "Greek Sculpture in Transition," 20 January–8 May 1981; Brockton Art Museum (Herrmann, *Shadow*, pp. 1, 12, 17, no. 2, illus.).

152. REDUCED VERSION OF A STANDING DISCOBOLUS (1974.123)
B.K. Hamanaka, in *Ancient Greece*, p. 156, under no. 76; Vermeule, *Sculpture and Taste*, p. 32, fig. 31.
Exhibited: Birmingham Museum of Art, 1976–1980 (Farmer, *Festival*, no. 4, illus.); Kelsey Museum of Ancient and Mediaeval Archaeology, Ann Arbor, "Greek Sculpture in Transition," 20 January–8 May 1981; Brockton Art Museum (Herrmann, *Shadow*, pp. 15–17, no. 1, illus.).

153. YOUNG GOD, HERO, OR ATHLETE (1974.124)
Zanker, *Klassizistische*, p. 105, no. 2, pl. 78, fig. 3; W.D.E. Coulson and D. Furmanik, *Antike Plastik* 17 (1978), p. 72.
Exhibited: Birmingham Museum of Art, 1979–1987. Deaccessioned 1986 (*Museum Year: 1985–1986*, p. 49).

154. ATHLETE (POURING OIL) (04.11)
F. Carinci, *Studi Miscellanei* 20 (1971–1972), p. 39, n. 78; Inan, *Side*, p. 74, under no. 20; A.F. Stewart, *AJA* 82 (1978), pp. 301–302, 305–307, 309–312, fig. 16; Vierneisel-Schlörb, *Glyptothek: Skulpturen*, pp. 304–307, under no. 29.
Exhibited: Brockton Art Museum (Herrmann, *Shadow*, pp. 12, 15, 17–18, no. 3, illus.).

155. ATHLETE HOLDING A STRIGIL (00.304)
Süsserott, *Griechische Plastik*, p. 159; A.F. Stewart, *AJA* 82 (1978), pp. 475 (n. 2), 476; Vierneisel-Schlörb, *Glyptothek: Skulpturen*, p. 307, n. 13.

156. HERMES OF THE ANDROS-BELVEDERE TYPE (1974.523)
C. Vermeule, *BMFA* 73 (1975), pp. 18–19, illus.; Weski, *Antiquarium*, pp. 180–181, under no. 59.
Exhibited: Birmingham Museum of Art, 1976–1987 (Farmer, *Festival*, no. 8, illus.). Deaccessioned 1986 (*Museum Year: 1985–1986*, p. 49).

157. HERMES WEARING A PETASOS (WITHOUT WINGS) (1974.522)
Weski, *Antiquarium*, p. 190, under no. 68.
Exhibited: Danforth Museum, Framingham, "The Mediterranean World," September 1977–March 1978.

158. APHRODITE (96.694)
C. Vermeule, *Archaeological News*, vol. 5, no. 1 (1976), p. 19; Vierneisel-Schlörb, *Glyptothek: Skulpturen*, p. 342, n. 30; A. Delivorrias et al., in *LIMC*, vol. 2, pt. 1, p. 39, no. 260; vol. 2, pt. 2, pl. 29.

159. APHRODITE (01.8200)
A. Delivorrias et al., in *LIMC*, vol. 2, pt. 1, p. 107, under no. 1067.

160. DIONYSOS (41.909)
M. Anderson, in Houser, *Dionysos*, p. 106, MFA 20, illus.

161. YOUNG GOD OR MYTHOLOGICAL BEING (1974.125)

Exhibited: Brockton Art Museum (Herrmann, *Shadow*, pp. 12, 14–15, 18–19, no. 4, illus.).

163. HERAKLES (97.287)
Vermeule, *Cyprus*, p. 64, n. 17; Fittschen, *Schloss Erbach*, p. 19; L. de Lachenal, in *MNR Sculpture*, vol. 1, pt. 1, p. 123, under no. 88; Vierneisel-Schlörb, *Glyptothek: Skulpturen*, pp. 319–320, n. 12; Koppel, *Tarraco*, p. 101, under no. 43.

164. SECTION OF A SMALL STATUE OF THE FARNESE HERCULES TYPE (76.738)
C. Vermeule, in *Festschrift Brommer*, p. 293, pl. 78, figs. 1–2; M. Wegner and R. Unger, *Boreas* 3 (1980), p. 77; Krull, *Herakles*, pp. 6, 218–219 (no. 102), 304, 346–348; Koppel, *Tarraco*, p. 101, under no. 143.

165. SILENOS (1974.126)
Koppel, *Tarraco*, p. 104, under no. 149, n. 5; G.B. Waywell, *The Lever and Hope Sculptures: Ancient Sculptures in the Lady Lever Art Gallery, Port Sunlight and A Catalogue of the Ancient Sculptures formerly in the Hope Collection, London and Deepdene* (Berlin, 1986), p. 20, under no. 3.
Exhibited: Birmingham Museum of Art, 1976–1979 (Farmer, *Festival*, no. 23); Allentown Art Museum (E.B. Harnett, in *Ancient Greece*, pp. 168–169, no. 82, illus.); Kelsey Museum of Ancient and Mediaeval Archaeology, Ann Arbor, "Greek Sculpture in Transition," 20 January–8 May 1981.

166. APHRODITE, CAPITOLINE TYPE (99.350)
MFA *Handbook*, p. 120, illus.

167. HEAD OF APHRODITE, CAPITOLINE TYPE (99.351)
Weski, *Antiquarium*, p. 143, n. 3.

168. YOUTHFUL HERO OR ATHLETE (01.8204)
Geominy, *Niobiden*, pp. 76–77, 383, n. 239.

169. YOUTH IN ATHLETIC POSE (97.285)
Süsserott, *Griechische Plastik*, pp. 176 (n. 175), 222; J. Papadopoulos, in *MNR Sculpture*, vol. 1, pt. 1, p. 193, under no. 122; Bol, *Bildwerke*, pp. 110, 113, under no. 30; Weski, *Antiquarium*, p. 184, under no. 62.

170. HANGING MARSYAS (01.8195)
Sturgeon, *Corinth*, p. 18, n. 24; H.A. Weis, *Journal* of Worcester Art Museum 2 (1978–1979), pp. 36, 40, n. 37; Schefold, *Göttersage*, p. 369, under nos. 235–236.

171. HANGING MARSYAS (01.8196)
H.A. Weis, *Journal* of Worcester Art Museum 2 (1978–1979), p. 37, n. 5; Schefold, *Göttersage*, p. 369, under nos. 235–236.
Exhibited: Danforth Museum, Framingham, "The Mediterranean World," September 1977–March 1978; Allentown Art Museum (H.A. Weis, in *Ancient Greece*, pp. 180–181, no. 87, illus.).

172. FAUN OR YOUNG SATYR (1974.127)
Reinach, *Rép. stat.*, vol. 6, p. 168, no. 1 (probably this statue); Galliazzo, *Vicenza*, p. 82, under no. 20.

173. YOUTH IN AN EASTERN CAP (00.306)
E. Raftopoulou, *Deltion* 26, pt. A (1971), p. 265.

175. APHRODITE UNTYING A SANDAL (01.8206)
Brinkerhoff, *Aphrodite*, p. 179, n. 21.

177. APHRODITE UNVEILED (03.760)
Brinkerhoff, *Aphrodite*, pp. 169 (n. 43), 179 (n.

21); A. Delivorrias et al., in *LIMC*, vol. 2, pt. 1, p. 86, no. 774; vol. 2, pt. 2, pl. 77.

178A. STATUETTE OF APHRODITE HOLDING HER TRESSES (1975.647)
L. de Lachenal, in *MNR Sculture*, vol. 1, pt. 2, p. 311, under no. 23.

179. APHRODITE (61.1409)
Exhibited: Birmingham Museum of Art, 1976–1980 (Farmer, *Festival*, no. 19); Kelsey Museum of Ancient and Mediaeval Archaeology, Ann Arbor, "Greek Sculpture in Transition," 20 January–8 May 1981.

180. APHRODITE (61.1408)
Exhibited: Birmingham Museum of Art, 1976–1980 (Farmer, *Festival*, no. 21); Kelsey Museum of Ancient and Mediaeval Archaeology, Ann Arbor, "Greek Sculpture in Transition," 20 January–8 May 1981.

182. APHRODITE OR A ROMAN LADY (30.543)
Galliazzo, *Vicenza*, p. 110, under no. 29; Bieber, *Copies*, pp. 45, 47, figs. 139–142; M. Denti, *ArchCl* 34 (1982), pp. 160, 165, n. 29; P. Karanastassis, *AM* 101 (1986), pp. 227, 229; Vermeule, *Cult Images*, p. 42, fig. 47A.

183. APHRODITE WITH EROS ON A DOLPHIN AT HER SIDE (1974.128)
Exhibited: Birmingham Museum of Art, 1979–1987.
Deaccessioned 1986 (*Museum Year: 1985–1986*, p. 49).

184. A GODDESS: HERA OR HYGEIA (07.487)
G. Traversari, in Caputo and Traversari, *Leptis Magna*, p. 80, under no. 59; Ghedini, *Padova*, p. 38, under no. 12.
Exhibited: Birmingham Museum of Art, 1976–1983 (Farmer, *Festival*, no. 9).

187. IDEAL FEMALE HEAD (89.8)
B. Palma, *MNR Sculture*, vol. 1, pt. 4, p. 194, n. 21.

189. TYCHE-FORTUNA (1970.242)
Exhibited: Birmingham Museum of Art, 1976–1987 (Farmer, *Festival*, no. 22).
Deaccessioned 1986 (*Museum Year: 1985–1986*, p. 49).

190. TYCHE-FORTUNA (1971.746)
C. Vermeule, in *Festschrift Bellido*, p. 214; idem, *Jewish Relationships*, p. 38, n. 37; Wrede, *Consecratio*, p. 222, under no. 81; Galliazzo, *Treviso*, p. 213, under no. 77; B. Freyer-Schauenburg, *Boreas* 6 (1983), pp. 140 (n. 59), 141 (n. 63); Williams, *Johns Hopkins*, p. 32, under no. 18.

191. APHRODITE-TYCHE AND EROS (1974.131)
K. Schauenburg, in *Festschrift Jucker*, p. 157, n. 70.

192. TRIPLE HEKATE (59.846)
Ridgway, *Copies*, p. 71, pl. 84.
Exhibited: Allentown Art Museum (K.E. Dohan, in *Ancient Greece*, pp. 188–189, no. 91, illus.).

196. PRIAPOS AND A MAENAD (68.770)
A.R. Tintner, *Apollo*, August 1976, p. 112 (copy of MFA group at Waddesdon Manor, as fig. 12).

197. SATYR, MAENAD, AND EROS (62.1a, b)
B. Palma, *Studi Miscellanei* 22 (1974–1975), p. 144, n. 25; F. Matz, *Die Dionysischen Sarkophage*, vol. 4 (Berlin, 1975), pp. 470, 490, n. 1; Vermeule, *Roman Art*, pp. 104, 135, 173, 198, 360, fig. 143; Houser, *Dionysos*, p. 14; M.

Anderson, in ibid., p. 106, MFA no. 22, illus.; E.K. Gazda, *AJA* 84 (1980), p. 208; idem, in *Excavations at Carthage 1977 Conducted by the University of Michigan*, vol. 6 (Ann Arbor, 1981), pp. 163–166 (figs. 54–55, 57), 172 (n. 88); idem, *Archaeology* 34, no. 4 (1981), p. 60, illus.; E. Alföldi, *AJA* 86 (1982), p. 606; L. Bonfante and C. Carter, *AJA* 91 (1987), pp. 253–255, fig. 10; A. Hermary, in *LIMC*, vol. 3, pt. 1, p. 881, no. 358.

198. EROS OR CHILD (76.734)
Söldner, *Eroten*, p. 487, n. 817.

199. SLEEPING EROS (loan 1426)
Wrede, *Consecratio*, p. 128, n. 33; Söldner, *Eroten*, pp. 272, 690–691, no. 171, figs. 160–161; H. Frosien-Leinz, in Weski, *Antiquarium*, pp. 443–444, under no. 365.

200. A SATYR WITH BEARD AND AMMON'S HORNS (76.745)
Petit, *Dutuit*, p. 122, under no. 51, n. 1.

203. YOUNG SATYR (89.3)
Exhibited: Birmingham Museum of Art, 1979–1983.

204. INFANT (03.761)
F. Ghedini, in Ghedini and Rosada, *Torcello*, p. 158, under no. 63; Weski, *Antiquarium*, p. 298, under no. 182, n. 9.

205. SATYRISKOS OR INFANT FAUN (03.762)
Weski, *Antiquarium*, p. 298, under no. 182, n. 9.

206. PRIAPOS (Res. 08.34a)
H. Blanck, *RM* 86 (1979), pp. 342 (n. 18, no. 1), 349 (n. 50); A. Sampson, *ArchEph* 1980 (1982), p. 147, n. 2; B. Palma, *MNR Sculture*, vol. 1, pt. 4, pp. 32 (n. 48), 194 (n. 21).

208. YOUNG GOD OR MYTHOLOGICAL BEING (1974.129)
Exhibited: Birmingham Museum of Art, 1979–1987.
Deaccessioned 1986 (*Museum Year: 1985–1986*, p. 49).

210. GOD, HERO, OR ATHLETE (76.756)
C.E. Vafopoulou-Richardson, *GettyMusJ* 11 (1983), p. 114, n. 7.

213. ZEUS WITH ATTRIBUTES OF ANATOLIAN DIVINITIES (Res. 53.63)
Hanfmann and Ramage, *Sculpture from Sardis*, p. 167, under no. 253; Noelke, *Iupitersäulen*, p. 378, n. 637; S.E. Johnson, in Temporini and Haase, *Aufstieg*, pt. 2, vol. 17, no. 3, p. 1592 (with ref. to Lane, *Numen* 27 [1980]).
Exhibited: Museum of Fine Arts, Boston (*Romans and Barbarians*, pp. 54–55, no. 73, illus.).

214. WOMAN IN THE ARCHAIC STYLE (23.1)
A. Andrén, *Opus Rom* 5 (1965), p. 112, under no. 38; E. Raphtopoulou, *AAA* 11 (1978), p. 88, n. 49.

215. ARCHAISTIC ARTEMIS (99.338)
Langlotz, *Nordostgriechischen Kunst*, p. 127, n. 52; Vermeule, Cahn, and Hadley, *Gardner Museum*, p. 27, under no. 34; E. Raphtopoulou, *AAA* 11 (1978), pp. 86 (n. 39), 91 (fig. 14); L. Kahil and N. Icard, in *LIMC*, vol. 2, pt. 1, pp. 685–686, no. 865; vol. 2, pt. 2, pl. 511; *Scritti Paribeni*, pp. 16–17 (n. 12), 204–206 (no. 6), pl. 114, figs. 328–329.

216. DOUBLE HERM: HERAKLES AND HEBE (01.8197)
Galliazzo, *Treviso*, p. 107, under no. 31; D. Buitron-Oliver, in *Bastis Collection*, p. 146.

Exhibited: Allentown Art Museum (E.B. Harnett, in *Ancient Greece*, pp. 192–193, no. 93, illus.).

217. PILLAR WITH HERM OF HERMES (acquired probably in the 1880s)
Siebert, *RA*, 1982, p. 274, n. 3.

219. TABLE SUPPORT: DIONYSOS WITH PANTHER (1970.241)
Vermeule, *Egypt*, p. 187, no. 29; idem, *Numismatic Art*, p. 122, under no. 94; idem, *Cult Images*, pp. 43, 47, fig. 5.
Exhibited: Birmingham Museum of Art, 1976–1987 (Farmer, *Festival*, no. 25).

222. LEFT KNEE OF A STATUE (18.444)
C. Vermeule, *GettyMusJ* 6/7 (1978–1979), pp. 101–102.

Graeco-Roman Sculpture, Relief

234. RELIEF: THE DEATH OF PRIAM (04.15)
J.F. Crome, *Die Skulpturen des Asklepiostempels von Epidauros* (Berlin, 1951), pp. 45, 47; W. Fuchs, in *EAA*, vol. 5, p. 416; J. Chamay, in Dörig, *Art Antique*, under no. 311; Brommer, *Denkmälerlisten*, vol. 3, p. 423, no. 3; L. Marangou, *Bone Carvings from Egypt*, vol. 1: *Graeco-Roman Period* (Tübingen, 1976), p. 49, n. 259; Froning, *Marmor-Schmuckreliefs*, p. 3, n. 12; G. Siebert, in *Iconographie Classique*, p. 63, n. 21; Vermeule, *Divinities*, p. 39, fig. 48; Freytag Gen. Löringhoff, *Telamon*, p. 66, n. 213.

235. VOTIVE PLAQUE TO ZEUS HYPSISTOS (Res. 08.34b)
Mulas, *Eros*, pp. 26–27, color illus.

236. SECTION OF A FRIEZE (01.8205)
C. Vermeule, in *Festschrift Arias*, p. 638, n. 12.

237. FRAGMENT OF A TRIUMPHAL RELIEF: HEAD OF A SIGNIFER (59.336)
MFA *Handbook*, pp. 128–129, illus.; H.P. Laubscher, in *Nachrichten der Akademie der Wissenschaften in Göttingen* I, *Philologisch-Historische Klasse*, 1976, no. 3, pp. 95–96, pl. 18; G.M. Koeppel, *RM* 90 (1983), p. 106, n. 21; *BullComm* 89 (1984), p. 380.
Exhibited: Museum of Fine Arts, Boston (*Romans and Barbarians*, p. 2, no. 2, illus.).

239. CINERARIUM (1972.15)
E. Filieri, in *MNR Sculture*, vol. 1, pt. 7, p. 387, under no. XII.21.

240. RELIEF: MITHRAS SLAYING THE BULL (92.2692)
M.J. Vermaseren, *Corpus Inscriptionum et Monumentorum Religionis Mithriacae* (The Hague, 1956), p. 229, no. 607, fig. 174.
Exhibited: Museum of Fine Arts, Boston (*Romans and Barbarians*, p. 8, no. 10, illus.).

241. FRAGMENTS OF A MELEAGER SARCOPHAGUS (?) (1970.267a,b)
Koch, *Meleager*, pp. 14, 98, no. 42, pls. 34a, 35a; Brommer, *Denkmälerlisten*, vol. 3, p. 229, no. 3; Koch and Sichtermann, *Sarkophage*, p. 262.

242. FRAGMENT OF SARCOPHAGUS RELIEF: THE FALL OF TROY (69.2)
Brommer, *Denkmälerlisten*, vol. 3, p. 459, no. 4; C. Vermeule, *Fenway Court 1984* (Boston: Isabella Stewart Gardner Museum, 1985), pp. 30–31, fig. 4; A. Sadurska, in *LIMC*, vol. 3, pt. 1, pp. 816–817, no. 31.

243. FUNERARY URN OF CASSIUS (1972.356)
M. Anderson, in Houser, *Dionysos*, pp. 105–106, MFA 19, illus.; Koch and Sichtermann,

Sarkophage, p. 54, pl. 59; Kranz, *Jahreszeiten-Sarkophage*, p. 104, n. 630.

244. SARCOPHAGUS WITH TRIUMPHAL PROCESSION OF DIONYSOS (1972.650)
S.E. Schur, *Technology & Conservation Magazine* 2, no. 2 (1977), p. 37, illus.; B. Andreae and H. Jung, *AA*, 1977, in table between pp. 434–435; Houser, *Dionysos*, pp. 13–14; M. Anderson, in ibid., p. 106, MFA 21, illus.; *Practice and Performance: The Guide to the Arts at Harvard and Radcliffe, 1985–1986*, cover illus.; Picón, *Antiquities*, p. 54, under no. 65; D.G. Mitten, in *Mildenberg Collection, Supplement*, p. 35, under no. II:168.

244A. SARCOPHAGUS WITH TRAINERS, TRAINED LIONS, AND PREY (1975.359)
M. Sapelli, in *MNR Sculture*, vol. 1, pt. 1, p. 314, under no. 187; H. Oehler, *Foto + Skulptur: Römische Antiken in englischen Schlössern* (Cologne, 1980), p. 64, under no. 45; Vermeule, *Jewish Relationships*, pp. 43, 106–107, figs. 30–31.
Exhibited: Museum of Fine Arts, Boston (*Romans and Barbarians*, p. 106, no. 115, illus.).

245. SARCOPHAGUS WITH SEA CREATURES, AMORINI, AND GARLANDS (62.1187)
Koch and Sichtermann, *Sarkophage*, pp. 224–226, 229, 231 (no. 3), 264–265.
Exhibited: Birmingham Museum of Art, 1976–1987 (Farmer, *Festival*, no. 30).

246. SECTION OF ASIA MINOR SARCOPHAGUS OF ATTIC DECORATIVE TYPE (1973.480)
Vermeule, *Cyprus*, pp. 88, 97 (n. 34), 100, fig. III.24; Waelkens, *Dokimeion*, p. 61, no. 7; Koch and Sichtermann, *Sarkophage*, p. 501, n. 41.
Exhibited: Danforth Museum, Framingham, "The Mediterranean World," September 1977–March 1978; Museum of Art, Rhode Island School of Design, Providence, "To Bid Farewell," 3 April–7 June 1987.

247. SEASON SARCOPHAGUS (92.2583)
MFA *Handbook*, pp. 130–131, illus.; Kranz, *Jahreszeiten-Sarkophage*, pp. 130, 214, no. 117, pl. 53, fig. 3; L.M. Vigna, *BullComm* 90 (1985), p. 58, under no. 15.

248. RIGHT FRONT OF A SEASON SARCOPHAGUS (58.584)
K. Schauenburg, in *Festschrift Jucker*, p. 154, n. 38; Kranz, *Jahreszeiten-Sarkophage*, p. 52, 198–199, under no. 50, pl. 36, fig. 2 (pl. 34, fig. 1, represents the complete sarcophagus while in the Giustiniani collection).
Exhibited: Museum of Art, Rhode Island School of Design, Providence, "To Bid Farewell," 3 April–7 June 1987.

249. SEASON SARCOPHAGUS OF THE CONSTANTINIAN PERIOD (68.623)
H. Sichtermann, *RM* 86 (1979), p. 369, n. 165; Kranz, *Jahreszeiten-Sarkophage*, pp. 210–211, no. 95, pl. 62, fig. 2.
Exhibited: Birmingham Museum of Art, 1976–1987 (Farmer, *Festival*, no. 31, illus.).
Deaccessioned 1986 (*Museum Year: 1985–1986*, p. 49).

251. SARCOPHAGUS WITH CHRISTIAN, PAGAN, AND TRADITIONAL FIGURES (Apparatus 1946)
H. Sichtermann, *RM* 86 (1979), p. 358; Himmelmann, *Hirten-Genre*, p. 150, n. 528; Koch and Sichtermann, *Sarkophage*, p. 172.

252. FRAGMENT FROM AN AMAZON SARCOPHAGUS: AMAZON ON HORSEBACK (76.715)
A. Kauffmann-Samaras, in *LIMC*, vol. 1, pt. 1, p. 621, no. 528.

253. FRAGMENT OF A MUSE SARCOPHAGUS (76.729)
Exhibited: Museum of Art, Rhode Island School of Design, Providence, "To Bid Farewell," 3 April–7 June 1987.

264. SARCOPHAGUS FRAGMENT: GALLOPING HORSES (76.743)
Galliazzo, *Treviso*, p. 139, under no. 47; M. Sapelli, in *MNR Sculture*, vol. 1, pt. 7, p. 291, under no. IX,51.

268. LEFT FRONT OF THE LID OF A LARGE HUNTING SARCOPHAGUS (76.748)
Exhibited: Museum of Art, Rhode Island School of Design, Providence, "To Bid Farewell," 3 April–7 June 1987.

270. CORNER OF A SARCOPHAGUS LID: TRITON'S OR SATYR'S HEAD (76.718)
L.M. Vigna, *BullComm* 90 (1985), p. 56, under no. 12.

273. SECTION OF SARCOPHAGUS LID: SEA MONSTERS (76.750)
Exhibited: Museum of Art, Rhode Island School of Design, Providence, "To Bid Farewell," 3 April–7 June 1987.

275. CHRISTIAN OSTEOTHEKE (64.703)
Exhibited: Museum of Fine Arts, Boston (*Romans and Barbarians*, p. 184, no. 209, illus.).

276. GRAVE STELE OF SOSIBIA (1971.209)
E.J. Walters, *AAA* 12 (1979), p. 220, n. 12.
Exhibited: Museum of Art, Rhode Island School of Design, Providence, "To Bid Farewell," 3 April–7 June 1987.

278. TONDO: ATHLETE WITH WREATH AND PALM (67.948)
Weski, *Antiquarium*, p. 231, under no. 111.

280. STELE HONORING THE DICAST LANTHES (84.53)
Merkelbach, *Assos*, p. 20, no. 9, pl. 5.
Exhibited: Newark Museum, 1975–1987.

281. SECTION OF A DICAST'S STELE (84.60a–b)
Merkelbach, *Assos*, p. 21, no. 10, pl. 6.

282. STELE HONORING THE DICAST LYKOMEDES (84.61)
Merkelbach, *Assos*, pp. 27–28, no. 11b, illus.

287. VOTIVE STELE TO ARTEMIS ANAÏTIS AND MÊN TIAMU (94.14)
Lane, *Corpus*, vol. 3, pp. 18–19, 38, 68, 79 (n. 62), 83; Hanfmann and Ramage, *Sculpture from Sardis*, p. 173, under no. 264; I. Diakonoff, *BABesch* 54 (1979), pp. 151–152 (no. 32), 157–158, 161–162, 164 (n. 139), 172 (n. 203), 182, fig. 19; C. Vermeule, in *Festschrift von Blanckenhagen*, p. 282; idem, *Sculpture in America*, p. 13; V.M. Strocka, in R.M. Boehmer and H. Hauptmann, eds., *Beiträge zur Altertumskunde Kleinasiens: Festschrift für Kurt Bittel* (Mainz, 1983), p. 494, n. 9.

288. RELIEF TO THE GOD MÊN (69.1223)
Lane, *Corpus*, vol. 3, pp. 99, 103 (n. 6), 105; D. Salzmann, *IstMitt* 30 (1980), p. 272, n. 62h; Vermeule, *Numismatic Art*, pp. 19, 120, fig. 78.

290–291. VOTIVE RELIEFS TO APOLLO SOZON (69.1255, 69.1256)
W. Lambrinudakis and G. Kokkorou-Alewras,

in *LIMC*, vol. 2, pt. 1, p. 245, nos. 487a–b; vol. 2, pt. 2, pl. 221 (no. 290 only).

292. SMALL VOTIVE SHRINE TO A RIDER GOD (1973.165)
Exhibited: Museum of Fine Arts, Boston (*Romans and Barbarians*, p. 56, no. 74, illus.).

293. SECTION OF LYCIAN VOTIVE RELIEF (64.47)
L. Robert, *BCH* 107 (1983), pp. 590–593, fig. 5.
Exhibited: Museum of Fine Arts, Boston (*Romans and Barbarians*, p. 56, no. 75, illus.).

294. VOTIVE RELIEF FROM SYRIA: TWO EAGLES (68.582)
Parlasca, *Proceedings*, p. 305; idem, *GettyMusJ* 8 (1980), p. 144; idem, *TrWPr* 3 (1981), pp. 14, 28, n. 137, pl. 16, fig. 2.
Exhibited: Birmingham Museum of Art, 1976–1987 (Farmer, *Festival*, no. 27, illus.).
Deaccessioned 1986 (*Museum Year: 1985–1986*, p. 49).

295. FRAGMENT OF A COPY OF THE SHIELD OF THE ATHENA PARTHENOS (76.740)
E.B. Harrison, *AJA* 85 (1981), p. 293; N. Leipen, in Berger, *Parthenon-Kongress*, p. 180; W.A.P. Childs, *AM* 100 (1985), p. 220, n. 69.

297. FRAGMENT OF A FRIEZE: A MAN, PERHAPS WOUNDED (18.443)
Koch and Sichtermann, *Sarkophage*, p. 408, no. 21.

299. PEDESTAL OF A CANDELABRUM OR DECORATIVE SHAFT (96.702)
W. Fuchs, in *EAA*, vol. 5, p. 416; Cain, *Marmorkandelaber*, pp. 27 (type 1, no. 12), 30, 98, 112, 121, 146, 151 (cat. no. 9), 176, 190, pls. 12 (figs. 1–2, 4), 17 (fig. 3), 18 (fig. 4), 72 (figs. 1, 3), suppl. pls. 7–8; H. Jung, *MarbWPr*, 1986, p. 30, n. 126.

300. BASE OF A CANDELABRUM OR DECORATIVE SHAFT: NIKE POURING A LIBATION (59.687)
Galerie Helbig, *Sammlung von antiken Gläsern, Terrakotten, Marmor Skulpturen und Bronzen aus dem Besitze von Fr. D. Kirchner-Schwarz*, Beirut, 22–23 June 1914; Cain, *Marmorkandelaber*, pp. 4 (n. 5), 91, 98, 114, 139 (n. 838), 151, cat. no. 8, pl. 76, fig. 2, suppl. pl. 7.

301. MASK OF A TRAGIC HERO (1972.203)
M.-A. Zagdoun, *BCH* 103 (1979), p. 418, n. 122; Williams, *Johns Hopkins*, p. 29, under no. 15, n. 2.
Exhibited: Birmingham Museum of Art, 1976–1987 (Farmer, *Festival*, no. 24).
Deaccessioned 1986 (*Museum Year: 1985–1986*, p. 49).

302. DECORATIVE RELIEF FRAGMENT: A DRAMATIC MASK (76.755)
Williams, *Johns Hopkins*, p. 27, under no. 14, n. 3.

305. SECTION OF ARCHITECTURAL PANEL (03.747)
MFA *Handbook*, pp. 130–131, illus.; F. Wolsky, in MFA *Art in Bloom*, 1982, p. 67.

306. SECTION OF ARCHITECTURAL PANEL (03.748)
F. Wolsky, in MFA *Art in Bloom*, 1982, p. 67, illus.

307. CORINTHIAN PILASTER CAPITAL: SILENOS IN ACANTHUS (01.8211)
C. Vermeule, in *Festschrift Schauenburg*, p. 136, n. 6.

308. CORINTHIAN PILASTER PANEL: SEASONAL AMORINO (66.71)
Vermeule, *Roman Art*, pp. 137, 198, 362, fig. 145; idem, in *Festschrift Schauenburg*, p. 136, n. 6.

310. ARCHITECTURAL TONDO WITH CANOPIC IMAGE (1970.243)
Exhibited: Museum of Fine Arts, Boston (*Romans and Barbarians*, p. 20, no. 26, illus.).

311. ARCHITECTURAL RELIEF (1970.366)
Exhibited: Birmingham Museum of Art, 1976–1987 (Farmer, *Festival*, no. 29).
Deaccessioned 1986 (*Museum Year: 1985–1986*, p. 49).

312. SECTION OF A MARBLE VASE: HERMES CARRYING THE INFANT DIONYSOS TO THE NYMPHS OF NYSA (01.8213)
Vermeule, *Roman Art*, pp. 46–47, 190, 271, fig. 50; T.H. Price, *Kourotrophos* (Leiden, 1978), p. 70, no. 714; Schefold, *Göttersage*, p. 347, n. 63.

315. SECTION OF AN URN OR VASE (76.742)
Exhibited: Cooper-Hewitt Museum, New York, "Wine: Celebration and Ceremony," 4 June–13 October 1985.

316. TABLE SUPPORT (TRAPEZOPHORUS) (S1236)
Vermeule, *Egypt*, p. 186, no. 6.

317. TABLE SUPPORT (TRAPEZOPHORUS) (84.63)
Vermeule, *Egypt*, p. 189, no. 51.

318. TABLE SUPPORT (TRAPEZOPHORUS) IN THE FORM OF A WINGED GOAT (28.893)
Nardi, *Orte*, pp. 224–225; Vermeule, *Egypt*, pp. 182, 186, no. 10A.
Exhibited: Birmingham Museum of Art, 1976–1987 (Farmer, *Festival*, no. 26).
Deaccessioned 1986 (*Museum Year: 1985–1986*, p. 49).

Roman Portraits

319. TOMB RELIEF OF THE PUBLIUS GESSIUS FAMILY (37.100)
T. Botticelli, *Studi Miscellanei* 20 (1971–1972), pp. 47–49; P. Zanker, *JdI* 90 (1975), pp. 303–304, fig. 43; Colledge, *Palmyra*, p. 288, n. 490; D.E.E. Kleiner, *Roman Group Portraiture* (New York, 1977), pp. 36–37, 51, 54, 56, 58, 63, 72, 74, 80, 82, 96, 101, 105, 107, 126, 135, 149, 154, 158, 167, 183, 192, 219–220 (no. 41), 263, fig. 41; Stemmer, *Panzerstatuen*, p. 145; Vermeule, *Roman Art*, pp. 36, 86, 143, 188–189, 211, 252, fig. 37; S. Nodelman, in *Self and Society*, p. 92, under no. 18; F. Baratte and C. Metzger, in Amiet, *Handbuch*, p. 499, no. 62, illus.; V. Picciotti Giornetti, in *MNR Sculture*, vol. 1, pt. 2, p. 258, under no. 50; P. Zanker, in Fittschen and Zanker, *Römischen Porträts*, vol. 3, p. 42, under no. 47, n. 9; idem, in Fittschen and Zanker, *Römischen Porträts*, vol. 1, p. 21, under no. 19, n. 8.

320. MAN OF THE LATE REPUBLIC (67.947)
R. Calza, in Calza, *Villa Doria Pamphilj*, p. 298, under no. 371, n. 3; Koppel, *Tarraco*, pp. 91 (under no. 120), 201 (nn. 3–4).
Exhibited: Birmingham Museum of Art, 1976–1980 (Farmer, *Festival*, no. 15).

321. ROMAN OF THE LATE REPUBLIC (99.343)
MFA *Handbook*, p. 121, illus.: M. De Min, in Baggio, *Oderzo*, p. 108, under no. 29; Bol, *Bildwerke*, pp. 218, 220, under no. 68; A.

Ambrogi, in *MNR Sculture*, vol. 1, pt. 7, p. 352, under no. XI,8.

322. ROMAN IN THE REPUBLICAN "VERISTIC" STYLE (88.638)
Exhibited: Birmingham Museum of Art, 1976–1987 (Farmer, *Festival*, no. 14).
Deaccessioned 1986 (*Museum Year: 1985–1986*, p. 49).

323. FAMOUS ROMAN OF THE LATE REPUBLIC, CA. 50 B.C. (1971.241)
Exhibited: Danforth Museum, Framingham, "The Mediterranean World," September 1977–March 1978.

324. MAN OF THE LATE REPUBLIC: HORACE (?) (00.311)
Vollenweider, *Catalogue Raisonné*, p. 34, under no. 32, n. 5; D.R. Shackleton Bailey, *Profile of Horace* (Cambridge, Mass., 1982), dust jacket; F. Johansen, *Berømte Romere fra Republikkens Tid* (Copenhagen, 1982), pp. 75–76, fig. 87; P. Zanker, *Augustus und die Macht der Bilder* (Munich, 1987), p. 68, fig. 46.

325. ROMAN FUNERARY RELIEF (1972.918)
Weski, *Antiquarium*, p. 236, under no. 117, n. 1.
Exhibited: Kelsey Museum of Archaeology, University of Michigan, Ann Arbor, 28 January–15 April 1977 (Gazda, *Portraiture*, pp. 4, 10, 12–13, no. 2, illus.).

326. LADY OF THE LATE REPUBLIC OR EARLY EMPIRE (68.767)
Exhibited: Birmingham Museum of Art, 1976–1987 (Farmer, *Festival*, no. 16).
Deaccessioned 1986 (*Museum Year: 1985–1986*, p. 49).

327. AUGUSTUS (06.1873)
U. Hausmann, *Römerbildnisse* (Stuttgart, 1975), pp. 25, 122; J.C. Balty, *AntK* 20 (1977), p. 114, n. 130; Andreae, *Rome*, p. 497, fig. 215; J. Inan, in Inan and Alföldi-Rosenbaum, *Porträtplastik*, pp. 59–60, 78; K. Fittschen, in Horn and Rüger, *Numider*, p. 224; H. Jucker, *JdI* 96 (1981), p. 244, n. 31; Vermeule, *Sculpture in America*, p. 15; U. Hausmann, in Temporini and Haase, *Aufstieg*, pt. 2, vol. 12, no. 2, pp. 543 (n. 120), 551 (no. 8), 562–563, 565, 581, pls. 12 (fig. 23), 15 (fig. 29); P. Zanker, in Fittschen and Zanker, *Römischen Porträts*, vol. 1, pp. 8–10, under no. 8 (entry no. 3); Pollini, *Portraiture*, p. 10, n. 38.

328. AUGUSTUS (90.163)
C. Vermeule, *GettyMusJ* 6/7 (1978–1979), pp. 100–101; P. Zanker, in Fittschen and Zanker, *Römischen Porträts*, vol. 1, p. 7, under no. 6, suppl. pl. 5b–d; B. Schmaltz, *RM* 93 (1986), pp. 215–222, 231, 234–236, 238–239, pls. 83 (fig. 1), 86 (fig. 2), 89 (fig. 2).

329. AUGUSTUS (99.344)
MFA *Handbook*, p. 123, illus.; G. Traversari, in Caputo and Traversari, *Leptis Magna*, p. 91, under no. 69; M. Grant, *History of Rome* (New York, 1978), p. 262, illus.; Vermeule, *Roman Art*, pp. 68, 191, 282, fig. 65; U. Hausmann, in Temporini and Haase, *Aufstieg*, pt. 2, vol. 12, no. 2, p. 589; Froning, *Marmor-Schmuckreliefs*, p. 94, n. 72; E. Simon, *AA*, 1982, p. 334, n. 85; R. Winkes, ibid., pp. 136–137, fig. 12; Hanhisalo, *Enjoying Art*, pp. 186–187, fig. 129; Kiss, *Études*, p. 33.
Exhibited: Glyptothek, Munich, December 1978–March 1979; Antikenmuseum, Berlin, April–June 1979 (K. Vierneisel and P. Zanker, *Die Bildnisse des Augustus* [Munich, 1979], pp. 66, 69 [fig. 6.3], 117).

330. AGRIPPA (?) IN RELIEF (99.347)
Vermeule, *Cyprus*, pp. 72, 93, n. 7; Toynbee, *Historical Portraits*, p. 65; A. Stewart, *Attika: Studies in Athenian Sculpture of the Hellenistic Age* (London, 1979), p. 98, n. 94; L. Fabbrini, in *Festschrift Jucker*, p. 102.

331. TIBERIUS CAESAR AUGUSTUS (1971.393)
C. Vermeule, in *Festschrift Bellido*, pp. 215–216, figs. 1–3; Weski, *Antiquarium*, p. 220, under no. 97, n. 4.

332. DRUSUS SENIOR, BROTHER OF TIBERIUS (88.346)
G. Rosada, in Baggio, *Oderzo*, p. 30, under no. 6; J.C. Balty, *AntK* 20 (1977), p. 105, n. 32; Fittschen, *Schloss Erbach*, p. 43, n. 16a; Vermeule, *Roman Art*, pp. 81, 193, 297, fig. 83; G. Rosada, in Ghedini and Rosada, *Torcello*, p. 53, under no. 14; K. Fittschen, in Fittschen and Zanker, *Römischen Porträts*, vol. 1, p. 27, under no. 22 (entry 2).

333. ROMAN WOMAN, PERHAPS OCTAVIA, HALF-SISTER OF AUGUSTUS (99.345)
Vermeule, Cahn, and Hadley, *Gardner Museum*, p. 29, under no. 36.

334. JULIA, DAUGHTER OF AUGUSTUS, AS ARTEMIS (88.641)
Exhibited: Birmingham Museum of Art, 1976–1987 (Farmer, *Festival*, no. 17).
Deaccessioned 1986 (*Museum Year: 1985–1986*, p. 49).

335. GIRL OF THE JULIO-CLAUDIAN PERIOD (88.642)
Exhibited: Birmingham Museum of Art, 1979–1983.

336. A ROMAN GIRL (96.697)
G. Bejor, *Trea: Un municipium piceno minore* (Pisa, 1977), p. 85, n. 139; Pollini, *Portraiture*, p. 27, n. 43.

337. LADY OF THE JULIO-CLAUDIAN PERIOD (01.8191)
S. Besques-Mollard, in *Festschrift Renard*, p. 26; Linfert, *Kunstzentren*, p. 58, n. 174d; Del Chiaro, *Sculpture*, p. 35, under no. 10, n. 4.

338. MAN OF THE JULIO-CLAUDIAN PERIOD (13.230)
G. Traversari, in Caputo and Traversari, *Leptis Magna*, p. 83, under no. 62; M. Krumme, *HASB* 6 (1980), p. 35; P. Zanker, in Fittschen and Zanker, *Römischen Porträts*, vol. 1, p. 21, under no. 19, n. 5; J. Pollini, *AJA* 90 (1986), p. 460.

339. MAN OF AFRICAN ORIGIN (88.643)
J. Frel, *GettyMusJ* 5 (1977), p. 20, n. 2; Snowden, *Prejudice*, pp. 88, 140 (n. 123), 155, fig. 49.
Exhibited: Museum of Fine Arts, Boston (*Romans and Barbarians*, p. 9, no. 11, illus.).

340. BUST OF A ROMAN (96.699)
G. Rosada, in Baggio, *Oderzo*, p. 36, under no. 9; P. Zanker, in Fittschen and Zanker, *Römischen Porträts*, vol. 1, p. 21, under no. 19, n. 5; Weski, *Antiquarium*, p. 225, under no. 103, n. 2.

341. SMALL BOY OF THE JULIO-CLAUDIAN PERIOD (01.8202)
MFA *Handbook*, pp. 124–125, illus.
Exhibited: National Museum of Western Art, Tokyo (*Human Figures*, no. 14, illus. [as 01.8201]).

342. BRITANNICUS, SON OF CLAUDIUS (9.27)
J. Jucker, *JdI* 92 (1977), p. 232, n. 116; J. Inan, in Inan and Alföldi-Rosenbaum, *Porträtplastik*, pp. 84–86, no. 33, pl. 26, figs. 3–4.

343. BOY (84.35)
J. Inan, in Inan and Alföldi-Rosenbaum, *Porträtplastik*, p. 153, no. 100, pl. 88, fig. 3.

344. TITUS (63.2760)
Bonanno, *Portraits*, pp. 64, 193, n. 333; Vermeule, *Roman Art*, pp. 87–88, 193, 304, fig. 92 (Martial); R. Trummer, *Die Denkmäler des Kaiserkults in der römischen Provinz Achaia* (Graz, 1980), p. 169, n. 1.

345. DOMITIAN (88.639)
M.T. Erim, in Inan and Alföldi-Rosenbaum, *Porträtplastik*, pp. 90–91; M. Bergmann and P. Zanker, *JdI* 96 (1981), pp. 342, 356, 358–359, p. 17, fig. 30a–b (as 88.633); Bol, *Bildwerke*, 185, under no. 56.

346. HEAD IDENTIFIED AS DOMITIAN (9.5)
Palma, *MNR Sculture*, vol. 1, pt. 4, p. 194, n. 4; P. Zanker, in Fittschen and Zanker, *Römischen Porträts*, vol. 1, p. 36, under no. 32, n. 4.
Exhibited: Birmingham Museum of Art, 1976–1980 (Farmer, *Festival*, no. 18).

347. CUIRASSED TORSO (99.346)
Nocentini, *Sculture greche, etrusche e romane del Museo Bardini in Firenze* (Rome, 1965), p. 5; Korres, *Kephalon*, p. 241; P. Acuña Fernandez, *Esculturas Militares Romanas De España y Portugal*, vol. 1, *Las Esculturas Thoracatas* (Burgos, 1975), p. 50, nn. 30–31; Willers, *Archaistischen Plastik*, p. 60, n. 238; MFA *Handbook*, pp. 128–129, illus.; Bonanno, *Portraits*, pp. 92, 200, n. 476; Stemmer, *Panzerstatuen*, pp. 28 (n. 84), 34, 80–81 (no. VII:11), 82, 84 (n. 243), 92, 95, 104, 159, 162–165, 169 (no. 84), pl. 55, fig. 2; F. Salviat and D. Terrer, *Dossiers de l'archéologie* 41 (February–March 1980), p. 82; Vermeule, *Cuirassed Statues*, pp. 4, 33, 75, fig. 36; W. Schürmann, *Untersuchungen zu Typologie und Bedeutung der stadtrömischen Minerva-Kultbilder* (Rome, 1985), p. 121, n. 582.
Exhibited: Museum of Fine Arts, Boston (*Romans and Barbarians*, pp. 2–3, no. 3, illus.).

348. MAN OF THE FLAVIAN PERIOD (4.70)
Inan, in Inan and Alföldi-Rosenbaum, *Porträtplastik*, pp. 153–154, no. 102, pl. 88, fig. 1.

349. LADY OF THE LATE FLAVIAN PERIOD (3.744)
Zanker, in Fittschen and Zanker, *Römischen Porträts*, vol. 3, p. 54, under no. 69, n. 5.

350. MARCIANA, SISTER OF TRAJAN (6.286)
Capecchi, Lepore, and Saladino, *Poggio Imperiale*, p. 129, under no. 67; P. Zanker, in Fittschen and Zanker, *Römischen Porträts*, vol. 1, p. 57, under no. 75, n. 3.

353. GIRL FROM CORINTH (96.698)
Snowden, *Image*, pp. 238, 241, fig. 334; Vermeule, *North Carolina Bulletin*, p. 39, under no. 4; B.S. Ridgway, *Hesperia* 50 (1981), p. 56, n. 58; F. Baratte and C. Metzger, in Amiet, *Handbook*, p. 544, no. 283, illus.; B. Corley, *Biblical Illustrator*, Summer 1982, p. 15, illus.; Snowden, *Prejudice*, pp. 16, 154, fig. 25a–b; Weski, *Antiquarium*, p. 169, under no. 46, n. 7.

354. TOMBSTONE OF PETRONIA HEDONE AND HER SON (99.348)

355. ROMAN MATRON OF THE HADRIANIC PERIOD (34.113)
Bieber, *Copies*, p. 223, figs. 867–868; H. Wrede, *RM* 85 (1978), p. 415, n. 23; idem, *Consecratio*, p. 295; K. Fittschen, in Fittschen and Zanker, *Römischen Porträts*, vol. 3, pp. 65–66, under no. 86b; Cain, *Marmorkandelaber*, p. 143, n. 5.

356. AN OFFICIAL OF THE HADRIANIC PERIOD (68.730)
Calza, *Ostia*, vol. 5, pp. 76–77, no. 123, pl. 71; Vermeule, *Iconographic Studies*, pp. 23–29, 31–32, figs. 3–6; Bol, *Bildwerke*, p. 235, under no. 74.
Deaccessioned January 11, 1978, and returned to the government of the Republic of Italy.

356a. HADRIAN (1975.292)
M.B. Comstock, *BMFA* 73 (1975), pp. 22–23, illus.; *Biblical Archaeology Review* 4, no. 3 (1978), cover and p. 41; Vermeule, *Roman Art*, p. 63, note; M. Wegner and R. Unger, *Boreas* 7 (1984), p. 118 (under Kairo); Kiss, *Études*, p. 59, figs. 118–119; K. Fittschen, in Fittschen and Zanker, *Römischen Porträts*, vol. 1, pp. 50–51, under no. 49, no. 20.
Exhibited: Museum of Fine Arts, Boston (*Romans and Barbarians*, pp. 21–23, no. 28, illus.).

357. MAN, HADRIANIC TO EARLY ANTONINE (99.349)
Inan and Alföldi-Rosenbaum, *Porträtplastik*, p. 21, n. 105; E.A. Rosenbaum, in ibid., p. 148, n. 2; J. Inan, in ibid., pp. 241–242, no. 215 (as 99.849), pl. 152, figs. 3–4; Krull, *Herakles*, pp. 88, 389, n. 168; Weski, *Antiquarium*, p. 243, under no. 126, n. 7.

358. LADY OF THE EARLY ANTONINE PERIOD (04.284)
Galliazzo, *Vicenza*, pp. 167, 169, under no. 47; Capecchi, Lepore, and Saladino, *Poggio Imperiale*, p. 122, under no. 62; Ghedini, *Padova*, p. 54, under no. 20; Wrede, *Consecratio*, p. 310, under no. 295a; V. Picciotti Giornetti, in *MNR Sculture*, vol. 1, pt. 2, 251, under no. 45; K. Fittschen, in Fittschen and Zanker, *Römischen Porträts*, vol. 3, pp. 69 (under no. 90, n. 2a), 76 (under no. 99, n. 6); Koppel, *Tarraco*, p. 96, under no. 128.

359. MAN OF THE ANTONINE PERIOD (24.419)
Calza, *Ostia*, vol. 9, p. 33, under no. 36; M. Wegner and R. Unger, *Boreas* 2 (1979), p. 141; O. Vasori, in *MNR Sculture*, vol. 1, pt. 1, p. 176, under no. 115; Galliazzo, *Treviso*, p. 113, under no. 34; J. Meischner, *AA*, 1983, pp. 607, 609–610, fig. 6; Kiss, *Études*, p. 63, figs. 143–144.

362. ROMAN OFFICIAL OF THE ANTONINE PERIOD (01.8193)
C. Vermeule, *BurlMag*, no. 897, vol. 119, p. 814, n. 18; K. Huber, in Jucker and Willers, *Gesichter*, p. 151, under no. 62.
Exhibited: National Museum of Western Art, Tokyo (*Human Figures*, no. 15, illus.).

363. NORTH SYRIAN FUNERARY STELE OF A YOUNG MAN (1971.424)
K. Parlasca, *GettyMusJ* 8 (1980), p. 144.

365. THE EMPEROR MARCUS AURELIUS (1971.93)
M. Wegner and R. Unger, *Boreas* 2 (1979), p. 141; K. Fittschen, in Fittschen and Zanker,

Colledge, *Palmyra*, p. 288, n. 490; Vermeule, *North Carolina Bulletin*, p. 39, under no. 4; M. Fuchs, *JdI* 99 (1984), p. 250, n. 208.
Exhibited: National Museum of Western Art, Tokyo (*Human Figures*, no. 16, illus.).

Römischen Porträts, vol. 1, p. 71, under no. 65, n. 2b; R. Invernizzi, *ASAtene* 57–58 (1986), p. 357, n. 72.
Exhibited: Birmingham Museum of Art, 1979–1983.

366. AN ANTONINE PRINCE AS THE INFANT HERAKLES KILLING THE SNAKES (1971.394)
C. Vermeule, in *Festschrift Brommer*, pp. 291–292, pl. 77, fig. 1; M. Wegner and R. Unger, *Boreas* 3 (1980), pp. 77, 113; S. Nodelman, in *Self and Society*, p. 68, under no. 12; M.R. Kaiser-Raiss, *Die stadtrömische Münzprägung wahrend der Alleinherrschaft des Commodus* (Frankfurt, 1980), pp. 14, 47, pl. 32A; Wrede, *Consecratio*, p. 138; E.R. Williams, *Hesperia* 51 (1982), pp. 363–364, pl. 88d; Söldner, *Eroten*, p. 453, n. 515; D.E.E. Kleiner, *Roman Imperial Funerary Altars with Portraits* (Rome, 1987), pp. 263–264, under no. 119.

367. SATURN (KRONOS) WITH FEATURES OF COMMODUS (65.1727)
C. Vermeule, in *Festschrift Brommer*, p. 294, pl. 78, fig. 3; M. Wegner and R. Unger, *Boreas* 3 (1980), p. 77; F. Ghedini, in Ghedini and Rosada, *Torcello*, p. 24, under no. 3; Picón, *Antiquities*, p. 46, under no. 53; Vermeule, *Cult Images*, pp. 34, 63–64, fig. 40.

368. LADY IN QUASI-DIVINE GUISE (1973.212)
Wrede, *Consecratio*, p. 307, n. 36.
Exhibited: Museum of Fine Arts, Boston (*Romans and Barbarians*, pp. 53–54, no. 72, illus.).

369. THE EMPEROR SEPTIMIUS SEVERUS (60.928)
Calza, *Ostia*, vol. 9, pp. 46–47, no. 58, pl. 45; Levi, *Atlas*, p. 206, illus.; S. Nodelman, *GettyMusJ* 10 (1982), pp. 118–120, fig. 23; J.D. Breckenridge, in Temporini and Haase, *Aufstieg*, pt. 2, vol. 12, no. 2, p. 502, pl. 15; J.-C. Balty, *RA*, 1983, pp. 306, 309, fig. 12.
Exhibited: Museum of Fine Arts, Boston (*Romans and Barbarians*, pp. 10–11, no. 13, illus.).

370. CAIUS MEMMIUS CAECILIANUS PLACIDUS (?) (88.349)
Capecchi, Lepore, and Saladino, *Poggio Imperiale*, p. 66, under no. 16; M. Bergmann, *Gnomon* 53 (1981), p. 181; J. Meischner, *JdI* 97 (1982), pp. 402–403, 406, no. 4; U. Hausmann, *AM* 98 (1983), p. 170, n. 6; C.A. Picon, in *The Treasure Houses of Britain: Five Hundred Years of Private Patronage and Art Collecting* (Washington, D.C., 1985), p. 305, under no. 229; Weski, *Antiquarium*, pp. 253–254, under no. 138, n. 4.

371. MAN OF AFFAIRS OR INTELLECT (1975.2)
Exhibited: Birmingham Museum of Art, 1979–1983.

372. LADY OF A.D. 230–240 (1970.325)
C. Saletti, *ArchCl* 30 (1978), p. 259; K. Fittschen, in Fittschen and Zanker, *Römischen Porträts*, vol. 3, p. 106, under no. 156, n. 1b; Wood, *Portrait Sculpture*, p. 64, pl. 22, fig. 31.

373. MAGISTRATE OR MAN OF INTELLECT (84.65)
J. Inan, in Inan and Alföldi-Rosenbaum, *Porträtplastik*, pp. 156–157, no. 108, pl. 91, figs. 4–5; J. Frel, *HASB* 10 (1984), p. 23.
Exhibited: Museum of Fine Arts, Boston (*Romans and Barbarians*, pp. 101–102, no. 110, illus.).

374. THE EMPEROR MAXIMINUS (89.4)
K. Fittschen, *AA*, 1977, pp. 321–322, figs. 1–2;

B. Palma, *MNR Sculture*, vol. 1, pt. 4, p. 194, n. 21.

Exhibited: Museum of Fine Arts, Boston (*Romans and Barbarians*, pp. 11–12, no. 14, illus.).

375. THE EMPEROR BALBINUS (88.347)
Bergmann, *Römischen Porträt*, p. 129; Vermeule, *Roman Art*, pp. 143–144, 146, 199, 368, fig. 151; J.C. Balty, *L'Antiquité Classique* 49 (1980), p. 283; Wrede, *Consecratio*, p. 302, n. 32; K. Fittschen, in Fittschen and Zanker, *Römischen Porträts*, vol. 3, p. 106, under no. 155, n. 15.

Exhibited: Museum of Fine Arts, Boston (*Romans and Barbarians*, pp. 98, 100, no. 109, illus.).

376. ROMAN OF THE YEARS 240 TO 260 (63.11)
Picón, *Antiquities*, p. 55, under no. 67.

377. THE EMPEROR NUMERIANUS (58.1005)
MFA *Handbook*, pp. 124–125, illus.; Bergmann, *Römischen Porträt*, pp. 119, 133–137; M. Wegner, J. Bracker, and W. Real, *Das römische Herrscherbild: Gordianus III. bis Carinus* (Berlin, 1979), p. 162; J. Meischner, *AA*, 1985, pp. 136–140, fig. 1.

Exhibited: Museum of Fine Arts, Boston (*Romans and Barbarians*, pp. 104–105, no. 114, illus.).

378. THE EMPEROR MAXIMIANUS HERCULEUS (61.1136)
Bergmann, *Römischen Porträt*, p. 151, n. 605; Vermeule, *Iconographic Studies*, p. 61 (no. 8), 74–75, fig. 10; F. de Ruyt, *Alba Fucens*, vol. 3: *Sculptures d' Alba Fucens* (Brussels and Rome, 1982), p. 37; C.C. Lorber, in *Hunt Collections*, p. 293, under no. 153; L'Orange, Unger, and Wegner, *Spätantike Herrscherbild*, p. 104.

Exhibited: Museum of Fine Arts, Boston (*Romans and Barbarians*, p. 108, no. 116, illus.).

379. FLAVIAN OR CONSTANTINIAN IMPERIAL PORTRAIT (89.6)
B. Palma, *MNR Sculture*, vol. 1, pt. 4, p. 194, n. 21; M. Fuchs, *JdI* 99 (1984), p. 250, n. 206; P. Zanker, in Fittschen and Zanker, *Römischen Porträts*, vol. 1, p. 36, under no. 32, n. 4.

Exhibited: Kelsey Museum of Archaeology, University of Michigan, Ann Arbor, 28 January–15 April 1977 (B.A. Kellum, in Gazda, *Portraiture*, pp. 6, 32–33, no. 12, illus.).

380. IMPERIAL LADY OF CONSTANTINE'S FAMILY: HELENA OR FAUSTA (62.662)
Bergmann, *Römischen Porträt*, pp. 190–192, 196–197, pls. 55 (fig. 1), 56 (fig. 1); F.K. Yegül, *GettyMusJ* 9 (1981), pp. 63, 65, fig. 6; P. Zanker, in Fittschen and Zanker, *Römischen Porträts*, vol. 3, p. 115, under no. 173; *Spätantike und frühes Christentum: Ausstellung im Liebieghaus Museum alter Plastik Frankfurt am Main* (Frankfurt, 1983), pp. 414 (under no. 31), 497 (under no. 101); L'Orange, Unger, and Wegner, *Spätantike Herrscherbild*, p. 144; Weski, *Antiquarium*, p. 175, under no. 53.

Exhibited: Museum of Fine Arts, Boston (*Romans and Barbarians*, pp. 109–110, no. 117, illus.); Metropolitan Museum of Art, New York (J.D. Breckenridge, in Weitzmann, *Spirituality*, p. 21, no. 14, illus.).

381. MAN OF INTELLECT, POSSIBLY SAINT PAUL (62.465)
MFA *Handbook*, pp. 130–131, illus.; P. Kranz, *AA*, 1979, pp. 95–96, n. 123.

Exhibited: Museum of Fine Arts, Boston (*Romans and Barbarians*, pp. 172–173, no. 192,

illus.); Metropolitan Museum of Art, New York (J.D. Breckenridge, in Weitzmann, *Spirituality*, pp. 291–292, no. 270, illus.).

382. MUNICIPAL MAGISTRATE (1971.18)
S. Sande, *ACTA ad Archaeologiam et Artium Historiam Pertinentia* VI (1975), pp. 91–92, pl. 12, figs. 41–42; Inan and Alföldi-Rosenbaum, *Porträtplastik*, pp. 28–29; K.T. Erim, in ibid., pp. 233 (n. 2), 235–236 (no. 207), 237, 239, pl. 263, figs. 1–3; H. Manderscheid, *Die Skulpturenausstattung der kaiserzeitlichen Thermenanlagen* (Berlin, 1981), p. 98, no. 248, pl. 33; J. Meischner, *BonnJb* 181 (1981), pp. 161–164, fig. 6; R. Özgan and D. Stutzinger, *IstMitt* 35 (1985), pp. 269–273; K.T. Erim, *Aphrodisias: City of Venus Aphrodite* (New York, 1986), p. 44.

Exhibited: Museum of Fine Arts, Boston (*Romans and Barbarians*, pp. 175–176, no. 193, illus.).

Etruscan Sculpture

383. SARCOPHAGUS AND LID (86.145a–b)
R. Bianchi Bandinelli, in *EAA*, vol. 3, p. 487; R. Lullies, *Vergoldete Terrakotta-Appliken aus Tarent* (*RM* suppl. 7, 1962), p. 76, n. 182; O.-W. von Vacano, *RM* 82 (1975), p. 221, n. 21; Torelli, *Elogia*, p. 53, n. 2; Sprenger and Bartoloni, *Etrusker*, pp. 38, 60, 143, pl. 209; Brendel, *Etruscan Art*, pp. 382–386, 389, figs. 294, 300; Foerst, *Gravierungen*, p. 27; Alvarez, *Celestial*, pp. 51, 266, fig. 29; Vermeule, *Death*, p. 146, fig. 1; F. Baratte and C. Metzger, in Amiet, *Handbook*, p. 462, no. 51, illus.; Riis, *Heads*, p. 65; Vermeule, *Sculpture in America*, p. 14; E. Mavleev, in *LIMC*, vol. 1, pt. 1, p. 659, no. 35; vol. 1, pt. 2, pl. 532; Froning, *Marmor-Schmuckreliefs*, pp. 86–87, n. 30; Dohrn, *Etruskische Kunst*, p. 90; Sprenger and Bartoloni, *Etruscans*, pp. 36, 58, 137–138, pl. 209; Haynes, *Etruscan Bronzes*, p. 79; Cristofani, *Etruschi*, p. 297, under no. 122; C. Weber-Lehmann, *RM* 92 (1985), p. 32, n. 79; J.P. Small, *RM* 93 (1986), p. 92, n. 121; Freytag Gen. Löringhoff, *Telamon*, pp. 146–147; H.-G. Buchholz, *JdI* 102 (1987), pp. 21–22, 53–54, no. 3, fig. 13; C. Vermeule, *GettyMusJ* 15 (1987), p. 31, n. 9.

384. SARCOPHAGUS AND LID (1975.799)
R. Bianchi Bandinelli, in *EAA*, vol. 3, p. 487; L. Reekmans, in ibid., pp. 83–84; M. Cristofani, *Dialoghi di Archeologia* 1 (1967), p. 294; L.B. Warren, *Archaeology* 26 (1973), p. 248, illus.; G. Hafner, *Aachener Kunstblätter* 45 (1974), pp. 35–36, fig. 35; Torelli, *Elogia*, p. 53, n. 2; Bonfante, *Etruscan Dress*, pp. 39, 182–183, figs. 84–85; F.R. Serra Ridgway, *ArchCl* 27 (1975), p. 422; J. Neils, *RM* 83 (1976), p. 21; MFA *Handbook*, pp. 112–113, illus.; Colledge, *Palmyra*, p. 288, n. 495; M.A. Littauer and J. Crouwel, *Antiquity* 51 (1977), pp. 102–103, pl. 11; B.M. Felletti Maj, *La tradizione italica nell' arte romana* (Rome, 1977), p. 88, pl. 2, figs. 4a–c; Sprenger and Bartoloni, *Etrusker*, pp. 38, 60, 143, pl. 208; Alvarez, *Celestial*, pp. 114, 216, 267, fig. 42; A.M. McCann, *Roman Sarcophagi in The Metropolitan Museum of Art* (New York, 1978), p. 127, fig. 163; Brendel, *Etruscan Art*, pp. 381–382, 389, figs. 293, 299; Vermeule, *Roman Art*, pp. 21–23, 36, 187, 243, figs. 27–28; Steingräber, *Möbel*, pp. 36 (n. 160), 50, 61, 255–256 (no. 308), pl. 15, fig. 1; Riis, *Heads*, p. 65; M. Schleiermacher, *Boreas* 4 (1981), p. 68; Vermeule, *Sculpture in America*,

p. 14; Froning, *Marmor-Schmuckreliefs*, pp. 86–87, n. 30; N.T. de Grummond, in de Grummond, *Etruscan Mirrors*, pp. 180–181, fig. 115; Dohrn, *Etruskische Kunst*, p. 90; Höckmann, *San Mariano*, pp. 32, 144 (no. E14), 147, 149, 153, 155; R. Stupperich, *Boreas* 6 (1983), p. 144; Richardson, *Votive Bronzes*, p. 238; Sprenger and Bartoloni, *Etruscans*, pp. 36, 58, 137–138, pl. 208; W.G. Moon, in W.G. Moon, ed., *Ancient Greek Art and Iconography* (Madison, Wisconsin, 1983), p. 109; G. Davies, *AJA* 89 (1985), p. 632; Haynes, *Etruscan Bronzes*, p. 79; C. Weber-Lehmann, *RM* 92 (1985), p. 32, n. 79; L. Bonfante, in *Etruscan Life and Afterlife: A Handbook of Etruscan Studies* (Detroit, 1986), pp. 237, 257, fig. VIII-4; Hostetter, *Spina*, p. 51, under no. 26; Freytag Gen. Löringhoff, *Telamon*, pp. 36 (n. 74), 146–147, 157 (n. 626); H.-G. Buchholz, *JdI* 102 (1987), pp. 21–22, 53–54, no. 4, fig. 14.

385. SARCOPHAGUS OR LARGE URN WITH COVER (13.2860)
K. Schauenburg, *RM* 87 (1980), p. 44, n. 122.

387. LEOPARD (61.130)
MFA *Handbook*, pp. 84–85, illus.; Hus, *Civiltà Arcaica*, pp. 41–42, no. 14, pl. 14e; M.A. Del Chiaro, *GettyMusJ* 5 (1977), pp. 53–54, fig. 19; Hornbostel, *Etrusker*, p. 56, under no. 58 (this and nos. 388–393).

388. LEOPARD (63.2756)
Hus, *Civiltà Arcaica*, p. 42, no. 15, pl. 14f.

389. LEOPARD (63.2757)
Hus, *Civiltà Arcaica*, pp. 42–43, no. 17, pl. 14c; M.A. Del Chiaro, *GettyMusJ* 5 (1977), p. 54.

390. LION (61.131)
Hus, *Civiltà Arcaica*, p. 44, no. 23, pl. 14d; M.A. Del Chiaro, *GettyMusJ* 5 (1977), p. 47, n. 12.

391. HIPPOCAMP (62.793)
Hus, *Civiltà Arcaica*, p. 41, no. 12, pl. 14a.

392. SPHINX (63.2758)
Hus, *Civiltà Arcaica*, p. 39, no. 6, pl. 13a; M.A. Del Chiaro, *GettyMusJ* 5 (1977), pp. 45–46 (n. 5), 47 (n. 9); M.D. Fullerton, *RM* 89 (1982), p. 15, no. 56.

393. SPHINX (63.2759)
Hus, *Civiltà Arcaica*, p. 40, no. 8, pl. 13b; M.D. Fullerton, *RM* 89 (1982), p. 15, n. 56.

Palmyrene Sculpture

395. BUST OF A MAN IN HIGH RELIEF (10.76)
MFA *Handbook*, pp. 128–129, illus.; Colledge, *Palmyra*, p. 247, entry B:a; Vermeule, *Roman Art*, pp. 105, 146, 161, 199, 373, fig. 156.

396. BEARDED HEAD IN HIGH RELIEF (96.682)
Colledge, *Palmyra*, p. 251, entry U:a.

397. HEAD OF A PRIEST IN HIGH RELIEF (10.74)
Colledge, *Palmyra*, p. 252, entry N.

398. HEAD OF A PRIEST (95.1970)
Exhibited: Museum of Fine Arts, Boston (*Romans and Barbarians*, p. 47, no. 62, illus.).

399. BUST OF A MAN IN HIGH RELIEF (10.79)
Colledge, *Palmyra*, p. 250, entry Q:a.

401. BUST OF A WOMAN IN HIGH RELIEF (22.659)
Colledge, *Palmyra*, p. 259, entry O:b; MFA

review, January 1977, illus.; Parlasca, *Proceedings*, p. 307; idem, *TrWPr* 3 (1981), pp. 9, 25 n. 65; with ref. to M.A.R. Colledge, *East and West* 29 [1979], 234, 237, 238, fig. 19); J. Ogden, *Jewellery of the Ancient World* (New York, 1982), p. 18, pl. 1 (color); A.R. Gup and R.S. Spencer, in T. Hackens and R. Winkes, *Gold Jewelry: Craft, Style & Meaning from Mycenae to Constantinopolis* (Louvain, 1983), p. 114 (fig. 14), 121–122; K. Parlasca, *RM* 92 (1985), p. 352, pl. 149, fig. 2.
Exhibited: Museum of Fine Arts, Boston (*Romans and Barbarians*, pp. vi [color illus.], 45–46 no. 61, illus.]).

403. BUST OF A WOMAN IN HIGH RELIEF (10.77)
Colledge, *Palmyra*, p. 259, entry K:a.
Exhibited: Birmingham Museum of Art, 1976–1987 (Farmer, *Festival*, no. 28).
Deaccessioned 1986 (*Museum Year: 1985–1986*, p. 49).

404. HEAD OF A WOMAN IN HIGH RELIEF (10.71)
Colledge, *Palmyra*, p. 257, entry H:b.

405. HEAD OF A WOMAN IN HIGH RELIEF (10.72)
Colledge, *Palmyra*, p. 264, entry L:e.

406. FUNERARY OR VOTIVE RELIEF: MEN PLAYING A BOARD GAME (1970.346)
Vermeule, *Death*, pp. 79–81, fig. 34.

Cypriote Sculpture

420. A GOD, HERO, OR VOTARY (72.322)
MFA Handbook, pp. 86–87, illus.

426. FRAGMENT OF THE BODY (AND WING) OF A SPHINX (Apparatus 1960)
A. Hermary, *Amathonte*, vol. 2, *Testimonia*, pt. 2: *La Sculpture* (Paris, 1981), pp. 9, 57, no. 56.

427. APHRODITE OR A VOTARY (72.327)
Exhibited: Birmingham Museum of Art, 1976–1980 (Farmer, *Festival*, no. 2).

433. HEAD OF A GOD OR YOUTH (72.323)
Bol, *Bildwerke*, p. 18, under no. 3.

436. PRIEST OR VOTARY (72.326)
Exhibited: National Museum of Western Art, Tokyo (*Human Figures*, no. 9, illus.).

441. PRIEST OR VOTARY (72.325)
Vermeule, *Cyprus*, pp. 19–20, 39 (n. 8), 43, fig. 15; Bol, *Bildwerke*, p. 18, under no. 3.

447. GODDESS OR VOTARY (72.328)
C. Vermeule, *GettyMusJ* 6/7 (1978–1979), pp. 97, 99, fig. 3; A. Hermary, *Report of the Department of Antiquities Cyprus, 1982* (Nicosia, 1982), p. 170, no. 53.

450. PTOLEMAIC KING OR OFFICIAL (72.336)
Vermeule, *Cyprus*, pp. 55–56, 66 (n. 23), 68, fig. II.21; C.C. Lorber, in *Hunt Collections*, p. 188, under no. 107.

452. AN OFFICIAL OR AN IDEALIZED PTOLEMAIC KING (72.335)
Exhibited: Museum of Fine Arts, Boston (*Second Greatest Show*, p. 11, no. 7).

454. BERENIKE II (72.329)
Vermeule, *Cyprus*, pp. 55, 65 (n. 22), 68, fig. II.20.

463. AUGUSTUS (1971.325)
Vermeule, *Cyprus*, pp. 72, 93 (n. 5), 99, fig. III.1; F. Johansen, in *Studia Romana in honorem Petri Krarup septuagenarii* (Odense, 1976), p.

57, n. 23; C. Vermeule, *AJA* 86 (1982), p. 244, n. 10.

Post-Classical Sculpture

465. HEAD OF A DACIAN (13.2722)
Türr, *Fälschungen*, pp. 149, 208–209 (no. RK16, illus.), 229.
Exhibited: Minneapolis Institute of Arts, 11 July–29 September 1973 (*Fakes and Forgeries*, Minneapolis, 1973, no. 18, illus.); Museum of Fine Arts, Boston (*Romans and Barbarians*, p. 238, no. 284, illus.).

Supplementary Bibliography for *Greek, Etruscan, and Roman Bronzes*

Greek Statuettes

1. VOTARY (64.2173)
Exhibited: Ackland Memorial Art Center, Chapel Hill (R.F. Townsend, in Sams, *Small Sculptures*, no. 2, illus.).

2. ZEUS AND HERA (?) (63.2755)
P. Zancani Montuoro, *Klearchos* 29–32 (1966), p. 221; K. Fittschen, *Untersuchungen zum Beginn der Sagendarstellungen bei den Griechen* (Berlin, 1969), p. 133, no. GP1; D.G. Mitten, *AJA* 74 (1970), p. 108; C. Rolley, *AJA* 78 (1974), p. 99; Schanz, *Sculptural Groups*, p. 8.

3. DEER AND FAWN (98.650)
R. Carpenter, *Greek Art* (Philadelphia, 1962), p. 60, fig. 12; D.G. Mitten, *AJA* 69 (1965), p. 280; S. Cheney, *Sculpture of the World: A History* (New York, 1968), p. 95, illus.; D. Pickman, *Curator* 12, no. 4 (1969), p. 241; A. Roes, *RA*, 1970, pp. 203–204, fig. 25; B. Schweitzer, *Greek Geometric Art* (New York, 1971), p. 152, pl. 189; Hoffmann, *Ten Centuries*, pp. 126 (under no. 43), 148 (under no. 69); J.-J. Maffre, *BCH* 99 (1975), p. 415; MFA *Handbook*, pp. 76–77, illus.; Coldstream, *Geometric*, p. 206; Boardman, *Archaic*, pp. 10, 30, fig. 9; B. Fellmann, *JdI* 93 (1978), pp. 28–29, n. 152; F. Hiller, *JdI* 94 (1979), p. 28, n. 25; P.J. Connor, in *Festschrift Trendall*, p. 65; Heilmeyer, *Tiervotive*, pp. 89 (n. 124), 106 (n. 144, no. c10), 150 (n. 193), 151 (n. 197); Himmelmann, *Hirten-Genre*, p. 36; Schmaltz, *Metallfiguren*, pp. 42 (n. 81), 100, 137 (n. 284); Philipp, *Bronzeschmuck*, p. 143, n. 345; Hampe and Simon, *Greek Art*, pp. 236, 253, 306, pl. 385; H. Jucker, *Quaderni ticinesi di numismatica e antichità classiche* 10 (1981), p. 46; F. Johansen, *MedKøb* 38 (1982), p. 87; Barron, *Greek Sculpture*, pp. 10–11, illus.; Weill, *Études Thasiennes*, p. 49, n. 5; Carter, *Ivory-Carving*, pp. 91, 111, n. 77.

4. FOUR SHEEP (58.1189)
Di Stefano, *Palermo*, p. 60, under no. 100; A. Keck, in Sams, *Small Sculptures*, under no. 5; F. Hiller, *JdI* 94 (1979), p. 29, n. 30; Heilmeyer, *Tiervotive*, p. 183, n. 223; Himmelmann, *Hirten-Genre*, p. 37.

5. HORSE (65.1316)
Hoffmann, *Ten Centuries*, p. 126, under no. 43.

6. HORSE (65.1292)
B. Fellmann, *JdI* 93 (1978), pp. 28–29, n. 152; Williams, *Johns Hopkins*, p. 36, under no. 22, n. 1.

7. HORSE (62.511)
Hoffmann, *Ten Centuries*, p. 120, under no. 38; Heilmeyer, *Tiervotive*, pp. 103 (n. 139), 108.

8. HORSE STANDING ON RING (65.101)
R.C.S. Felsch, *AA*, 1980, p. 60, n. 93; I. Kilian-Dirlmeier, in Philipp, *Bronzeschmuck*, p. 349, n. 578.

11. BIRD (64.1460)
Hoffmann, *Ten Centuries*, p. 130, under no. 48; Mitten, *Classical Bronzes*, pp. 26 (under no. 7),

28 (n. 17); D.K. Hill, *AJA* 81 (1977), p. 120; F. Johansen, *MedKøb* 38 (1982), p. 97, n. 60; Weill, *Études Thasiennes*, p. 52, n. 2.

15. MANTIKLOS "APOLLO" (03.997)
AJA 11 (1896), p. 250; W. Deonna, *Les "Apollons Archaïques"* (Geneva, 1909), p. 254, n. 5; E. Langlotz, in *Festschrift Amelung*, p. 117; R. Lullies, *JdI* 51 (1936), p. 146; L. Curtius, *Die Antike Kunst*, vol. 2, pt. 1 (Potsdam, 1938), pp. 80, 84, 91, 97, 100, 102, 139, 171–175, 179–181, 183, 190, 290, 292, fig. 108; L. Quarles van Ufford, *BABesch* 19 (1944), p. 11; G.E. Mylonas, *AJA* 49 (1945), p. 562; Karo, *Greek Personality*, pp. 70–71; G.M.A. Richter, *Archaic Greek Art* (New York, 1949), p. 22; D. von Bothmer, *AJA* 57 (1953), p. 40; A. De Franciscis, in *EAA*, vol. 1, p. 464, fig. 629; E. Lissi, in *EAA*, vol. 2, p. 145; K. Levin, *AJA* 68 (1964), p. 16; G. Kaschnitz von Weinberg, *Mittelmeerische Kunst: eine Darstellung ihrer Strukturen (Ausgewählte Schriften*, vol. 3, Berlin, 1965), pp. 270, 272–274, 277–278, 281, 290, pl. 61; A. Schachter, *BICS* 14 (1967), p. 3; M. Bieber, *AJA* 71 (1967), p. 377; E. Kjellberg and G. Säflund, *Greek and Roman Art: 3000 B.C. to A.D. 500* (London, 1968), p. 57, pl. 22; B. d'Agostino, *ArchCl* 20 (1968), p. 378; D. Pickman, *Curator* 12, no. 4 (1969), p. 241; Fuchs, *Skulptur*, pp. 21 (figs. 3–4), 22–25, 154; H. Hoffmann, *AA*, 1969, p. 344; D.G. Mitten, *AJA* 74 (1970), pp. 109–110; Boucher, *Lyon Bronzes*, p. 17, n. 1; R. Brilliant, *The Arts of the Ancient Greeks* (New York, n.d.), p. 44, fig. 2–40; C. Rolley, *RA*, 1970, p. 134; F. Canciani, *ArchCl* 24 (1972), p. 425; G. Pfohl, *ArchCl* 25–26 (1973–1974), p. 545; C. Rolley, *AJA* 78 (1974), p. 98; N. Himmelmann-Wildschütz, *AA*, 1974, p. 541; Freyer-Schauenburg, *Bildwerke*, p. 71, under no. 35; Mitten, *Classical Bronzes*, pp. 37–38 (under no. 11), 40 (n. 17); A. Lebessi, *BSA* 70 (1975), p. 171; G. Phylactopoulos, ed., *History of the Hellenic World: The Archaic Period* (University Park, 1975), p. 383; M.K. Langdon, *A Sanctuary of Zeus on Mount Hymettos* (Princeton, 1976), p. 45; MFA *Handbook*, pp. 78–79, illus.; L.H. Jeffery, *Archaic Greece: The City-States, c. 700–500 B.C.* (New York, 1976), p. 78, pl. 7; Pedley, *Island Workshops*, p. 20; M.K. Langdon and L.V. Watrous, *Hesperia* 46 (1977), p. 165, n. 7; Ridgway, *Archaic*, pp. 27 (n. 16), 55 (n. 12); Coldstream, *Geometric*, p. 302; Boardman, *Archaic*, pp. 10, 30, fig. 10; Devambez, *Great Sculpture*, pp. 90–91, illus.; D.K. Hill, in *Festschrift von Blanckenhagen*, p. 248, n. 10; Lullies, *Griechische Plastik*, pp. 16, 42, no. 10, pl. 10; Houser, *Dionysos*, p. 12; M.R. Popham, L.H. Sackett, and P.G. Themelis, eds., *Lefkandi*, vol. 1: *The Iron Age* (London, 1980), pp. 91, 378, n. 13; Biers, *Greece*, pp. 136–137, fig. 6.12; E. Walter-Karydi, *AntK* 23 (1980), p. 4; A. Pasquier, in Amiet, *Handbook*, p. 368, no. 137, illus.; *Masterpieces*, no. 13, color illus.; Hampe and Simon, *Greek Art*, pp. 256, 277, 307, pls. 427–428; Vermeule, *Prehistoric through Perikles*, pp. 80, 83–85, 217, 377–379, fig. 138; P. Blome, *Die figürliche Bildwelt Kretas in der geometrischen und frūharchaischen Periode* (Mainz, 1982), p. 52; A.C. Brookes, *AA*, 1982, p. 610; S. Besques, *AntK* 26 (1983), p. 25; Richardson, *Votive Bronzes*, pp. 34 (n. 62), 37, 100 (n. 19); Barron, *Greek Sculpture*, pp. 10–11, illus.; O. Palagia and W. Lambrinudakis, in *LIMC*, vol. 2, pt. 1, pp. 194, 314, no. 40; vol. 2, pt. 2, pl. 185; R.R. Holloway, *Gnomon* 56 (1984), p. 789; P.C. Bol, *Antike Bronze-*

technik: Kunst und Handwerk antiker Erzbildner (Munich, 1985), p. 207, n. 147; idem, in Bol and Weber, *Bildwerke*, p. 48, under no. 13; Carter, *Ivory-Carving*, pp. 179 (n. 50), 192 (n. 148); F. Brommer, *JdI* 101 (1986), p. 41; Houser, *Bronze Sculpture*, p. 162, n. 5.

16. MAN AND WOMAN IN OXCART (58.696)
Himmelmann, *Hirten-Genre*, p. 61, n. 156; Höckmann, *San Mariano*, pp. 32, 135 (no. G5), 139, 141.

19. ARTEMIS (98.658)
Karo, *Greek Personality*, p. 154; E. Lissi, in *EAA*, vol. 2, p. 145; M.W. Stoop, *BABesch* 39 (1964), pp. 85–87, no. 6, fig. 3; C. Davaras, *Die Statue aus Astritsi* (*AntK*, suppl. 8, Bern, 1972), p. 63; Freyer-Schauenburg, *Bildwerke*, p. 15, under no. 2A-C; M. Jost, *BCH* 99 (1975), p. 349, n. 41; G. Ortiz, in Dörig, *Art Antique*, under no. 177; H. Gropengiesser, *AA*, 1975, p. 237; Robertson, *History*, pp. 101, 142, 630, n. 62, pl. 44d; MFA *Handbook*, pp. 82–83, illus.; M.W. Stoop, *BABesch* 55 (1980), p. 176; Congdon, *Caryatid Mirrors*, p. 84; S. Besques, *AntK* 26 (1983), p. 25; Richardson, *Votive Bronzes*, pp. 61 (n. 61), 248 (n. 10); W. Gauer, *AM* 99 (1984), p. 43; L. Kahil and N. Icard, in *LIMC*, vol. 2, pt. 1, p. 630, no. 81; vol. 2, pt. 2, pl. 448; B.S. Ridgway, *GettyMusJ* 12 (1984), p. 40 (with additional bibliography); Weill, *Études Thasiennes*, pp. 170 (n. 1, as 95.658), 201–202; Morrow, *Footwear*, pp. 26, 189–190, n. 18; F. Brommer, *JdI* 101 (1986), pp. 39–40; Walter-Karydi, *Bildhauerschule*, p. 62 (no. 9), 64–65 (figs. 81–83).

20. ATHENA PROMACHOS (54.145)
C. Picard, *La Sculpture Antique* (Paris, 1926), vol. 2, p. 10; H. Herdejürgen, *AntK* 12 (1969), p. 107, n. 32; MFA *Handbook*, pp. 88–89, illus.; Shefton, *Phönizier*, p. 362, n. 70; Richardson, *Votive Bronzes*, p. 347, n. 76.

21. HERAKLES SHOOTING HIS BOW (98.657)
J. Boardman, in *Festschrift Schauenburg*, p. 132, n. 12.

22. HERMES KRIOPHOROS (04.6)
L. Byvanck-Quarles van Ufford, *BABesch* 30 (1955), p. 59; H. Sichtermann, in *EAA*, vol. 4, pp. 2, 4, 7, fig. 3; Mitten, *Classical Bronzes*, p. 44, under no. 12, n. 6; MFA *Handbook*, pp. 86–87, illus.; Gauer, *Olympia*, p. 153, n. 148; D.G. Mitten, in *Mildenberg Collection*, p. 129, under no. 108; Hanhisalo, *Enjoying Art*, pp. 173–174, fig. 122; Morrow, *Footwear*, p. 39, 192, n. 50.

23. HERMES KRIOPHOROS (99.489)
Hyde, *Victor Monuments*, p. 108; Poulsen, *Einzelaufnahmen*, col. 29, under nos. 3760 and 3761; H.G. Beyen and W. Vollgraff, *Argos et Sicyone* (The Hague, 1947), p. 57; Karo, *Greek Personality*, p. 140; D. von Bothmer, *AJA* 57 (1953), p. 40; L. Byvanck-Quarles van Ufford, *BABesch* 30 (1955), p. 59; A.W. Byvanck, *BABesch* 36 (1961), p. 81; *EAA*, vol. 4, p. 2, fig. 3; Fuchs, *Skulptur*, pp. 42–43, figs. 27–28; G.K. Jenkins, *The Coinage of Gela* (Berlin, 1970), p. 47, pl. 40, fig. 2; C. Vermeule, in MFA *Western Art*, pp. 161–162, color pl. 12; Wallenstein, *Korinthische Plastik*, p. 191, n. 410; H.-V. Herrmann, *Olympia Heiligtum und Wettkampf-stätte* (Munich, 1972), p. 245, n. 459; F.K. Fall, *Art Objects: Their Care and Preservation* (La Jolla, 1973), p. 142, fig. 76; C. Rolley, *AJA* 78 (1974), p. 99; H.B. Jessen, in *Mélanges Mansel*, vol. 1, p. 626; Devambez,

Great Sculpture, pp. 90–91, illus.; D.G. Mitten, in *Mildenberg Collection*, p. 129, under no. 108; Gauer, *Olympia*, p. 159, n. 176; Vermeule, *Prehistoric through Perikles*, pp. 136–137, 224 443–444, fig. 193; MFA *Art in Bloom*, 1983, p. 113, illus.; Morrow, *Footwear*, pp. xxi, 35 (pl. 34), 41, 192 (n. 59); Walter-Karydi, *Bildhauerschule*, pp. 23 (fig. 17), 95.

24. HERM
C.H. Greenewalt, Jr., in *Festschrift Hanfmann*, p. 44, n. 46; H. Hoffmann, in Muscarella, *Schimmel Collection*, no. 27, illus.; Mitten, *Classical Bronzes*, p. 45, under no. 12, n. 9; U. Gehrig, in *Von Troja bis Amarna: The Norbert Schimmel Collection New York* (Mainz, 1978), no. 28, illus.; Petit, *Dutuit*, p. 106, under no. 41, n. 3.

25. HEAD OF A YOUTH (95.74)
F. Studniczka, in *Festschrift Amelung*, p. 246; Poulsen, *Einzelaufnahmen*, col. 28, under nos. 3758 and 3759; Karo, *Greek Personality*, p. 155; M. Weber, *AM* 89 (1974), pp. 40–41; H.A. Cahn, *Kleine Schriften zur Münzkunde und Archäologie* (Basel, 1975), p. 108; H. Jucker, in *In Memoriam–Otto J. Brendel: Essays in Archaeology and the Humanities* (Mainz, 1976), p. 33; Boardman, *Archaic*, pp. 76, 116, fig. 122; Bol, *Grossplastik*, p. 8; I. Caruso, *RM* 88 (1981), p. 84, n. 202; Congdon, *Caryatid Mirrors*, p. 48; R.R. Holloway, *Art and Coinage in Magna Graecia* (Bellinzona, n.d.), pp. 37, 95 illus.

26. YOUTH (34.211)
Quilici and Quilici Gigli, *Antemnae*, p. 84, n. 426.

27. YOUTH (03.996)
Wallenstein, *Korinthische Plastik*, pp. 80, 82, 156, no. VII/B28, pl. 26, fig. 4; Mitten, *Classic Bronzes*, p. 38, under no. 11, n. 1; C.C. Mattusch, *Archaeology* 27 (1977), p. 329, illus.; Congdon, *Caryatid Mirrors*, p. 98 (as 09.336); Quilici and Quilici Gigli, *Antemnae*, p. 84, n. 426; Houser, *Bronze Sculpture*, p. 51, nn. 25–26.

28. YOUTH (99.488)
Houser, *Bronze Sculpture*, p. 51, nn. 25–26.

29. YOUTH (APOLLO ?) (01.7481)
Hostetter, *Spina*, p. 64, under no. 33, n. 307.

30. YOUTH (66.251)
Hostetter, *Spina*, p. 92, under no. 58, n. 400.

32. YOUTH ON HORSEBACK (03.993)
H. Hoffmann, in Muscarella, *Schimmel Collection*, under no. 26 bis; Thomas, *Athletenstatuetten*, p. 67, pl. 28, fig. 1; J.S. Østergaard, *MedKøb* 41 (1985), p. 54, n. 34; idem, *MedKøb* 42 (1986), p. 99.

33. YOUTH ON GALLOPING HORSE (98.659)
H. Payne and G.M. Young, *Archaic Marble Sculpture from the Acropolis* (London, n.d.), p. 7, n. 4; M. Bieber, *AJA* 74 (1970), p. 91; H. Hoffmann, in Muscarella, *Schimmel Collection*, under no. 26 bis; Thomas, *Athletenstatuetten*, pp. 65–66, 160, n. 777, pl. 25, fig. 2.

34. HORSEMAN (01.7486)
G.K. Sams, in Sams, *Small Sculptures*, under no. 9; D.K. Hill, *AJA* 81 (1977), p. 121.

35. SPHINX (51.2469)
J.C. Wright, *Hesperia* 46 (1977), p. 252, n. 27; Carter, *Ivory-Carving*, p. 266, n. 30.

36. GRIFFIN (96.665)
Hoffmann, *Ten Centuries*, p. 160, under no. 7; Herrmann, *Kessel*, pp. 202 (nn. 43, 47), 206 (n. 8).

39. Fragment of a Limestone Pedestal in the Shape of a Capital (01.8214)
U. Gehrig, *Jahrbuch der Berliner Museen*, 1975, p. 50, nn. 19, 25; A. Landi, *Dialetti e Interazione Sociale in Magna Grecia* (Naples, 1979), p. 295, no. 178, pl. 63; D. Loiacono, in E. De Juliis and D. Loiacono, *Taranto: Il Museo Archeologico* (Taranto, 1985), p. 285.

40. Athena (98.670)
P. Demargne, in *LIMC*, vol. 2, pt. 1, p. 972, no. 147; vol. 2, pt. 2, pl. 721; R. Tölle-Kastenbein, *Frühklassische Peplosfiguren: Typen und Repliken* (Antike Plastik, vol. 20, Berlin, 1986), p. 20, n. 19.

41. Warrior (01.7507)
F. Brommer, *JdI* 101 (1986), p. 41.

42. Diskobolos (01.7480)
Thomas, *Athletenstatuetten*, pp. 32, 35, 37–38, 57–58, 84, 163, pl. 12, figs. 1–2; A. Hermary, *Exploration archéologique de Délos*, fasc. 34: *La Sculpture archaïque et classique* (Paris, 1984), p. 13; Oggiano-Bitar, *Bouches-du-Rhône*, p. 50, under no. 45.

43. Diskophoros (support for a mirror) (96.706)
F.H. Robinson, *MAAR* 7 (1929), pp. 161–162; L. Alscher, *Götter vor Gericht* (Berlin, 1963), pp. 77, 114 (n. 136), fig. 56; G. Schneider-Herrmann, *BABesch* 45 (1970), pp. 40, 46, fig. 5; M. Sprenger, *Die etruskische Plastik des V. Jahrhunderts v. Chr. und ihr Verhältnis zur griechischen Kunst* (Rome, 1972), p. 79; Langlotz, *Nordostgriechischen Kunst*, p. 154, n. 5; W.D.E. Coulson and D. Furmanik, *Antike Plastik* 17 (1978), p. 72, n. 4; P. Kranz, *RM* 85 (1978), pp. 224 (n. 79), 225 (n. 83); B.K. Hamanaka, in *Ancient Greece*, p. 210, under no. 102, n. 3; I. Caruso, *RM* 88 (1981), pp. 51–52 (E12), 93–94; Congdon, *Caryatid Mirrors*, pp. 50, 218 (under no. 127), 226; E. Paribeni, *Atti e Memorie della Società Magna Grecia* 21–23 (1980–1982), p. 182.

46. Youth Taking an Oath (01.7475)
G. Sassatelli, in *Prima Italia*, p. 165, under no. 112; I. Caruso, *RM* 88 (1981), p. 77, n. 151; Thomas, *Athletenstatuetten*, p. 95, n. 414.

47. Youth Taking an Oath (01.7476)
Thomas, *Athletenstatuetten*, p. 98, n. 435.

48. Youth Putting a Weight (01.7487)
Hostetter, *Spina*, p. 80, under no. 45, n. 372.
Exhibited: Brockton Art Center, 2 October 1972–1 July 1973.

49. Youth (34.223)
Exhibited: Brockton Art Center, 2 October 1972–1 July 1973; Ackland Memorial Art Center, Chapel Hill (R.F. Rhodes, in Sams, *Small Sculptures*, no. 22, illus.).

50. Youth (96.709)
Hostetter, *Spina*, p. 96, under no. 60.

51. Stooping Youth (96.710)
P. Zancani Montuoro, *Stockholm Studies in Classical Archaeology* 5 (1968), p. 21; H.A. Harris, *Sport in Greece and Rome* (London, 1972), p. 116, pl. 55; A. Linfert, *Antike Plastik* 12 (1973), p. 87; M. Vickers, *JHS* 95 (1975), p. 237; Thomas, *Athletenstatuetten*, p. 71, pl. 30; Cristofani, *Etruschi*, p. 255, under no. 4.5; Hostetter, *Spina*, p. 142; Gschwantler, *Guss*, p. 116, under no. 163.
Exhibited: Ackland Memorial Art Center, Chapel Hill (J.B. Adler, in Sams, *Small Sculptures*, no. 21, illus.).

52. Satyr (98.669)
F.H. Robinson, *MAAR* 7 (1929), p. 161, pl. 9, fig. 3; E. Kunze, in *IV. Bericht über die Ausgrabungen in Olympia* (Berlin, 1944), p. 142; Höckmann, *Kassel*, p. 21, under no. 23; Di Stefano, *Palermo*, p. 46, under no. 77; K. Schefold, "Klassische Statuette aus Elfenbein," *ΣΤΗΛΗ* (Athens, 1978), pp. 113–114.

53. Silen or Satyr (67.643)
Höckmann, *Kassel*, p. 21, under no. 23; Di Stefano, *Palermo*, p. 46, under no. 77.

54. Girl with a Dove (01.7497)
Thomas, *Athletenstatuetten*, pp. 152 (n. 739), 155 (n. 752, as 10.7497); A. Delivorrias et al., in *LIMC*, vol. 2, pt. 1, p. 26, no. 168; vol. 2, pt. 2, pl. 19; A. Oliver, Jr., in *Bastis Collection*, p. 182.

55. Girl with Offering (98.668)
Fuchs, *Skulptur*, pp. 185–186, figs. 195–196; Arnold, *Polykletnachfolge*, p. 82, n. 308; E. La Rocca, *Annuario* 50–51 (1972–1973), pp. 426–427; E. Walter-Karydi, *JdI* 91 (1976), p. 11, n. 20 (as cat. no. 455); M.A. Minutola, *Dialoghi di Archeologia* 9–10 (1976–1977), p. 411, n. 34; E. Paribeni, in *MNR Sculture*, vol. 1, pt. 1, p. 38, under no. 35; Haynes, *Etruscan Bronzes*, p. 297, under no. 142.

56. Protome of River God (59.552)
H.P. Isler, in *LIMC*, vol. 1, pt. 1, p. 20, under no. 112.

57. Votive Bull (98.663)
K. Herbert, *AJA* 66 (1962), p. 382; Leibundgut, *Westschweiz*, pp. 72–73 (under no. 62), 74 (n. 8); Schmaltz, *Metallfiguren*, pp. 89 (no. 356), 118 (n. 195).

58. Votive Bull (67.743)
Schmaltz, *Metallfiguren*, p. 90, no. 357.

59. Goat (99.491)
S. Boucher, *RA*, 1973, pp. 81–83, fig. 1; C.J. Watson, in Sams, *Small Sculptures*, under no. 26; Leibundgut, *Westschweiz*, p. 72, under no. 62; A. Romualdi, in G. Colonna, ed., *Santuari d'Etruria* (Milan, 1985), p. 161, under no. 9.1.

60. Horse (01.7518)
J. Neils, in *Mildenberg Collection*, p. 128, under no. 107.

61. Aphrodite (04.8)
A. Delivorrias et al., in *LIMC*, vol. 2, pt. 1, p. 63, no. 523; vol. 2, pt. 2, pl. 51.

63. Snake (13.182)
P. Quiri, *NSc* 28 (1974), suppl., p. 296, under no. 362; D.G. Mitten, in *Mildenberg Collection*, p. 179, under no. 161; Weill, *Études Thasiennes*, p. 54, n. 4.
Exhibited: Brockton Art Museum (Herrmann, *Shadow*, pp. 74–75, no. 137).

64. Aphrodite (95.75)
L.M. Gigante, in Sams, *Small Sculptures*, under no. 59; Neumer-Pfau, *Aphrodite-Statuen*, p. 463, n. 750; A. Delivorrias et al., in *LIMC*, vol. 2, pt. 1, p. 53, no. 415.

65. Aphrodite (00.313)
Mitten, *Classical Bronzes*, p. 75, under no. 20, n. 7; L.M. Gigante, in Sams, *Small Sculptures*, under no. 59; Neumer-Pfau, *Aphrodite-Statuen*, p. 463, n. 750; A. Delivorrias et al., in *LIMC*, vol. 2, pt. 1, pp. 52–53, no. 414; vol. 2, pt. 2, pl. 39.

66. Centaur (63.1039)
E. Schwinzer, *Schwebende Gruppen in der Pompejanischen Wandmalerei* (Beiträge zur Archäologie 11, Würzburg, 1979), p. 184, n. 522; Menzel, *Bonn*, p. 34, under no. 74.

67. Dionysos (03.987)
E. Zwierlein-Diehl, *Gnomon* 53 (1981), p. 795, n. 12; Manfrini-Aragno, *Bacchus*, pp. 69 (no. 2), 70–71, fig. 59; A. Oliver, Jr., in *Bastis Collection*, p. 198.
Exhibited: Cooper-Hewitt Museum, New York, "Wine: Celebration and Ceremony," 4 June–13 October 1985.

68. Head of Dionysos (24.957)
N. Himmelmann, *Drei hellenistische Bronzen in Bonn* (Mainz, Abhandlungen der Geistes- und Sozialwissenschaftlichen Klasse, 1975, no. 2), p. 22, under no. 3; M.G. Raschke, in Temporini and Haase, *Aufstieg*, pt. 2, vol. 9, no. 2, p. 946, n. 1184; Manfrini-Aragno, *Bacchus*, pp. 115 (no. 2), 171, fig. 220.

71. Dioskouros (60.137)
A. Hermary, in *LIMC*, vol. 3, pt. 1, p. 575, under no. 93; A. Oliver, Jr., in *Bastis Collection*, p. 234.

72. Arm from a Statuette (62.978)
C. Rolley, *AJA* 78 (1974), p. 99; D.K. Hill, *Hesperia* 51 (1982), p. 282, no. 2, pl. 77c.

73. Eros (72.4440)
Exhibited: Brockton Art Center (Morgan, *Ancient Mediterranean*, pp. 37–38, no. 39, fig. 15); Danforth Museum, Framingham, "The Mediterranean World," September 1977–March 1978.

74. Nike on Orb (62.971)
T. Hölscher, *Victoria Romana* (Mainz, 1967), p. 14; K. Schauenburg, *GettyMusJ* 2 (1975), p. 65, n. 46; A. Leibundgut, *Die römischen Bronzen der Schweiz*, vol. 2: *Avenches* (Mainz, 1976), p. 48, n. 3; *MFA Preview*, December 1979–January 1980, illus.; C. Vermeule, in *Festschrift Trell*, p. 100, n. 15.
Exhibited: Ackland Memorial Art Center, Chapel Hill (G. Koeppel, in Sams, *Small Sculptures*, no. 67, illus.).

75. Pan (99.490)
D. von Bothmer, in Muscarella, *Schimmel Collection*, under no. 25 bis.

80. Boy (10.166)
A. Adriani, *Studi Miscellanei* 22 (1974–1975), p. 19, n. 14; Petit, *Dutuit*, p. 96, under no. 34, n. 7.
Exhibited: Ackland Memorial Art Center, Chapel Hill (J.C. Anderson, in Sams, *Small Sculptures*, no. 35, illus.).

82. Negro Boy (59.11)
Snowden, *Image*, p. 204, fig. 259; A. Kaufmann-Heinimann, *Die römischen Bronzen der Schweiz*, vol. 1: *Augst* (Mainz, 1977), p. 81, under no. 83; Vermeule, *Socrates to Sulla*, pp. 92, 134, 278–279, fig. 122; Snowden, *Prejudice*, pp. 93, 143, n. 157.

83. Dwarf Seated (34.42)
Himmelmann, *Alexandria*, p. 92.

84. Sleeping Boy (72.4439)
Himmelmann, *Alexandria*, p. 91; Rühfel, *Kind*, p. 357, n. 313.

85. Sleeping Children (10.170)
Rühfel, *Kind*, p. 357, n. 313; Söldner, *Eroten*, p. 570, n. 1421.

87. Queen Arsinoë II (96.712)
Reinach, *Monuments*, vol. 2, p. 228; R. Horn, *RM*, suppl. 2 (1931), p. 59; G.H. Macurdy, *Hellenistic Queens* (Baltimore, 1932), pp. 111–112, fig. 5b; I. Noshy, *The Arts in Ptolemaic Egypt* (London, 1937), p. 94; M.T. Marabini Moevs, in *EAA*, vol. 1, p. 687; E. Lissi, in *EAA*, vol. 2, p. 145; R. Carpenter, *Greek Sculpture*

(Chicago, 1960), pp. 187, 263; A.W. Byvanck, *De Kunst der Oudheid*, vol. 4 (Leiden, 1960), pp. 87, 430, pl. 5, fig. 22; D. McCord, *Poem for the Occasion* ([Boston], 1970), p. 10; C. Vermeule, in MFA *Western Art*, pp. 12, 163, color pl. 17; Di Stefano, *Palermo*, p. 69, under no. 114; Kyrieleis, *Bildnisse*, pp. 89, 91 (n. 365), 105, 111; MFA *Handbook*, pp. 112–113, illus.; Brinkerhoff, *Aphrodite*, pp. 17–18, 53; Vermeule, *Socrates to Sulla*, pp. 72, 81, 129, 234, fig. 90; F.-H. Massa-Pairault, *Recherches sur l'art et l'artisanat étrusco-italiques à l'époque hellénistique* (Rome, 1985), p. 120, figs. 45, 59.

91. HEAD OF A DOG (52.189)
Exhibited: The Dog Museum of America, New York, "Fidoes and Heroes in Bronze," 11 February–3 June 1983.

92. SOW AT BAY (64.510)
Vermeule, *Socrates to Sulla*, pp. 97–98, 136, 296, fig. 137; D.G. Mitten, in *Mildenberg Collection*, p. 163, under no. 144; MFA *Art in Bloom*, 1983, p. 68, illus.
Exhibited: Museum of Fine Arts, Boston (*The Rathbone Years*, p. 41, no. 26, illus.).

Graeco-Roman Statuettes

93. APOLLO (98.674)
Raftopoulou, *Études Delphiques*, pp. 419–420, fig. 9.

94. APOLLO (96.664)
Leibundgut, *Westschweiz*, p. 20, under no. 10, n. 1; E. Simon, in *LIMC*, vol. 2, pt. 1, p. 407, no. 302c; vol. 2, pt. 2, pl. 320.

95. DIVINITY SIMILAR TO THE EPHESIAN ARTEMIS (66.951)
Fleischer, *Artemis*, pp. 25 (no. E83), 90 (n. 3), 104, pl. 43a; idem, in *Festschrift Dörner*, p. 333; idem, in *LIMC*, vol. 2, pt. 1, p. 762, no. 131; vol. 2, pt. 2, pl. 572.

96. ASKLEPIOS (01.7484)
B. Holtzmann, in *LIMC*, vol. 2, pt. 1, p. 888, no. 370; vol. 2, pt. 2, pl. 665.
Exhibited: Brockton Art Center (Morgan, *Ancient Mediterranean*, p. 34, no. 33); Danforth Museum, Framingham, "The Mediterranean World," September 1977–March 1978; Brockton Art Museum (Herrmann, *Shadow*, p. 77, no. 142, illus.).

96A. ASKLEPIOS (67.1025)
B. Holtzmann, in *LIMC*, vol. 2, pt. 1, pp. 880–881, no. 194; vol. 2, pt. 2, pl. 649; Vermeule, *Cult Images*, p. 46, fig. 4.

97. ATHENA (87.7)
RA 27 (1895), p. 253; *AJA* 11 (1896), pp. 133, 511; Reinach, *Monuments*, vol. 1, p. 251; C. Rolley, *AJA* 78 (1974), p. 99; F. Canciani, in *LIMC*, vol. 2, pt. 1, p. 1088, no. 189.

98. ATHENA (03.990)
Leibundgut, *Westschweiz*, p. 50, under no. 44, n. 4; F. Canciani, in *LIMC*, vol. 2, pt. 1, p. 1088, no. 188; vol. 2, pt. 2, pl. 800; Vermeule, *Cult Images*, pp. 61–62, fig. 37.

100. DISPATER (59.692)
C. Rolley, *AJA* 78 (1974), p. 99.
Exhibited: Museum of Fine Arts, Boston (*Romans and Barbarians*, pp. 70–71, no. 97, illus.).

100A. DIONYSOS (69.1257)
C. Vermeule, in *Festschrift Trell*, p. 91; Manfrini-Aragno, *Bacchus*, p. 195, n. 163.

103. HARPOCRATES (59.30)
Menzel, *Aufstieg*, p. 148, n. 141.

104. TRIPLE HEKATE (64.6)
Höckmann, *Kassel*, p. 33, under no. 66; V. Galliazzo, *Bronzi romani del Museo Civico di Treviso* (Rome, 1979), p. 56, under no. 5; Menzel, *Aufstieg*, p. 148, n. 141.

106. HERAKLES (95.76)
A. Furtwängler, *Kleine Schriften*, vol. 2 (Munich, 1913), p. 450; Hornbostel, *Etrusker*, p. 123, under no. 152; Gschwantler, *Guss*, p. 128, under no. 189.

107. HERAKLES (01.8375)
S.H. Wilson, Jr., in Amyx and Forbes, *Echoes*, suppl., p. 27, under no. 36.

108. HERAKLES AND THE "HYDRA" (Res. 08.32g)
AJA 14 (1910), p. 118; Brommer, *Denkmälerlisten*, vol. 1, p. 79; R.G. Leslie, in Sams, *Small Sculptures*, under no. 40.

109. HERMES (03.988)
P. Lebel and S. Boucher, *Bronzes figurés antiques (Musée Rolin)* (Paris, 1975), p. 45, under no. 61; S. Boucher, *BCH* 100 (1976), p. 102, fig. 7; idem, *Recherches*, p. 104, n. 48; Himmelmann, *Hirten-Genre*, p. 65, n. 175.

110. HERMES (04.9)
Leibundgut, *Westschweiz*, p. 26, under no. 14, n. 1; D.K. Hill, *Hesperia* 51 (1982), p. 278, pl. 76a; J.M. Cody, in *Hunt Collections*, p. 130, under no. 45; S.B. Matheson, *Yale University Art Gallery Bulletin*, Winter 1983, pp. 16–19.

111. HERMES-APOLLO (08.535)
Di Stefano, *Palermo*, p. 18, under no. 25; Leibundgut, *Westschweiz*, p. 29, under no. 17, n. 2; P.C. Bol, in Bol and Weber, *Bildwerke*, pp. 146–147, under no. 67.

112. HERMES (98.676)
C. Rolley, *AJA* 78 (1974), p. 99; Vermeule, *Gold and Silver*, p. 16, under no. 44; idem, *Cult Images*, pp. 40–41, 60, fig. 35a–b.

113. HYGIEIA (06.2372)
Menzel, *Aufstieg*, p. 148, n. 141.
Exhibited: Ackland Memorial Art Center, Chapel Hill (C. Phillips, in Sams, *Small Sculptures*, no. 31, illus.).

114. ISIS (04.1713)
F. Solmsen, *Isis among the Greeks and Romans* (Cambridge, Mass., 1979), dust jacket; Vermeule, *Cult Images*, p. 64, fig. 16.

116. ISIS-FORTUNA (58.968)
M. True and C. Vermeule, *BMFA* 72 (1974), p. 128, under no. 9.
Exhibited: Museum of Fine Arts, Boston (*Romans and Barbarians*, p. 19, no. 24, illus.).

118. PANTHEISTIC DIVINITY ON COUCH (65.100)
Exhibited: Museum of Fine Arts, Boston (*Romans and Barbarians*, pp. 18–19, no. 23, illus.).

118A. PANTHEISTIC TYCHE (67.1036)
C. Vermeule, *BMFA* 68 (1970), p. 211, fig. 19a; idem, *Gold and Silver*, p. 21, under no. 61; Menzel, *Aufstieg*, p. 148, n. 141; Vermeule, *Divinities*, p. 28, under no. 111.

119. POSEIDON (96.705)
H. Rolland, *Bronzes antiques de Haute Provence (Basses-Alpes, Vaucluse)* (Paris, 1965), p. 34, under no. 15; W.J. Young, in *Art and Technology*, pp. 87–88, fig. 6a; Vermeule, *Cult Images*, p. 55, fig. 21 (as Jupiter).

121. ZEUS (65.462)
E. Berger, *RM* 76 (1969), pp. 70–73, no. 4, pl. 26, figs. 5–6; Leibundgut, *Westschweiz*, pp. 11, 13, no. 17; D.K. Hill, *Hesperia* 51 (1982), p.

281, no. 21; Weski, *Antiquarium*, p. 285, under no. 170.

122. ZEUS (98.678)
B. Krause, *AA*, 1972, p. 256, n. 24; M. True and C. Vermeule, *BMFA* 72 (1974), pp. 124–125, under no. 6; MFA *Handbook*, pp. 116–117, illus.; Boucher, *Recherches*, p. 378; E. Poulsen, *ActaA* 48 (1977), pp. 21–22, no. 4, fig. 13; *Römisches im Antikenmuseum* (Staatliche Museen Preussischer Kulturbesitz, Berlin, 1978), p. 17; *Het verhaal bij het materiaal* (*Archaeologica Traiectina* 14, Utrecht, 1980), p. 68, n. 1; Noelke, *Iupitersäulen*, p. 380, n. 654; Vermeule, *Cult Images*, pp. 53, 55, fig. 19.

123. ZEUS (59.298)
Kater-Sibbes, *Sarapis*, p. 201, no. 1073; V. Tran Tam Tinh, *Sérapis Debout* (Leiden, 1983), p. 116, no. IB31, pl. 45a–b; Vermeule, *Cult Images*, p. 57, fig. 28A.

124. CARIAN ZEUS (67.730)
Fleischer, *Artemis*, pp. 88, 110, 312–313, 318, 322, no. K6, pl. 140a–b; idem, in *Festschrift Dörner*, p. 350.
Exhibited: Museum of Fine Arts, Boston (*Romans and Barbarians*, p. 52, no. 69, illus.).

125. BUST OF SARAPIS (60.1450)
Kater-Sibbes, *Sarapis*, p. 7, no. 31.
Exhibited: Museum of Fine Arts, Boston (*Romans and Barbarians*, p. 19, no. 25, illus.).

128. GLYKON (03.986)
Exhibited: Museum of Fine Arts, Boston (*Romans and Barbarians*, p. 57, no. 77, illus.).

129. PRIAPOS (Res. 08.32m)
Grigson, *Aphrodite*, p. 65, fig. 11; Vermeule, *Numismatic Art*, p. 119, under no. 74.

130. PRIAPOS (Res. 08.32p)
Boardman and La Rocca, *Eros in Greece*, p. 33, color illus.; M. Anderson, in Houser, *Dionysos*, pp. 106–107, MFA no. 23, illus.; Petit, *Dutuit*, p. 138, under no. 70, n. 2; Leibundgut, *Westschweiz*, p. 35, under no. 27, n. 1; Johns, *Sex or Symbol*, p. 52, fig. 35.

131. SEATED FIGURE (Res. 08.32O)
Boardman and La Rocca, *Eros in Greece*, p. 157, color illus.; Mulas, *Eros*, p. 71, color illus.; Johns, *Sex or Symbol*, p. 72, fig. 55.

132. PYGMY (96.669)
D.K. Hill, *Catalogue of Classical Bronze Sculpture in the Walters Art Gallery* (Baltimore, 1949), p. 73, under no. 156; H. Hoffmann, in Muscarella, *Schimmel Collection*, under no. 39; Boucher, *Recherches*, p. 79; S. Boucher and S. Tassinari, *Bronzes antiques du Musée de la Civilisation Gallo-Romaine à Lyon*, vol. 1 (Lyon, 1976), p. 86, under no. 75, n. 1; Himmelmann, *Alexandria*, p. 74, n. 263.

133. SATYR (Res. 08.32b)
Menzel, *Aufstieg*, p. 148, n. 141.

134. ATHLETE (98.675)
Exhibited: Brockton Art Center (Morgan, *Ancient Mediterranean*, pp. 16–18, no. 9, fig. 2); Danforth Museum, Framingham, "The Mediterranean World," September 1977–March 1978.

136. YOUTH (96.663)
Koppel, *Tarraco*, p. 109, under no. 161, nn. 1, 3; Manfrini-Aragno, *Bacchus*, p. 88, no. 4, fig. 123.

138. SQUATTING WOMAN (Res. 08.32f)
Boardman and La Rocca, *Eros in Greece*, pp. 150–152, color illus.

139. COMIC ACTOR (98.677)
Webster, *New Comedy*, p. 226 (UB11); MFA

Handbook, pp. 116–117, illus.; Petit, *Dutuit*, p. 103, under no. 38, n. 1.

140. Comic Actor (08.371)
Webster, *New Comedy*, p. 141 (UB2).

141. Bearded Man (An Actor?) (Res. 08.32a)
Petit, *Dutuit*, p. 98, under no. 36, n. 9.

143. Dwarf (Res. 08.32d)
M.I. Davies, *AJA* 86 (1982), p. 117, n. 16.

144. Dwarf Dancing (Res. 08.32j)
Hornbostel, *Gräbern*, p. 143, under no. 83.

145. Dwarf Boxing (Res. 08.32k)
Boucher, *Lyon Bronzes*, p. 54, n. 1; Petit, *Dutuit*, p. 105, under no. 40, n. 1; Hornbostel, *Gräbern*, p. 143, under no. 83.

146. Dwarf (Res. 08.32e)
R.G. Leslie, in Sams, *Small Sculptures*, under no. 40.

150. Left Arm and Hand of a Romano-Egyptian Statuette of Isis (68.39)
E.R. Williams, *JARCE* 16 (1979), p. 101, n. 25.

152. Right Foot of a Statue (01.7509)
H. Jung, *JdI* 94 (1979), p. 530, n. 22.

155. A Votary, Probably a Priest of Diana (59.10)
AJA 14 (1910), pp. 114–115; M. True and C. Vermeule, *BMFA* 72 (1974), pp. 126–127, under no. 8; S.H. Wilson, Jr., in Amyx and Forbes, *Echoes*, suppl., p. 21, under no. 26; F. Huemer, in Sams, *Small Sculptures*, under no. 69; M.C. Galestin, *BABesch* 52–53 (1977–1978), p. 43, n. 59; *Antické Umění v Československých Sbírkách: Národní Galerie v Praze* (Prague, 1979), p. 63, under no. 241; Cristofani, *Etruschi*, pp. 273 (under no. 67), 284 (under no. 100, citing MFA nos. 155–164); Gschwantler, *Guss*, p. 97, under no. 123; G. Walberg, *AA*, 1987, p. 460, under no. 18.

156. Apollo (?) (88.615)
S. Quilici Gigli, *BullComm* 90 (1985), p. 21, n. 25.

157. Diana (88.613)
E. Simon, in *LIMC*, vol. 2, pt. 1, p. 813, no. 69.

158. Diana (?) (15.860)
E. Simon, in *LIMC*, vol. 2, pt. 1, p. 813, no. 69b.

159. Diana (88.614)
E. Simon, in *LIMC*, vol. 2, pt. 1, p. 813, no. 69a.

160. Man (88.616)
Oggiano-Bitar, *Bouches-du-Rhône*, p. 53, under no. 57.

161. Seated Woman (15.859)
Leibundgut, *Westschweiz*, p. 187, under no. 289.

162–163. Dogs (88.618, 619)
K.P. Erhart, in *Mildenberg Collection*, p. 162, under no. 143.
Exhibited: The Dog Museum of America, New York, "Fidoes and Heroes in Bronze," 11 February–3 June 1983 (no. 162 only).

167. Eagle with Wings Spread (65.1183)
Menzel, *Aufstieg*, p. 148, n. 141.

168. Bull (96.707)
Hoffmann, *Ten Centuries*, pp. 180–181, under no. 84 (as 98.707); Vermeule, *Gold and Silver*, p. 36, under no. 100; Mitten, *Classical Bronzes*, p. 186, under no. 63, n. 3; Menzel, *Aufstieg*, p. 148, n. 141.

169. Bull (98.680)
Vermeule, *Gold and Silver*, pp. 34 (under no. 99), 36 (under no. 100); Mitten, *Classical Bronzes*, p. 186, under no. 63, n. 2; P.N. Boulter, in *Festschrift von Blanckenhagen*, p. 252.

170A. Reclining Ewe (67.1033)
K.P. Erhart, in *Mildenberg Collection*, p. 162, under no. 143; Menzel, *Aufstieg*, p. 148, n. 141.

172. Bear with a Stick in Her Mouth (67.627)
Leibundgut, *Westschweiz*, p. 111, under no. 131; Menzel, *Aufstieg*, p. 148, n. 141.

172A. Standing Stag (67.1034)
Menzel, *Aufstieg*, p. 148, n. 141.

173. Griffin of Nemesis (67.645)
Wrede, *Consecratio*, p. 33, n. 20.

174. Hero (Alexander the Great ?) (64.702)
C.C. Vermeule, in *Festschrift Jucker*, pp. 187–188, under L; E. Simon, in *LIMC*, vol. 2, pt. 1, pp. 521, 553, no. 130; vol. 2, pt. 2, pl. 392.

174A. Small Statue of a Roman in a Toga (67.1185)
H. Kunckel, *Die römische Genius* (*RM*, suppl. 20, Heidelberg, 1974), pp. 96–97 (no. FV5), 141, pl. 59, fig. 1; Vermeule, *Gold and Silver*, p. 36, under no. 101; Z. Kiss, *L'Iconographie des Princes Julio-Claudiens au temps d'Auguste et de Tibère* (Warsaw, 1975), pp. 82, 84, fig. 243; Mitten, *Classical Bronzes*, p. 193, under no. 67.
Exhibited: Ackland Memorial Art Center, Chapel Hill (F. Huemer, in Sams, *Small Sculptures*, no. 66, illus.).

175. Head of a Roman (96.703)
F. Poulsen, *Greek and Roman Portraits in English Country Houses* (Oxford, 1923), p. 83, n. 1; P. Herrmann, in *Festschrift Amelung*, p. 93; S. Boucher, *Vienne: Bronzes antiques* (Paris, 1971), p. 93, under no. 46–47, n. 1; *Greek & Roman Portraits, 470 BC–AD 500* (Boston: Museum of Fine Arts, 1972), no. 67, illus.; C. Rolley, *AJA* 78 (1974), p. 99; K. Fittschen, in *Festschrift Jucker*, p. 112, n. 37; J. Meischner, *BonnJb* 181 (1981), p. 152, n. 67; idem, *JdI* 97 (1982), pp. 412–413, 418, no. 16.
Exhibited: Museum of Fine Arts, Boston (*Romans and Barbarians*, pp. 98–99, no. 108, illus.).

176. Back of a Statue of a Himation-Clad Man (01.7524)
H. Lechtman and A. Steinberg, in *Art and Technology*, pp. 22–32, figs. 27, 29–30, 32–38; C. Vermeule, in ibid., p. 236; R.H. Brill, W.R. Shields, and J.M. Wampler, in Young, *Application of Science*, pp. 74–75 (fig. 2), 81; A. Steinberg, in ibid., pp. 121–123, 125–129, 131, figs. 41, 44, 50–51, 54, 58, 60–63.

176A. Right Leg of an Over-Life-Sized Male Statue (68.732)
A. Steinberg, in Young, *Application of Science*, pp. 124 (fig. 45), 127 (fig. 55); C. Vermeule, in *Festschrift Jucker*, pp. 188–189 (N), pl. 62, fig. 1; Menzel, *Aufstieg*, p. 148, n. 141.

177. Statuette of the Emperor Constantinus Magnus (62.1204)
Vermeule, *Cuirassed Statues*, p. 11; L'Orange, Unger, and Wegner, *Spätantike Herrscherbild*, p. 120.
Exhibited: Ackland Memorial Art Center, Chapel Hill (J.T. Folda, in Sams, *Small Sculptures*, no. 73, illus.); Museum of Fine Arts, Boston (*Romans and Barbarians*, p. 73, no. 103, illus.).

Etruscan and Italian Statuettes

178. "Apollo" (98.653)
G.A. Mansuelli, *The Art of Etruria and Early Rome* (New York, 1965), p. 86; V. Poulsen, *Etruskische Kunst* (Königstein im Taunus, 1969), p. 10, illus.; H. Jucker, in *Art and Technology*, pp. 200–201, fig. 10a–b; S. Settis, *ArchCl* 23 (1971), p. 67, fig. 21, figs. 1–3; E. Schmidt, *Geschichte der Karyatide* (*Beiträge zur Archäologie* 13, Würzburg, 1982), p. 182, n. 285; Shefton, *Phönizier*, p. 362, n. 68; P.C. Bol, in Bol and Weber, *Bildwerke*, p. 43, under no. 12.

179. "Apollo" (98.654)
E.M. Lewis and K.K. Albertson, in *Ancient Greece*, p. 202, under no. 98, n. 8.

180. "Apollo" or an Orant (98.655)
Richardson, *Votive Bronzes*, p. 212.

182. Silenus (13.112)
M.I. Davies, *AntK* 14 (1971), p. 149, n. 8; Di Stefano, *Palermo*, p. 46, under no. 77.

184. Zeus (or Homer) (65.565)
Hostetter, *Spina*, p. 39, under no. 13.

186. Warrior or Hero, Probably Herakles (08.328)
G. Colonna, *Bronzi Votivi Umbro-Sabellici a Figura Umana: I-Periodo "Arcaico"* (Florence, 1970), p. 30, no. 12; Boucher, *Lyon Bronzes*, p. 87, n. 3.

187. Diskobolos (01.7492)
Arnold, *Polykletnachfolge*, p. 114, n. 423; Hostetter, *Spina*, p. 66, under no. 35.

191. Warrior (52.186)
E.H. Richardson, in *Festschrift Hanfmann*, p. 166, no. 7; Falconi Amorelli, *Pesaro*, p. 30, under no. 1; Richardson, *Votive Bronzes*, pp. 173, 192, no. 12; Gschwantler, *Guss*, p. 99, under no. 127.

194. Horseman (13.139)
D.G. Mitten, in Muscarella, *Schimmel Collection*, under no. 75; K. Kilian, *JdI* 92 (1977), p. 58, n. 81.

195. Youth Seizing Horse (98.660)
Mitten, *Classical Bronzes*, p. 104, under no. 29, n. 13.

196. Three Figures in Open Relief (01.8376)
Mitten, *Classical Bronzes*, p. 104, under no. 29, n. 13.

197. Dancer (01.7482)
Art and Technology, p. 235; C. Vermeule, in MFA *Western Art*, p. 161, color pl. 11; G.K. Sams, in Sams, *Small Sculptures*, under no. 44; Vermeule, *Roman Art*, pp. 7–8, 185, 211, 225, fig. 8; F. Jurgeit, in *Festschrift Hampe*, p. 279, n. 45; Richardson, *Votive Bronzes*, pp. 140, 272, 293–294, no. 4, pl. 205, figs. 693–694.

198. Running Girl ("Lasa") (98.662)
MFA *Handbook*, pp. 98–99, illus.

199. Dancing Maenad (98.661)
Bonfante, *Etruscan Dress*, p. 180, under caption for fig. 81; I. Caruso, *RM* 88 (1981), pp. 83, 86–87; Hostetter, *Spina*, pp. 34 (under no. 9), 50 (under no. 25).

200. Herakles (18.506)
S. Woodford, *AJA* 80 (1976), p. 293, n. 37.

206. Warrior (18.502)
Di Stefano, *Palermo*, p. 56, under no. 94.

209. DRAPED WOMAN (18.503)
Richardson, *Votive Bronzes*, pp. 273, 316, no. 43.

210. DRAPED WOMAN (18.495)
Richardson, *Votive Bronzes*, pp. 274, 319, no. 16.

212. DRAPED WOMAN (18.501)
Falconi Amorelli, *Pesaro*, p. 45, under no. 29.

213. DRAPED WOMAN VOTARY (68.41)
E.M. Lewis and K.K. Albertson, in *Ancient Greece*, p. 202, under no. 98, n. 7; G. Walberg, *AA*, 1987, p. 458, under no. 14.

215. DOUBLE-HEADED RAM (52.185)
P.J. Connor, in *Festschrift Trendall*, pp. 63–64; M. Landolfi, in *Prima Italia*, p. 110, under no. 69; Hornbostel, *Etrusker*, p. 23, under no. 2; Falconi Amorelli, *Pesaro*, p. 102, under no. 103; Oggiano-Bitar, *Bouches-du-Rhône*, p. 29, under no. 2; G. Walberg, *AA*, 1987, p. 452, under no. 4.

217. DOG (96.713)
Di Stefano, *Palermo*, p. 80, under no. 139; E. Hostetter, *RM* 85 (1978), p. 263, n. 25; Petit, *Dutuit*, p. 202, under no. 1, n. 3; K.P. Erhart, in *Mildenberg Collection*, pp. 162 (under no. 143), 188 (under no. 173); D.G. Mitten, in ibid., p. 195, under no. 182.

218. LION (01.7469)
Höckmann, *San Mariano*, p. 174, n. 453.

219. CICADA (01.7470)
P.F. Davidson and A. Oliver, Jr., *Ancient Greek and Roman Jewelry in the Brooklyn Museum* (Brooklyn, 1984), p. 13, under no. 4.

Works in the Manner of the Antique

220. LEGIONARY (64.2197)
Exhibited: Museum of Fine Arts, Boston (*Romans and Barbarians*, p. 221, no. 265, illus.).

Cypriote Jewelry

252. FIBULA (72.374)
V. Karageorghis, *BCH* 97 (1973), p. 621, n. 28.

Greek and Graeco-Roman Jewelry

253. FRAGMENTS OF WREATH (81.333)
D.M. Robinson, *AJA* 39 (1935), p. 236, n. 2.

255. EARRING (90.238)
Philipp, *Bronzeschmuck*, pp. 122 (n. 305), 124 (under no. 417).
Exhibited: Brockton Art Museum (Herrmann, *Shadow*, pp. 78–79, no. 143, illus.).

256. BRACELETS OR HAIR ORNAMENTS (96.676, 677)
Mitten, *Classical Bronzes*, p. 78, under no. 21, n. 3; Philipp, *Bronzeschmuck*, p. 214.

257–258. SPIRALS (94.44, 45)
Mitten, *Classical Bronzes*, p. 78, under no. 21, n. 3.

263. FIBULA (96.675)
D.G. Mitten, *Gnomon* 45 (1973), p. 596; idem, *Classical Bronzes*, p. 200, under no. 70, n. 3.

264. FIBULA (98.643)
W.J. Young, in *Art and Technology*, pp. 88–89, figs. 8–9; R. Hampe, *Katalog der Sammlung antiker Kleinkunst des Archäologischen Instituts der Universität Heidelberg*, vol. 2, *Neuerwerbungen 1957–1970* (Mainz, 1971), p. 89; D.G.

Mitten, *Gnomon* 45 (1973), p. 596; K. DeVries, *Hesperia* 43 (1974), p. 101, n. 70; Mitten, *Classical Bronzes*, p. 200, under no. 70, n. 3.

265. FIBULA (98.644)
D.G. Mitten, *Gnomon* 45 (1973), p. 596; idem, *Classical Bronzes*, p. 200, under no. 70, n. 3.

266. FIBULA (64.302)
D.G. Mitten, *Gnomon* 45 (1973), p. 596; idem, *Classical Bronzes*, p. 200, under no. 70, n. 3.

267–268. FIBULAE (98.645, 646)
M. True and C. Vermeule, *BMFA* 72 (1974), p. 118, under no. 1.

271–272. PINS (98.647, 648)
Liepmann, *Skulpturen*, p. 108, under no. B11; T. Weber, in Bol and Weber, *Bildwerke*, pp. 58–59, under no. 17.

287. RING (23.601)
Vermeule, *Death*, pp. 173–174, fig. 25; A. Hermary, in *LIMC*, vol. 3, pt. 1, p. 929, no. 963.

288. RING (01.7531)
Exhibited: Brockton Art Museum (Herrmann, *Shadow*, pp. 81–83, no. 152, illus.).

289. RING (01.7533)
A. Hermary, in *LIMC*, vol. 3, pt. 1, p. 912, no. 728; vol. 3, pt. 2, pl. 650.
Exhibited: Brockton Art Museum (Herrmann, *Shadow*, pp. 83–84, no. 161, illus.).

290. RING (01.7532)
Exhibited: Brockton Art Museum (Herrmann, *Shadow*, pp. 80, 82–83, no. 153, illus.).

292. RING (27.748)
Exhibited: Brockton Art Museum (Herrmann, *Shadow*, pp. 82–83, no. 154, illus.).

27.771. RING
J.D. Beazley, *The Lewes House Collection of Ancient Gems* (Oxford, 1920), pp. 69–71, no. 85, pl. 5.
Exhibited: Brockton Art Museum (Herrmann, *Shadow*, pp. 81, 83, no. 151, illus.).

Etruscan, Italian, and Roman Jewelry

298–299. CIRCULAR HOOPS (22.730, 731)
T. Weber, in Bol and Weber, *Bildwerke*, p. 79, under no. 34.

300–301. SPIRAL RINGS (22.725, 723)
Mitten, *Classical Bronzes*, p. 78, under no. 21, n. 2.

303. NECKLET (02.293)
T. Weber, in Bol and Weber, *Bildwerke*, p. 82, under no. 39.
Exhibited: Brockton Art Center (Morgan, *Ancient Mediterranean*, p. 47, no. 60); Danforth Museum, Framingham, "The Mediterranean World," September 1977–March 1978.

304. NECKLET (02.294)
T. Weber, in Bol and Weber, *Bildwerke*, p. 82, under no. 39.

305. NECKLET (?) (02.295)
Falconi Amorelli, *Pesaro*, p. 97, under no. 97.

318. FIBULA (98.685)
J.W. Hayes, *Studi Etruschi* 43 (1975), p. 75, under no. 6.

337. FIBULA (13.128)
Philipp, *Bronzeschmuck*, p. 320 (listed as catalogue no. 33).

338–341. FIBULAE (22.711–714)
F. Naumann, *Antiker Schmuck* (Kassel: Staat-

liche Kunstsammlungen, 1980), p. 67, under no. 173.

340. ARC OF FIBULA (22.713)
De Puma, *Tomb-Groups*, p. 93, n. 72.

Greek Mirrors

351. HANDLE (98.651)
L. Kahil and N. Icard, in *LIMC*, vol. 2, pt. 1, p. 630, no. 78; vol. 2, pt. 2, pl. 448.

352. MIRROR STAND: APHRODITE AND EROTES (04.7)
Wallenstein, *Korinthische Plastik*, p. 191, n. 410; I. Caruso, *RM* 88 (1981), p. 84, n. 202; Gauer, *Olympia*, p. 156, n. 158; Congdon, *Caryatid Mirrors*, pp. 20–21, 36, 50–52, 83–84, 90, 94–95, 100, 105, 140–141 (no. 19), 146 (under no. 27), 272, 282, pls. 16–17; Rolley, *Bronzes Grecs*, pp. 95–96, fig. 74; I.S. Mark, *Hesperia* 53 (1984), p. 299, n. 48; A. Delivorrias et al., in *LIMC*, vol. 2, pt. 1, p. 18, no. 92; vol. 2, pt. 2, pl. 12; Morrow, *Footwear*, pp. 53, 197, n. 37; Rolley, *Greek Bronzes*, p. 104, pl. 74; idem, *RA*, 1986, p. 382; Walter-Karydi, *Bildhauerschule*, pp. 69, 105–108, no. 6, figs. 165–167.

353. MIRROR STAND (01.7483)
Congdon, *Caryatid Mirrors*, pp. 34, 36, 62–64, 84–85 (fig. 8), 90 (n. 341), 91, 101, 105, 143–144 (no. 24), 203 (under no. 95), 204 (under no. 99), 273, 282, pl. 21; Walter-Karydi, *Bildhauerschule*, pp. 105, 108, figs. 168–169.

354. MIRROR STAND (01.7499)
L. Quarles van Ufford, *BABesch* 16, no. 2 (1941), pp. 18–19; G.M.A. Richter, *The Sculpture and Sculptors of the Greeks*, 4th ed. (New Haven and London, 1970), p. 59, fig. 269; MFA *Handbook*, pp. 90–91, illus.; Petit, *Dutuit*, p. 36, under no. 3; Congdon, *Caryatid Mirrors*, pp. 13, 38, 58–62, 64, 79, 85 (fig. 8), 87 (fig. 10), 90, 92, 101, 105, 149–150 (no. 31), 273, 283, pls. 26–27; Boardman, *Classical*, pp. 27, 32, 243, fig. 16; M. Vickers, *RA*, 1985, pp. 20–21, fig. 8; Morrow, *Footwear*, p. 197, n. 29; C. Rolley, *RA*, 1986, p. 383.

355. MIRROR AND STAND (98.667)
Boucher, *Lyon Bronzes*, p. 29, n. 2; Congdon, *Caryatid Mirrors*, pp. 21, 36, 65, 90 (n. 341), 102, 105, 172–173 (no. 62), 276, 285, pl. 58; K.P. Erhart, in *Mildenberg Collection*, p. 140, under no. 117; N.T. de Grummond and M. Hoff, in de Grummond, *Etruscan Mirrors*, p. 36, n. 33; I.S. Mark, *Hesperia* 53 (1984), p. 299, n. 48; Weill, *Études Thasiennes*, p. 50, n. 10.

355A. EROS FROM A MIRROR WITH STAND (69.56)
Congdon, *Caryatid Mirrors*, p. 117, no. 17.

356. MIRROR AND HANDLE (96.716)
M.-F. Briguet, *Mélanges de l'école française de Rome* 87, pt. 1 (1975), pp. 194, 196, fig. 40; I. Caruso, *RM* 88 (1981), pp. 61–62 (no. F20, listed as both 96.716 and 98.667), 95; N.T. de Grummond and M. Hoff, in de Grummond, *Etruscan Mirrors*, p. 34, n. 14; A. Hermary, in *LIMC*, vol. 3, pt. 1, p. 884, no. 406a; K. Schauenburg, *JdI* 102 (1987), pp. 222 (n. 105), 229 (n. 124).

357. MIRROR HANDLE (UPPER PART) (01.7523)
Mitten, *Classical Bronzes*, p. 58, under no. 17, n. 4; Bruschetti, *Lampadario*, p. 52; I. Caruso, *RM* 88 (1981), pp. 32 (no. C6), 74, 77–79.

357A. MIRROR AND HANDLE (1970.239)
C. Vermeule, *BurlMag*, January 1971, p. 38,
figs. 48–49; A. Mutz, *Die Kunst des Metalldre-
hens bei den Römern* (Basel, 1972), p. 132, figs.
355–356; I. Caruso, *RM* 88 (1981), pp. 62 (no.
F21), 95; A. Kossatz-Deissmann, in *LIMC*, vol.
1, pt. 1, pp. 89 (no. 374), 95, 199; vol. 1, pt. 2,
pl. 95; Picón, *Antiquities*, p. 32, under no. 31.

358. FRAGMENT OF HANDLE FROM
A MIRROR (99.468)
Mitten, *Classical Bronzes*, p. 58, under no. 17,
n. 4.

360. MIRROR AND COVER (99.492a,b)
J. Vocotopoulou, *BCH* 99 (1975), p. 776, n.
153; I.A. Papapostolou, *Deltion* 32, pt. A
(1977), p. 333, n. 336; A. Enklaar, in Brijder,
Drukker, and Neeft, *Enthousiasmos*, p. 187, n.
39.

361. MIRROR CASE AND COVER (98.671)
E. Speier, in *EAA*, vol. 3, p. 430; K. Schauen-
burg, *GettyMusJ* 2 (1975), p. 65, n. 52; A.
Andriomenou, *AM* 91 (1976), p. 199; F.W.
Hamdorf, in *Kerameikos*, vol. 10 (Berlin, 1976),
p. 211, under K101; M. Harari, *Il "Gruppo
Clusium" nella ceramografia etrusca* (Rome,
1980), p. 141, n. 56; A. Stewart, *AntK* 23
(1980), pp. 29, 31, pl. 10, fig. 4; I. Caruso, *RM*
88 (1981), p. 99; A. Hermary, in *LIMC*, vol. 3,
pt. 1, p. 868, no. 172; vol. 3, pt. 2, pl. 618.

362. MIRROR AND CASE (98.673)
E. La Rocca, in *Roma medio repubblicana*, p.
289, under no. 427; C. Cerchiai, in *Enea nel
Lazio*, p. 36, under no. A67; C. Gasparri and A.
Veneri, in *LIMC*, vol. 3, pt. 1, p. 476, no. 633;
vol. 3, pt. 2, pl. 372.

363. MIRROR AND CASE (01.7516a,b)
J. Vocotopoulou, *BCH* 99 (1975), p. 776, n.
153; E. La Rocca, in *Roma medio repubblicana*,
p. 289, under no. 427; C. Cerchiai, in *Enea nel
Lazio*, p. 36, under no. A67.

364. MIRROR CASE (96.714)
E. Raftopoulou, *Études Argiennes* (*BCH*, suppl.
6, Paris, 1980), pp. 127–128, fig. 13; A. Enk-
laar, in Brijder, Drukker, and Neeft, *Enthousias-
mos*, p. 187, n. 39.

365. MIRROR AND CASE (01.7513a,b)
Brommer, *Denkmälerlisten*, vol. 3, p. 50, no. 4;
Hornbostel, *Schätze*, p. 100, under no. 69; E.
Künzl, in Horn and Rüger, *Numider*, pp. 289–
290; C. Gasparri and A. Veneri, in *LIMC*, vol.
3, pt. 1, pp. 486 (no. 753), 512.
Exhibited: Brockton Art Museum (Herrmann,
Shadow, pp. 13, 74, 76, no. 139, illus.).

366. MIRROR WITH CASE AND COVER
(98.672)
E. Speier, in *EAA*, vol. 3, p. 430; Brommer,
Denkmälerlisten, vol. 2, p. 94, no. 3; K.
Schauenburg, *GettyMusJ* 2 (1975), p. 65, n. 52;
J. Vocotopoulou, *BCH* 99 (1975), p. 776, n.
153; Carter, *Taras*, p. 111, n. 59; E.G. Pemberton,
Hesperia 54 (1985), p. 294; S.G. Miller, *AJA*
90 (1986), pp. 161 (no. 5), 168, pl. 14, figs.
7–8; A. Hermary, in *LIMC*, vol. 3, pt. 1, p. 868,
under no. 168; A. Enklaar, in Brijder, Drukker,
and Neeft, *Enthousiasmos*, p. 187, no. 39.

367. MIRROR AND COVER (05.59a,b)
G. Daltrop, *Die Kalydonische Jagd in der Antike*
(Hamburg and Berlin, 1966), p. 22, pl. 17; V.
von Graeve, *Der Alexandersarkophag und seine
Werkstatt* (*Istanbuler Forschungen* 28, Berlin,
1970), pp. 70–71; F.S. Kleiner, *AntK* 15 (1972),
pp. 10–11, no. 5; C. Vermeule, *BurlMag* 115

(1973), p. 118; Koch, *Meleager*, p. 72; W.A.P.
Childs, *RA*, 1976, p. 306, n. 3; Brommer,
Denkmälerlisten, vol. 3, p. 237, no. 3; Stewart,
Skopas, pp. 53, 136, no. 8; Vermeule, *Socrates
to Sulla*, pp. 43, 48, 124, 204, fig. 58; E.G.
Pemberton, *Hesperia* 54 (1985), p. 293; C.
Bruns-Özgan, *Lykische Grabreliefs des 5. und 4.
Jahrhunderts v. Chr.* (*IstMitt*, suppl. 33,
Tübingen, 1987), p. 184.

368. MIRROR CASE (01.7514a,b)
D. von Bothmer, in Muscarella, *Schimmel Col-
lection*, under no. 32; J. Vocotopoulou, *BCH* 99
(1975), p. 776, n. 153; A. Stewart, *AntK* 23
(1980), pp. 27 (no. 6), 29, 31, 33, pl. 9, fig. 4;
A. Delivorrias et al., in *LIMC*, vol. 2, pt. 1, p.
120, no. 1243.

369. MIRROR AND COVER (Res. 08.32c)
A. Rumpf, *AJA* 55 (1951), p. 10, n. 75; O.J.
Brendel, in T. Bowie and C.V. Christenson, eds.,
Studies in Erotic Art (New York and London,
1970), pp. 42–46, fig. 27; Boardman and La
Rocca, *Eros in Greece*, pp. 133–135, color
illus.; Mulas, *Eros*, pp. 60–61, color illus.;
Johns, *Sex or Symbol*, pp. 118 (fig. 95), 135
(fig. 112); Rolley, *Bronzes Grecs*, pp. 168–169,
fig. 157; idem, *Greek Bronzes*, pp. 176–177, pl.
157; A. Hermary, in *LIMC*, vol. 3, pt. 1, p. 904,
no. 627.

370. MIRROR AND CASE (01.7494)
J. Vocotopoulou, *BCH* 99 (1975), p. 776, n.
153; A. Delivorrias et al., in *LIMC*, vol. 2, pt. 1,
pp. 43 (no. 317), 119 (no. 1224); vol. 2, pt. 2,
pl. 32; A. Enklaar, in Brijder, Drukker, and
Neeft, *Enthousiasmos*, p. 187, n. 39.

372. MIRROR AND CASE (03.992a,b)
A. Delivorrias, in *LIMC*, vol. 2, pt. 1, p. 111,
no. 1128.

373. MIRROR CASE (01.7309)
J. Vocotopoulou, *BCH* 99 (1975), p. 776, n.
154; A. Enklaar, in Brijder, Drukker, and Neeft,
Enthousiasmos, p. 187, n. 39; Barr-Sharrar,
Decorative Bust, p. 158, n. 5.

Etruscan, Italic, and Roman Mirrors

376. MIRROR (95.73)
M.A. Del Chiaro, *Archaeology* 27 (1974), p.
120, illus.

376A. MIRROR AND HANDLE (1971.138)
Fischer-Graf, *Spiegelwerkstätten*, pp. 2–4, no.
11; idem, *AntK* 25 (1982), p. 117, n. 3; N.T. de
Grummond, in de Grummond, *Etruscan Mir-
rors*, p. 10, n. 9, no. 6.

377. MIRROR (92.2740)
Fischer-Graf, *Spiegelwerkstätten*, pp. 78 (n.
753), 96, 100, 107 (no. V91), 110, 112, 123;
De Puma, *Corpus*, p. 32, under no. 17.

378. MIRROR (98.686)
Fischer-Graf, *Spiegelwerkstätten*, p. 60; I.
Jucker, *AntK* 29 (1986), p. 128, n. 6.

381. MIRROR (99.494)
M.I. Davies, *AntK* 14 (1971), p. 154, pl. 48,
fig. 3; B.B. Shefton, *RA*, 1973, pp. 208–210;
M.I. Davies, *AntK* 16 (1973), p. 65, n. 28 (with
additional references); Brommer, *Denkmäler-
listen*, vol. 3, p. 15, no. 9; O. Touchefeu, in
LIMC, vol. 1, pt. 1, pp. 331 (no. 135), 335; vol.
1, pt. 2, pl. 250; I. Jucker, *Museum Helveticum*
39 (1982), p. 12, n. 34; G. Colonna, in *LIMC*,
vol. 2, pt. 1, p. 1065, no. 178.

382. MIRROR (99.495)
MFA Handbook, pp. 108–109, illus.; Fischer-
Graf, *Spiegelwerkstätten*, pp. 87, 91–92 (no.
V55), 110, 112–113, 116–117, pl. 23, fig. 3;
R.D. DePuma, *AJA* 86 (1982), p. 147; A.
Oliver, Jr., in *Bastis Collection*, p. 221 (as
no. 282).

383. MIRROR (01.7467)
Brommer, *Denkmälerlisten*, vol. 1, p. 48, vol. 2,
p. 23; R.D. De Puma, in de Grummond, *Etrus-
can Mirrors*, p. 98, n. 68.

385. MIRROR (03.991)
J.M. Turfa, in de Grummond, *Etruscan Mirrors*,
pp. 146–147.

386. MIRROR (08.253)
Fischer-Graf, *Spiegelwerkstätten*, pp. 66–67; I.
Krauskopf, in *LIMC*, vol. 2, pt. 1, pp. 342, 356,
no. 37a.

387. MIRROR (13.207)
D.K. Hill, *Archaeology* 18 (1965), pp. 189–190,
fig. 6; Brommer, *Denkmälerlisten*, vol. 3, p.
335, no. 1; A. Stibbe-Twist, in *Thiasos: Sieben
archäologische Arbeiten* (Amsterdam, 1978), p.
95; N.T. de Grummond, *AntK* 25 (1982), p. 3,
pl. 1, fig. 1; I. Krauskopf, in *LIMC*, vol. 2, pt. 1,
pp. 348, 358, no. 88; vol. 2, pt. 2, pl. 294.

388. MIRROR (61.1257)
Brommer, *Denkmälerlisten*, vol. 3, p. 389, no. 3.

389. MIRROR (61.1258)
Boardman and La Rocca, *Eros in Greece*, pp.
128–129, color illus.

390. MIRROR (19.314)
Lambrechts, *Miroirs*, p. 72, under no. 10;
Fischer-Graf, *Spiegelwerkstätten*, pp. 84–85,
no. 7.

391. MIRROR (95.72)
Krauskopf, *Supplemento Annali*, p. 328, n. 36;
J.P. Oleson, *AJA* 79 (1975), p. 196; K. Schauen-
burg, in *Homenaje a Garcia Bellido*, vol. 2 (*La
Revista de la Universidad Complutense* 25
[Madrid], 1976), p. 176, n. 6; Lambrechts,
Miroirs, p. 333, under no. 60.

392. MIRROR (13.2886)
L.G. Eldridge, *AJA* 22 (1918), p. 294 (this and
nos. 393–397); Lambrechts, *Miroirs*, p. 339,
under no. 62, n. 1; De Puma, *Corpus*, p. 49,
under no. 29.

393. MIRROR (13.2887)
P.G. Guzzo, *NSc*, ser. 8, vol. 28 (1974), p. 481.

395. MIRROR (13.2888)
F. Brommer, *Hephaistos* (Mainz, 1978), pp. 72,
114, 231, no. 6; De Puma, *Corpus*, p. 35, under
no. 19.

399. MIRROR (84.571)
P.G. Guzzo, *NSc*, ser. 8, vol. 28 (1974), pp. 456,
481; M.F. Zuccàla, *NSc*, ser. 8, vol. 33 (1979),
p. 13, n. 16.

400. MIRROR AND COVER (48.1093a,b)
Exhibited: Brockton Art Center (Morgan,
Ancient Mediterranean, p. 42, no. 45); Danforth
Museum, Framingham, "The Mediterranean
World," September 1977–March 1978.

400A. MIRROR (69.71)
Mitten, *Classical Bronzes*, p. 183, under no. 61;
Vermeule, *North Carolina Bulletin*, pp. 30–31,
38–39, fig. 3.

Greek Vessels

401. BOWL (66.182)
Vermeule, *Prehistoric through Perikles*, pp.
47–48, 212, 315, fig. 81.

402. Siren from
the Rim of a Lebes (99.458)
L. Quarles van Ufford, *BABesch* 19 (1944), pp. 8 (n. 5), 12; Wallenstein, *Korinthische Plastik*, pp. 98 (no. I / C4), 167 (n. 39); C. Rolley, *AJA* 78 (1974), p. 98; M. Weber, *AM* 89 (1974), pp. 36, 39, 41, 45; Mitten, *Classical Bronzes*, p. 59, under no. 17, n. 10.

403. Handle of a Tripod (?) (72.4452)
P.C. Bol, in Bol and Weber, *Bildwerke*, pp. 22, 24, under no. 5.

406. Head of a Griffin (01.7471)
Martelli Cristofani, *Céramiques*, p. 171, n. 61; Herrmann, *Kessel*, pp. 136, 166, no. 275.

407. Parts of a Cauldron: Three
Griffin Heads and Section of a
Rim (50.144a–d)
Martelli Cristofani, *Céramiques*, p. 170, n. 61; Herrmann, *Kessel*, p. 165, nos. 246–248; B.B. Shefton, *Die "Rhodischen" Bronzekannen* (Marburger Studien zur vor- und frühgeschichte 2, Mainz, 1979), p. 44, n. 62.

408. Head of a Griffin (01.7472)
Martelli Cristofani, *Céramiques*, p. 171, n. 61.

410. Handle of a Hydria or Pitcher
(85.515)
K.P. Erhart, in *Mildenberg Collection*, p. 137, under no. 114.

411. Handle of a Hydria or Pitcher
(99.460)
K.P. Erhart, in *Mildenberg Collection*, p. 137, under no. 114.

412. Handle of a Hydria (61.380)
D.G. Mitten, *AntK* 9 (1966), p. 5.

413. Handle of a Hydria (01.7474)
G. Schneider-Herrmann, *BABesch* 45 (1970), pp. 42, 45, fig. 10; Wallenstein, *Korinthische Plastik*, pp. 83, 157, no. VII / B34, pl. 24, fig. 2; Gauer, *Olympia*, p. 153, n. 148; K.P. Erhart, in *Mildenberg Collection*, p. 137, under no. 114.

414. Handle of a Hydria (99.462)
G. Schneider-Herrmann, *BABesch* 45 (1970), pp. 42, 45, fig. 10; Wallenstein, *Korinthische Plastik*, pp. 84, 157, no. VII / B35; Gauer, *Olympia*, p. 153, n. 148; K.P. Erhart, in *Mildenberg Collection*, p. 137, under no. 114.

415. Handles from a Hydria
(99.463a–c)
A. Andrioménou, *BCH* 99 (1975), p. 543.

416. Handle (99.461)
K.P. Erhart, in *Mildenberg Collection*, p. 137, under no. 114.

419. Handle of a Hydria (99.467)
M. Maass, *AntK* 26 (1983), p. 14, n. 55.

420. Handle and Foot of an Amphora
(62.1105a,b)
M. True and C. Vermeule, *BMFA* 72 (1974), p. 121, under no. 3; A.W. Johnston, in H.A.G. Brijder, ed., *Ancient Greek and Related Pottery: Proceedings of the International Vase Symposium in Amsterdam 12–15 April 1984* (Amsterdam, 1984), p. 211.

421. Handle of a Long-Beaked Jug
(62.188)
Gauer, *Olympia*, p. 154, n. 153; C. Abadie and T. Spyropoulos, *BCH* 109 (1985), p. 400.

422. Handle of a Beaked Oinochoe
(60.233)
Wallenstein, *Korinthische Plastik*, p. 85; Gauer, *Olympia*, p. 154, n. 153; C. Abadie and T. Spyropoulos, *BCH* 109 (1985), p. 400.

423. Oinochoe (99.481)
R.V. Schoder, *Masterpieces of Greek Art* (Greenwich, 1960), p. 9, no. 38, color pl.; C. Rolley, *AJA* 78 (1974), p. 98; A. Andrioménou, *BCH* 99 (1975), p. 555, n. 59; J. Vocotopoulou, in ibid., pp. 746 (n. 57), 749; D. von Bothmer, in *Festschrift von Blanckenhagen*, pp. 65–66, pl. 19, figs. 1–3; Rotroff, *Agora*, p. 34, n. 81; Rolley, *Bronzes Grecs*, pp. 161–162, 239, cat. no. 279, illus.; C. Abadie and T. Spyropoulos, *BCH* 109 (1985), p. 400; Rolley, *Greek Bronzes*, pp. 169, 245, pl. 279.

424. Handle of a Hydria (99.469)
D. von Bothmer, *GettyMusJ* 1 (1974), p. 16, no. 10; P. Amandry, *Études Argiennes* (*BCH*, suppl. 6, Paris, 1980), p. 216; C. Abadie and T. Spyropoulos, *BCH* 109 (1985), p. 400.

425. Handle of a Small Jug (64.303)
Liepmann, *Skulpturen*, p. 115, under no. B19.

426. Two Handles, Probably
from an Amphora (99.471a,b)
Liepmann, *Skulpturen*, p. 118, under no. B25; G. Zahlhaas and H. Fuchs, *AA*, 1981, p. 581; C. Rolley, in *Megale Hellas*, p. 737, n. 52.
Exhibited: Brockton Art Museum (Herrmann, *Shadow*, pp. 13, 74–76, no. 138, illus.).

427. Parts of Hydria:
Two Side Handles and Foot
(99.472a–f)
Hornbostel, *Schätze*, p. 91, under no. 63; idem, *Gräbern*, p. 167, under no. 98; C. Abadie and T. Spyropoulos, *BCH* 109 (1985), p. 402; M. Pfrommer, *GettyMusJ* 13 (1985), pp. 12–14, fig. 4.
Exhibited: Brockton Art Museum (Herrmann, *Shadow*, pp. 13, 74–77, no. 140, illus.).

428. Situla with Double Handles
(03.1001)
E.R. Williams, *Hesperia* 45 (1976), p. 49, n. 27; M. Bonghi Jovino, in *Festschrift Renard*, p. 74; D.R. Conover, *A Dionysiac Scene: A Study in Roman Cameo Production* (master's thesis, Brown University, 1978), p. 6; J.M. Turfa, *PBSR* 50 (1982), p. 173, under no. 25; Rolley, *Bronzes Grecs*, pp. 173–175, fig. 161; idem, in *Megale Hellas*, p. 737, n. 47; E. Lippolis, in E.M. De Juliis et al., *Gli Ori di Taranto in Età Ellenistica* (Milan, 1984), pp. 35 (no. I1), 38–39; Rolley, *Greek Bronzes*, pp. 178, 182–183, pl. 161.

429. Louter with Figured Handles
(03.999)
H. Bulle, *Der Schoene Mensch im Altertum* (Munich, 1912), col. 179, fig. 40; Hyde, *Victor Monuments*, p. 232; R. Ginouvès, *Balaneutikè* (Paris, 1962), pp. 67 (n. 3), 68 (n. 9), 73–74 (n. 13); V. Mitsopoulou-Leon, *AAA* 10 (1977), pp. 296 (n. 5), 300–301 (no. 1); Fischer-Graf, *Spiegelwerkstätten*, p. 34; Gauer, *Olympia*, pp. 116 (n. 10), 120 (n. 30), 130 (n. 53), 140 (n. 95); Rolley, *Bronzes Grecs*, pp. 140, 142, fig. 130; Haynes, *Etruscan Bronzes*, p. 301, under no. 153; Rolley, *Greek Bronzes*, pp. 148, 150, pl. 130; A. Enklaar, in Brijder, Drukker, and Neeft, *Enthousiasmos*, p. 187, n. 38.

431. Handle of a Bowl or Basin
(81.196)
U. Knigge, in *Rundbauten im Kerameikos* (*Kerameikos*, vol. 12, Berlin, 1980), p. 69, n. 35; Hornbostel, *Gräbern*, p. 12, under no. 11; A. Enklaar, in Brijder, Drukker, and Neeft, *Enthousiasmos*, p. 187, n. 38.

432. Handle of a Bowl or Basin
(81.197)

V. Mitsopoulou-Leon, *AAA* 10 (1977), p. 296, n. 5; Hornbostel, *Gräbern*, p. 12, under no. 11; A. Enklaar, in Brijder, Drukker, and Neeft, *Enthousiasmos*, p. 187, n. 38.

432A. Handle-Plate of a Basin
(Louter) (1970.7)
Gauer, *Olympia*, p. 116, n. 10.

433. Lion from a Vessel or Box (?)
(66.9)
S. Doeringer and D.G. Mitten, in Muscarella, *Schimmel Collection*, under nos. 83–85; A. Oliver, Jr., in *Bastis Collection*, p. 210.

433A. Reclining Lion (67.1035)
K.P. Erhart, in *Mildenberg Collection*, p. 175, under no. 157.

434. Boar from the
Shoulder of a Large Circular
Vessel (10.162)
MFA *Handbook*, pp. 92–93, illus.; D.G. Mitten, in *Mildenberg Collection*, p. 163, under no. 144.

435. Lion from the
Shoulder of a Large Circular
Vessel (10.163)
I. Caruso, *RM* 88 (1981), p. 96 (listed as no. 453); K.P. Erhart, in *Mildenberg Collection*, p. 139, under no. 116; D.G. Mitten, in ibid., p. 163, under no. 144; Dohrn, *Etruskische Kunst*, p. 65, pl. 45, fig. 1; Cristofani, *Etruschi*, p. 295, under no. 121.

436. Oinochoe (99.479)
Rotroff, *Agora*, p. 34, n. 81; Williams, *Johns Hopkins*, p. 40, under no. 25, n. 8.
Exhibited: Walters Art Gallery, Baltimore (Hill, *Metalware*, no. 26, illus.).

437. Oinochoe (96.708)
Krauskopf, *Supplemento Annali*, p. 332, n. 49, pl. 44, fig. 20; Bruschetti, *Lampadario*, p. 65, pl. 26a; MFA *Calendar*, May 1981, illus.; Rotroff, *Agora*, p. 34, n. 81.

438. Oinochoe (01.7485)
A. Hermary, in *LIMC*, vol. 3, pt. 1, p. 931, no. 985.

440. Oinochoe (solid) (96.668)
Petit, *Dutuit*, p. 181, under no. 98, n. 2; T. Weber, in Bol and Weber, *Bildwerke*, pp. 83–84, under no. 40.

441. Volute Krater (99.483)
Lohmann, *Grabmäler*, p. 140, n. 1150; K. Schauenburg, in Hornbostel, *Gräbern*, p. 201, under no. 116; M.W. Stoop, *BABesch* 55 (1980), pp. 166–167; Rotroff, *Agora*, p. 34, n. 81; M. Pfrommer, *JdI* 98 (1983), p. 248.

443. Olpe (99.482)
L.D. Caskey and J.D. Beazley, *Attic Vase Paintings in the Museum of Fine Arts, Boston*, pt. 1 (London and Boston, 1931), p. 21, fig. 20; J. Vocotopoulou, *BCH* 99 (1975), pp. 742, 777, n. 156; I. Krauskopf, *Prospettiva* 20 (1980), p. 14, n. 1; A. Calinescu, in *The Art of South Italy: Vases from Magna Graecia* (Richmond, 1982), p. 153, under no. 61.

444. Olpe (99.485)
M. Pfrommer, *JdI* 98 (1983), pp. 240–241, fig. 2.

449. Aryballos (99.480)
Höckmann, *Kessel*, p. 39, under no. 93; Hornbostel, *Schätze*, p. 104, under no. 75.
Exhibited: Brockton Art Center (Morgan, *Ancient Mediterranean*, pp. 25–26, no. 19); Danforth Museum, Framingham, "The Mediterranean World," September 1977–March 1978.

450. PEAR-SHAPED VASE
(PERIRRHANTERION) (98.693)
A. Andrioménou, BCH 99 (1975), p. 571; D.
von Bothmer, in Notable Acquisitions, 1982–
1983, The Metropolitan Museum of Art, p. 9;
J.R. Green, in Greek Vases in The J. Paul Getty
Museum 3 (Occasional Papers on Antiquities 2,
Malibu, 1986), p. 121, n. 20.
Exhibited: Brockton Art Museum (Herrmann,
Shadow, pp. 13, 77, no. 141, illus.).

451A. HANDLE OF A LIBATION DISH
(69.956)
K.P. Erhart, in Mildenberg Collection, pp. 137–
138, under no. 115; M. Martelli, in Festschrift
Arias, p. 188, n. 22.

452. HANDLE OF A PATERA:
WOLF'S HEAD TERMINAL (99.474)
L.Y. Rahmani, Israel Exploration Journal 31
(1981), p. 195, n. 19.

454–455. INKWELLS AND LIDS (65.910, 911)
Mitten, Classical Bronzes, p. 160, under no. 45,
n. 1; Hamdorf, Olympia, p. 207, n. 27.
Exhibited: Brockton Art Center (Morgan,
Ancient Mediterranean, p. 56, no. 87); Danforth
Museum, Framingham, "The Mediterranean
World," September 1977–March 1978.

456. MONEY BOX, FOR VOTIVE
OFFERINGS (61.102)
L.R. Laing, Coins and Archaeology (New York,
1970), p. 59; C. Vermeule, Gnomon 47 (1975),
p. 221.

Graeco-Roman and Roman Vessels

457. FOOT OF A CISTA (98.681)
Petit, Dutuit, p. 143, under no. 74, n. 9.

460. HANDLE OF A CALYX KRATER
(99.477)
Haynes, Etruscan Bronzes, p. 308, under no.
167.

461. VERTICAL HANDLE (99.473)
Hornbostel, Gräbern, p. 268, under no. 151.

464. OINOCHOE (99.486)
C. Rolley, AJA 78 (1974), p. 98.
Exhibited: Walters Art Gallery, Baltimore (Hill,
Metalware, no. 27, illus.).

466. OINOCHOE (24.958)
C. Rolley, AJA 78 (1974), p. 98.

467. OINOCHOE (08.539)
C. Rolley, AJA 78 (1974), p. 98.

470. ASKOS (08.250)
Hill, Metalware, under no. 36; Hornbostel,
Schätze, p. 105, under no. 76; Hayes, Metal-
ware, p. 71, under no. 112.

471. ASKOS (24.366)
Hayes, Metalware, p. 65, under no. 101.

472. BASIN WITH TWO HANDLES AND
RELIEF MEDALLION (24.979)
V. Mitsopoulou-Leon, AAA 10 (1977), p. 301,
no. 6; L. Guimond, in LIMC, vol. 1, pt. 1, pp.
460 (no. 68), 467; vol. 1, pt. 2, pl. 355; H.
Williams, Kenchreai: Eastern Port of Corinth,
vol. 5: The Lamps (Leiden, 1981), p. 17, under
no. 55; M. Pfrommer, GettyMusJ 13 (1985),
pp. 12–13, fig. 3; idem, IstMitt 35 (1985), p.
176, n. 27.

473. TWO-HANDLED DISH (08.247)
J.W. Hayes, Supplement to Late Roman Pottery
(London, 1980), p. liv; idem, Metalware, p.
124, under no. 196.
Exhibited: Brockton Art Center (Morgan,

Ancient Mediterranean, pp. 50–51, no. 73);
Danforth Museum, Framingham, "The Mediter-
ranean World," September 1977–March 1978.

476. SITULA WITH COVER (01.7522a,b)
K. Schauenburg, AA, 1981, p. 463, n. 4; J.M.
Turfa, PBSR 50 (1982), p. 173, under no. 25.

477. BELL-SHAPED SITULA (65.394)
G. Zahlhaas, Hamburger Beiträge zur Ar-
chäologie, vol. 1, pt. 2 (1971), p. 128, n. 36; K.
Schauenburg, AA, 1981, p. 463, n. 4; G. Zahl-
haas and H. Fuchs, ibid., p. 581.

479. COOKING VESSEL (?) (63.2644)
A. Giuliano, in Il Tesoro di Lorenzo il Mag-
nifico: Le gemme (Florence, 1973), p. 33; S.A.
Goldblith and J.A. Clark, The Red Devil, June
1975, p. 11, illus.; C. Vermeule, Swiss Numis-
matic Review 54 (1975), p. 9, entry d; G. Sena
Chiesa, Gemme di Luni (Rome, 1978), p. 17, n.
26; Vermeule, North Carolina Bulletin, pp.
26–27, 38, fig. B.

480. BOTTLE (12.794)
Höckmann, Kassel, p. 39, under no. 93;
Hornbostel, Schätze, p. 104, under no. 75;
Hayes, Metalware, pp. 93–94, under no. 147.

483. INCENSE BOWL (58.704)
Exhibited: Museum of Fine Arts, Boston (Ro-
mans and Barbarians, p. 118, no. 128, illus.).

485. CYLINDER AND COVER:
PROBABLY AN INKWELL (84.83a,b)
Hamdorf, Olympia, p. 207, n. 27.

486. AMPULLA: SEATED BEAR (62.1203)
D.A. Amyx, in Amyx and Forbes, Echoes,
suppl., p. 29, under no. 38; Mitten, Classical
Bronzes, p. 64, under no. 19, n. 4; A.P. Kozloff,
Bulletin of the Cleveland Museum of Art (March
1976), pp. 86–87, fig. 26.
Exhibited: Museum of Fine Arts, Boston (Ro-
mans and Barbarians, p. 119, no. 131, illus.).

487. LAMP (60.1451)
M.C. Gualandi Genito, Lucerne Fittili delle
Collezioni del Museo Civico Archeologico di
Bologna (Bologna, 1977), p. 184, n. 11; D.G.
Mitten, in Mildenberg Collection, p. 197, under
no. 185; N.V. Mele, Catalogo delle Lucerne in
Bronzo (Museo Nazionale Archeologico di
Napoli) (Rome, 1981), p. 81, n. 10.

488. LAMP (72.392)
A. Andrioménou, BCH 99 (1975), p. 561, n.
80; de' Spagnolis and De Carolis, MNR
Lucerne, p. 85, under inv. no. 72108.

489. LAMP (24.967)
Hornbostel, Schätze, p. 101, under no. 71;
Leibundgut, Westschweiz, p. 119, under no.
150, n. 2; Hornbostel, Gräbern, p. 266, under
no. 150; de' Spagnolis and De Carolis, MNR
Lucerne, p. 45, n. 9; Menzel, Bonn, p. 165,
under no. 460, n. 1; D.G. Mitten, in Mildenberg
Collection, Supplement, p. 33, under no. II:152;
A. Oliver, Jr., in Bastis Collection, p. 229 (as
24.976).

491. LAMP (06.1925)
De' Spagnolis and De Carolis, MNR Lucerne, p.
12, under inv. no. 256290; S. Fischer and M.-T.
Welling, Boreas 7 (1984), p. 394, under no. 4.
Exhibited: Walters Art Gallery, Baltimore (Early
Christian, p. 63, no. 242, pl. 38); Museum of
Fine Arts, Boston (Romans and Barbarians, p.
178, no. 198, illus.).

493. LAMP (88.629)
Exhibited: Brockton Art Center (Morgan,
Ancient Mediterranean, p. 49, no. 66); Danforth
Museum, Framingham, "The Mediterranean
World," September 1977–March 1978.

495. LAMP (85.229)
Vermeule, North Carolina Bulletin, p. 39, under
no. 4.

498. LAMP: DOVE OR PARTRIDGE (64.2171)
Mitten, Classical Bronzes, p. 196, under no. 69.
Exhibited: Museum of Fine Arts, Boston (Ro-
mans and Barbarians, p. 178, no. 197, illus.).

501. PENDANT CROSS SUPPORT (64.704)
Exhibited: Museum of Fine Arts, Boston (Ro-
mans and Barbarians, p. 184, no. 210, illus.).

Etruscan Vessels

505. VASE: HEAD OF APHRODITE (98.682)
Hornbostel, Etrusker, p. 103, under no. 124.

507. HANDLE OF AN AMPHORA (99.464)
O.-H. Frey, Hamburger Beiträge zur Ar-
chäologie, vol. 1, pt. 2 (1971), p. 99, n. 5;
Bruschetti, Lampadario, pp. 43–44, pl. 18c.

509. HANDLE, PROBABLY OF A STAMNOS
(64.280)
M. Maass, AntK 26 (1983), p. 10, n. 26.

510. HANDLE OF A STAMNOS (01.7488)
E. Hostetter, RM 85 (1978), pp. 273–275, 278,
280, pl. 116, fig. 1; Haynes, Etruscan Bronzes,
p. 306, under no. 163; Hostetter, Spina, pp.
24–26, under no. 4, pl. 8a.

511. HANDLE (04.3)
W.M. Whitehill, Museum of Fine Arts Boston:
A Centennial History (Cambridge, Mass., 1970),
p. 137; U. Liepmann, Niederdeutsche Beiträge
zur Kunstgeschichte 11, pp. 11–12, 14, 16–18,
no. 3, illus.; Hoffmann, Ten Centuries, p. 193,
under no. 90; Hostetter, Spina, pp. 27–28,
under no. 5; De Puma, Tomb-Groups, p. 97, n.
78; H. Gabelmann, in LIMC, vol. 3, pt. 1, p.
735, under no. 89.

512. PAIR OF HANDLES FROM A STAMNOS
(60.232a,b)
U. Liepmann, Niederdeutsche Beiträge zur
Kunstgeschichte 11, pp. 11–12, 14, 16–19, nos.
7–8, illus.; Hoffmann, Ten Centuries, p. 193,
under no. 90; J. Chamay, in Dörig, Art Antique,
under no. 265; Brommer, Denkmälerlisten, vol.
3, p. 107, no. 1; Schefold, Göttersage, pp. 294,
359, n. 639; Hostetter, Spina, pp. 27–28 (under
no. 5), 187, 219 (no. 6), pl. 9c–e; H. Gabel-
mann, in LIMC, vol. 3, pt. 1, pp. 735–736 (no.
89), 738; vol. 3, pt. 2, pl. 560.

513. HANDLE OF A JUG (OINOCHOE)
(63.788)
Hoffmann, Ten Centuries, p. 188, under no. 86;
M. Cristofani Martelli, Civiltà Arcaica dei
Sabini nella Valle del Tevere, vol. 3 (Rome,
1977), p. 40, n. 96.

515. LONG-SPOUTED
JUG (BEAKED OINOCHOE) (96.711)
Williams, Johns Hopkins, p. 53, under no. 37,
n. 5.

516. JUG WITH HIGH HANDLE (ROUND
MOUTHED OINOCHOE) (95.71)
J. Vocotopoulou, BCH 99 (1975), p. 759, n.
93; Hornbostel, Schätze, p. 88, under no. 58;
idem, Gräbern, p. 246, under no. 139; J.M.
Turfa, PBSR 50 (1982), p. 172, under no. 22;
Falconi Amorelli, Pesaro, p. 129, under no. 138.

517. PITCHER OR JUG (08.540)
J. Vocotopoulou, BCH 99 (1975), p. 759, n.
93; Krauskopf, Supplemento Annali, p. 326, n.
28; M. Maass, AntK 26 (1983), p. 8, n. 18.

519. TOY OINOCHOE (22.727)
Falconi Amorelli, *Pesaro*, p. 99, n. 71; T. Weber, in Bol and Weber, *Bildwerke*, p. 83, under no. 40.

520. SITULA AND COVER (91.228a,b)
K. Schauenburg, *JdI* 84 (1969), p. 36, n. 36; Hill, *Metalware*, under no. 5; H. von Hesberg, *Konsolengeisa des Hellenismus und der frühen Kaiserzeit* (*RM*, suppl. 24, Mainz, 1980), p. 140, n. 700; I. Caruso, *RM* 88 (1981), p. 96; K. Schauenburg, *AA*, 1981, p. 463, n. 4; Hayes, *Metalware*, p. 30, under no. 34; Haynes, *Etruscan Bronzes*, p. 307, under no. 165.

522. HANDLE BASES OF A SITULA (63.1516a,b)
Krauskopf, *Supplemento Annali*, p. 335, n. 60, pl. 45, fig. 24; Nardi, *Orte*, p. 271.

523. CISTA WITH COVER (93.1439a,b)
E. Macnamara, *Everyday Life of the Etruscans* (London, 1973), pp. 116–118, fig. 70A (part of contents); C. Rolley, *AJA* 78 (1974), p. 98; Carter, *Taras*, pp. 26–27; Krauskopf, *Supplemento Annali*, p. 335, n. 60; Mitten, *Classical Bronzes*, p. 146, n. 20; Foerst, *Gravierungen*, p. 8, n. 21; R.D. DePuma, *AJA* 84 (1980), p. 112; I. Caruso, *RM* 88 (1981), p. 96; G. Camporeale, in *LIMC*, vol. 1, pt. 1, p. 206, no. 91; K.P. Erhart, in *Mildenberg Collection*, p. 139, under no. 116; N.T. de Grummond, in de Grummond, *Etruscan Mirrors*, p. 176, n. 65.

525. TWO FEET OF A CISTA (99.466a,b)
C. Rolley, *AJA* 78 (1974), p. 98; F. Jurgeit, in *Festschrift Hampe*, pp. 270, 272, 275–277, no. L1, entry 1–2, pl. 59, fig. 3; I. Krauskopf, in *LIMC*, vol. 2, pt. 1, p. 783, no. 60; F. Jurgeit, in *LIMC*, vol. 3, pt. 1, pp. 1075 (no. 40), 1077; vol. 3, pt. 2, p. 738.

526. THREE FEET OF A CISTA (99.475a–c)
W. Gauer, *AM* 99 (1984), p. 52, n. 81; Haynes, *Etruscan Bronzes*, p. 288, under no. 117.

527. JAR (99.484)
I. Krauskopf, *Prospettiva* 20 (1980), pp. 10–11; Nardi, *Orte*, p. 209.

528. BOWL (97.499)
De Puma, *Tomb-Groups*, p. 49, n. 65.

529. SUPPORT: GIRL (98.679)
Hoffmann, *Ten Centuries*, p. 193, under no. 90; Di Stefano, *Palermo*, p. 95, under no. 170; *Masterpieces*, no. 17, color illus.; M.A. Del Chiaro, in A.J. Heisserer, ed., *Classical Antiquities: The Collection of the Stovall Museum of Science and History: The University of Oklahoma* (Norman and London, 1986), pp. 74–75, under no. 121; Hostetter, *Spina*, p. 28, under no. 5.

Bronze-Age Weapons

533. SWORD (61.376)
Paoletti, *Archivio*, p. 58, n. 51.

534. SHORT SWORD OR DAGGER (64.511)
Petit, *Dutuit*, p. 34, under no. 2, n. 1.

538. DOUBLE AX (64.515)
Liepmann, *Skulpturen*, p. 104, under no. B1; Hornbostel, *Gräbern*, p. 1, under no. 1.

Cypriote Weapons, Tools, etc.

539, 544, 549, 556, 559, 561, 562, 572, 573.
DAGGERS, SPEAR HEAD,
ARROWHEAD, TOOLS OR TWEEZERS
(72.401, 72.404, 72.4888, 72.400, 72.410, 72.4898, 72.4899, 72.387, 72.4889)

Vermeule, *Prehistoric through Perikles*, pp. 210, 280, fig. 57.

566–578. TWEEZERS (72.381, 72.4873, 72.382, 72.383, 72.386, 72.4874, 72.387, 72.4889, 72.388, 72.4872, 72.4871, 72.414, 72.416)
A. Dierichs, *Boreas* 8 (1985), p. 25, n. 110 (566–578), n. 111 (566.571).

Greek, Etruscan, and Roman Tools, Weapons, etc.

581. HELMET (98.664)
Kendall, *Nuzi*, p. 214, n. 45.

582. HELMET (48.498a–d)
J.H. Turnure, *AJA* 69 (1965), p. 45; F. Johansen, *Reliefs en Bronze d'Étrurie* (Copenhagen, 1971), p. 39, n. 8; Korres, *Kephalon*, p. 64, n. 6; Kendall, *Nuzi*, p. 214, n. 45; Williams, *Johns Hopkins*, p. 39, under no. 24, n. 1.

583. HELMET FRAGMENT (01.7479)
P. Cartledge, *JHS* 97 (1977), p. 14, n. 25; Williams, *Johns Hopkins*, p. 39, under no. 24, n. 8.

584. GREAVE (98.665)
Exhibited: Brockton Art Center (Morgan, *Ancient Mediterranean*, p. 28, no. 24); Danforth Museum, Framingham, "The Mediterranean World," September 1977–March 1978.

585. CHESTPIECE (64.727)
G. Jaculli, in *Prima Italia: Arts italiques du premier millénaire avant J.C.* (Brussels, 1980), p. 225, under no. 147; Stary, *Eisenzeitlichen*, p. 339, n. 423.

586. HELMET (61.375)
Paoletti, *Archivio*, p. 58, n. 51; Kendall, *Nuzi*, p. 214, n. 45.

587. GREAVE (61.377)
Paoletti, *Archivio*, p. 58, n. 51.

588, 589. STRIGILS (61.378, 379)
M. Ohly-Dumm, *MJb* 24 (1973), p. 245, n. 11; P. Santoro, *NSc* 31 (1977), p. 251, under no. 8; Paoletti, *Archivio*, pp. 49 (n. 23), 58 (n. 51); Hornbostel, *Gräbern*, p. 173, under no. 101.

589A. HELMET OF PHRYGIAN TYPE (69.1077)
H. Hoffmann, *AA*, 1974, p. 60, under no. 14; Hornbostel, *Gräbern*, p. 10, under no. 10; H.P. Laubscher, in *Festschrift Hampe*, p. 232, n. 26; Kendall, *Nuzi*, p. 214, n. 45; J. Vokotopoulou, *AA*, 1982, pp. 506 (no. 11), 518; J.M. Cody, in *Hunt Collections*, p. 112, under no. 35.

589B. HELMET (69.1075)
H. Bloesch, in *Mélanges d'histoire ancienne et d'archéologie offerts à Paul Collart* (Lausanne, 1976), p. 85, n. 9; Kendall, *Nuzi*, p. 214, n. 45.

589C. HELMET (1970.35)
A. Krug, in *Festschrift Brommer*, p. 212, n. 44; G. Hafner, *Rivista di Archeologia* 1 (1977), p. 42, n. 16; Kendall, *Nuzi*, pp. 213–214, n. 45.

591. TWO LION'S HEADS (57.749, 57.750)
Petit, *Dutuit*, p. 120, under no. 50, n. 1.

592. DAGGER AND SHEATH (03.998a,b)
H. Müller-Karpe, *Prähistorische Bronzefunde*, vol. 20, pt. 1, *Beiträge zu italienischen und griechischen Bronzefunden* (Munich, 1974), pp. 56, 73, pl. 16, D; J.W. Hayes, *Studi Etruschi* 43 (1975), p. 84, under no. 22, n. 25.

593. MACE HEAD (65.1335)
H.-G. Buchholz, in H.-G. Buchholz, St. Foltiny, and O. Höckmann, *Kriegswesen*, pt. 2 (*Archaeologia Homerica*, vol. 1, ch. E, Göttingen, 1980), p. E322, n. 1931.

Exhibited: Museum of Fine Arts, Boston (*Romans and Barbarians*, p. 75, no. 106, illus.).

596. ARROWHEAD (84.570)
J.T. Clarke, *Report on the Investigations at Assos, 1882, 1883* (New York, 1898), pp. 44–45, fig. 2.
Exhibited: Brockton Art Center (Morgan, *Ancient Mediterranean*, p. 27, no. 23); Danforth Museum, Framingham, "The Mediterranean World," September 1977–March 1978.

603. FISH HOOK (88.8)
NSc 28 (1974), suppl., p. 267, under no. 256.

604. ASPERGILLUM (99.497)
S. Drougou, *AA*, 1979, p. 281, n. 48.

605. LADLE (90.187)
Mitten, *Classical Bronzes*, p. 153, under no. 41, n. 2; S. Drougou, *AA*, 1979, p. 281, n. 48.
Exhibited: Brockton Art Center (Morgan, *Ancient Mediterranean*, p. 49, no. 67, fig. 23); Danforth Museum, Framingham, "The Mediterranean World," September 1977–March 1978. Compare a similar ladle in *The Swedish Cyprus Expedition*, vol. 2 (Stockholm, 1935), p. 272, no. 43, pl. 154, from tomb 34 at Marion, dated Cypro-Classical II, and another example at the Higgins Armory, Worcester, Mass. (both references provided by Jane Barlow).

606. LADLE (52.58)
J.W. Hayes, *Studi Etruschi* 43 (1975), p. 78, under no. 14; idem, *Metalware*, p. 41, under no. 48.

607. STRAINER (99.498)
S.A. Goldblith and J.A. Clark, *The Red Devil*, June 1975, p. 10, illus.; *I Galli e L'Italia* (Rome, 1978), p. 169, under n. 6; Hayes, *Metalware*, p. 31, under no. 35.
Exhibited: Cooper-Hewitt Museum, New York ("Wine: Celebration and Ceremony," 4 June–13 October 1985).

608. HARPAGO OR MEAT HOOK (99.496)
S.A. Goldblith and J.A. Clark, *The Red Devil*, June 1975, p. 10, illus.; Hornbostel, *Etrusker*, p. 106, under no. 128; De Puma, *Tomb-Groups*, p. 92, n. 67.

609. HOOK (84.84)
Waldbaum, *Metalwork*, p. 102, under no. 600.

612. STRIGIL (01.7478)
M. Ohly-Dumm, *MJb* 24 (1973), p. 245, n. 11; Paoletti, *Archivio*, pp. 49 (n. 23), 53 (n. 34); H. Marwitz, *AntK* 22 (1979), p. 74, n. 14.

613. STRIGIL (03.1152)
Paoletti, *Archivio*, pp. 49 (n. 23), 55; H. Marwitz, *AntK* 22 (1979), p. 74, n. 14.

614. STRIGIL (90.186)
M. Ohly-Dumm, *MJb* 24 (1973), p. 245, n. 11; Paoletti, *Archivio*, p. 49, n. 23; H. Marwitz, *AntK* 22 (1979), pp. 74–75, n. 14; P.C. Bol, in Bol and Weber, *Bildwerke*, p. 108, under no. 53.
Exhibited: Brockton Art Center (Morgan, *Ancient Mediterranean*, p. 25, no. 18); Danforth Museum, Framingham, "The Mediterranean World," September 1977–March 1978.

615. STRIGIL (52.191)
M. Ohly-Dumm, *MJb* 24 (1973), p. 245, n. 11; Cristofani, *Volterra*, p. 256; Paoletti, *Archivio*, p. 49, n. 23; H. Marwitz, *AntK* 22 (1979), p. 74, n. 14.

616. STRIGIL (66.932)
Paoletti, *Archivio*, p. 49, n. 23; H. Marwitz, *AntK* 22 (1979), p. 74, n. 14.

617. STRIGIL HANDLE (84.85)
Cristofani, *Volterra*, p. 256; Paoletti, *Archivio*,

p. 49, n. 23; H. Marwitz, *AntK* 22 (1979), p. 74, n. 14.

618. STRIGIL HANDLE (84.568)
Paoletti, *Archivio*, p. 49, n. 23; H. Marwitz, *AntK* 22 (1979), p. 74, n. 14; Vermeule, *Prehistoric through Perikles*, pp. 210, 280, fig. 57.

619. STRIGIL (88.617)
Paoletti, *Archivio*, p. 49, n. 23; H. Marwitz, *AntK* 22 (1979), p. 74, n. 14.

621. TWO CYMBALS OR CASTANETS (65.1346, 1347)
B. Rutkowski, *JdI* 94 (1979), p. 186, n. 45. Exhibited: Brockton Art Center (Morgan, *Ancient Mediterranean*, p. 53, no. 78); Danforth Museum, Framingham, "The Mediterranean World," September 1977–March 1978.

622. CYMBALS (96.670)
B. Fellmann, *Frühe olympische Gürtelschmuckscheiben aus Bronze* (*Olympische Forschungen*, vol. 16, Berlin, 1984), p. 101.

623–625. PLECTRUM HANDLES (Res. 08.32q, Res. 08.32h, Res. 08.32i)
Himmelmann, *Alexandria*, p. 74, n. 265.

626. TWEEZERS (01.7511a,b)
W.M. Whitehill et al., *In Tribute to Suzanne E. Chapman* (Boston, 1970), illus.; A. Dierichs, *Boreas* 8 (1985), pp. 26 (fig. 8a-b), 28, 30.

627. TWEEZERS (Res. 08.37)
Mitten, *Classical Bronzes*, p. 168, under no. 51, n. 2.

628. TWEEZERS (65.1345)
Exhibited: Brockton Art Center (Morgan, *Ancient Mediterranean*, p. 43, no. 48, fig. 19); Danforth Museum, Framingham, "The Mediterranean World," September 1977–March 1978; Museum of Fine Arts, Boston (*Romans and Barbarians*, p. 179, no. 201, illus.).

629–637. SURGICAL INSTRUMENTS (13.160–168)
J. Chamay, in Dörig, *Art Antique*, under no. 366.

638. KEY (01.7515)
NSc 26 (1972), suppl., p. 123, under no. 227; E. Bielefeld, in *Festschrift Homann-Wedeking*, p. 56, n. 6; M. Guarducci, *Epigrafia Greca*, vol. 4 (Rome, 1978), p. 291, fig. 83; Philipp, *Bronzeschmuck*, pp. 24 (n. 113), 223–224 (n. 428); Weill, *Études Thasiennes*, p. 54, n. 8; V. Mitsopoulos-Leon, *JOAI* 56 (1985), p. 94, n. 17.

639. KNUCKLEBONE (65.1184)
Exhibited: Brockton Art Center (Morgan, *Ancient Mediterranean*, p. 54–55, no. 82); Danforth Museum, Framingham, "The Mediterranean World," September 1977–March 1978.

641. STEELYARD WEIGHT (58.16)
D.A. Amyx, in Amyx and Forbes, *Echoes*, suppl., p. 24, under no. 30; Raftopoulou, *Études Delphiques*, pp. 415 (fig. 6), 416 (n. 21); D.K. Hill, in *Festschrift von Blanckenhagen*, p. 250, n. 20; J.S. Crawford, *AJA* 83 (1979), p. 478, n. 3; H. Philipp, *AM* 94 (1979), p. 138, n. 5; S.G. Miller, *Two Groups of Thessalian Gold* (University of California Publications in Classical Studies 18, Berkeley, 1979), p. 35, n. 214; Petit, *Dutuit*, pp. 46 (under no. 7, n. 19), 201 (under no. 114, n. 2); Eğilmez, *Artemis*, pp. 164–165; C.E. Vafopoulou-Richardson, *Greek Terracottas* (Ashmolean Museum, Oxford, 1981), p. 34, under no. 34; Von Hesberg, *Aufstieg*, p. 1153; Waldbaum, *Metalwork*, p. 80, n. 46; L. Kahil and N. Icard, in *LIMC*, vol. 2, pt. 1, p. 683, no. 816; vol. 2, pt. 2, pl. 508; B. Barr-Sharrar, *AJA* 89 (1985), p. 689, n. 2; idem, *Decorative Bust*,

pp. 48 (no. C60), 49 (under no. C64), 91, 93–94, pl. 20.

642. STEELYARD WEIGHT (60.153)
D.A. Amyx, in Amyx and Forbes, *Echoes*, suppl., p. 24, under no. 30; W.D. Wixom, *GESTA* 15, nos. 1 and 2 (1976), pp. 275 (fig. 4), 277; D.K. Hill, in *Festschrift von Blanckenhagen*, p. 250, n. 20; H. Philipp, *AM* 94 (1979), p. 138, n. 9; Hornbostel, *Gräbern*, p. 270, under no. 154; Von Hesberg, *Aufstieg*, p. 1153; Waldbaum, *Metalwork*, p. 80, n. 46.

643. STEELYARD WEIGHT (59.653)
G.M.A. Hanfmann, in *Opus Nobile, Festschrift zum 60. Geburtstag von Ulf Jantzen* (Wiesbaden, 1969), p. 67, n. 26; D.A. Amyx, in Amyx and Forbes, *Echoes*, suppl., p. 24, under no. 30; W.D. Wixom, *GESTA* 15, nos. 1 and 2 (1976), p. 275, n. 7; J.S. Crawford, *AJA* 83 (1979), p. 478, n. 3; H. Philipp, *AM* 94 (1979), p. 138, n. 9; Hornbostel, *Gräbern*, p. 270, under no. 154; Von Hesberg, *Aufstieg*, p. 1153; Waldbaum, *Metalwork*, p. 80, n. 46; Barr-Sharrar, *Decorative Bust*, pp. 15–16, 51 (no. C74), 91, 95, pl. 24.

644. STEELYARD WEIGHT (59.961)
D.A. Amyx, in Amyx and Forbes, *Echoes*, suppl., p. 24, under no. 30; C.W.J. Eliot, *Hesperia* 45 (1976), pp. 167–168; Vermeule, *Roman Art*, pp. 180, 203, 419, fig. 199; Von Hesberg, *Aufstieg*, p. 1153; Waldbaum, *Metalwork*, p. 80, n. 46.
Exhibited: Museum of Fine Arts, Boston (*Romans and Barbarians*, p. 177, no. 194, illus.).

645. SUPPORT FOR A CROSS (63.789)
W. Eckhardt, in *Museum für Kunst und Gewerbe Hamburg Bildführer 3. Erwerbungen 1962–1971* (Hamburg, 1972), p. 143, under no. 74.

Miscellaneous Greek and Graeco-Roman Objects

646. CADUCEUS (01.7501)
D.G. Mitten, in *Mildenberg Collection*, p. 129, under no. 108.

661. CRADLE (96.671)
Herrmann, *Shadow*, p. 55, under no. 68.

662. TRIPOD FIXTURE OR FOOTSTOOL SUPPORT (03.1656)
A. Pariente, *BCH* 108 (1984), p. 304, n. 6.

663. PAIR OF SUPPORTS FOR A FOOTSTOOL (67.609–610)
A. Pariente, *BCH* 108 (1984), p. 304, n. 6.

665. SPOUT: LION'S HEAD (99.499)
Vermeule and Neuerburg, *Getty Catalogue*, p. 18, under no. 34, n. 1.

666. SPOUT: PANTHER'S HEAD (01.7519)
Di Stefano, *Palermo*, p. 114, under no. 211; Vermeule and Neuerburg, *Getty Catalogue*, p. 18, under no. 34, n. 1.

669. BOAR'S HEAD (03.985)
Vermeule and Neuerburg, *Getty Catalogue*, p. 18, under no. 34, n. 1.

670. CARPENTUM OR CHARIOT POLE: FOREPART OF A BOAR (60.1392)
Vermeule and Neuerburg, *Getty Catalogue*, p. 18, under no. 34, n. 1.

671. REIN GUIDE FROM A CARPENTUM OR CHARIOT (03.983)

F. Vian, in *EAA*, vol. 3, p. 891; C. Roring, *Untersuchungen zu römischen Reisewagen* (Koblenz, 1983), p. 163, no. 13 (to hold belt to suspend carriage).
Exhibited: Museum of Fine Arts, Boston (*Romans and Barbarians*, p. 62, no. 83, illus.).

672. HANDLE OF A CHEST: STYLIZED LION'S HEAD (59.654)
R. Lullies, *AA*, 1972, p. 21, under no. 22; G. Koch, *AA*, 1977, p. 111, n. 2; Petit, *Dutuit*, p. 120, under no. 50, n. 1.

673. HANDLE OF A CHEST: LION'S HEAD (61.1235)
CJ 64 (1969), p. 186, illus.; *CJ* 65 (1970), p. 181, illus.; G. Koch, *AA*, 1977, p. 111, n. 2; Petit, *Dutuit*, p. 120, under no. 50, n. 1.

674. LION'S HEAD FROM A SARCOPHAGUS (63.631)
G. Koch, *AA*, 1977, p. 111, n. 2; Petit, *Dutuit*, p. 120, under no. 50, n. 1.

Miscellaneous Etruscan, Italian, and Roman Objects

688. THIN BAND WITH STAMPED DECORATION: BATTLE OF THE GODS AND THE GIANTS (01.7528)
G.M.A. Hanfmann, *AJA* 41 (1937), pp. 113–114; F. Vian, in *EAA*, vol. 3, p. 889, fig. 1106; M.A. Del Chiaro, *AA*, 1970, pp. 347, 349 (fig. 4), 350 (n. 16); Brommer, *Denkmälerlisten*, vol. 1, p. 53; R.O. Carlucci, *AJA* 82 (1978), p. 546, n. 7; Steingräber, *Möbel*, p. 193, no. 4; G. Camporeale, in *LIMC*, vol. 1, pt. 1, p. 448, no. 4; vol. 1, pt. 2, pl. 341; Stary, *Eisenzeitlichen*, p. 404, no. 1; G. Colonna, in *Festschrift Dohrn*, p. 37; idem, in *LIMC*, vol. 2, pt. 1, p. 1070, no. 235; Beck, *Ares*, pp. 88, 170, no. 202.

689. THIN BAND WITH STAMPED DECORATION: BATTLE OF THE GODS AND THE GIANTS (01.7529)
G.M.A. Hanfmann, *AJA* 41 (1937), pp. 113–114; Brommer, *Denkmälerlisten*, vol. 1, p. 53; Steingräber, *Möbel*, p. 193, no. 4; G. Camporeale, in *LIMC*, vol. 1, pt. 1, p. 448, no. 4; Stary, *Eisenzeitlichen*, p. 404, no. 1; G. Colonna, in *Festschrift Dohrn*, p. 37; idem, in *LIMC*, vol. 2, pt. 1, p. 1070, no. 235.

690. THIN BAND WITH STAMPED DECORATION: RUNNING FIGURES AND A HUNTING SCENE (01.7530)
Steingräber, *Möbel*, p. 193, no. 4; Oggiano-Bitar, *Bouches-du-Rhône*, p. 30, under no. 3.

691–695. DISCS FOR ARMOR (01.7502–7506)
Mitten, *Classical Bronzes*, pp. 87, 89, under no. 27, n. 5.

696. BUTTONS (88.624–627)
Exhibited: Brockton Art Center (Morgan, *Ancient Mediterranean*, p. 47, no. 62); Danforth Museum, Framingham, "The Mediterranean World," September 1977–March 1978.

699. PART OF SNAFFLE (88.623)
J.M. Turfa, *PBSR* 50 (1982), p. 183, under no. 70.

700–710. BRIDLE TRAPPINGS (00.622–625, 02.328–332, 06.2449, 92.2619)
J.W. Hayes, *Studi Etruschi* 43 (1975), p. 85, under no. 25, n. 26; Falconi Amorelli, *Pesaro*, p. 127, under no. 136 (nos. 700, 701, 703 only).

711. Boss of a Votive
Shield: Ram's Head (08.534)
Mitten, *Classical Bronzes*, p. 106, under no. 30;
Hornbostel, *Gräbern*, p. 245, under no. 138; J.
Neils, in *Mildenberg Collection*, p. 132, under
no. 110.

712. End of a Chariot
Pole: Lion's Head (55.497)
Höckmann, *San Mariano*, pp. 44 (under no. 9),
117.

Concordance
for *Sculpture in Stone*

Accession number	Catalogue number	Accession number	Catalogue number	Accession number	Catalogue number
72.322	420	97.288	121	04.14	37
72.323	433	97.289	15	04.15	234
72.325	441	98.641	144	04.16	65
72.326	436	98.642	70	04.17	72
72.327	427	99.122	51	04.283	59
72.328	447	99.338	215	04.284	358
72.329	454	99.339	18	06.1873	327
72.335	452	99.340	92	07.487	184
72.336	450	99.341	48	08.205	30
72.732	107	99.343	321	08.288	16
76.715	252	99.344	329	08.537	38
76.718	270	99.345	333	Res.08.34a	206
76.729	253	99.346	347	Res.08.34b	235
76.734	198	99.347	330	Res.08.34c	115
76.738	164	99.348	354	Res.08.34d	116
76.740	295	99.349	357	10.70	56
76.742	315	99.350	166	10.71	404
76.743	264	99.351	167	10.72	405
76.745	200	00.304	155	10.74	397
76.748	268	00.305	52	10.76	395
76.750	273	00.306	173	10.77	403
76.755	302	00.307	26	10.79	399
76.756	210	00.311	324	10.159	31
84.35	343	00.312	10	10.160	113
84.53	280	01.8190	142	13.230	338
84.60	281	01.8191	337	13.2722	465
84.61	282	01.8192	69	13.2860	385
84.63	317	01.8193	362	13.4500	95
84.65	373	01.8194	39	14.733	139
84.67	19	01.8195	170	15.856	47
84.68	20	01.8196	171	16.62	135
84.70	348	01.8197	216	16.286	350
86.145	383	01.8198	50	17.324	98
88.346	332	01.8200	159	17.598	11
88.347	375	01.8201	35	18.424	136
88.349	370	01.8202	341	18.431	34
88.351	103	01.8203	151	18.436	79
88.638	322	01.8204	168	18.440	57
88.639	345	01.8205	236	18.441	104
88.641	334	01.8206	175	18.442	88
88.642	335	01.8207	130	18.443	297
88.643	339	01.8208	129	18.444	222
88.734	8	01.8210	112	19.318	81
89.3	203	01.8211	307	19.320	82
89.4	374	01.8212	24	22.593	29
89.5	346	01.8213	312	22.659	401
89.6	379	03.743	55	23.1	214
89.8	187	03.744	349	24.419	359
89.152	90	03.745	149	28.893	318
90.163	328	03.746	146	30.543	182
92.2583	247	03.747	305	34.113	355
92.2692	240	03.748	306	34.169	13
94.14	287	03.749	148	35.60	4
95.66	33	03.750	93	36.218	28
95.67	145	03.751	42	37.100	319
95.68	127	03.752	43	37.1152	114
96.682	396	03.753	23	38.1615	40
96.694	158	03.754	134	39.552	12
96.695	46	03.755	141	40.576	17
96.696	77	03.757	71	40.724	17
96.697	336	03.760	177	41.909	160
96.698	353	03.761	204	1946 App.	251
96.699	340	03.762	205	51.1404	32
96.702	299	04.10	14	52.1741	126
97.285	169	04.11	154	Res.53.63	213
97.286	91	04.12	44	58.584	248
97.287	163	04.13	119	58.1005	377

Accession number	Catalogue number	Accession number	Catalogue number
59.51	131	1971.782	150
59.336	237	1972.15	239
59.687	300	1972.34	128
59.715	140	1972.78	78
59.845	68	1972.203	301
59.846	192	1972.356	243
60.45	120	1972.391	89
60.928	369	1972.650	244
1960 App.	426	1972.864	74
61.130	387	1972.868	1
61.131	390	1972.869	2
61.1089	5	1972.899	122
61.1136	378	1972.918	325
61.1408	180	1972.971	125
61.1409	179	1973.165	292
62.1a, b	197	1973.169	67
62.465	381	1973.209	25
62.662	380	1973.212	368
62.793	391	1973.480	246
62.1187	245	1973.600	109
63.11	376	1974.122	143
63.120	105	1974.123	152
63.1040	75	1974.124	153
63.2683	106	1974.125	161
63.2756	388	1974.126	165
63.2757	389	1974.127	172
63.2758	392	1974.128	183
63.2759	393	1974.129	208
63.2760	344	1974.131	191
64.47	293	1974.522	157
64.703	275	1974.523	156
65.563	76	1974.581	127A
65.1727	367	1975.2	371
66.71	308	1975.292	356A
66.971	66	1975.359	244A
66.1076	102	1975.647	178A
67.758	3	1975.799	384
67.947	320	1976.6	104A
67.948	278	S 1236	316
67.1032	118	188-(?) gift	217
68.582	294	Ath. loan 1070a, b	384
68.623	249	Loan 1426	199
68.730	356	179.67	124
68.767	326	95.1970	398
68.770	196	1986.885	124
69.2	242		
69.27	342		
69.1223	288		
69.1255	290		
69.1256	291		
1970.241	219		
1970.242	189		
1970.243	310		
1970.267a, b	241		
1970.325	372		
1970.346	406		
1970.366	311		
1971.18	382		
1971.93	365		
1971.129	64		
1971.209	276		
1971.241	323		
1971.325	463		
1971.393	331		
1971.394	366		
1971.424	363		
1971.746	190		

Concordance
for *Greek, Etruscan and Roman Bronzes*

Accession number	Catalogue number	Accession number	Catalogue number	Accession number	Catalogue number
72.374	252	96.669	132	99.471	426
72.381	566	96.670	622	99.472	427
72.382	568	96.671	661	99.473	461
72.383	569	96.675	263	99.474	452
72.386	570	96.676–677	256	99.475	526
72.387	572	96.703	175	99.477	460
72.388	574	96.705	119	99.479	436
72.392	488	96.706	43	99.480	449
72.400	556	96.707	168	99.481	423
72.401	539	96.708	437	99.482	443
72.404	544	96.709	50	99.483	441
72.410	559	96.710	51	99.484	527
72.414	577	96.711	515	99.485	444
72.416	578	96.712	87	99.486	464
72.4439	84	96.713	217	99.488	28
72.4440	73	96.714	364	99.489	23
72.4452	403	96.716	356	99.490	75
72.4871	576	97.499	528	99.491	59
72.4872	575	98.643	264	99.492	360
72.4873	567	98.644	265	99.494	381
72.4874	571	98.645	267	99.495	382
72.4888	549	98.646	268	99.496	608
72.4889	573	98.647	271	99.497	604
72.4898	561	98.648	272	99.498	607
72.4899	562	98.650	3	99.499	665
81.196	431	98.651	351	00.313	65
81.197	432	98.653	178	00.622	700
81.333	253	98.654	179	00.623	701
84.83	485	98.655	180	00.624	702
84.84	609	98.657	21	00.625	703
84.85	617	98.658	19	01.7309	373
84.568	618	98.659	33	01.7467	383
84.570	596	98.660	195	01.7469	218
84.571	399	98.661	199	01.7470	219
85.229	495	98.662	198	01.7471	406
85.515	410	98.663	57	01.7472	408
87.7	97	98.664	581	01.7474	413
88.8	603	98.665	584	01.7475	46
88.613	157	98.667	355	01.7476	47
88.614	159	98.668	55	01.7478	612
88.615	156	98.669	52	01.7479	583
88.616	160	98.670	40	01.7480	42
88.617	619	98.671	361	01.7481	29
88.618	162	98.672	366	01.7482	197
88.619	163	98.673	362	01.7483	353
88.623	699	98.674	93	01.7484	96
88.624–627	696	98.675	134	01.7485	438
88.629	493	98.676	112	01.7486	34
90.186	614	98.677	139	01.7487	48
90.187	605	98.678	122	01.7488	510
90.238	255	98.679	529	01.7492	187
91.228	520	98.680	169	01.7494	370
92.2619	710	98.681	457	01.7497	54
92.2740	377	98.682	505	01.7499	354
93.1439	523	98.685	318	01.7501	646
94.44	257	98.686	378	01.7502	691
94.45	258	98.693	450	01.7503	692
95.71	516	99.458	402	01.7504	693
95.72	391	99.460	411	01.7505	694
95.73	376	99.461	416	01.7506	695
95.74	25	99.462	414	01.7507	41
95.75	64	99.463	415	01.7509	152
95.76	106	99.464	507	01.7511	626
96.663	136	99.466	525	01.7513	365
96.664	94	99.467	419	01.7514	368
96.665	36	99.468	358	01.7515	638
96.668	440	99.469	424	01.7516	363

Accession number	Catalogue number	Accession number	Catalogue number	Accession number	Catalogue number	Accession number	Catalogue number
01.7518	60	Res.08.32k	145	58.16	641	65.1184	639
01.7519	666	Res.08.32m	129	58.696	16	65.1292	6
01.7522	476	Res.08.32O	131	58.704	483	65.1316	5
01.7523	357	Res.08.32p	130	58.968	116	65.1335	593
01.7524	176	Res.08.32q	623	58.1189	4	65.1345	628
01.7528	688	Res.08.37	627	59.10	155	65.1346–1347	621
01.7529	689	10.162	434	59.11	82	66.9	433
01.7530	690	10.163	435	59.30	103	66.182	401
01.7531	288	10.166	80	59.298	123	66.251	30
01.7532	290	10.170	85	59.552	56	66.932	616
01.7533	289	12.794	480	59.653	643	66.951	95
01.8214	39	13.112	182	59.654	672	67.609–610	663
01.8375	107	13.128	337	59.692	100	67.627	172
01.8376	196	13.139	194	59.961	644	67.643	53
02.293	303	13.160	629	60.137	71	67.645	173
02.294	304	13.161	630	60.153	642	67.730	124
02.295	305	13.162	631	60.232	512	67.743	58
02.328	704	13.163	632	60.233	422	67.1025	96A
02.329	705	13.164	633	60.1392	670	67.1033	170A
02.330	706	13.165	634	60.1450	125	67.1034	172A
02.331	707	13.166	635	60.1451	487	67.1035	433A
02.332	708	13.167	636	61.102	456	67.1036	118A
03.983	671	13.168	637	61.375	586	67.1185	174A
03.985	669	13.182	63	61.376	533	68.39	150
03.986	128	13.207	387	61.377	587	68.41	213
03.987	67	13.2886	392	61.378	588	68.732	176A
03.988	109	13.2887	393	61.379	589	69.56	355A
03.990	98	13.2888	395	61.380	412	69.71	400A
03.991	385	15.859	161	61.1235	673	69.956	451A
03.992	372	15.860	158	61.1257	388	69.1075	589B
03.993	32	18.495	210	61.1258	389	69.1077	589A
03.996	27	18.501	212	62.188	421	69.1257	100A
03.997	15	18.502	206	62.511	7	1970.7	432A
03.998	592	18.503	209	62.971	74	1970.35	589C
03.999	429	18.506	200	62.978	72	1970.239	357A
03.1001	428	19.314	390	62.1105	420	1971.138	376A
03.1152	613	22.711	338	62.1203	486		
03.1656	662	22.712	339	62.1204	177		
04.3	511	22.713	340	63.631	674		
04.6	22	22.714	341	63.788	513		
04.7	352	22.723	301	63.789	645		
04.8	61	22.725	300	63.1039	66		
04.9	110	22.727	519	63.1516	522		
04.1713	114	22.730	298	63.2644	479		
05.59	367	22.731	299	63.2755	2		
06.1925	491	23.601	287	64.6	104		
06.2372	113	24.366	471	64.280	509		
06.2449	709	24.957	68	64.302	266		
08.247	473	24.958	466	64.303	425		
08.250	470	24.967	489	64.510	92		
08.253	386	24.979	472	64.511	534		
08.328	186	27.748	292	64.515	538		
08.371	140	34.42	83	64.702	174		
08.534	711	34.211	26	64.704	501		
08.535	111	34.223	49	64.727	585		
08.539	467	48.498	582	64.1460	11		
08.540	517	48.1093	400	64.2171	498		
Res.08.32a	141	50.144	407	64.2173	1		
Res.08.32b	133	51.2469	35	64.2197	220		
Res.08.32c	369	52.58	606	65.100	118		
Res.08.32d	143	52.185	215	65.101	8		
Res.08.32e	146	52.186	191	65.394	477		
Res.08.32f	138	52.189	91	65.462	121		
Res.08.32g	108	52.191	615	65.565	184		
Res.08.32h	624	54.145	20	65.910	454		
Res.08.32i	625	55.497	712	65.911	455		
Res.08.32j	144	57.749–750	591	65.1183	167		